ART SUBJECTS

ART SUBJECTS

MAKING ARTISTS

IN THE AMERICAN

UNIVERSITY

Howard Singerman

UNIVERSITY OF CALIFORNIA PRESS

Berkeley Los Angeles London

University of California Press
Berkeley and Los Angeles, California

University of California Press, Ltd.
London, England

© 1999 by
The Regents of the University of California

Library of Congress Cataloging-in-Publication Data

Singerman, Howard.
 Art subjects : making artists in the American university / Howard
Singerman.
 p. cm.
 Includes bibliographical references and index.
 ISBN 0-520-21500-1 (alk. paper).—ISBN 0-520-21502-8 (alk.
paper)
 1. Art—Study and teaching (Graduate)—United States.
 2. Universities and colleges—United States—Graduate work.
 I. Title.
 N346.A1S56 1999
 707'.1'173—dc21 98-41460

Printed in the United States of America

9 8 7 6 5 4 3 2 1

The paper used in this publication meets the mini-
mum requirements of American National Standard
for Information Sciences—Permanence of Paper for
Printed Library Materials, ANSI Z39.48-1984.

To my mother,
and in memory
of my father

CONTENTS

ACKNOWLEDGMENTS

It is customary to thank one's family last, but since they have lived with this book most intimately and worked for it the longest, there is no sense in making them wait any more. I owe immeasurable thanks to Lillian, Rosalie, and Janet Ray: their love, loyalty, understanding, good humor, and, above all, patience have allowed me to write it.

The book has been around for a very long time. I have been at work on this project—or on its problem—in one way or another since undergraduate school. I owe a great deal to Allan Jones, who, in the guise of teaching painting and printmaking at Antioch College, taught the problems and questions of being an artist. He insisted on thinking and talking, and was able to convey both the scope and seriousness of the issues raised by conceptual art and the necessity of a few square inches of red-orange on the surface of a Diebenkorn.

The question and I both were transformed many times over by a community of artists, critics, historians, and friends in Los Angeles: John Baldessari, Ellen Birrell, Al Boime, David Bunn, Chris Burden, Dorit Cypis, Sande Cohen, Craig Gilmore, Ruthie Wilson Gilmore, Ann Goldstein, Mike Kelley, Christopher Knight, Tom Lawson, Susan Morgan, Teri Pendlebury, Steve Prina, Lane Relyea, Alan Sekula, and Christopher Williams. Many I cannot thank enough, and I know there are others I have forgotten. Some of this book's arguments began to take a public shape in paragraphs of catalogue essays and lines of criticism as a way to

explain the art I saw there, and in many ways this book is about Los Angeles, its art world and its universities and my experience in them.

What distance I have gained on the topic can be credited to the University of Rochester, where it became a dissertation. Janet Wolff was the perfect dissertation director; her patient reading and judicious questions were invaluable. Michael Holly's kindness and her support of my work were crucial, as was her unflagging belief in my ability to finish. Other members of the University of Rochester faculty, past and present, deserve real thanks: Mieke Bal, Cristelle Baskins, Norman Bryson, Douglas Crimp, David Deitcher, Arch Miller, Kaja Silverman, and Michael Venezia. George Dimock, whose past was as long as mine when we returned to graduate school, is a remarkable and generous reader, and good friend. Along the New York State Thruway, I need to add Tony Conrad, at Buffalo; Hal Foster, then at Cornell; and Sherrie Levine, Keith Moxey, Suzanne Joelson, and Gary Stephan in New York, for listening and commentary. Stephen Melville's support, first from Syracuse, and since by e-mail, has been a gift.

While I have carried the question around for some time, the book was written in Charlottesville. I thank my colleagues at the University of Virginia for their comments, facts, and advice: Matthew Affron, who read my chapters very closely, Paul Barolsky, Jonathan Flatley, Larry Goedde, Christopher Johns, Roger Stein, and David Summers. I have learned a great deal from them, and from my readers for the University of California Press, Carl Goldstein and Richard Cándida Smith, whose comments were absolutely right. Stephanie Fay, my editor at California, shepherded this manuscript through thickets both conceptual and bureaucratic, and I owe her many thanks. I am indebted to Thierry de Duve, as well, for his insistence that I come to a real conclusion, but I am still not sure I have made it there.

Finally, and appropriately since this is something of a bildungsroman, a story of education, I thank my mother, Gloria Singerman, for her support: emotional, financial, and logistical. This is for her, and in memory of my father.

INTRODUCTION

It is a commonplace of recent criticism that even before I begin, and in ways I cannot tell, I am captured by and folded inside the object of my research. However I attempt to stand at a distance and view objectively, the blindnesses of ideology and interest, the entanglements of identification and transference, and the traps of textuality lie in wait. It is easy for me to acknowledge the impossibility of distance here. My study is on the graduate training of artists in the American university (and in the degree-granting art schools fashioned in its image), and I have been captured by and folded into that object once before—bodily, and as its object. You might read what follows as a confession of my critical involvements and complicities, or, if you are of a different school, as an inside view.

I have a B.A. degree in studio art from a small liberal arts college. Most of my undergraduate courses were in painting, supplemented by a year of printmaking and two semesters of life drawing, in a course whose title, Drawing and Composition, was left over from a slightly earlier, yet more "modern" conception. The drawing program, a familiar one, proceeded from mark-making exercises to the nude model, rendered first in gesture and blind contour drawings, and then in increasingly extended poses. In printmaking, instruction was technical and craft based: I ground stones, scraped rollers, learned the uses of gum arabic, Carborundum, asphaltum. In introductory painting too there were mechanics, though fewer: how to build a stretcher and stretch a

canvas, how to apply gesso as a ground. I was asked to make a color chart. I learned how to glaze and stain, but these techniques I picked up later from other, older students. Working as a studio assistant for my painting teacher, I used a spray gun. Painting problems were given only in the introductory class: make a painting with only three colors. The unspoken problem of the course in painting as it advanced was to make something that was convincing as a painting. Not long after Painting 1, looking like a painting became an issue of scale; I made five-by-eight-foot monochromes and, later on, shaped canvases of equal size.

In class and out we discussed art, its physiological or anthropological or psychological necessity, its political and social value. What formed the discussion and continued in it was the question of what to do, a question at once personal and what might be called professional. The question "What should I do?" was also always the question "What do artists do?"[1] As students we were troubled by the title "artist," not simply because of our status, but also because of those attributes of "creativity and genius, eternal value and mystery" that, as reading Walter Benjamin would teach us in graduate school, "lead to a processing of data in the Fascist sense," a mythical sense as opposed to a historical one.[2] We were, for at least a while, "technicians" or "cultural workers." It was clear to us that something historical was at stake in the name we took. Long after our one visiting artist, a painter from New York, had departed, discussion continued about his insistence on identifying himself as a painter rather than an artist. The labels proposed different objects and different questions concerning what was to be done: a critical art practice after Duchamp, on the one hand, and a history of painting descended from Cézanne, on the other.[3] I would learn from the shop assistant in graduate school to run a few more power tools, but this was the sum of my technical instruction in art. It took place precisely where merely manual or specialized professional instruction was not supposed to occur, in an undergraduate liberal arts college.

What manual training I had in graduate school might be imagined as an updated, and markedly abbreviated, version of the master's workshop. Under the tutelage of the shop assistant, I learned to make maple frames and bases (for use by my department chair) and to hang drywall. That is, I learned to craft the edges and outsides and supports of art, or what Jacques Derrida has called, after Kant, the *parergon*, that "outside which is called to the inside of the inside in order to constitute it as an inside. . . . the limit between work and absence of work."[4] The

frame is a particularly critical modern lesson; its enclosure extends from the page to the professional field, from Hans Hofmann's insistence that the "four sides of the paper are the first lines of the composition"[5] to Raymond Parker's observation that in art schools "teachers demonstrate how they participate in the art-world, or discuss how others do it. . . . [T]he art-world can be understood and taught as a subject."[6] My passage as an apprentice from maple frames to gallery walls might be read as an emblem for what is taught, and indeed what needs to be taught, in graduate school: again in Derrida's words, "the marking out of the work in a field."[7]

What took place outside my graduate school woodshop, in the program's seminars and organized activities and in the individual cubicles where we worked at doing our own work, was the teaching that Raymond Parker described, our training as participating artists in the art world. Artists are the subject of graduate school; they are both who and what is taught. In grammar school, to continue this play of subjects and objects, teachers teach art; in my undergraduate college, artists taught art. In the graduate school, I argue throughout this book, artists teach artists. Artists are, again, both the subject of the graduate art department and its goal. The art historian Howard Risatti, who has written often on the difficulties of training contemporary artists, argued not long ago that "at the very heart of the problem of educating the artist lies the difficulty of defining what it means to be an artist today."[8] The "problem" is not a practical one; the meaning of being an artist cannot be clarified and solved by faculty or administration, although across this book a number of professors and administrators try. Rather, the problem of definition is at the heart of the artist's education because it is the formative and defining problem of recent art. Artists are made by troubling over it, by taking it seriously.

Since the 1960s the visiting artist program—the display of the exemplary artist—has been crucial to teaching artists.[9] I address a logic of the visiting artist in Chapter 6; here I want only to note the most obvious of that artist's functions: to embody a link between the school and a professional community of what graduate schools refer to as "national" artists. Visiting artists are chosen by students or faculty from national journals and magazines, from the pages of *Flash Art* or *Art in America,* and they speak to students, whatever they say, in the shared language of those journals and that community; their speech constructs that community. The visiting artists who spoke to me and my peers modeled for us what an artist was. Our assignment, as we watched and

listened, was not secret, or no longer seems so. In graduate seminars we researched artists in the magazines, presenting to the class our favorites or least favorites, making clear and verbal the relations and positions we needed to plot for ourselves within that field emblematized by drywall and maple frames. In one assignment we were asked to invent an artist of another type than we imagined ourselves to be—since we were to know ourselves as types—and then to produce an oeuvre, to make slides and do the talk, to model a speech or slouch. We learned to run our own careers as well, to produce cards and catalogues and slides, and to attend openings, which were staged like rehearsals every other week in the fall, every week in the spring.

Although I hold a Master of Fine Arts degree in sculpture, I do not have the traditional skills of the sculptor; I cannot carve or cast or weld or model in clay. I think the question that I began this book to answer is, why not? In some sense, I must admit, my inability was not my program's fault. The tools and skills of sculpture were available to me as options. If I needed them to do my work as an artist, to address the issues or make the objects I wanted to make, there were people who could teach me. But it was clear at the time that the craft practices of a particular métier were no longer central to my training; we learned to think, not inside a material tradition, but rather about it, along its frame. The problem of being an artist occupied the center. The question I posed to my teachers, and that they posed to me again and again, was not how to sculpt or to paint, but what to do as an artist, and as "my work." Perhaps this is where my program failed me—after all, I am not an artist; at the time, however, I imagined that its failure lay in its outmoded map of recent art and its issues, in its parochial roster of gallery exhibitions and visiting artists. I am still not sure why, but at some point not long after graduation it became very difficult to imagine myself as an artist, or to be convinced by what I made.

Although this book is predicated on my own experience, and on my own failings, it speaks now to a set of less self-absorbed questions: what constitutes training as an artist now, and what has determined its shape? What did my training mean, historically and ideologically, and what was it in? To forecast the ground where I look for answers, I sketch a narrative of education that, like my own, takes place in a college and university, stresses theorization and a verbal reenactment of the practices of art and the role of the artist, and is rewarded by a degree. Artists have not always been trained and credentialed on university campuses, or at art schools that envision themselves, not as ateliers

or academies, but as "universities for the arts" and "aesthetic think tanks."[10] The basic assumption of this project is that where and how artists are educated now—and, indeed, where art and its criticism take their places now—makes a difference. It is currently making the difference labeled postmodernism: criticism and text are important products in departments across the university. But it has also ensured that the practice of art in America is even more fully modern, that is to say, more specialized, more rationalized, and more historically conscious, endowed with an ever fuller and more critical sense of its position.

My interest in the sites and practices of art in the university is not only personal. In looking to the institutional formation of artists as a way to understand recent art, I am following Ernst Gombrich's advice that a "study of the metaphysics of art should always be supplemented by an analysis of its practice, notably the practice of teaching."[11] But what emerges throughout the book, I hope, is that teaching does not come without a metaphysics. It is not offered, nor is it heard, outside an ensemble of representations, values, and beliefs woven in and out of course assignments, studio critiques, and modeled roles; this ensemble might be called, after Gombrich, a metaphysics, but it is more precisely an ideology. The university too has its representations, its discourses of service and citizenship, of independent research and *Bildung*, and there are types and legends of the artist that it cannot easily include. The first assignment of this book is to examine how the practices of art and the identity of the artist are fashioned in the discourse of the American university, fitted to the image of the liberal arts college, the university-based professional school, and the research university in America. The artist, or artistic subjectivity, is the university's problem and its project. From the turn of the century on, it has offered a series of new artistic subjects, written over and over in the likeness of the university professional.

The chapters that follow address not only the various images of the artist on campus but also the arguments those images advance for the place and position of art as a study in the university: its likeness to university scholarship and theoretical research. On campus, art cannot be a calling or a vocation. To be included among the disciplines, art must give up its definition as craft or technique, a fully trainable manual skill on the guild or apprenticeship model. At the same time, it cannot be purely inspirational or simply expressive: the work of genius is unteachable and self-expression is untutored. Moreover, art in the university must be different from a certain "common sense" of its problems

and procedures. Whatever has called a student to enter the depart-ment—the love of past art, an excitement about the process of creation, a desire for personal growth, the ability to draw—one of the primary lessons of the graduate program is that art can no longer be seen as a simple response to, or merely the repository of, those needs and excite-ments. Among the tasks of the university program in art is to separate its artists and the art world in which they will operate from "amateurs" or "Sunday painters," as well as from a definition of the artist grounded in manual skill, tortured genius, or recreational pleasure. Moreover, art in the university must constitute itself as a department and a discipline, separate from public "lay" practices and equal to other studies on campus.

My project requires that I at least begin a history of professional training in the university, although I do not pretend to tell it fully or in strict order: there are over a hundred and eighty universities and degree-granting art schools now awarding the Master of Fine Arts in studio art. The first M.F.A.s were awarded in the mid 1920s at the Uni-versities of Washington and Oregon; Yale and Syracuse, the nation's oldest campus-based art schools, place their first M.F.A.s in the late 1920s.[12] But the Master of Fine Arts did not become widespread, nor did it become the terminal degree in studio art that it is now, until much later. At the beginning of the 1940s there were 60 graduate studio can-didates enrolled at eleven institutions; in 1950–51 there were 320 can-didates at thirty-two institutions. Many of these students worked to-ward advanced degrees with other names: the Master of Creative Arts, for example; or the Master of Painting; or, at Ohio State, a studio art Ph.D. Only in 1960 did the College Art Association approve the "M.F.A. rather than the Ph.D. as the terminal degree for graduate work in the studio area."[13] In that year 1,365 students were enrolled at sev-enty-two institutions. Thirty-one new M.F.A. programs opened in the 1960s, forty-four in the 1970s. In 1994–95 there were at least 7,100 students enrolled full-time for the M.F.A.; more than ten thousand de-grees were awarded between 1990 and 1995.[14] If these statistics suggest the unchallenged administrative success of the M.F.A., that victory has taken place in the midst of a continuing debate over the place of the artist and of graduate training in the university.

The chapters that follow examine the discourses that surrounded and shaped the history of studio training in the university that is abbre-viated in these numbers. Recorded in assignments and lectures, in pa-pers presented to College Art Association meetings, in essays in the *Col-*

lege Art Journal or *Arts in Society,* and in the mission statements of the new art departments, the debates over art and artist in the university and the calls for reappraisal and reform bear witness to a set of unresolved contradictions. These thread through the book as recurring motifs. I introduce them here with a quotation from Walter Gropius, who founded the most influential art school of the century, the Bauhaus, which—to broach one of the contradictions—although it changed the way artists were made, did not acknowledge itself as a school for artists. Making artists was a problem; indeed Gropius insisted it was impossible: art is not a "profession which can be mastered by study"; it "cannot be taught and cannot be learned," even if the "manual dexterity" of the craftsman can and must be.[15]

Gropius's insistence that art cannot be taught is repeated again and again by American educators through mid century, most often by artists teaching in increasingly well organized and articulated university art departments. By 1951 it was "widely held opinion" in the pages of the *College Art Journal* that "all one can teach are techniques, but that artistry is completely a matter of endowment and self-induced personal growth.[16] That same year, a teacher from Bard discounted the possibility of even much effective technical instruction: "All but the most elementary techniques are fundamentally not teachable."[17] So did the dean of Washington University's degree-granting professional school: "There just isn't enough to teach—enough that can be taught—to justify six years of an artist's life."[18] The contradiction between the triumphal history of the M.F.A. and the doubts—or certainties—expressed by its teachers should be obvious, but the strongest and strangest effect of this argument might be its displacement of art, the first of a series of displacements at the same site. Gropius's equation makes technique and dexterity necessary to the practice of art, perhaps, but it assumes, as well, an essential separation of art from technique: art is the name of that which escapes teaching; technique, as the name of what can be taught, is destined to become "merely" technique.

In insisting that art is not a profession, Gropius targeted both the teaching of the classical academy and the presumption that acquiring the skills of representational drawing and its accompaniments—perspective, chiaroscuro—was becoming an artist.[19] He sought, like many late-nineteenth- and early-twentieth-century educators, to displace the figure and technique of academic drawing with the objects and rigorous skills of the craftsman. The artist isolated in his studio would be replaced by, or reborn as, a skilled craftsman; moreover, he would be liberated by a

new audience, a broad general public trained, in Gropius's words, in a "common language of visual communication . . . made valid through general education."[20] The express goal of most of the new art departments, and of their new methods, was the visual education of the nonartist. One of the corollaries of the equation that art cannot be taught is that everyone can be taught, if not manual techniques, then visual fundamentals. In the aftermath of the Bauhaus, in the idea of design and the visual arts—the assertion of a "language of vision," and of teaching as "training the eye to see"—the craft skills that Gropius had earlier forwarded as a cure for the academic isolation of the artist are themselves displaced, replaced by the field of vision and the rectangular canvas plotted in its image by the foundations and fundamentals of art.

Despite Gropius's protest but according to his logic, I would again claim art as a profession: the privileging of overarching principles over specific technical competencies—the grounding and guiding of art practice in visual fundamentals and the fashioning of individual works as experiments, researches, proofs—echoes the severing of articulated theory from manual labor that characterizes the process of professionalization. But if the themes I highlight in my educational story—university education, the theorization and formalization of knowledge, and the receipt of a degree—are the hallmarks of professionalization in the United States, nonetheless the label professional does not easily correspond to our image of the artist. The idea of the "artist born" runs long and deep, from Pliny's Lysippus, who had no teacher, to Dürer's Geertgen tot Sint Jans, who was "a painter in his mother's womb,"[21] and even to Gropius's declaration that art is not a profession but, rather, the "grace of heaven."[22]

The image of the artist that we have inherited from the nineteenth century—a driven, alienated, and silent individual—clashes directly with the idea of a university-trained professional artist. Indeed, that inward figure is a particular target of those who champion the artist on campus. For both critics and supporters, the university stands for the presence of language and the production of formal knowledge, and against the silence and inspiration of the born artist. I spend a good deal of time in the chapters that follow on language as it displaces both manual craft skills and traditional academic skills, the drawing of an earlier version of the professional artist. Whether the language of the university displaces technique—becomes the technique of a new art—or displaces art itself in the practice of criticism, I leave an open question.

The question posed most insistently in these pages is whether the artist is a professional and, following from it, what the struggle with that word—its acceptance or rejection—might mean for the fashioning of artists. Finally, I take the M.F.A. at its word that it is a professional degree. But even that clear answer poses other questions, raised by both recent training and recent art: What is that profession and (a corollary) where is it practiced? Is art a profession learned in the university and practiced outside it, like medicine or, closer to home, architecture? Or is it a profession in and of the university, an academic discipline, like history or mathematics or, perhaps, literary criticism? Still other questions follow from these, most obvious among them, how does that difference change what is taught and learned in school?

While the themes I have introduced with Gropius's insistence that art cannot be taught—the displacement of academic figure drawing and craft skills, the place of language and the questions of professionalization—cross the text from beginning to end in different guises, *Art Subjects* proceeds, sometimes roughly, chronologically, falling into three sections of two chapters each. The opening chapters stress the university's discourse on the problem of the artist, the language with which the products of the European academy and the avant-garde were caricatured. Chapter 1 charts the vision of a new college-educated American artist across the often conflicting demands of the undergraduate college and the high university, and it rehearses their shared disdain for the nineteenth-century European artist (or for a broadly drawn stereotype of that artist), the academy that trained him, and the studio that housed him. The university's artist, like the university-trained models he is offered, is always male; the excessive artist lampooned by educators is marked and marred by the "problem" of femininity. Chapter 2 examines that problem as it both covers for and reveals the structuring role played by women art educators and women's institutions—and by the women who, as students, continually outnumbered males in art schools and university departments—in shaping the practice of art in colleges and universities.

The middle chapters, too, turn around language, the "language of art," and the discourse that supported the Bauhaus and its foundation course. Chapter 3 addresses the difference written in the shift from the "fine arts" to the "visual arts," a change that embeds the work of art making in the eye and signals the displacement of the figure and the practices of representation. It traces that shift—and certain specific practices—from the nineteenth-century schools of design and the industrialization of artisanal training; the grids and type forms of schools of

design become the symbols of science in the Bauhaus and after. Chapter 4 links the "trained eye," gridded by the fundamentals and grammars of art, to the "innocent eye." The innocent eye is at once the intrinsic, necessary source of the fundamentals of vision taught as grammar, and a tabula rasa that must be trained and gridded. This chapter also begins in the nineteenth century, not with industrial education but in the kindergarten classroom, and continues through early-twentieth-century school art to general education in the postwar college.

The closing chapters once again focus on language; not a discourse on the artist, but of the artist. A central character through them is the artist who speaks as a teacher, a student, a visiting artist or lecturer. Chapter 5 argues that the rapid expansion of the New York art world's influence after World War II was reciprocally related to the equally rapid expansion of university-based graduate art programs. It also looks closely at the teaching of the artists of the New York school, and the work of speech around the work of art, as its displacement or extension: forcing the student to find his or her place in that speech becomes the teaching of professional subjectivity. Chapter 6 returns to those debates of the 1950s and 1960s over art practice in the university that cast the tension between the artist and the university as a struggle between vision and language. That same struggle between vision and language has, of course, characterized the question of postmodernism in the visual arts, and the chapter maps the questions of the earlier debate with the answers provided by the theorization of postmodernism in the 1980s. Finally, Chapter 7 returns to the autobiography I started with, and to the question of professionalization, by asking one more time, "What does the M.F.A. certify?"

WRITING

ARTISTS ONTO I

CAMPUSES

"If there is a single crucial point in the process of academic profession-alization," writes the educational historian Roger Geiger, "it would be the formation of a national association with its attendant central jour-nal."[1] Heeding his words, I start at that founding moment. The Col-lege Art Association was established as an independent association in 1912, organized out of the Department of University Art Instruction of the Western Drawing and Manual Training Association, a federa-tion of mostly elementary and high school teachers of art, freehand and mechanical drawing, home economics, and industrial arts.[2] The first issue of the *Art Bulletin,* dated 1913, was little more than a pam-phlet. Its single article, "Problems of the College Art Association," by the CAA's first president, Holmes Smith, recounts the history I have abbreviated here.[3]

The second number of the *Art Bulletin,* published in January 1917, included an address by then president John Pickard, an art historian from the University of Missouri, who continued his predecessor's focus on the association's problems. He assailed the indifference of college ad-ministrators and the general public to the goals of art education, but he looked most closely at the internal tensions and divisions threatening the young association. To unite his audience against a "common enemy, the commercial, the vicious and the ugly," he offered a slogan: "Art for higher education and higher education for artists."[4] But Pickard's for-mula merely cobbled together the divided interests of the CAA. Teaching

art and teaching artists remain at odds; his address lists the symptoms of their opposition.

Research University, State School, and Liberal College

"In our Association," Pickard noted, "the Art School, the Technical School and the old College are all represented. We have among us the painter, the sculptor and the architect, the lecturer, the critic and the historian."[5] Such a divided membership would have differing expectations of an annual meeting and the publication that would follow from it, and Pickard's first order of business was to address what he understood as clearly opposing, and professionally determined, demands. "On the one hand were those who urged that our Association could not hope to take important rank and position among the learned societies of our time until our meetings are characterized by profound discussions of technical subjects—and not even then unless such learned papers are published as 'original work' by our members."[6] Pickard's call for original work issued, not from the artists in his audience—it was neither romanticism's nor modernism's demand—but from professors in the graduate schools and research universities who, like German scientists of whatever department, understood themselves, distinguished themselves, not as college teachers but as published professionals in their fields.

Beginning in the 1870s with the success of Johns Hopkins, a number of American universities, consciously patterning themselves on the German model, had begun to stress graduate education and independent faculty research in increasingly articulated and specialized disciplines and departments. The founding of specialist organizations—a learned society such as the CAA—and the publication of a scholarly journal were crucial steps to creating those disciplines, allowing research professors to construct allegiances and a reputation beyond the college and among colleagues. By 1893 Columbia, Cornell, Harvard, Princeton, and Yale all offered graduate courses in the fine arts. Princeton began its Ph.D. program in art history in 1908; Harvard awarded its first art history doctorate in 1913. Pickard's own graduate program at Missouri was established in 1914, and in the September 1919 number of the *Bulletin,* he too insisted that "we must have a periodical of our own, issued at first quarterly, ably edited, with trenchant articles by strong men."[7]

John Pickard received responses to his request for advice on the new association's program not only from those in the research universities,

but also from the colleges, whose primary focus was undergraduate teaching in the broad liberal arts, and the schools and institutes that offered specialized vocational training. Classroom teachers of undergraduates insisted that they could use annual meetings and the association's publications to "compare syllabi of lecture courses, discuss whether or not textbooks should be used in our classes and so endeavor to 'standardize' our work."[8] Certainly standardization reflected the needs of teacher training, or "normal," schools and departments, which were responsible for ensuring that the elementary and secondary art teachers they graduated could be examined and credentialed at the state level.

In 1870, spurred by representatives of local manufacturers, Massachusetts passed a law mandating drawing in the public schools and instruction in "industrial and mechanical drawing" for those over fifteen. The Massachusetts Normal School of Art, established in 1873, trained teachers and examiners to carry out these provisions. By 1920, after "untold efforts," a contributor to the *Art Bulletin* asserted that "in all the states of the union the secondary schools teach drawing; in all the states but one the elementary schools teach drawing."[9] Most practical art instruction in turn-of-the-century art schools and colleges in fact trained teachers. Indeed, in all disciplines at the time such training was the primary activity of American higher education: "By the end of the nineteenth century, American colleges and universities were producing more teachers than anything else."[10] Of the seventy-six colleges and universities offering courses in the practice of art in 1916–17, some forty-eight either offered a normal or school arts course or specialized entirely in training teachers.[11] The larger independent art and technical schools listed with them in the *American Art Annual*'s 1917 survey offered another twenty-seven normal or school arts courses.

The emphasis on consistent standards served, as well, the needs of the technical schools that turned out commercial artists, mechanical drafters, and designers for industry as the normal schools turned out teachers, quickly and efficiently. In a 1919 *Bulletin* essay entitled "Supply and Demand," Ellsworth Woodward of Sophie Newcomb College called for more schools "devoted to training designers, and those who are to pursue the manual arts," and for students "definitely prepared to meet the needs of industry."[12] Departments of industrial art and schools of applied design, as well as many normal art and broader "practical" or "technical" art programs, entered CAA as parts of state colleges and the agricultural and mechanical schools founded in the three decades after the passage of the Morrill Act in 1862. The course of study and

the student body at the land-grant colleges and most of the publicly funded state universities—categories that frequently overlapped—differed greatly from those of both the Latin- and Greek-based pre–Civil War classical college and the post–Johns Hopkins research university, which turned to those same classical texts, not as the grindstone of mental discipline, but as the object of philological and historical scholarship. The land-grants instead taught large numbers of the children of farmers, mechanics, and local merchants who had not studied Latin and Greek in seminary or academy. Moreover, as the title of Woodward's essay suggests, they educated them for specific vocational outcomes.

The mandate of the Morrill Act—to "promote the liberal and practical education of the industrial classes in the several pursuits and professions of life"[13]—and the more general demand for efficiency and service that spurred the growth of the state universities led to the standardization, and formal theorization, of a number of occupations that had once been learned in the family or through apprenticeship. By the first decade of the twentieth century, "such untraditional disciplines as pedagogy, domestic science, business administration, sanitary science, physical education, and various kinds of engineering" were made teachable, grounded in basic principles, like the professions, at what the historian Laurence Veysey termed the "serviceable university."[14] The state universities were marked by their emphasis on professional training, and Veysey writes that "many of them in the years 1890–1930 became primarily congeries of professional schools, which they created to satisfy public demand."[15] As a collection of autonomous, specialized schools for new professions, the large state university resembled, and indeed moved closer to, the research university, with its increasingly divided and specialized departments named after new fields of knowledge and scholarly expertise.

If the technical and normal schools called for standardization, so did the liberal arts colleges, whose commitment to undergraduate teaching and the humanities consciously opposed both the vocational emphasis of the technical schools and the increasingly specialized and segmented knowledge of the research university. Their demand for standardization, coupled with or disguised as a plea for standards, begins with the idea that there is a necessary body of knowledge, above and beyond the demands of one's field or one's job, that anyone who wishes to call himself educated must know. Moreover, liberal education holds out the promise that that knowledge, because it is shared, will unify both indi-

vidual and culture: it will become understanding. "A young man must take from the college of liberal training, the contributions of philosophy, of humanistic science, of natural science, of history and of literature," wrote President Alexander Meiklejohn of Amherst, defending the liberal arts college in 1912. "So far as knowledge is concerned, these at least he should have, welded together in some kind of interpretation of his own experience."[16]

Liberal culture requires the study of broad fields rather than the fragments and specialized depths of professional training, but more important than breadth is unity—the ability to understand the university's knowledge as finally joined and whole. "The mission of the teacher," Meiklejohn insisted, is "not the specialized knowledge which contributes to immediate practical aims, but the unified understanding which is Insight."[17] The unity that liberal education offered was most often cast, like Meiklejohn's "insight," in visual terms: vision is the equivalent of synthesis, grasp, understanding. But if art was to become liberal, to be secure as a study in the college, it had to be separated from vocationalism and, in the pages of the *Art Bulletin* and then the *Art Journal,* from art practice and professional studio training. Further, it had to be connected with the goals and disciplines of the college, a relationship that was envisioned as early as 1874–75, when Charles Eliot Norton at Harvard was named lecturer on the History of Fine Arts as Connected with Literature.

At the 1918 annual meeting and in the pages of John Pickard's *Bulletin,* Wellesley's Alice Van Vechten Brown asked, "Is it too much to place before ourselves as a desirable, even though far distant objective, the standardization of art methods in some such sense as is the case with Greek, Latin or Mathematics?"[18] Gertrude Hyde of Mount Holyoke shared these concerns and, at the same meeting, urged the congruence of the study of art and the other, older fields of the college. To give her students a better grasp of "the aesthetic principles which govern all great art," and to ensure that courses in art could be "properly graded and correlated with those offered in other departments," "no separate courses are offered in painting, drawing, modeling or design and no college credit is given for this practical work except as it is taken in connection with courses in Art History and very closely related to such courses."[19] A similar proposal to teach art practice only as a laboratory for art history—an opportunity to examine historical means and methods—had been offered as early as the association's annual meeting in 1913, where it was once again joined with a call to

compare courses in art to those in other, more established disciplines. According to the *American Art Annual* account, "it was evident that the majority of those present favored technical work," that is, work in studio art, only "as a laboratory process, supplementing the study of the theory, history and philosophy of aesthetics. Professor Arthur Pope presented the course developed at Harvard as being cultural rather than professional and as comparable to methods of teaching English Composition."[20]

Teaching studio practices as art-historical skills in conjunction with period art history classes spread to a number of liberal arts colleges through mid century. Placing art practice in the art history classroom and on its syllabus ensured that art would be made in and out of the historied media and that it would be produced, as Harvard's Pope has it, as culture. Despite calls for teaching the industrial arts and assertions of the nobility of the crafts, painting, sculpture, and the older printmaking methods remain the primary, often the sole, media of studio art in liberal arts colleges and university studio departments, insisting, as they do, on the individual, the humane, and the historical. Even if they are no longer taught as adjuncts to art history, art history remains their subject.

College Art and Art History

Gertrude Hyde's argument for placing the practice of art under the sponsorship of art history, where it might become liberal and meet the college's standard, brings up a division within the CAA that remains familiar and visibly active today in both the association and individual departments. Pickard commented diplomatically in his 1916 presidential address on the split between the practitioners of art and the teachers of art history:

> It is possible that there may be among us today technical artists who hold that any study of Art without artists' tools in the students' hands is of no value, but I trust there is no one here who is so provincial. There may be within the sound of my voice someone who is convinced that no form of technical art has any place in our institutions of higher education but I hope there is no one here who is so illiberal.[21]

Pickard chose his words artfully. "Illiberal" and "provincial" seem intended to suggest a typology of the American university and a geographical survey of art on its campuses. When Lura Beam, of the Association of American Colleges, conducted such a survey ten years later, in 1927, she found "a schism between those who think art is learning and those who

think art is doing. An arbitrary line drawn between these theories would leave the East on one side, the West and South on the other and Chicago cut by the boundary, one-half for each side."[22] Art historians inhabited the old liberal arts colleges, the private institutions of the Northeast, or the graduate departments that grew around and drew from them. Art teachers worked in the provinces that Pickard all but named—the state-supported colleges and normal schools of the West and South.

Lura Beam's dividing line and my redescription of it seem harsh and reductive. Pickard's own early graduate program in art history at the University of Missouri, on the far side of the Mississippi, suggests that the division was not monolithic. Laurence Veysey, whose typology I have introduced with Pickard's speech, has argued, moreover, that the movements toward research, utility, and liberal culture that shaped the American university cannot be plotted directly onto the research university, the state school, and the liberal arts college, or simply across a map of the United States. They were sometimes housed in a single university; Harvard's faculty and administration, for example, included spokespersons for all three directions. Nor were geographical divisions so clear-cut: across the state from the University of Missouri, Washington University in Saint Louis divided art and the practice of drawing on its campus. Holmes Smith, the CAA's first president, headed the Department of Drawing and History of Art, its combination echoing John Ruskin's one-man role at Oxford as well as the department Ruskin's colleague Charles Eliot Norton established at Harvard (Norton's first appointment was Charles Moore, a drawing master trained by Ruskin). Students in art history were "graduated of the College, The School of Engineering or The School of Architecture," from the liberal arts and established professions. Drawing was also taught across campus in the School of Fine Arts, along with painting, sculpture, modeling, illustration, design, interior decoration, metalwork, etching, pottery, bookbinding, and wood carving, to students whose goals were avowedly vocational and technical.[23] Despite such exceptions, however—or, as in the case of Washington University, encapsulated in microcosm within them—the divided goals of higher education were mirrored by a partition along geographic lines, by a regionalism that was at its height in the early years of the CAA.[24]

The division between history and practice in what was arguably a single discipline—certainly in a single professional organization—embodied the ideological and regional divisions that shaped early-twentieth-century higher education as a whole. In contrast, perhaps, to other disciplines

more effectively articulated in the university, the division between art history and art practice remained rhetorically inseparable from the division between East and West in the association's debates into the 1950s. When Robert Goldwater suggested in his survey of American art education in 1943 that "the practice of art bursts the boundaries of the liberal arts framework," his boundaries were not only institutional—courses in art practice were most often tied to "pointedly pre-professional training"— but, once again, geographic.[25] While every one of the fifty colleges he surveyed by 1940 "gave some attention to the history of art, eight of the fifty made no provision at all for studio work. . . . In the East especially, the omissions are strongly in evidence."[26] The division continued after World War II as veterans surged into colleges and universities under the G.I. Bill, raising fears for the liberal arts and for art as a liberal endeavor. Perhaps fear lent stridency to a 1946 committee report to the College Art Association entitled "The Practice of Art in Liberal Education."

> It is our opinion that the College Art Association has the double responsibility of combatting the handing over of college positions in the practice of art to teachers of the latter type ["teachers of the practice of art who are not concerned with liberal education cannot be encouraged to *join* a *College* Art Association in the first place"], and of supporting the training, and recognition by college administrators, of the "right" kind of teachers. . . . In tackling this task, considerable allowance will have to be made for regional disparities within the United States. The situation in the West and the western central states differs a great deal from the situation in the East and the eastern central states. Over and over again, pleas from the former region call for both greater emphasis on the history of art (in contrast with the situation elsewhere) and the elevation of the standards of practice courses from the point of view of liberal education. No doubt, the second point is indissolubly linked with intricate problems of state education credential requirements, in turn influenced by problems of supply and demand. In this regard, well-considered aid by the College Art Association might easily result in important and hopeful developments, and such proposals as the one calling for a system of exchange professorships in Eastern and Western institutions could possibly gain momentum.[27]

I have quoted the committee report at length not only because it reiterates the educational and geographic divisions I have stressed, even to the point of calling for art-historical missionaries, but also because it repeats the calls for standards sounded at the establishment of the College Art Association, tied here once again to concerns for teacher training and credentialing. Moreover, despite the pessimism of the report, it issues a demand and begins to provide a profile for a different kind of artist. The "right" kind of artist would be a teacher at home on a col-

lege campus, an artist-teacher, perhaps, who could instruct undergrad-uates in the practice of art as it exemplifies "problems pertaining to es-thetics, the theory and the philosophy of art."[28]

The Artist-Teacher

By the 1940s the larger midwestern state schools, led by the University of Iowa, had begun to formulate just such an artist-teacher. In 1938 Lester Longman, a Princeton-trained art historian hired at Iowa in 1936 as both professor of art history and head of the Department of Graphic and Plastic Arts, combined his two departments into the single Department of Art; they had been separate since 1909, when an academy-inspired School of Fine Arts was established at Iowa and courses in art history were ceded to the archaeology department. Shortly after uniting the departments, Longman instituted the Bache-lor and Master of Fine Arts as preprofessional and professional de-grees for "the profession of an artist," as he told the Midwestern College Art Conference,[29] a phrase that gives the term "profession" a cast different from that in Goldwater's survey.

Longman's guidelines for professional study, presented as "four prin-ciples" in a report to his dean at Iowa in 1943, forecast the CAA com-mittee's suggestion that art be taught as the problems of aesthetics and theory. He outlined a curriculum that "dynamically relate[d] the study of art history and criticism to work done in the studio," and encour-aged "wide independent reading and the study of such allied subjects as literature, history, philosophy, and the other arts."[30] John Alford of the University of Toronto, one of the signatories of the 1946 committee re-port, noted Iowa's example in 1940: "The regulations for the B.F.A. de-gree at Iowa stress (over and beyond the essential practical courses) the literary, linguistic, and historical studies usually attached to the history of art." At the graduate level, the M.F.A. emphasizes "technical and professional excellence, though additional studies in the history and theory of art, in languages and other subjects outside the Department of Art are variously required. . . . Curricula [are] calculated to provide both technical competence and breadth of organized knowledge."[31] As conceived by Longman, the artist-teacher would be trained in and "sympathetic to both the history and the practice of art . . . slighting neither aspect."[32] Armed with the Master of Fine Arts degree, the artist-teacher could be employed on the college level and ranked among his faculty peers.

The artist-teacher returns in other chapters and guises in this project, often discussed alongside or played off another image of the university-made artist: the artist aligned, not with the academic humanities, but with the sciences. For Toronto's Alford these paired figures—embodied in the programs at Iowa and at László Moholy-Nagy's School of Design in Chicago—offered paradigms for the professional education of a new kind of artist. Where Iowa is "governed by the anthropomorphic drama common to all phases of the humanistic tradition," Moholy-Nagy's school "abandons the nexus of the older humanistic tradition and substitutes courses in *Physical Sciences, Life Sciences, Social Sciences,* and *Intellectual Integration.*"[33] But what matters to Alford is that the student-artists in both schools pursue their studies outside the studio. "For my present purposes [their] mutual exclusiveness is less significant than the representative *in*clusiveness of the intellectual relevants."[34] The hyphenated figures of the artist-teacher and the artist-scientist are attempts to fit the artist to the courses and disciplines of university study, to understand the artist in relation to existing departments. By the 1960s the artist-teacher in particular was derided as a "confused hybri[d], not fully acceptable to either species";[35] here I use that hybrid to suggest that in the years before World War II the artist was an institutional problem for the university—and perhaps has remained one: the artist-teacher was a symptomatic attempt at a solution.

Across the twentieth century, countless art educators repeated some version of John Pickard's call for art in higher education and higher education for the artist, insisting that art must be taught: as history, perhaps, or as appreciation or problem solving or creative expression, as basics and fundamentals. But in the debates over the place of art in college, artists, even if they can and must be liberally educated, cannot be taught, or as it is often less arguably put, they cannot be made. Raymond Parker, a recognized painter who received his M.F.A. from the University of Iowa in 1948, noted in 1953 that the degree raised, or rather intensified, just this question:

> Nowadays, schools hold with reservations the idea of training artists. They accept the responsibility of developing skills useful to commercial and applied arts. They stand behind the education they offer as relevant to art history, art appreciation and the cultivated man. They produce art teachers and patrons. But the popular Master of Fine Arts degree reflects a dilemma. . . . since art escapes the formulation of standards and methods.[36]

Parker itemized the goals of art education on campus: to educate enlightened patrons in the liberal arts college, to produce historical schol-

ars in the graduate school, to teach the fundamentals of design and the specific technical practices of art in the practical course and the art school. But in his formulation art escapes, necessarily and logically: if it can be formulated, then it is not art. This paradox begins to point to the artist's value for the university—why he must be there, particularly on the liberal arts campus, and at the same time why he cannot be made there, why he is taken with reservations.

The liberal arts college, to maintain the liberalness of the fine arts, and the otherness of the fine artist, must insist, with Harold Taylor of Sarah Lawrence, that even if it offers painting and sculpture, or hires an artist-in-residence or a whole art department, "the curriculum is not professionalized, that is to say turned into a program to produce . . . exhibited painters or sculptors."[37] Instead, as Norman Rice of the Carnegie Institute of Technology said in seconding President Taylor's statement, artists are needed on college campuses so that they can be seen: "By observing the ways in which the arts are transmitted, through the association of artists with artists, we are provided with a clue as to the whole of humane learning. Thus the humanities need the arts in order to preserve the image of what all such learning can be."[38] For Rice, art is the very image—and a last vestige, perhaps—of the tradition and transcendence promised by liberal culture; curiously, the artist too appears as an image, something to be watched.

Rice was dean of an old technical college of art, established in 1905 to train architects, artists, and designers, but he opened "Art in Academe," an essay published in 1963, by "accepting all the old precepts . . . artists are born, not made; no artist ever became an artist because of a school; art is the product of a great mind, not merely a great hand and eye; . . . the artist must teach himself."[39] He argued, on behalf of independent professional art schools such as Carnegie, that it is possible to create "an environment which is conducive to the development of artists, a spiritually, intellectually, and technically tempered aether in which students can discover themselves and accomplish initial artistic growth"—but soon after he added an urgent disclaimer: "I did not say 'to become artists.' "[40] The caveat is redundant, for the becoming he described is at once so mythologized (aether) and so biologized, or perhaps psycho-biologized (discover and grow), that it is clear the institution made neither promises nor artists. In a brief footnote, Rice himself pursued the point, hedging in the name of frankness: "I define professional schools as those which frankly and openly state as their object the preparation of students for mature participation in art-based enterprises."[41]

Artists are an ontological rather than an epistomological problem; theirs is a question of being, rather than of knowing. In the professional school, as in the liberal arts college, the artist exceeds his education: the artist is precisely what is not educated.

This equation stands even in the declarations of the most influential technical art school of the century. In his "Theory and Organization of the Bauhaus," written in 1923, Walter Gropius insisted that

> the artist has been misled by the fatal and arrogant fallacy . . . that art is a profession which can be mastered by study. Schooling alone can never produce art! Whether the finished product is an exercise in ingenuity or a work of art depends on the talent of the individual who creates it. This quality cannot be taught and cannot be learned. On the other hand, manual dexterity and the thorough knowledge which is a necessary foundation for all creative effort, whether the workman's or the artist's, can be taught and learned.[42]

The difference between artist and craftsman is precisely essential: even if technique can and must be taught, the remainder that is art cannot be. For Gropius, offering technical training is not the same as making artists, and it is not clear that he would want artists made. The final step, the object's becoming art, the craftsman's becoming artist, is an act outside school. But here I have gotten ahead of myself. With Rice's statements and Taylor's, even as they echo Gropius, I have moved well into the 1960s. In the pre–World War II technical or professional school, in an earlier version of Carnegie Tech or of the Chicago Art Institute, the artist's essence—or rather his excess, the way he exceeds the possibility of education—is constructed differently, a difference to which I will turn in the following section. In these earlier schools, the manual and technical skills of art must be teachable to guard, like Gropius, against the artist, to ensure that the artists who are made will *not* be different, but will instead be illustrators and designers and draftsmen.

The Problem of the Artist

The artist is a curious, laughable, pitiable figure as he is portrayed in writings on art in America in the years after World War I. A certain kind of artist, it is clear, is misplaced in America. An article from the *Chicago Evening American,* reprinted in 1921 under the headline "Lowly Artist Now Earns Big Sums" in the *Art Student,* a correspondence course magazine published by the School of Applied Art of Battle

Creek, Michigan, searches for him with some irony.[43] "Where is the artist of the scraggly beard and long apexed nails that were used for color palettes, who roamed the streets in lopsided tam and affected limp ties of temperamental virtue?"[44] The question's author, Fanny Kendall, identified as registrar of the School of the Chicago Art Institute, locates that artist and then misplaces him in the space of a paragraph. He is "certainly not in America, where artists are hustled from the class-rooms into offices," but he has an address here: "If there are any artists who paint for 'art's sake,' they are of the half-mad Greenwich Village type, whose conception of true art is a skyscape with a blue cat perched on an orange ashbarrel peeling at an orchid and black moon."[45] Unlike the American artist trained in the university or art school or even through a correspondence school—the one in transit from classroom to office—the comic painter exists elsewhere, at the margins, in Greenwich Village. And not really even there; he is, after all, merely that "type." Kendall situates him elsewhere in time as well; "his habitat," the registrar writes, finding him once again, but in the past tense, "was an attic. And forever there burned in his genius-lit eyes the brilliancy that bespoke consumption."[46]

The *Art Student*'s artist is obviously a caricature, a "popular conception," in the words of R. L. Duffus, who surveyed the field of art for the Carnegie Foundation at the end of the 1920s.[47] Duffus's thesis in *The American Renaissance,* the resulting publication, was that a distinctly American art education had begun to emerge in the 1920s, one that took place in the same classrooms that Fanny Kendall noted. Duffus cited two new "crusaders" who were "bringing art home to America." "One is the college or university professor who sets up standards by which we can tell the difference between good art and bad art, honest art and dishonest art. The other is the sound craftsman who teaches his pupils how to do necessary things beautifully."[48] From their places in the university and the technical art school, the professor and the craftsman were moving closer together; their melding would characterize a "not only modern but peculiarly American" art training.[49]

> Spokesmen for the universities openly lay claim to the professional art school, as they have successfully done to the professional schools of medicine, law and engineering. Schools of the crafts approach the fine arts; schools of the fine arts find new value in the workmanlike integrity of the craft schools. Teachers of the arts realize more and more that their work is not half done if they do not enable their students to fit into an actual, industrial commercial world.[50]

Duffus's sunny forecast was troubled by "a third, and very disturbing element. . . . the man who approaches art as a personal adventure and the schools which minister to his needs."[51] To describe that man, Duffus turned to the same itemization of dress and notes on character Fanny Kendall had used. "It is he, if anyone, who is responsible for the popular conception of the painter as a freak with long hair, a pointed beard, a flowing tie, baggy trousers, and morals no board of censorship would endorse."[52] Again the painter, a repetition, a type, exists elsewhere in time; "we might find real artists who looked and acted like this if we could turn back the clock a generation or two."[53]

For both of these writers on art and, more to the point, art education in the 1920s, a certain type of artist was no longer feasible—certainly no longer believable. Each described precisely a personality type, a story captured by a story. Cecilia Beaux, a successful painter and member of the National Academy, spoke of that capture in a roundtable discussion, "What Should the College A.B. Course Offer to the Future Artist?" at the College Art Association's 1916 annual meeting: Those "hundreds, I might say thousands, of young people [who] select the life of artist as being the most interesting and sympathetic" choose a life rather than a career.[54] Duffus too says as much. "This is a kind of person who regards art not as a way of earning a living but as a way of life"; Duffus's simple qualifiers, "kind of" and "way of," insist on and redouble the artist's fictionality.[55] The artist is given a setting—Greenwich Village, an attic—and a scene. "Here come scores of young people," Duffus writes, stressing numbers as Beaux did, "to whom the thought of art and the artist's life has proved alluring. . . . The majority will drop out in a year or two. Art is not for them. For those who remain the struggle will be long and desperate, and there will be casualties all along the line of march."[56] In the course I am plotting, being an artist precedes seeing and then speaking as one—other markers for the artist in the university that I address in subsequent chapters.

Duffus's narrative is marked by an exaggerated temporality; the slow creep of the "line of march" stands in obvious contrast to the efficiency of the art education offered in the classroom. Speed is the attribute of the American artist. Kendall's American artists are "hustled from the class-rooms into offices," and in the *American Renaissance* Duffus emphasizes the acceleration of art education in the university and the technical school: "If there is a shorter cut than the one customarily followed Yale is inclined to follow it."[57] Pratt Institute, too, "long ago made a study of short-cuts. . . . the problem is to get as much art as possible

into the least amount of time."[58] Speed and efficiency, virtues shaped in the mold of college and technical school education with their hour-long time slots and two- and four-year limits, mirror the demands of the university in the first quarter of the century. Ellsworth Woodward of Sophie Newcomb, at the CAA roundtable with Cecilia Beaux, suggested that the other new majors of the "serviceable university" might provide models for an efficient art education: "Professional study in art seems too long delayed if it must wait on academic graduation. The liberal electives now offered in B.A. courses in mechanical arts, in agriculture, household economy, etc., should be extended in the same liberal spirit to the future artist," fitted between "adequate time and opportunity for instruction in drawing, painting, and design with art theory and history."[59]

In Duffus's description, the would-be artist's long, slow march is marked by the disconnection between education and outcome; there are no happy endings, or very few. At Yale, in contrast, "artists are made as shipwrights used to be," trained to perform specific tasks of work, even if those tasks include murals and medals and portraits. "When he graduates," Duffus writes, "it is expected that he will be ready to begin a career, and need not waste precious years in fumbling and experimenting."[60] Yale's artist will be able to make paintings and sculptures for architectural commissions, to produce models and illustrations, and to design goods for home and office, as well as their packages and their advertisements. For the other artist, the narrated artist, education provides no such guarantee; it cannot make artists of those who are not and has next to nothing to do with the student who is already an artist: "Once or twice in a generation a genius will appear—and if the school helps him, even to the extent of teaching him how to mix his paints or clean his brushes, it may have justified the grief, the cost, the waste of what is admittedly a haphazard scheme of education."[61]

Similar recitations of extravagance and waste and declamations against the squandering of education and of lives appear frequently early in the century. In 1915 a survey by the American Federation of Arts recorded "109 schools of Academic Art in the United States with a total enrollment of 6,252 students" in training to become "painters, sculptors and illustrators."[62] Like Duffus in the late 1920s, the AFA survey worried over and italicized the haphazardness and the waste of professional art education: "About 1 per cent of those who receive this professional training become professional artists and the remaining 99 per cent either drift *without special training* into industrial and commercial arts, or

entirely abandon the pursuit of the profession."[63] John Pickard, in his 1917 address to the College Art Association, pointed to the AFA statistics, asking whether "too many are not now thronging our art schools, whether we are not making it too easy to enter the road which is supposed to lead to art as a profession." "In no other profession," he asserted, anticipating Duffus's imagery of excess and dissipation, "is there such a woful [sic] waste of the raw material of human life as exists in certain phases of art education."[64] We have come again to waste.

Artists, if they are artists, already are; they are marked by an excess of being, or, as in Kendall's description, by being too much. The born artist cannot be made an artist by education because he already is one. He is joined in the art schools by "imitators and admirers, whose name is legion," but who cannot be made artists because they are not.[65] Theirs, too, is an excessive presence, an overenrollment. They are always too much and too many, hundreds and thousands and throngs and legions, and they figure the tragedy even of the true artist, the waste of his education or his talents. The artist of the garret, even a real one, is unwholesome, pathological. In all the writings I have cited, the born and suffering artist and legions that mirror him are linked together as a reproach to the old-fashioned professional art school, to an education that cannot fulfill what it promises, cannot guarantee an outcome. The stories of missed opportunities, of unhappy endings and forever deferred outcomes, are repeated again and again, made to stand in obvious contrast to the simplicity and efficiency of a happy, wholesome existence.

At once born and future, artists are, in the language of American art education, elided in the present. The artist, or again this life of the artist, is always out of time and place, particularly on the college campus. The College Art Association banished him at the start. CAA president Pickard, despite his plea for unity in 1916 and his expressed concern for the failures of art training a year later, insisted in his 1917 convocation that the "great educational work" of the association could not be the training of the future painter or sculptor: "The education of the technical specialist is the function of the art school and the atelier or of the graduate school of art."[66] Pickard's list of educational sites removes the training of the artist from the campus, the association, and time, into the past of the atelier and into the future. Although in 1918 the graduate school of art did not yet exist, he foresaw "the day when, even in a state university, it shall be recognized that art is as valuable to the state as agriculture, when a graduate department

of art shall be established coordinate with the graduate departments of law, medicine and engineering."[67] Like university presidents of the time, Pickard argued for social efficiency, offering art as a rational public policy choice. And in the models he chose, in his vision of a graduate, rather than a technical, school, he raised his sights from the vocational—from the land-grant analogies of Sophie Newcomb's Woodward: home economics, mechanical arts—to the professional. In Pickard's future, the artist is made reasonable, and reasonably made, educated as a professional, in the same system and institution—the professional school as satellite of the liberal arts campus—that educates doctors and lawyers and professors.

The Problem of the Academy

The difference of the artist troubles writers on art education across the century. Curiously, the academy, held responsible in the literature for the artist's otherness, was criticized as well for its sameness, its repetition and formulas. Duffus suggested that the troubled, driven artist "is more often found in a certain sort of art school than in certain other sorts." That observation, along with his description of the bearded artist in baggy pants, is part of his segue from a discussion of college art departments and technical schools to a survey of American academies, an account of his visits to the National Academy of Design, the Pennsylvania Academy of the Fine Arts, and the Art Students League. While Duffus noted differences between these institutions—the two academies, unlike the Art Students League, have a "progressive curriculum, with a beginning, a middle and an end"[68]—they were united, for him, by their disdain for the practical arts and their avoidance of a general education for their students.

> At the Philadelphia Academy, at the Art Students' League and too many other art schools . . . he doesn't learn about life, he learns about art.
> He may remain ignorant of even the rudiments of information regarding the world in which he lives—of history, literature, science, politics. He may associate largely with art students who have his own tastes and limitations, and so miss the wholesome give and take of more diversified circles. He may shut himself up in a little art universe all by himself, away from the swirl and flow of life, like a Trappist, and there offer up perfunctory prayers for the artistic salvation of a public which he despises. He won't understand the public and the public won't understand him, which is bad for the public, bad for the artist, and possibly even bad for art. For the work of the artist . . . ought to be just as necessary, just as understandable and in a way just as

commonplace as that of the farmer, carpenter and tailor. He ought to be friendly and human first, then artistic. But the older-fashioned art schools, it is said, haven't made him so.[69]

In his final sentences Duffus, like Pickard, offers agriculture as the benchmark for the normality and necessity of art. But those same sentences perform an interesting slide from the commonplaceness, the friendliness, of the work of art to that of the artist. Not only his work but also his persona is to resemble the farmer's or the carpenter's: the artist himself needs to be worked on and corrected. The older-fashioned schools—or to insist on the name, the academies—have not made him friendly, have not made him a citizen.

The academy, in particular its training in representation, the life drawing that formed its center and with which it had been identified since the early 1600s, both caused the artist's failure and embodied the attributes of the failed artist it made. Together artist and academy are marked by isolation, uselessness, and waste, by a disjunction of means and ends. Against this caricature of the academy a new vision of the artist and his education was constructed, one that fit the artist to the university's image of itself both broadly, as a reasonable, rational institution, and specifically, as an institution that fits the life of its students at a particular age and time and places them at a certain site, a particular rung, at the end of their tenure.

Although Cecilia Beaux regretted that the college could not be fitted into the life of a "future artist," she insisted in her CAA address that a "young person whose potentialities were only possible" should not be "treated as if he were abnormal or superhuman. Nothing could be worse for him than this."[70] Her fellow panelist, Sophie Newcomb's Woodward, repeated her concern, and her hierarchy of danger: art schools are "in many ways ineffective, but above all there is danger in the fostering of the idea through specialization that the artist is a man apart from his fellows to whom is due special consideration. This is injurious to his standing as a citizen, a member of organized society."[71] Again and again, the figure of the artist segregated too soon from his fellows in a pursuit too intensive and technical appears in writing on art in the university and on the problems of art in this century. The artist's isolation is used to explain the problems of art education and of the artist as a personality, as well as the isolation and peculiarity of modern art.

The academic artist was separated early on, shunted off to a special school and kept there too long, drilled in a technique that matched no end. Indeed, the technique he learned was a study in isolation: the iso-

lated figure on the page. Drawing education in the academy, according to its critics in particular, consisted of drawing, first parts, fragments of the body on paper and in cast, then from the whole body cast, and finally from the live model. But even in its final move, the figure stood in isolation, unconnected. Centered on the page that must be made to disappear and carrying within it its own center as plumb, the academic figure was created in the line that severed figure from ground and figure from world: the hard, drawn outline of the *dessin au trait*. "Misery," wrote Mondrian in 1920, "is caused by *continual separation*."[72]

Against academic isolation, the teaching of modernism would insist again and again on the placing of forms in relation to each other and to the frame and the page. Georges Braque, to begin early in the century, argued that he painted, not things, but the relation between things; the space "*entre-deux*"—in between—is "just as important as the objects themselves."[73] That relationship, Arshile Gorky suggested in the early thirties, is mapped not only in relation to the world, but also on the surface of page or canvas: "Every time one stretches canvas he is drawing a new space," a "measurable space, a clear definite shape, a rectangle, a vertical or horizontal direction."[74] Gorky's declaration of the canvas itself as already a drawing repeats Hans Hofmann's lesson of the late twenties that the "four sides of the paper are the first lines of the composition."[75] Hofmann's teaching, according to one student of his school at Munich in the 1920s, directly challenged the lessons and methods of academic drawing, and the academic plumb. "Easy understanding of it for most of us was impeded by some previous Beaux Arts training. . . . We had to learn to substitute the horizontal and vertical axes of the picture plane for the optical axis against which we had previously seen the subject. Those who didn't cross that threshold left either confused or bitter, or both."[76]

Mimicking the split of figure from page were the more damaging divisions between academic teaching and the processes and production of works of art, and between training in the academy and working. In a 1902 issue of the *Craftsman* Walter Perry, who had founded the art course at Pratt in the 1880s, complained that "it is not honest to take time and tuition from a student, and give him nothing in return but cast drawing and life drawing. That is not art education."[77] Duffus echoed Perry's criticism and his descriptions to stress the difference between the program at Yale, where "fine art is pursued, but by craftsmanlike methods," and the "older method in art education":

The older method in art education has been to provide the student with a technique and let him whistle for his ideas. He would begin by drawing from the antique—moldings, casts, block heads and statues. This might last a year—in some art schools it still does. He would then be promoted to a class in drawing and painting from life, and do that for another year. . . . The student of painting . . . may graduate from any one of several reputable art schools with literally no notion of composition or any conception of what to do with such skills as he has acquired. He has to learn that, often painfully, after he gets out.[78]

The academic artist is stunted by his education, by his isolation, and by the disconnection between his excessive technique, his remarkable ability, on the one hand, and his ideas, his employment, his public, on the other. The mirror image of the artist isolated in the academy is the artist isolated in his garret.

Despite their historical animosity—and explaining it—the bohemian artist and the academic are yoked together in American essays; they share their isolation. The artist as other, educated in a special school, exaggerated in his differences: this description fits both the academician, who seemingly transcends the tasks and foibles of daily society, and the bohemian, who dwells beneath it. Duffus's caricatured art student could attend either the National Academy or the Art Students League, and he matches as well Fanny Kendall's Greenwich Village type, the bohemian painter of the acid-colored skyscape. Each, in American writing, is marked by too much art; combined, they embody once again a waste of time and technique and livelihood. The academic artist has too much training, too much technique and facility. The bohemian artist is forced into technical experiment or expressive violence in search of "salvation from that mortal arrest and decay called academic art"[79]—thus no less a figure than John Dewey links the academic and the bohemian in a pathological, parasitic relation.

The struggle against the academy leaves its mark on the work as an excess of subjectivity, Dewey argued. The "arbitrary and willfully eccentric character" of the works of the avant-garde is "due to discontent with existing technique, and is associated with an attempt to find new modes of expression."[80] At their worst, Dewey continued, "these products are 'scientific' rather than artistic"—the quotation marks around "scientific" suggest a dubious honor, a reference to the merely technical, a barren experimentalism.[81] If the academic has nothing to say, the bohemian cannot be understood: neither can communicate; neither can be understandable and friendly, as Duffus, for example, would like him to be, or happy and wholesome. "The present segregation of art stu-

dents tends to foster the already hyper-individualistic point of view," wrote the director of the University of Pennsylvania's art program in 1929.[82] That point of view is mirrored and restated in their works of art, in Dewey's phrase, in the "over-individualistic character of the products."[83] Against the academician and the avant-gardist, or between them, the university painter occupies a *juste milieu*.[84]

Studio Problems

There is one further figure for the old-fashioned artist in the writings of American art educators in the first half of the century; in scenarios like Fanny Kendall's, the artist's studio—the empty, cold-water garret—is the very image of uselessness and self-inflicted loneliness. The walls of the studio defined an absolute perimeter, another world for the other-worldly artist; as Caroline Jones has recently argued, it was, for a certain vision of the artist, "a powerful topos—the solitary individual artist in a semi-sacred studio space."[85] But precisely because the artist in it was withdrawn, separate, troubled, it was a troubling place for the project of a meaningful and effective art education, which had as its goals the artist as a citizen and the integration of the arts into national life. Over three decades the studio is replaced, in essays in the CAA's *Parnassus* and the *College Art Journal,* by invocations of the guild workshop and the *bottega*. In the discourse of American art education these locations make possible a different artist and a different work, a public art, architecturally scaled and fitted.

In the privacy of the studio the artist works alone, on his own inventions, at an easel and on a set of genre pictures whose subject matter only repeats the studio's isolation. In 1936 Meyer Schapiro used the close confines of the studio to accuse the modern artist of painting only

> himself and the individuals associated with him; his studio and its inanimate objects, his model posing, the fruit and flowers on his table, his window and the view from it. . . . all objects of manipulation, referring to an exclusive, private world in which the individual is immobile, but free to enjoy his own moods and self-stimulation.[86]

Delivered as a call against the artist's onanistic refusal of politics at the American Artists' Congress against War and Fascism, Schapiro's critique of the subjects of modern painting is a central text of the mid-1930s artistic left, but his charges were leveled from the right, as well. A decade earlier, Thomas Craven, who publicly championed Americanism in painting, had railed against the studio and the still life as its exemplary

image, complaining extravagantly about the "tilted table and stiff, flow-ered cloth, the lopsided vase with its artificial flowers, the phallic banana and the ponderous bowl—how can one be patient with these perform-ances, and how can one hope for a healthy revival of painting while able-bodied young men continue to paint such trumpery?"[87]

From opposite sides of the political spectrum and in decidedly differ-ent language, both Craven and Schapiro demanded a public artist and an art for the public sphere by calling for an end to the studio. For Schapiro, artists "who are concerned with the world around them in its action and conflict . . . cannot permanently devote themselves to a painting committed to the aesthetic moments of life . . . or to an art of the studio."[88] Craven's call for public artists, and for the murals that have come to characterize the socially responsive art of the 1930s, was even more forceful. "The notion that painting is something 'to be lived with' is a modern sophistry born of that innocuous ornament called the easel-picture,"[89] he declared, demanding that those few artists "with sense and a talent for living should be expelled from their studios, made to observe American civilization for ten years, and then to record the results in the form of murals for public buildings or drawings for news-papers and magazines."[90]

These passages are often cited in discussions of twentieth-century American art. If they seem to take us some distance from the campus, the public artist, constructed in discourse as the choice between the studio's inside and the world outside, in fact runs through the college art depart-ment and the art school. The idea of the mural as the primary medium of a public art, and a necessary alternative to easel painting and the private exhibition, was current by the opening years of the century: "It is this lack of relation between the artist and the public that has created the modern exhibition," wrote Kenyon Cox, a member of the National Academy and a participant in America's turn-of-the-century mural re-naissance; "it created those bastard forms of art, the 'gallery picture' and the 'machine du Salon.' "[91] Beginning in 1904 a series of articles in the Arts and Crafts journal the *Craftsman* emphasized the mural as a public, democratic form. As the appropriate medium for the advancement of an American art, it was once again pitted against the easel painting and the studio: "Monumental art in a democracy can never be a toy for the rich, nor will it ever be a field for the exploitation of studio reminiscences and echoes of the old classical and academic art of Europe."[92]

While the mural could render and support social values and provide powerful images, the ameliorative discourse that promoted it stressed,

not its ability to convey a specific, pointed content to a politically dis-
tinct audience (the task perhaps imagined for murals in the wake of the
1930s or the 1970s), but its very publicness. The mural's primary value
was as a form, one that assured its patrons—civic, business, and educa-
tional leaders—and perhaps its audience that there was a "general pub-
lic," both by making public places for it and by showing a public art to
it. Thus the mural had a particular attraction to those who wished to
make functioning citizens of artists; it demanded artists who did "not
scorn to work with builders and industrialists," wrote Peyton Boswell
in 1930 of a younger generation of artists working in California, "even
those who heretofore have preferred the easel picture."[93] The mural is
the mark of a skilled and social artist, a professional working on behalf
of others, painting not himself and his objects, but others and their
world.

Boswell's editorial comments were published in the same number of
the *Art Digest* that announced José Clemente Orozco's *Prometheus* at
Pomona College, and just as Diego Rivera arrived in San Francisco to
complete a mural at the California School of Fine Arts. Most of the
work completed in the United States by the Mexican muralists Rivera,
Orozco, and David Alfaro Siqueiros was commissioned by art schools
and colleges: the California School of Fine Arts, the Chouinard Insti-
tute, Pomona College, Dartmouth College, and the New School for So-
cial Research. The muralists' presence in the United States was extraor-
dinarily influential in the 1930s, and the mural had specific lessons to
teach in those institutions. All Orozco's murals in the United States
were painted for schools; he completed his first in 1930 at Pomona, and
his second in 1931 at the New School. Looking back from the early
1950s, Stefan Hirsch credited Orozco's third mural and his presence at
Dartmouth from 1932 to 1934 with giving a "tremendous impetus to
the idea of the artist in residence. It virtually began the revolutionary
action which within a few years made almost every university in the
country put artists on their faculties and allow the students academic
credit for this work."[94]

Hirsch suggests the impact of the muralists on campus but credits
Orozco with leading a curious and exaggerated uprising. He makes no
mention of the critical politics of Orozco's *Epic of American Civiliza-
tion*—including its scathing critique of university knowledge. What mat-
ters instead—what is revolutionary—is the public presence of the artist
on campus. Dartmouth's official account of the mural and the contro-
versy accompanying its debut also stressed its value to the college. In

1934 the college published a pamphlet defending the educational bene-
fits of debate rather than the mural's content or Orozco's politics. "Pas-
sive acceptance has no legitimate place in the educational process. . . . The
Orozco project at Dartmouth was primarily an educational venture."[95]
The mural and its difficulty fit the college's self-image, and Dartmouth's
publicist paused to note that Orozco had painted it as a professor: com-
missioned to do the Baker Library mural, "he would accept appoint-
ment to a regular faculty rank in the department of art."[96] The critical
content of *American Civilization* could be contained as the statement of
an individual professor, protected by the college's promise of academic
freedom. That is, its meaning belonged, not to a public, much less the
masses, but to a single person. It was the lesson of the mural as public
form, and the example of the public artist, working and efficient, that
was important to the "educational venture."

The public artist at work was the central image of Rivera's mural for
the California School of Fine Arts, one of the first he completed in the
United States (Figure 1). Painted for an art school or, as Rivera put it, a
"technical school of the plastic arts," the fresco was a lesson in its own
making, intended to "express exactly the objective situation which pro-
duced it and to contain, technically, all the possibilities of mural paint-
ing."[97] At the center of Rivera's analysis of the mural's possibilities is
the fresco painter at work, dressed in working clothes, shirtsleeves
rolled up, and surrounded by his assistants. They labor alongside the
roster of citizens Peyton Boswell enumerated—architects and develop-
ers, sculptors and masons, and factory and foundry workers—to build
a city and to paint at its center "the gigantic figure of a worker grasping
the power control of the machine with his right hand and with his left
the lever which regulates its speed."[98] The enfranchisement of the
artist—the commensurability of his labor with that of workers in cov-
eralls, and of his reason with that of architects and engineers dressed in
lab coats and armed with slide rules—was a subject that, at least osten-
sibly, crossed political lines, that was called for by all sides.

Rivera's commission from the San Francisco Art Association asked
for something "suitable to an art institution," suggesting that "the
character of the mural might have a very wide choice of subject mat-
ter—anything but of a political nature."[99] As Anthony Lee has recently
argued, Rivera's public artist was ironic, and his subject was, in fact,
marked by politics.[100] Rivera, refusing the idea of a public outside poli-
tics, segmented and segregated industrial and intellectual labor, and
labor and capital; more immediately noticed, he painted himself with

Figure 1. Diego Rivera, *The Making of a Fresco Showing the Building of a City*, 1931. Fresco, 223 ⅝ × 390 ⅜ inches. San Francisco Art Institute. Photography: David Wakely.

his back turned, presenting his rear to the patrons of "public" art as panacea or public relations, the bankers and industrialists who underwrote public art and the California school. Still, Rivera's self-portrait insisted on the value of his work as a worker, as a technical and manual laborer.

In "The Revolution in Painting," an essay published in the United States in early 1929, Rivera fashioned himself as a workman, in direct contrast to the Paris-trained cubist studio painter he had once been: "Probably that is why I have been able to paint buoyantly, without fatigue, fifty easel pictures, any number of drawings, a quantity of watercolors, and 150 mural paintings in fresco."[101] The insistence on quantity, on productivity and capability, characterizes the public artist who can work together with builders and industrialists: an appeal to efficiency instead of struggle—and certainly not inner struggle—marks writing on the mural. "Ten years ago there were comparatively few murals by art students in campus buildings," wrote a commentator on the University of Georgia's art department in 1940; "today acres of wall space are being covered with individual and class projects."[102] Rivera's

mural painter and his workman are both productive members of or-
ganized society; they are citizens, where enfranchisement is the equiva-
lent of and the name for productive employment.

Men as Artists

The guild craftsman of the Middle Ages had served Arts and Crafts crit-
ics of art training as the first model for the necessary, integrated artist,
who could refashion everyday mass-produced items with renewed care
and beauty. William Morris's influential image of the artisan appeared
often in American publications of the Arts and Crafts, figured, as in
Morris's *News from Nowhere* and other essays and images, in sensible,
well-made medievalist garb and, as in Rivera's mural, in rolled-up shirt-
sleeves. In Germany, Walter Gropius's 1917 program for the Bauhaus
invoked the same medieval moment in its call for "a new guild of
craftsmen."[103] Like the Arts and Crafts writers, Gropius cited Ruskin
and Morris by name, crediting them with rediscovering the "basis of a
reunion between the creative artist and the industrial world."[104] For
American commentators, as for Gropius, the reunification of artist and
world, and of artist and craftsman, needed to be matched—and would
only be secured—by reconnecting learning and doing and the now sep-
arate and specialized arts and crafts. That list of contingent reunions
formed Duffus's optimistic vision of the present in the concluding pages
of *The American Renaissance:* craft schools approaching the fine arts,
schools of fine arts discovering "new value in the workmanlike integrity
of the craft schools," and both preparing their students—in words
echoing Gropius's tribute to Ruskin and Morris—to "fit into an actual,
industrial commercial world."[105] Duffus and other American writers
recast the utopianism of the Arts and Crafts and later of the Bauhaus as
professional success and gainful employment.

 The image of the new artist and of the arts united with industry was
found first in the medieval craftsman, but beginning in the late 1920s
the *bottega* was invoked with increasing frequency as the most relevant
model for the new artist's studio. In the *bottega,* or in the discourse on
it, the artist was refashioned not only as a citizen, but as a college-
educated one. Although the image of the guildsman did indeed promise
an employed and integrated artist, the Arts and Crafts worker was too
innocent, his labor too manual: the stonecutter of Ruskin's *Stones of
Venice* was precisely not an accomplished humanist. Moreover, the
guild model, with its explicit class identifications and its rejection of the

open shop and free trade, too closely resembled the modern-day trade union for the university in the 1930s, a connection made clear in the names unionized artists chose for their organizations in that decade: the Sculptors' Guild and the Mural Artists' Guild were both affiliated with the American Federation of Labor.[106] The legal, economic, and class implications of the term "guild" were finessed in the unfamiliar and redolently southern European *bottega,* fashioned by its supporters as a voluntary meritocracy, focused on teaching and useful production rather than economic organization. In its image, the art schools' apologists sought to combine the humanism of the Renaissance masters with the utility of the guild, replacing an idealized, often socialist, Middle Ages with an equally imaginary—and importantly individualistic—Renaissance.[107]

"We must take for our model the *bottega,* the real workshop of the masters, the creative system of training the artist from prehistoric times to the seventeenth century, when its gradual breakdown gave rise to art schools," declared Yale's Eugene Savage in a 1929 essay on art education prepared for the Carnegie Corporation.[108] "This golden age came to an end when the arts and crafts of the *bottega* were dissolved by separatism into their component parts," he argued, leaving both art schools and the modern art they produced a "clutter of separatism, incidentalism, and genre."[109] Against that confusion, the *bottega,* its art, and particularly its master offered the possibility of unity and integration. "In those eras a teacher was often at once architect, sculptor, painter, and engineer, and sometimes a literary man, a musician, and a scientist as well."[110] Savage's *bottega* teacher is extravagantly accomplished, the very embodiment of the unity of the arts: in him—as an individual—are finally joined the industrial artist promised in the new art schools and land-grant colleges and the liberal artist, the artist promised by the university.

The College Art Association's version of the *bottega* was held together by architecture as the culmination of the arts. The historical artist Savage described was focused, like the artist of the Bauhaus, on architecture as the end of art; he produced for "every architectural purpose, doorways, pulpits, doors and mouldings. . . . loggias, overdoors, ceilings, altar pieces."[111] The program Savage championed at Yale in the 1920s and 1930s attempted to re-create painting and sculpture as architectural arts: "The outstanding feature of the Yale plan is that the course in painting and sculpture is interwoven with the architectural uses to which these arts can be put."[112] Like the professional practice of

architecture, producing murals and sculpture for a particular site and purpose required study, material investigation, and theorization; these, rather than the simply technical and "applied" teachings of a guild apprenticeship, or the arbitrary, individualistic experiments of the art school, would characterize the lessons of *bottega* pedagogy.

The shift from guild to *bottega,* and from artisan to architect as the allegorical figure of the unified arts, suggests a shift in class status and in pedagogical background. The architect in the twentieth-century imagination is the artist as rationalist, and certainly as professional, armed with theoretical knowledge and concerned to solve the problems of his clients and his world. The figure of the *bottega* artist, repeated across the war years and into the 1950s, becomes as exaggerated in his professionalism as the academy artist was in his picturesque failure. Pleading for solid craftsmanship and necessary art against the fashions of Fifty-seventh Street and the isolation of the museum, Gibson Danes of the University of Texas was among the many administrators who offered his art students the model of the architect, "ministering to the basic needs of the people. . . . solving problems from the requirements of the region and the needs of the client."[113] Artists, he insisted, must be trained like the architect to work with him, in schools like the Bauhaus and in programs that saw themselves once again as *bottegas:* "If the twentieth century counterpart of Verrocchio's *bottega* could be realized by the art schools, art would begin to operate for the public again."[114] The *bottega* held out the promise of an effective rational artist, a fully professional model citizen, precisely because it produced a broadly trained and widely interested artist. "Artists in the Renaissance," Danes proclaimed in 1943, "were men, craftsmen, that were not limited to a particular kind of artistic production."[115]

By the 1950s the *bottega* artist was marshaled to stand not only for the dignity and necessity of artistic labor and technical command, but also for the wholeness and cohesiveness of public culture. He is a liberal artist and, more than that, a professor: the perfect figure for the artist in the university. In 1951 Ralph Wickiser, the head of the art department at Louisiana State University, redoubled Danes's prescription, arguing that the "creative artist must educate himself in many fields, much as the Renaissance artists did, so that he will become the cultural leader of his time."[116] The artist, Wickiser concluded, concentrating Danes's stuttering plural description of Renaissance artists as "men, craftsmen," must move beyond his particular training to become "truly the 'man-as-artist' first, the 'painter' or 'sculptor' as specialist second."[117]

The artist of the *bottega* was a special individual precisely because he was not a specialist, or rather not too peculiar. In contrast to the long-fingernailed, foppish artist of Greenwich Village and the studio, he was marked by his liberal education, his rightful place in society, and, most clearly, by an insistently repeated masculinity. The exaggerated insistence on the masculinity of the university artist was determined by a number of factors—enumerating some of them is the task of Chapter 2. Here, I would note only that art education constructed a masculine model for the university artist out of its discomfort with the private studio, the easel picture, and the individual practice of art, its fear of the caricature that popular discourse—and its own essays—had constructed for the painter. The American artist, wrote Thomas Craven in the twenties, "is an effeminate creature who paints still-life, tepid landscapes, and incomprehensible abstractions purporting to express the aesthetic states of his wounded soul."[118] Because Craven has been charged with racism and xenophobia since the 1930s, it would be easy to dismiss his sexism and homophobia as part of his bad politics, but Meyer Schapiro, too, invoked the specter of femininity to critique the studio and the artist isolated in it.

> In its most advanced form, this conception of art is typical of the rentier leisure class in modern capitalist society. . . . A woman of this class is essentially an artist, like the painters whom she might patronize. Her daily life is filled with aesthetic choices; she buys clothes, ornaments, furniture, house decorations; she is constantly rearranging herself as an aesthetic object. Her judgments are aesthetically pure and "abstract," for she matches colors with colors, lines with lines. But she is also attentive to the effect of these choices upon her unique personality.[119]

Schapiro's terms, or rather his conflations—of femininity and a certain kind of artistic practice with domesticity, ornamentation, display, and consumption—are among the themes and alignments I trace in the chapter that follows.

WOMEN AND ARTISTS, STUDENTS AND TEACHERS

2

At the close of Chapter 1, Gibson Danes and Ralph Wickiser insisted above all else that the artist be male. This insistence has been implicit in most of the commentaries on art and its decline that I have cited. For Meyer Schapiro and Thomas Craven and Diego Rivera, who embraced fresco as a "masculine and simple method,"[1] the debates over the artist's image as medievalized craftsman or *bottega* master were written along the lines of sexual division.

The artists of the "artistic type" that R. L. Duffus and Fannie Kendall caricatured in the 1920s were gendered by their excessive image and an exaggerated visibility. Their long fingernails, outlandish hats, and "impossible hair and neckties," as one graduate of the School of Fine Arts at Yale wrote from Paris to Yale's John Ferguson Weir in 1897, feminized them; it made them something to look at.[2] Arguing that the artistic female in eighteenth-century British culture "received definition only in contrast to the professionalism of the male artist," Ann Bermingham links a disabling and excessive visibility to the female practitioner: "The accomplished woman was understood to be 'artistic' but not an artist. The word 'artistic' inscribes art on to the body and into the personality of the subject who makes art. 'Artistic types' are works of art themselves, embodying art without necessarily mastering it."[3] Bermingham's accomplished woman is redundant; she is the object of the gaze as both art-making woman and work of art. The artist, too, insofar as *he* is produced as a visual type, a work of art—usually of

melodrama or romantic fiction—becomes an accomplished woman or simply, as in the writings of critics like Craven, a woman.

Masculine / Feminine

In 1973 the artist June Wayne wrote of "the male artist as a stereotypical female," noting that according to the myth of genius and the "demonic" artist, or to what I call in Chapter 1 the ontological problem of the artist, "the artist 'can't help it.' " "Unless one is *born* an artist," she continues, "neither effort nor intelligence (not even surgery) makes one into one. So the demonic myth presents the artist as biologically determined. . . . The biology of the woman, like that of the artist, is proposed to be her destiny."[4] Mary Garrard suggests that Wayne's reading "can be applied not only to the artist but to art itself," arguing that, at least in the United States over the past two centuries, art, like the artist, is gendered female.[5] James Jackson Jarves, whose collection of trecento pictures was installed in Yale's new School of Fine Arts when it was completed in 1869, divided feminine art and masculine science and then, in an equation Garrard cites, married them off.

> Art adorns science, Science is the helpmeet of art. . . . Apart, the one is erratic, mystic, and unequal in its expression, the other cold, severe, and formal. . . . Art [is] the ornamental side of life, as Science is its useful. . . . We build, manufacture, classify, investigate and theorize under [Science]. . . . But our pleasure is more intimately related to art as the producer of what delights the eye and ear and administers to sensuous enjoyment.[6]

Sensuous enjoyment, Garrard points out, was structured along the same binary lines as the category Woman in nineteenth-century culture. Art was "perceived as coming in two varieties, seductive and virtuous":[7] art could ameliorate or seduce. Garrard quotes the warning of Charles Butler, in an 1836 instructional manual for young men, against too great an interest in the fine arts: "Ornamental education, an attention to graces, has a connection with effeminacy. In acquiring the gentleman, I would not lose the spirit of a man."[8] She could easily have continued with Jarves, who cautioned his readers that "while art, therefore, is valuable as an elementary teacher by reason of its alliance with science, it particularly exposes man to seductive influences, through the medium of his senses, from its greater affinity for feeling."[9] Art is gendered female in Jarves's warning not only in its seductiveness and emotionalism, but in the figure (perhaps not meant so literally as I take it), to which I will return, of the elementary teacher.

Still, the artist is male; this assumption is repeatedly threatened, and insistently affirmed, in all the complaints and models I marshaled in Chapter 1. The presumption and protection of masculinity is at work even in Thomas Craven's charge of effeminacy and inversion against American artists, and it is the implication of Schapiro's more thoughtful criticism as well. Schapiro relied on the a priori assumption of the artist's masculinity to construct his likeness to "a woman of this class" as cutting criticism.[10] Even, perhaps particularly, the avant-garde cited the male artist as a woman, as a "female soul in a male body." In 1916 Marius de Zayas, an artist and dealer and member of the Stieglitz circle in New York, described the inhabitants of America's art world as the "flowers of artificial breeding. . . . They live in an imaginary and hybrid atmosphere. They have the mentality of homosexuals."[11] De Zayas's diagnosis, which repeats the themes of isolation and uselessness that are a leitmotif of the preceding chapter, also returns to the artist's delusion, to the conjunction of the artist and fiction; the artist's habitat is the Greenwich Village of Fanny Kendall's article and, beyond that, an imaginary bohemian Europe.[12]

Beginning in the 1930s and accelerating after World War II through the 1960s, artists became the subject of, and were mapped by, psychological and educational testing, particularly as they were linked to women and homosexuals as types, as the typical subjects of what Michel Foucault characterized as an "*incorporation of perversions* and a new *specification of individuals.*"[13] In Terman and Miles's 1936 study *Sex and Personality: Studies in Masculinity and Femininity,* to cite an early example, artists are grouped with clergymen and editors "as the most feminine among the occupational classes."[14] Their Masculine-Feminine (M-F) score "at a point significantly below the norm for persons of college education" is explained by "some other factor besides education, age, and intelligence. . . . We have called this factor 'culture.' . . . It may well be that not only the positive factor of culture but certain negative factors, generally its correlates, are also operative in the placement of these most feminine of our normal groups. Lack of mechanical, administrative, and financial interests are perhaps to be considered here."[15] Terman and Miles illustrate the M-F scale as a vertical line with masculine at the top, calibrated in positive integers descending from 100. College athletes appear first at 92.5; artists rest near the bottom of the "normal" masculine range at 8.4. Femininity descends in negative integers from 0, but it seems women are much more deeply embedded in their femininity than males along the masculine axis: the

first women to appear on the line are high school and college teachers at −48.1. The authors insist that analysis of the artist's group is "not complete without reference to the difference between this least masculine of the occupational classes and the M-F averages of women's populations." The group of artists, clergymen, and editors is saved, finally, by the 98.1-point "difference between it and the total population of all adult women."[16]

Positive and negative, top and bottom, masculinity and femininity are clearly much more value-laden terms and positions in Terman and Miles's analysis than one would expect from scientists. Much is being projected, and much protected. The psychologists' judgments are marked again in the way in which they name the male artist's female counterparts. Rather than "female artists," women artists, designers, and photographers are charted at −83.3 under the heading "artistic occupations,"[17] a term that should recall Ann Bermingham's comment on the artistic "accomplished woman." Male artists are feminine, but they are saved from being women, and from being homosexuals as well. In the study's final appendix, the table "male artists vs. passive homosexuals" argues that while both categories finish well below the masculine mean on a battery of tests, "these two extremely feminine groups of men resemble one another very little in profile. . . . [There is] a contrast between the femininity of culture and the femininity of homosexuality."[18]

The value of Terman and Miles's survey now is its stereotype of the artist, of the image the university's artist had to defeat to become a fitting product of higher education. The clichés of the artist's femininity, his kinship to the homosexual, are overlaid and bound together with art constructed as an endeavor that was still manual, if not mechanical. The descending status order Professions, Occupations, and Vocations is matched by descending rank on the masculinity scale: artists, clergymen, and editor / journalists are named together as the "Vocational Group." The label, unexplained by the authors, is remarkably inappropriate in light of theology's place among the oldest "learned professions" of American education. Perhaps it is the artist who brings the taint of the hands, and he finishes lowest of the three on Terman and Miles's scale. Architects and college teachers, the models that Savage and Longman offer for the university's artist, are, in contrast, classed among the professions. College teachers score 45.3, and "engineers and architects are far more masculine than any other group," even if architects, "being akin to artists," separately score below engineers, at 58.5.[19] The goal of

professional art training in the university, then, might be read through Terman and Miles as making artists into professional men.

Sex and Personality is an outdated example; certainly we know better now. There are, however, findings and corroborations of the feminine artist from the thirties through the sixties, and the figure appears as late as 1971, in the pages of *Psychology Today,* along with a three-page spread of Jackson Pollock's Jungian drawings. Before turning to Stephanie Dudek's "Portrait of the Artist as a Rorschach Reader," I want to pause with the mention of Jackson Pollock's name to remark on the dissonance between the effeminate artist Terman and Miles find, who troubles art education, and the image of the modernist artist as superman, as worker or rebel or cowboy, that feminist criticism has addressed. June Wayne noted the male modernist's exaggerated displays of masculinity, riding motorcycles and doing drugs, even as she characterized the male artist as a woman, describing those behaviors as "props" and "camouflage."[20] More recently Lisa Tickner, in her examination of the British avant-garde in the early twentieth century, has suggested that the bohemian "parade" of masculinity—and indeed, "masculinity as masquerade"—were historically specific responses to the identification of art and the feminine: "Men moving into art—an area identified with 'feminine' sensibility and increasingly occupied by women art students—might feel the need . . . to distinguish Vital English Art from the pastimes of women and school girls and to adopt the mask of a heightened and aggressively heterosexual masculinity."[21] Tickner's mention of the growing numbers of women art students arrives beforehand at a destination I want to come to. But first I need to turn again to *Psychology Today.*

Artists, writes Stephanie Dudek, citing not only her own research, but earlier findings in studies like Terman and Miles's, "are intensely confused about their sexual identities and roles."[22] The future artist "often shows unusual fears, sensibilities and affinities by the time he is an adolescent. In terms of male-female identification, he already scores high on scales of femininity by the first grade."[23] The events of early childhood and the pathologies of the family establish and explain the artist's difference; but if the artist is made rather than born, that making takes place far from (and well before) art school.

While Dudek finds the markers of the artist's difference where Terman and Miles found them, she prizes his femininity and his ability to slip the boundaries of sexual identity. The artist's "psychological hermaphrodit[ism]" is "a kind of *gift*": "Hermaphroditus *is* art, *is* the

artist."[24] For Dudek the overlapping of art and artist follows from the artist's own doubling of masculine and feminine—and follows as well the artist's lead. The confusion of art and self, she insists, is the artist's own: it is he who "fail[s] to distinguish art from artist," who "insist[s] on making his life part of the artistic process."[25] Embedding the art in the artist, joining his being and his production and casting them as one with his sexuality, Dudek repeats in all of its points Foucault's synopsis of the production of the category "homosexuality":

> The nineteenth-century homosexual became a personage, a past, a case history, and a childhood, in addition to being a type of life, a life form, and a morphology. . . . Nothing that went into his total composition was unaffected by his sexuality. It was everywhere present in him. . . . consubstantial with him. . . . a hermaphrodism of the soul.[26]

In Terman and Miles and in a number of other psychological tests from mid century, the Strong Vocational Interest Blank, for example, artists appear as feminine, not so much because of their Freudian family histories as because of the already determined femininity of an interest in art, or in the objects and activities of art. For Terman and Miles, "the masculine man has typically masculine interests. The feminine man has cultural interests. . . . art [is] the most feminine male interest."[27] Thus the male artist's place on the M-F scale comes as no surprise. Clearly, the coupling of art and femininity in both Terman and Miles's social determinants and Dudek's psychoanalytic ones—a coupling that seems commonsensical and natural—is encultured and ideological; art is already feminine, and male art students will be female because art is feminine, *because,* as the art educator Georgia Collins writes, "tests which measure masculinity and femininity take as one indicator of femininity an expressed interest in art."[28] Thus "the circularity of the psychological notion of art as feminine evidenced by such instruments as M-F scales is most apparent."[29] Because of the circular logic, the answer will always be the same, and the true artist, however damaged, will always be male. "It would appear," Collins writes, "that where the female interested in art conforms to her sex-role stereotype, the male who would be an artist is a rebel."[30] Terman and Miles confirm her diagnosis: where the "feminine man has cultural interests," the "feminine woman has feminine interests."[31] Precisely in his troubled sexuality the artist is resecured as male, and re-dressed in denim and leather.

Across the postwar period, the ideological function of psychological testing was twofold, perhaps even threefold: first and foremost, artists

as the objects of psychological and educational testing were assumed to be male, whatever gender art students might be: Dudek writes "Man as artist" even if she follows it with "is different from other men."[32] Second, the tests worked actively to rescue the category artist from the being of homosexuality, from a more ontic otherness: hence Terman and Miles's "cultural femininity" and Dudek's assurances that the artist's hermaphroditism was not "an unusual anatomical variation from the norm, nor a painful sense of being *half* this and *half* that."[33] Third, the testing allowed the artist his difference not only from other men—an incremental difference, a sliding scale—but also from women: male artists transcended the category man; women artists could only double and reconfirm its excesses. "The woman artist," wrote June Wayne, who was corroborated by Terman and Miles and repeated by Georgia Collins, "is only underscored to be a woman."[34]

The Female Artist as Invisible

There is no room in the psychological discourse of the artist-as-female, or the artist-as-homosexual, or in its popular version, either for women or for male homosexuals. The comparisons provide a list of attributes that take on meaning only if the artist is assumed to be a male heterosexual, so that he can then be a different man. The artist's difference is an instance of what Rosi Braidotti calls the philosopher's "old mental habit of thinking the masculine as synonymous with universal . . . [and] translating women into metaphor."[35] Ann Bermingham, writing of the "feminized" (as opposed to female) artist, argues similarly that the discourse of femininity excluded women: while "charges of effeminacy . . . were commonly used to discredit certain cultural forms as deviant in order to validate others as proper—that is to say as 'manly,' "—it is "not femininity but high culture" at stake in the charge and the binarism.[36]

But the discourse of high culture and the demands for virility go beyond the tropological or metaphorical to have real effects. The problem is not the denial of status to artists because of their alignment with some abstract femininity or that art, seen as feminine, was therefore extraneous. Rather, the issue is that despite their numerical predominance in art schools and college art departments from their inception at Syracuse and Yale in the 1870s, women were excluded both from and by the discourse. Their presence in the classroom and the studio is, one might say with Pierre Macherey, the "structuring absence" of the discourse of art education in the university.[37]

The "question" of women art students worked to determine the *bottega* and the Renaissance artist as proper images for the new artist in the university. The architect and designer were recommended not only by an abundance of psychological masculinity, but also, not coincidentally, since social practice was being measured, by an actual dearth of women practitioners. According to the Census Bureau statistics cited by Duffus and Carnegie Foundation president Frederick Keppel, writing together in the 1933 report *The Arts in American Life,* there were five women "artists, sculptors and teachers of art" in 1910 for every six men; that same year, less than 2 percent of architects and under 20 percent of designers were women; by 1930, women constituted just over a third of designers, but the percentage of women architects had dropped to 1.7: of 22,000 architects, 379 were women.[38] Keppel and Duffus cite another set of statistics, gathered by Royal B. Farnum of the Rhode Island School of Design in 1931, estimating the "membership of art courses in the colleges and universities as being about seventy percent feminine."[39]

In Chapter 1 and in the opening pages of this chapter I left those numbers unremarked and built around their absence. I have staged an omission, but my negligence only restages that of other commentators. At a number of places in *The American Renaissance,* for example, Duffus looks up and suddenly, rhetorically, realizes that the students he has been praising for their virility, and for the rugged masculinity of their art and their program, are women. "The arts are no lackadaisical affair at Pratt. They are athletic and virile. No engineer from across the street ventures to hint . . . that the male 'Arties' had better put on skirts and be done with it. . . . The percentage of men in the arts classes is rising steadily; a few years ago the males were a small minority, now they are nearly quite half."[40] He opens his discussion of the Cleveland Museum School of Art by comparing it to the tough-minded program at Pratt: "The would-be artist at the Cleveland school must work as hard and submit to as severe a discipline as he would at the Massachusetts Art School, at Pratt, or at the Philadelphia Museum School."[41] He ends his discussion of its pragmatic, goal-oriented training by admitting that he "should add that though I have used the masculine gender in speaking of the students in the Cleveland School seventy-five percent of the attendance is in fact feminine."[42]

I neglected earlier to underscore that John Ferguson Weir's Paris correspondent, Mary Hubbard Foote, was a woman student at Yale—I neglected to point out or explain the oddity of her presence there. Al-

though Yale remained a men's college until 1969, the art school, founded in 1869, enrolled women as early as 1873; by 1876 and through 1913 at least three-quarters of the school's students were female.[43] Their presence underscores the marginality of the School of Fine Arts to Yale College; their appearance there confirmed rather than caused the school's separateness. This eccentricity was administratively enforced: undergraduate men were not permitted to take art courses for credit until the 1890s, and art school students, never considered Yale undergraduates, were barred from commons dining and communal chapel.[44]

Duffus begins his survey of art in the colleges in the late 1920s by noting the invisibility of the art school at Yale and the true undergraduate student's ignorance of even its location. "In a corner of the campus at Yale stands a modified Gothic structure. . . . Until very recent years few of the undergraduates of Yale College ever attempted to pass its doors, not to speak of its courses. Some of them seem not even to have known it was there."[45] Against the backdrop of the old and unknown nineteenth-century school, Duffus sets the new and rigorous *bottega*-inspired program introduced at Yale by Everett Meeks before 1920 and lauded by Eugene Savage in the thirties. By the mid 1920s the old building had begun to "reek of energy, ambition, determination," like an undergraduate gymnasium. Besides invisibility and marginality, Duffus marshals the trope of excessive visibility, which for Ann Bermingham marks the conjunction of women and the arts, to dismiss as insignificant the first half-century of the Yale school. Writing of the nineteenth-century school under Weir, he explains that "it became quite a fad for young ladies in New Haven to study art for a year or two while waiting to be married. This was, possibly, an advance over tatting and embroidery."[46]

In sliding from Weir's rigidly academic course in drawing and painting to the specifics of needlework, Duffus expressly linked the early Yale school to the traditional female "accomplishments" that characterized the education of well-to-do urban women in the United States from the colonial period to the mid nineteenth century. Watercolor, drawing, needlework, dancing, elocution, and French were taught privately by tutors as well as in "adventure schools" through the early 1800s; a Boston school of 1712 announced its courses of study in "writing, ciphering, dancing, treble violin, flute, spinet, English and French, quilting, embroidery, flourishing, and marking."[47] The female academies and seminaries established in the nineteenth century greatly

expanded formal educational opportunities for women. These schools continued to teach the accomplishments as "ornamentals"—a term whose appeal to the excesses of vision cannot go unremarked—supplementing a course in modern languages and a selection of mathematics and natural sciences. Up to the Civil War, according to the educational historian Guy Hubbard, "drawing continued as an appropriate part of a girl's education in conjunction with such subjects as filigree embroidery, French, English, and geography."[48]

Ornament and the Excesses of Education

The "ornamentals" were the target of a great deal of criticism, not only from opponents of women's education in the first half of the nineteenth century, but also from its serious supporters, who wanted to offer women a solid education on an equal footing with men's. Before the Civil War the proponents of a more practical women's education demanded teacher-training, or "normal," courses and instruction in household arts and domestic economy; from the 1830s Catharine Beecher, in particular, lobbied to realign women's education to teaching, both as an *"appropriate profession"* and as preparation for family life.[49] With increasing intensity after the war, proponents of a more liberal and scholarly women's education demanded classical and scientific courses modeled after those of men's colleges—an education marked, not by an "appropriate" difference, but by an almost sameness. Despite criticism, however, the teaching of ornamental courses continued throughout the period, "as of necessity," in Louise Boas's words: "A compromise developed whereby two courses of study appeared in the college bulletin, namely, the 'first course' which included 'solid subjects,' and the 'second course' which included the 'ornamental branches.' "[50]

The new coeducational colleges repeated wholesale the division that marked the women's seminaries; at Oberlin, founded in 1833 as the nation's first coeducational college, the majority of women enrolled through the 1860s took, not the collegiate, but the "Ladies' Course," which repeated "the useful branches taught in the best female seminaries."[51] "Useful" is a curious word here, for it describes precisely the ornaments that critics dismissed as useless, but it points them toward the productive goals of the educational reformers, toward the manual, perhaps, or toward the home. It is not coincidental that of the very few American colleges offering courses in the practice of art before the establishment of the school at Yale, all but one—New York University,

which had ties to West Point and military topographical drawing—were early coeducational schools: Oberlin offered drawing from the 1840s, the University of Rochester from 1850, and Antioch College from 1853.[52]

For much of the century, certainly through the 1850s, attempts to reform women's seminaries proceeded by expanding the array of studies offered. Instead of grounding and stabilizing seminary education, the addition of Latin or algebra was seen by the seminary's critics as simply an expansion of the ornaments: women's visibility tainted the solid courses too. Margaret Fuller, who would become editor of the *Dial* in 1840, wrote the previous year of the proliferation and the spectacle of women's studies.

> Women are now taught, at school, all that men are. They run over, specifically, even *more* studies, without being really taught anything. But with this difference: men are called upon from a very early period, to reproduce all that they learn. . . . to use what they have learned. . . . Women learn without any attempt to reproduce [their learning]. Their only reproduction is for purpose of display.[53]

The complaint forecasts Ann Bermingham's description of the accomplished woman as the object of the gaze, and Fuller was far from alone in linking women's knowledge and display; an unnamed author in the *American Annals of Education* in the same period repeats her terms: "The whole circle of attainment bears upon one subject—the desire of display."[54]

The debate over women's education, and the place of the practice of the arts within it, shifts during the nineteenth century. Before 1820 women's schools of any name were scarce; female seminaries experienced their greatest period of growth from the 1830s through the 1860s; after the Civil War, the institutions that were chartered were increasingly named colleges.[55] Beginning with the founding of Vassar in 1865, the top rank of those colleges offered a course of study fashioned directly after traditional undergraduate men's colleges. The first prospectus for what was initially called Vassar Female College recalled, not Yale, but Catharine Beecher or the goals of a land-grant school; it promised training in "the peculiarly feminine employment" of telegraphy and bookkeeping and, insisting that "the household is, by common consent, woman's peculiar province," proposed to "foster a womanly interest in its affairs."[56] No such courses were offered by the college when it opened its doors in 1867; officially renamed Vassar College, it was "the first college for women not to be known as a 'female college.' "[57]

From its beginning Vassar required Latin for entrance; Smith re-
quired Latin and Greek, as did Wellesley after 1881.[58] Their admission
requirements matched those of the best men's colleges, as did the work
they required over the four years. Unlike the men at Harvard or Yale,
however, women at Wellesley were required in their first year to take a
course in drawing and were offered instruction in flower painting and
watercolor as part of their regular tuition, from the college's founding
in 1875 until 1893. Wellesley, Smith, and Vassar all established free-
standing schools of art and music, open, like the school at Yale, to
"special students not candidates for an academic degree," but for very
different, if equally pragmatic reasons: according to Smith's first presi-
dent, Laurenus Seelye, "the college was too poor, at first, to make ade-
quate provision for the instruction needed in those subjects for the reg-
ular academic students."[59] Smith's courses in practical art and music
were optional, but President Seelye insisted, in language that suggests
continued popular demand as well as personal conviction, that

> it would seriously detract from the value of a college education for women
> . . . if, during the time allotted to it, no opportunity were given to cultivate
> musical or artistic talents; or if the experience were given, a stigma or a re-
> straint were placed upon the culture by not permitting the time and thought
> thus expended to have any consideration in the computation of the work ac-
> complished for an academic degree.[60]

As Hubbard notes, Seelye was striving for a balance "between the ne-
glect of art in the men's colleges and its exaggerated emphasis in the fe-
male seminaries."[61] Such a balance would have to separate the practice
of art from what Bryn Mawr's president Carey Thomas dismissed as
the "so-called practical geisha education" of the seminaries.[62]

Thomas issued her dismissal in 1908, contributing to a debate over
practical education in the women's college that echoed the disputes be-
tween midwestern land-grant colleges and eastern universities over
questions of "service" and vocational training. The conflict affected
women's education in a particular way. For Thomas, according to the
historian Joyce Antler, "There was 'nothing more disastrous' than spe-
cialized education for women as a sex . . . the introduction of practical
or professional courses in the college curriculum, whether domestic sci-
ence, drawing, painting, instrumental music, library work, typing, ste-
nography, shop work or manual training of any kind."[63] Antler's list
clarifies Thomas's misgivings and her harsh juxtaposition of "practical"
and "geisha." Her list of professions and specialties mixes useless orna-
ments and the paying jobs early Vassar had termed "peculiarly feminine

employments"—precisely the collapse performed by "practical geisha." Specialized training for women offered only an updated version of seminary education and promised the continued impossibility of liberal education for women.

In 1891 Vassar's president recommended that the free-standing schools of art and music be abolished, that regular college professorships be established, and that "instruction be offered in the theory of the arts as part of the College curriculum, and . . . practice be provided for, though not as belonging to the College course." "The trustees," write the historians of the college in 1914, "adopted the recommendation at once, and a . . . great step was taken toward making Vassar a homogeneous college of liberal learning."[64] According to proceedings reported in the *American Art Annual,* Vassar's O. S. Tonks told the College Art Association's annual meeting in 1913 that "technical work in drawing, painting, and modeling has no place in the college course."[65] Tonks's call might be added to the more diplomatic voices of Alice Van Vechten Brown and Gertrude Hyde, who, as I noted at the outset of Chapter 1, asked the 1918 meeting for a homogeneous college, or at least a college in which the study of art could be both literally and figuratively creditable, an equal partner with the established course of the university. I did not pause to mention there, or underline as significant, that the speakers who argued for placing the study of the practice of art under the aegis of art history, where it could be "properly graded and correlated with those [courses] offered in other departments," represented women's colleges, Mount Holyoke and Wellesley.[66] Wellesley, which offered the nation's first undergraduate major in art history, closed its school of art in 1896, Smith in 1902. Studio practices continued to be taught at both schools, but they were taught in conjunction with period art history classes as art-historical skills. As I argued in the preceding chapter, that link determined not only that painting, sculpture, and printmaking would be the media taught, but also that they would be taught as historical projects in relation to questions of craft.

Women's Art Education and Ruskin in America

In 1916 the art historian A. V. Churchill represented Smith on Cecilia Beaux's panel discussing the college course for the future artist. His talk was not reprinted in the *Art Bulletin*—as befit an emissary of a college that had disbanded its art school and discredited the teaching of art— and a note attached to his name indicates that the journal received no

abstract of it. Besides Beaux and Churchill—one, the most famous woman artist in America, the other, a representative of one of the nation's most prestigious schools for women—the two other panelists were Jeanette Scott, a painter and head of painting in the College of Fine Arts at coeducational Syracuse University, and Ellsworth Woodward of Sophie Newcomb, the coordinate women's college of Tulane University. The panel's makeup suggests the central, if often contradictory, roles played by women, women's institutions, and the image of Woman in bringing the practice of art onto, or barring it from, college campuses. Each of the three colleges represented at the CAA roundtable was in some sense unique: Smith was the culmination of the women's college movement of the 1860s and 1870s; Syracuse's College of Fine Arts was the first degree-granting professional art school situated on a college campus; and Sophie Newcomb had gained an international reputation as a center for the arts and crafts by the 1890s. At the same time they can be read as examples of how art is placed in the university at the end of the nineteenth century. They allow me to retell, from a different place, the history I started in Chapter 1.

From the late 1870s both Syracuse and Sophie Newcomb were devoted to teaching the practice of art, but at those sites, as in the elite women's colleges, the purpose of women's art education would turn from the acquisition of ornaments to the production of culture. Both schools bear direct marks of John Ruskin's influence, which was stronger in the new educational and cultural institutions in the United States than it was in Ruskin's native England. A list of American Ruskinites, friends and readers, members of John Ruskin clubs or Arts and Crafts societies, would include a number of the figures I have discussed thus far: James Jackson Jarves, whose collection helped found the School of Fine Arts at Yale, as well as Charles Eliot Norton at Harvard and Irene Sargent at Syracuse.[67] The goal of the ornamental course, even for its supporters, had been the beautification and culturing of an individual woman; the goal of art education in Ruskin's name was the beautification of society. Women and art shared the task of ameliorating the ills of industrial society.

The elite women's colleges, like Vassar and Smith, that emerged after the Civil War sublimated the ornamental course as art-historical scholarship. At Syracuse and Sophie Newcomb, the cultural replaced the ornamental at the site of art practice. In both women's and coeducational colleges art was understood to play a special and different role in the education of women; increasingly after 1850 and into the twentieth

century, art was delivered as culture, as the equivalent of, and the figure for, education. In Jarves's writings, and in those of other American Ruskinites, such as James Mason Hoppin, a divinity professor who became the second professor of art history in the Yale School of Fine Arts, or George Fisk Comfort, who founded Syracuse's College of Fine Arts, the recognizably Ruskinian conjunction of art and morality was joined both to the task of teaching and to women as mothers and teachers. For Jarves by 1864 all art had been transformed into education; he wrote in *The Art-Idea* of art "as a vehicle of knowledge" and even, as I noted above, as a teacher dedicated particularly to the education of the young: "art . . . in its primary stage, is the elementary education of individuals and nations."[68]

In words that recall Jarves's prescription for a familial pairing of art and science, C. J. Little of Syracuse University suggested in 1889 that the College of Fine Arts offered something that made Syracuse "distinct, unique":

> the coordination of the sciences that sustain and perfect the workshop and the State, with the literature and the arts which adorn the home and glorify society. Here knowledge and the humanities dwell side by side, co-equal with the creative sister who first taught men to give permanence to form, to fling the secrets of the rainbow upon the answering canvas.[69]

Little pronounced art's sibling status at the dedication of the college's new building, which was christened the John Crouse Memorial College for Women, although both the university and the College of Fine Arts had been coeducational since their founding in the early 1870s and would remain so. If the decision to take the name was pragmatic—a coordinate college for women is what the donor had pursued—its acceptance posed no meaningful problem for the university's administration. The title fit both the broad ideals of art as feminine and the particular demographics of the art school's student body. In its first year the College of Fine Arts admitted nine women and six men; twenty-one years later, in 1896, the art school would enroll 284 women and 42 men. Over half the women who graduated from the college in the last quarter of the nineteenth century became teachers.[70] Little's separation of the public and private spheres as the fitting realms of men and women repeated, perhaps not coincidentally, John Ruskin's; it was institutionalized in the division of the colleges of fine and liberal arts, and only verified by the rechristening.

Ruskin's own *Sesame and Lilies,* a gendered pair of lectures on the education of boys and girls that was published at least a dozen times in the

United States between 1864 and 1900, had already done much of the work for Jarves and Comfort, continually casting its recommendations for women's education, in whatever field, as aesthetic education. Like most midcentury writers on the necessity of women's education—for example, Catharine Beecher—Ruskin assumed that it was "woman who watches over, teaches, and guides the youth."[71] Ruskin's plan for a woman's education was based on difference, not only of her particular roles as mother and teacher, but also of her ostensibly particular character and faculties: "Her intellect is not for invention or creation, but for sweet ordering, arrangement and decision."[72] Therefore, he reasoned, a girl should be taught whatever a boy is, but differently: "His command of it should be foundational and progressive; hers, general and accomplished for daily and helpful use."[73] Or again, "all such knowledge should be given her . . . and yet it should be given, not as knowledge,— not as if it were, or could be, for her an object to know; but only to feel, and to judge."[74] Women, then, are born for the role that Meyer Schapiro gave them in his criticism of the avant-grade artist in 1936, and for what would become the lessons of art appreciation and the "beauty corner" by the end of the nineteenth century: ordering and arranging.

Ruskin's description of a boy's acquisition and use of knowledge as "foundational and progressive" echoes a Kantian definition of reason as the systematic unity of understanding, terms that also recall the goals of the research university. In Kantian terms women are endowed, not with the faculty of reason, but with that of judgment; philosophically, a woman's realm is precisely the aesthetic, but it is also the elementary classroom: she knows things through feeling and sensibility, helpfully, day in, day out. The educational historian Mary Ann Stankiewicz notes Ruskin's influence in the crossing of judgment and classroom, in two movements that mark turn-of-the-century public school art education: schoolroom decoration and picture study, early modes of art appreciation and art history. "Told by Ruskin and other Victorian writers that they had a duty to refine the lives of those around them, women took an active role in organizing school art societies to promote the distribution and study of pictures."[75]

The Art Teacher

In 1870 women constituted 66 percent of public school teachers; by 1900, they made up 73 percent of the profession nationwide; in larger cities, they numbered more than 80 percent of teachers.[76] As the

metonymical, even redundant, mirror of both femininity and education, teaching art would be an almost exclusively female profession from the mid nineteenth century on. When Henry Turner Bailey, a strong supporter of Arts and Crafts movement ideals as editor of *School Arts Magazine,* produced the manual *Art Education* in 1914, he assumed almost throughout that the teacher was a woman.[77] In contrast to Duffus, he used the feminine pronoun in discussing classroom decoration and school dress as factors in the training of students' taste and sensibility that was the task of art education in the primary grades. For the teacher, "cleanliness, neatness, a becoming coiffure, a simple costume appropriate to her profession and in right relation to her figure and complexion are absolutely essential. No principle of composition of line, no theory of harmonious coloring should be violated in herself."[78] Viewing the teacher herself as an exemplary work of art, Bailey "inscribes art on to the body," in Ann Bermingham's words, and makes her embody the principles she teaches: their display, and her exaggerated visibility, become pedagogical.

The Boston-based Public School Art League began a program in 1892 to place good reproductions of fine works of art in schoolrooms. Bailey actively participated in the program, and his primer on art education insists that the schoolroom should follow the rules governing both fine art and a teacher's clothing and appearance; it should be "decorated and furnished in such a way that its equipment and appearance are calculated to promote the growth of skill and taste." He calls on the teacher to assemble the room as though it too were a work of art, to choose a pleasing color scheme, hang fine art prints, allow for flower arrangements, and present exhibitions of handicraft. He offers a remarkable list of aesthetic objects the room might include—a list that already includes the wares of the *bottega:*

> a box in cloisonné from Japan, a vase of bronze from China, a fan of carved wood from India, a Tanagra statuette from Greece, a bit of mosaic from Italy, a porcelain figurine from Germany, a handwrought jewel from France, a piece of lace from Belgium. A teacher of established reputation can always secure such objects as these for children to see.[79]

The teacher borrows; she shops or at least chooses; she orders and decides. These tropes can be followed from Ruskin's *Sesame and Lilies* to Meyer Schapiro's woman of the rentier class. In each case, aesthetic expression is the same as aesthetic choice, and that choice—or art reduced to good choosing, to appreciation—is coded female.

Forty years later, in 1949, another surveyor, Royal Bailey Farnum, vice president of the Rhode Island School of Design, appraised the professions and possibilities of employment in the arts in the United States on the occasion of Cooper Union's ninetieth anniversary. While Farnum chose the masculine pronoun for architects and designers, painters and sculptors, interior decorators and textile designers and merchandising display artists, teachers take the feminine pronoun: they are women, and they fill the ranks of the last professional opportunity on his list. Farnum writes as though they filled it by conspiracy, in a language of reverse discrimination that seems remarkably fresh given present debates on affirmative action: "Opportunities for teaching in both public and private schools and colleges are more numerous for the woman artist than the man. Men seldom teach art at the elementary level, and a preponderance of women is found, too, in high schools. In colleges of education, the majority of instructors are women."[80] Against this legion of women, he continues, "in other colleges and universities both sexes find equal opportunity. . . . In advanced art programs professional standing, technical proficiency and subject, rather than sex, determine appointments almost exclusively."[81]

Women did not "win" appointments at the primary and secondary levels because they were women. Rather, the art students who were steered out of professional studio programs toward those in art education or led to imagine art education as the most probable future—the future that had been laid out for them—were women.[82] And although Farnum's suggestion that the more professionalized the department and the higher the degree it offers its students, the less likely it will be to have women faculty was accurate in 1949 and remained on point through the 1970s and 1980s, his clear implication—that where there is "equal opportunity," women artists will be found less capable—is suspect at best.[83] While many college and university studio art departments began as teacher training programs, the institution of the M.F.A. as a professional (and explicitly not a teaching) degree for artists in the 1930s, followed hard by the G.I. Bill in the 1940s, worked to segregate the university-trained artist, even the artist-teacher, from the art teacher along gender lines. These displacements are still at work, as is the "problem" of the number of women students. In 1931 it was estimated that 70 percent of students taking courses in art and art history were women. In 1970–71 women earned 60.5 percent of all studio art degrees and 77.8 percent of all art history degrees;[84] from 1987 to 1992 women earned 58 percent of M.F.A. degrees.[85] And yet in the early

1970s women accounted for only 20.5 percent of full-time faculty in college art and art history departments.[86] By 1992 the percentage was 29.5 in graduate studio art programs, and in 1996 it was 31.[87]

Farnum offered his set of statistics as Cooper Union debated whether to continue setting aside space for female students in the face of the numbers of G.I. Bill–funded veterans, overwhelmingly male, who were seeking admission. Although Dana Vaughan, dean of Cooper's art school, acknowledged that "women as professionals face a social problem," he focused his comments on the problems of the school, which had opened in 1859, ironically enough, as the New York School of Design for Women: "If an educational institution faces the problem of making a choice between a male and female applicant of approximately equal qualifications, will the choice fall on the male, since there is a greater likelihood he will continue to work in the profession?"[88] Cooper Union's problem, then, becomes a problem for women:

> How can women compete with men if the most productive years of their lives are taken out of their professional development? In a competitive society, professionals will be evaluated in competitive terms. In this respect, will women continue to take a secondary place in the professions? If so, are professional schools justified in setting a "quota" for women?[89]

While recognizing the historical presence of women in the art school and their place at Cooper's origins, Vaughan exonerates himself for his institution's future decisions: "In regard to art schools, they least of all practice discrimination toward women."[90] His argument, however, implies that the professionalization of art training at Cooper, and elsewhere in the years after World War II, is the same as its masculinization.

If the issue is to make the practice of art into a profession—that is, to make it male—then professionals cannot be women. Farnum writes of teaching painting as a profession in terms very different from those he uses when the profession is teaching. For the painter working in a college or university department or in an art school, teaching "is not only an acceptable avocation, but it enriches the painter's point of view, keeps the artist mentally and intellectually alert and becomes a challenge to his art expression."[91] The pronoun Farnum uses for this "painter-teacher" is—by now obviously—masculine; he is separated from being an art teacher by both his biological and grammatical gender: he is an artist-teacher; she is not an artist. Moreover, he teaches artists, the task, as Farnum points out, that is precisely not that of the art teacher:

> Art education in elementary and secondary schools, contrary to popular opinion, is not offered to develop and promote artists and craftsmen, but rather through use and manipulation of art mediums and materials to develop an appreciation of artistic products, a cultivated taste in the selection of better designed consumer goods, and a background knowledge of art history. . . . all people are consumers of art, consciously or otherwise, in the clothes they wear, the homes they establish, and the innumerable objects they purchase.[92]

All people are women when they consume, when they teach children; they are men, virile and efficient, when they produce. Art schools such as Cooper Union and university art departments must separate the teaching of teachers, and perhaps the teaching of art—"the use and manipulation of art mediums and materials"—from the teaching of artists. In elementary school, teachers teach art; in the colleges, artists teach art; in the graduate and professional schools, artists teach artists.

The development of separate degree programs and professional organizations for art teachers and for artists institutionalizes the sexual differentiation of art education. Art teachers, after all, make it hard to count artists, especially when they are in the same graduate classrooms; Duffus noted this in 1928. Writing of the increasing ratio of men to women in the art courses at Pratt—noting that "now they are nearly quite half"—Duffus pads the number by masculinizing at least a segment of Pratt's female students. "The number of women who are preparing for work rather than for matrimony, and who will prove anything but effeminate . . . is also increasing. That tendency, however, is difficult to measure statistically. It is complicated by the fact that more women than men become teachers."[93] Art teachers count neither as artists nor as women artists of a certain tendency; they must be counted elsewhere, and not as artists.

Women's Arts and Crafts

Duffus takes one more shot at John Ferguson Weir's students at Yale at the end of the nineteenth century, using one more trope of femininity. Some pages before the comment on tatting and embroidery, Duffus had already crafted the art school a finishing school, "a school where young ladies prepared themselves for the responsibilities of matrimony by learning to paint china."[94] China painting was not part of the art school's curriculum in Weir's time; Yale's stolidly academic course centered on drawing after the engraving, cast, and model, like Syracuse's

course during this same period. What determined Duffus's characterization, what allowed its obviousness, was the success of women's potteries, such as Rookwood and Sophie Newcomb in the 1880s and 1890s, and the widespread involvement of women in the Arts and Crafts movement and its local clubs at the turn of the century.

China painting and tatting and embroidery were accomplishments of different eras, and they belonged to different sets of concerns. The roots of china painting lie with Ruskin and William Morris and the production of art as culture and as education, as well as with the Ruskinian concern for just and useful and appropriate work. Under the banner of the Arts and Crafts, the practice of art—or of certain arts—could, like teaching, become a profession for women of a certain class. Walter Smith, who oversaw the founding of the Massachusetts Normal School of Art, and who taught as well at Cooper Union's Female School of Art, insisted in 1873 that there are "many branches of art workmanship, requiring delicate fingers and native readiness of taste, which could be better performed by women than men. It seems to me that an infinite amount of good would be done by opening up the whole field of art instruction and art workmanship to the gentler sex."[95]

Women played a significant role in disseminating the ideals of the Arts and Crafts movement, not only as teachers and writers, as in the case of Syracuse's Irene Sargent—who, as the editor of Gustave Stickley's *Craftsman,* published Ruskin, Morris, and the Russian anarchist Kropotkin—but also as manufacturers, most famously in Cincinnati's Rookwood Pottery, founded by Maria Longworth in 1880. In 1903 Oscar Triggs, a strong supporter of the Arts and Crafts and of William Morris–style socialism, as well as professor of art history at the University of Chicago, called Rookwood an "ideal workshop," crediting its success as both an art manufacture and a social experiment to women's nurturing: "The Rookwood Pottery has—so to speak—a soul. A woman's intelligence went to its upbuilding."[96]

An outgrowth of a woman's interest and of a local women's ceramics club, Rookwood offered a model for workshop work, and for the inseparability of artist and craftsman, and of designer and manufacturer—fundamental elements of the Arts and Crafts idea. At the same time, just these divisions were encoded along gender lines. There was a division of sexual labor in the Arts and Crafts movement, a conscious and discussed division, one that is both continued and transformed in twentieth-century practice. At Rookwood from its beginning in 1880, and at Sophie Newcomb's pottery from its opening in 1895 until 1918,

men produced the clay forms and fired the finished pots; women artists and designers painted and glazed them. The division translates literally Ruskin's distinction between those who build and those who beautify. The workshop of Sophie Newcomb College, founded in part through the offices of the feminist and suffragist Julia Ward Howe, was second only to Rookwood Pottery (some of whose alumnae would teach in New Orleans) in the production of Arts and Crafts art pottery, winning prizes and commendations worldwide. The training Sophie Newcomb offered was neither the traditional ornamental course of the women's seminaries nor the fully vocational course of schools such as Cooper Union or the Philadelphia School of Design for Women. Rather, the school was a professional cultural workshop in which "each decorator had her own portfolio, pencil studies of various plant forms, trees, etc., that she knew well and probably grew in her own garden: wild iris, Cherokee rose, Confederate jasmin, oak, pine, or cypress trees."[97] Instead of form books of historical decoration and the repetitive assignments of Greek anthemia and acanthus that characterized design education at Cooper or Philadelphia, Newcomb's students and designers were given the particularly Arts and Crafts directive to (re)make an indigenous and local art; according to Mary Sheerer, who had designed at Rookwood before coming to Sophie Newcomb, "The whole thing was to be a southern product, made of southern clays, by southern artists, decorated with southern subjects."[98] Works were judged and released as those of Newcomb Pottery. The pottery was, according to the art historian Anthea Callen, a "particularly good example of American initiative in helping women in need of a career."[99]

Candace Wheeler, an artist and textile designer who joined with Louis Comfort Tiffany and others in a workshop, Associated Artists, patterned after William Morris's, made the broader argument for art as the preferred answer to the pragmatic question of women's careers in 1897. For Wheeler, the necessity of professional artistic training for women had become economic as much as social. Art training provided a class-appropriate way to integrate middle- and professional-class women economically as producers, or, as Wheeler more deftly puts it, a way for "the daughters of professional men of narrow means, or of merchants who have not achieved fortune" to "maintain themselves and others," and lift themselves from what was "appropriately characterized as genteel poverty."[100] Placing that education in a college and enfolding it in the arguments of the Arts and Crafts movement—which stressed precisely the virtues Wheeler imagined art itself would empha-

size "if women really come to the front in power of expression . . . the natural, domestic, and religious side of humanity"[101]—clearly separated the productions of Rookwood or Newcomb from those of nameless working-class women, and their equally unnamed productions.

The art learned in colleges and art schools and cast as fulfilling, affirming work rather than industrial toil allowed the daughters of the professional classes to turn their skill and work "to profit," without the fear of being "relegated . . . without question to the ranks of cooks and seamstresses."[102] When Duffus wrote later of the metalwork and jewelry as well as the well-known pottery that Sophie Newcomb College's students had produced, he reminded his readers, in terms similar to Wheeler's of 1897, that "these products, carried to a salable stage by graduates, . . . are the outcome not of a school of crafts but of courses whose aims are cultural."[103] It matters, not that they have been turned to profit, but that they are cultural work, educational labor. As Syracuse's Irene Sargent announced in a lecture entitled "A Revival of the Old Arts and Crafts," delivered in 1901, "what has been named the Century of Commerce has now given way to what . . . will be the Century of Education."[104]

Local Women

As art educators and as artists, the theorists of the Arts and Crafts movement produced the image of art making that colleges and universities, not to mention elementary and high schools, continue to offer: a process or procedure enlightening and purposeful in itself, a healthful activity, organizing, rationalizing, and integrative. William Morris distinguished between "useful work" and "useless toil";[105] art is the model for Morris's useful work, and the product of that work, the art object—or the right furnishings or crafts or pictures—mirrors its making: enlightening, healing, ameliorative. Art as general education and as individual betterment for the common good—as a variety of individual betterments, from taste and sophistication for the late-nineteenth-century aesthete; to unalienated, holistic work for the early-twentieth-century craftsperson; to the varieties of self-expression, critical thinking, or visual literacy that mark the grant proposals of the latter part of this century—is a constant motif of art education. It is the strongest and most effective means of integrating art and public and higher education. Art in these latter-day Arts and Crafts declarations and proposals is a metonym of education: it is good for you.

The attempts to bring art onto campuses, to fit art to the image of the college and the university after the mid 1920s, also masculinize it or, perhaps more complexly, attach to the ameliorative model of art a set of masculine adjectives and admonishments. Thus masculinity cast as an image of return, of a public art and culture regained, is central to the arguments against vocationalizing and domesticating art by a legion of adversaries: by the academy, by modernism understood as hyperindividualism, and by women as students, teachers, and artists. Lura Beam's 1927 Association of American Colleges report on the teaching of the visual arts on campus borrows Duffus's voice when it speaks derisively of state school and teacher college programs that offer certification in exchange for courses in "basketry, china painting, stencilling, [and] leather, . . . carefully separated from any theory," taught by "someone living in town." To make clear whom she is describing, she continues, "or a teacher in the department of home economics."[106]

Even in those colleges where, according to the AAC report, the practice of art is taken seriously and thoughtfully, the presence—the preponderance—of women as faculty is understood and unquestioned as a sign of the slow progress art has made in college, and even of its impossibility there. The "germinating" theories of these departments—either "that art must be useful or that it is inner expression, grows out of the unconscious, cannot be learned and must be done"—are "contrary to the theories of the college."[107] The contrariness of the practice of art, its alienness in the college, is indicated in the report by the "status of the teachers: of 126 persons, eighty-seven are women, eighty-four have no college degree, and about sixty are instructors in rank."[108] In Beam's survey, women are a status, a rank equal to instructor and to those without proper certification. Certifying, the production of professional degrees, will function after World War II to institutionalize that marginal status.

The attempt to rescue art practice from the margins, and from its "implication of effeminacy,"[109] powers and underlies the shift, credited to the Bauhaus, from art as a decoration for the domestic sphere to art as a model or plan for the public sphere. Both movements, the Arts and Crafts and the Bauhaus, decried the mass-produced ugliness and meanness of the objects of everyday life. Both envisioned the artist as a designer of a better world, a better life, and both imagined that the objects of daily use are the correct and necessary objects for the artist's attention and production.

The Bauhaus's acceptance of industrial materials and, rather later, of industrial methods and the shaping forces of mass production in its

own manufacture of lamps and tables and tea services made public and allowed for the masculinization of the practices of the arts and crafts. But it continued, without dropping a stitch, the ameliorative and productive image of art inherited from the Arts and Crafts movement. Le Corbusier's "architecture or revolution" is the program of Hull-House, but, most important for the university, it is written in the public sphere, it is given large public consequences rather than merely tragic individual ones, and it is cast as the demand for professionals who make for the people rather than as a plea for amateurs, or demiprofessionals such as those at Sophie Newcomb, who make art that is *of* them.

The tasks of the Arts and Crafts movement were local and particular. Both the clay and the motifs of Newcomb Pottery were drawn from New Orleans and its environs; the crafts of the Hull-House studios and labor museum, opened in 1900, were those brought to Chicago by immigrants. The ameliorative properties of work in the arts and crafts, too, were local. Those who benefited from that work were those who performed it—because it was handiwork, and because it tied them to a community and a heritage of work. Jane Addams, of Hull-House, made this tie explicit: "The women of various nationalities enjoy the work and the recognition which it very properly brings them as mistresses of an old and honored craft . . . but the whirl of wheels recalls many a reminiscence and story of the old country, the telling of which makes a rural interlude in the busy town life."[110]

Individually handmade, culturally and geographically particular, rural even in the new industrial city, Arts and Crafts objects were local objects. Perhaps the purchaser too would be bettered by the experience of a hand-carved sideboard or a work of art pottery, but once again the cause was proximate, the effect local. The object was valued for its peculiarity and the specificity of its story; Thorsten Veblen famously made fun of this in his *Theory of the Leisure Class,* invoking the names of Ruskin and Morris: "Hand labour is a more wasteful method of production; hence the goods turned out by this method are more serviceable for the purpose of pecuniary reputability; hence the marks of hand labour come to be honorific, and the goods which exhibit these marks take rank as of higher grade than the corresponding machine product. . . . The ground of the superiority of hand-wrought goods, therefore, is a certain margin of crudeness."[111]

By the 1930s the discourse of professionalism would weave together the feminine and the local: they are conflated, for example, in R. L. Duffus's dismissive description of the nineteenth-century art school at

Yale as a "fad among young ladies of New Haven," a portrait that en-
lists the ideal of modern Yale as a national university in the struggle to
make its art into a fittingly masculine endeavor. Local becomes a par-
ticular attribute not only of the feminine but also of the overly technical
or procedural characteristics that mark the handicrafts for their critics:
when Lura Beam depicts the part-time art teacher at the local college—
who teaches an exhaustive list of techniques and objects—as "someone
living in town," she signals both that the teacher is neither artist nor
professor, and that she is a woman. The attractions of the Bauhaus and
its solutions, in contrast, would be universal: "Without any exaggera-
tion," wrote Kandinsky in 1926, calling for an International Art Insti-
tute, "it may be suggested that any broadly based science of art must
have an international character."[112] At least in aspiration, the Bauhaus's
scale was global, its attentions theoretical, its effects distant. To use a
term that is never far from the discourse of the Bauhaus, its interests
were "foundational," a word omnipresent across the postwar years in
the United States perhaps because of its implicit—and implicitly gen-
dered—opposition to the ornamental.

In the chapters that follow the Bauhaus and its foundation course
stand for a project of professionalizing artists and rationalizing art in
the university—for producing, on the one hand, the artist of the univer-
sity and for securing, on the other, the idea of art as central to a general
education, as the core of the liberal arts. These projects are character-
ized, not by the local, manual instances of art—not by any particular
technique or medium—or by the proximity of touch, but by the dis-
tance of vision, by what can be seen and known and formed in the
image of the eye.[113] Art education from the mid twentieth century on
promised to train the eye, perhaps even to arm it. At the end of World
War II, Edward Rannells of the University of Kentucky insisted that
"the whole of art education is predicated on seeing."[114] A decade later,
the designer of the foundation course at the University of Georgia could
report, as though in answer, that "seeing has been developed into an ag-
gressive act."[115]

THE PRACTICE

OF MODERNISM 3

The earliest college-based art schools in the United States, the programs at Yale and Syracuse, were named after the pedagogical program they continued, the nineteenth-century French Ecole des Beaux-Arts. The Yale School of Fine Arts was established in 1864, the Syracuse University College of Fine Arts, in 1873. Today, neither the school at Yale nor that at Syracuse retains the name it was first given. In 1889 Syracuse's College of Fine Arts was renamed the John Crouse Memorial College for Women, and later it was called by the hybrid name Crouse College of Fine Arts; the Fine Arts were, in the words of one speaker at the dedication of the College for Women, "the creative sister" of "knowledge and the humanities."[1] Syracuse's program is now the School of Art and Design, housed in the university's College of Visual and Performing Arts. The school at Yale kept its original name until the 1950s, when renaming became an issue. Josef Albers was hired by the School of Fine Arts as chair of the Departments of Painting and Sculpture, which were combined and renamed the Department of Design. Under Albers's successor, Gibson Danes, the Yale school was renamed twice, the School of Architecture and Design in 1958 and the School of Art, its present name, in 1961. If this name seems innocent, a great deal was at stake in it.

Removing "fine arts" from the names of programs in studio art and art history recasts both the mission of art, in the eyes of the school or department that teaches it, and art's object. "Fine arts" signified the alignment of art practice, as well as art history, with the academic

humanities, with the literature, poetry, and music of the Beaux-Arts, and with their histories; Syracuse's College of Fine Arts offered courses and bachelor's degrees in painting, architecture, music, and what it termed Belles Lettres.[2] But despite the name of the degree itself, only eleven of the over 180 programs currently granting the degree Master of Fine Arts in the United States are housed in departments or schools or buildings of fine art; there are three academies. According to the CAA's 1992 directory of graduate programs in what the association labels "visual art," there are 160 university-based programs: ninety-five are offered in departments of art; another twenty-one in schools of art, a difference that suggests arguments, implicit or on paper, over the place of the arts and the training of professionals. "Department" places the training in the college of arts and sciences, in an updated version of the liberal or scholarly; "school" suggests a freestanding and decidedly professional training. The names of the other programs—fifteen in visual arts, eleven in art and design, four in studio art, one each in fine and applied art and the theory and practice of art—bear still other traces of the debates of the 1950s and 1960s about what the teaching of art and of artists should entail.

In the preceding chapters I addressed debates over the kind of artist the university should train, and what the artist might look like in the image of the university, shaped by the liberal college, the professional school, and the research university. In this chapter I focus on methods of that training, tracing their history, their reformulations and forgettings, and their subjects and assignments. I concentrate on the language of design and the passage of the German Bauhaus, its courses, publications, and faculty, into the debate over how and whether art should be taught in the American university, to whom and for what purpose. The Bauhaus is offered, not as an origin, but as a switching point; in this chapter and Chapter 4 I spend a good deal of time in nineteenth-century studios and classrooms, and on post–World War II college campuses. The lessons learned from the Bauhaus in the United States from the 1940s through the 1960s are not necessarily the lessons taught at Weimar or Dessau, or not all of them. For example, the professed purpose of the Bauhaus preliminary course, or *Vorkurs,* in America as in Germany, was to unify art and the branches of industrial design. On college campuses, however, the course's design experiments and material investigations pointed, not toward tubular steel and product design, but toward painting, conducted in departments that continued to offer only the historical, personal media that had been the fine arts. I

want to begin this turn to the Bauhaus by examining the implications of the visual arts—and what might be written in the adjective "visual" at Harvard, where Walter Gropius had come to teach in 1937. The discourse of vision and the tropes that go with it are crucial to adapting art to the university campus; it is both professionalizing and democratizing. Vision counters the vocational, the local, and the manual; the visual artist shapes the world, designing its order and progress.

Vision, Design, and the Designation "Visual Arts"

When a committee marshaled to survey the teaching of art at Harvard published its report in 1956, its first recommendation was to change the name of the venerable art history program from " 'Fine Arts,' which has been used at Harvard since Professor Norton's time," to the History of Art.[3] The renamed Department of the History of Art would be housed with a proposed Department of Design, an undergraduate studio art program, in a new Division of the Visual Arts. On paper the program for the new Department of Design bore the strong imprint of the Bauhaus—far from coincidentally, given its name.[4] A "basic course in the theory of design, to be adjusted to modern methods and needs and coordinated with studies in the techniques of drawing, painting, and sculpture," was proposed as a shared and required foundation for "advanced practice courses in the various branches of design, stressing materials and processes of building, drawing and painting, sculpture, the graphic arts, and the decorative and industrial arts."[5] To explain abandoning "fine arts" for "visual arts" (and "abandoning" is their description), the Committee on the Visual Arts at Harvard argued for the primacy of vision—"Sight is the most used of our senses. . . . [I]mpressions derived from sight are the most manifold"—and for artistic vision as the ordering of perception: "To be art the objects must be mancreated. They must also be ordered. It is with the ordering of the visible attributes—color, line, and mass—that the visual arts are concerned, whether we approach them in historical or in theoretical or in creative terms."[6]

The term "visual art" was intended to recast the hierarchy between the fine and industrial arts written in the organization of the fine arts. According to the *Encyclopedia of the Arts*, compiled at the end of World War II, the term had its origins just where Harvard would use it, in the field of education. It was "introduced into the nomenclature of art education in an attempt to . . . avoid the distinction between fine

and not fine, practical and impractical, or useful and non-useful concepts of art."[7] The Committee on the Visual Arts described their proposed basic course in studio art in remarkably similar language: the "distinction between fine arts, applied arts, and functional arts should be avoided in favor of their common denominator, contemporary design."[8] Under the heading "visual arts" and under the "common denominator" of design, the artist and the designer become one. Certainly they shared a single foundation, the foundation course that the Bauhaus had introduced and that Harvard was poised to adopt.

Visual art, the Harvard committee's name for both itself and the division it championed, marks an attempt to reposition the artist and redefine art in the American university in the years before and after World War II. Harvard's proposal stood near the end of what David Deitcher has characterized as a "growing inclination on university campuses, from the mid 1930s through the late 1940s, to train artists with the skills of designers, while educating designers to conceive of their profession in terms hitherto reserved for the work of artists."[9] Fifteen years before the Harvard committee report, Royal Bailey Farnum of the Rhode Island School of Design had insisted on the identity of artist and designer: "The artist is a designer whose scope of activity is quite unlimited. . . . His expressions cover all fields of visual form, he should not be confined in one's mind to the painter of pictures alone."[10]

Clearly, the activity Farnum refers to is not manual but visual and constructing; he opposes it explicitly to the uselessness and the handmade-ness of a certain older version of the artist and proposes for it a new educational program. Farnum's new method was close to—based on, if not named as—the Bauhaus preliminary course, which he differentiated from Beaux-Arts training by opposing creation to copy, experiment to dictation, and synthesis to segregation. Unlike the remnants of an academic tradition grounded in the human figure and its "meticulous and dictated rendering with charcoal, pencil, crayon, and paint . . . supplemented by separate lectures on perspective, composition, anatomy, and possibly color," the new art education was "based upon the idea of experimental freedom in the beginning, by means of which principles of design and technique are evolved through self-discovery. . . . Discussion, guidance (rather than imposed ideas) and self-discipline lead the student to a clearer understanding of the demands of art expression."[11]

An entire pedagogical program was written in the term "visual art" and in the teaching of design; and much was implied, as well, in the

name "fine arts," threatened at Harvard and displaced at Yale and Syracuse; its jettisoning marks a reassessment, and perhaps a historical criticism, of its encrusted and well-rehearsed assumptions. The fine arts were historically representational; formalized in the eighteenth century, the Beaux-Arts linked painting, sculpture, and architecture to poetry and music under a common representational principle, which Abbé Charles Batteux summarized in 1746 as the "imitation of beautiful nature."[12] Functionally and institutionally, the term insisted on the separation between representational artists, trained in the academy in the figure and the antique, and those artisans schooled in the Arts et Métiers, in specific techniques and material processes. The Beaux-Arts marked "the boundary which now separated representations from other artefacts. The representational product distinguished the artist utterly from the artisan."[13] Moreover, the fine arts were necessarily historical; the particular skills its artists learned were, as Thierry de Duve has noted, "always received from the past, and while they are ruled by ideas that are allegedly eternal, those ideas are situated upstream in history—in *antiquity*. In the academic model, to teach painting is necessarily to transmit a heritage."[14]

The name "visual arts" argued for an endeavor that would no longer be understood primarily historically; the practice of art in its name— and sometimes even of art history, with its turns to theory, to formal or technical analysis, and to the X ray—was marked by an insistent presentness. "We are impressed," the Committee on the Visual Arts wrote, "by the extent to which such work [that of university-based studio art departments] provides students with an opportunity to gain understanding of modern idioms of expression as they have been fashioned by major contemporary artists."[15] Rehearsing and downplaying earlier arguments for college art appreciation and introductory drawing courses, they continued: "It is not merely a question of sharpening the power to observe, or even of quickening the imagination. Rather, it is a question of participating in the give and take of one's own time. The forms of creativity are surely as much a part of that time as the latest developments in scientific or political thinking."[16] Vision is in the present; it is forward-looking. Rather than a learned and, more damningly, literary branch of the humanities, art under the name "visual art" would be aligned with science.[17]

George Wald, a professor of biology and member of the Committee on the Visual Arts, produced just this distinction in arguing for studio art and, more important, the studio artist at Harvard. Most departments

of present-day universities, he argued, continue the "medieval tradition" of scholarship: "It is *talking about knowing* that is enshrined."[18] Against the scholasticism still embodied in the classroom and the library, Wald paired the artist's studio and the scientist's lab:

> The situation of the artist in the university resembles in many ways that of the scientist. . . . Other departments of the university are concerned for the most part with contemplating, ordering, and evaluating the activities of others; the scientist himself produces the material of his field of learning. . . . Successful experimentation in science is permeated with qualities of intuition and imagination that make it a creative experience. It involves the same interplay of head and hand that goes into the production of a work of art. Just as the scientist has found his place within the university. . . . just as his laboratory has become academically respectable, so the artist and the studio, given time and opportunity, should find their places.[19]

The model, clearly, is independent scientific research, the production of new knowledge in new fields, instead of commentary on, and re-arrangements of, the old. "The painter or sculptor is a pure research man in the field of aesthetic phenomena and expressive reality," insisted David Durst of the University of Arkansas.[20] Because he researches and because that research is pure, the artist has a fundable place in the university.

The image of art as kin to science, not literature—and certainly not to education or home economics—has helped to determine its place and its characteristics in the postwar university: as science's relative, art addresses a visual field governed, not by inherited tradition or commercial demands, but by experimentally discoverable physical and physiological forces; art promises progressive developments and further discoveries. As Harold Rosenberg complained in 1969, in the university "creation is taken to be synonymous with productive processes and is broken down into sets of problems and solutions."[21] Indeed, the forms of contemporary practice—the project, the series, and, most important, the idea of art making, of what one does in the studio, as "problem solving"—follow the model of the artist as researcher. According to the accreditation guidelines of the National Association of Schools of Art and Design, to take only a current official example of the linkage of principles and problems, the first of the "essential competencies" for B.F.A. students in painting is an "understanding of basic design principles, concepts, media, and formats. [Thus] the development of solutions to aesthetic and design problems should continue throughout the degree program."[22] The purpose of the M.F.A., for those continuing, is

to advance the development of "individuals with the potential to solve
contemporary problems in all aspects of the visual arts and to explore
and address new questions and issues."[23] To pose those problems, as
Harvard did in the mid 1950s, in the image of "scientific and political
thinking" or to situate their solutions in interdisciplinary research cen-
ters on the model of the sciences, as MIT did with the Center for Ad-
vanced Visual Studies in 1967, insists, as well, that the design questions
of the visual arts lie outside and beyond the studio. When the under-
graduate studio art program was established by Harvard in 1963, it too
was named on the model of the sciences as the Department of Visual
and Environmental Studies, situated in the Carpenter Center for Visual
Art, some distance from the art historians, who had decided to keep the
name "fine art."

Gyorgy Kepes, who taught at László Moholy-Nagy's New Bauhaus
in Chicago and at the Massachusetts Institute of Technology, where he
founded the Center for Advanced Visual Studies, yoked the visual, the
political, and the scientific with a marked urgency in his *Language of
Vision,* which one writer, a decade after its publication in 1944, called
"the most influential single volume in art education in the 1940's and
early 1950's."[24] For Kepes, "the task of the contemporary artist is to re-
lease and bring into social action the dynamic forces of visual imagery.
As contemporary scientists are struggling to liberate the inexhaustible
energy of the atom, the painters of our day must liberate the inex-
haustible energy reservoir of visual associations."[25] Kepes's painter, like
Farnum's artist—and unlike the caricatured academics and avant-
gardists of my opening chapters—is not a painter at all, even if what is
produced in the laboratory-as-studio are paintings. At the same time
this artist-designer is not an artist craftsman;[26] the unification he em-
bodies is no longer that of the fine and applied arts promised by the
Arts and Crafts, or by the German Werkbund. Unity in the figure of the
designer and in the ideal of the visual arts is an intellectual project; it
takes place at the level of research.

The struggles between handicraft making and industrial production,
and between application—whether Werkbund *Qualitätsarbeit* or func-
tionalism on the factory model—and "experimentalism," to use the
word with which Theo van Doesburg tarred Moholy-Nagy, troubled
the Bauhaus throughout its history. Artists—that is, easel painters—oc-
cupied a particular and ambiguous place in these conflicts, and in
Bauhaus teaching. Like many other reformers, and indeed like the
American educators I introduced in earlier chapters, Gropius decried

the *Kunstproletariat* that traditional studio training produced: useless, isolated artists who worked at the mercy of a commercial market.[27] Each of the Bauhaus positions on the role of art training and its products was forwarded as a remedy for the artist's isolation and his overbearing subjectivity. Gropius's early call for the artist as craftsman, the constructivist challenge to imagine and design a utopian future, and the productivist demand for the artist's obeisance to needs, typeforms, and plans, all required sublimating the artist's difference in the name of objectivity, which Gropius, in the language of the Werkbund, termed *Sachlichkeit*.

Although Gropius sought out the best-known of the Bauhaus teachers—Lyonel Feininger, Oskar Schlemmer, Paul Klee, and Wassily Kandinsky—because they were painters, they did not teach painting. The products of Bauhaus teaching in its earliest program included landscapes and still lifes, but the teachers and students who made them did so outside the regular course; until 1928 there was no workshop at all in easel painting—or free painting, as the workshop was called when it was finally established. Klee and Kandinsky taught painting, not as a medium or a professional practice at Weimar, but as theory; painting for the Bauhaus was what the figure had been for the Ecole des Beaux-Arts: its theory of perception, visual analysis, form, and space. As David Durst would promise at Arkansas, looking both across campus at the science building and perhaps at a copy of Kepes's *Language of Vision* or Moholy-Nagy's *Vision in Motion,* painting was pure research. At Weimar, Klee and Kandinsky offered *Formlehre*, the theory of form, not for direct application to shopwork but as an investigation into the visual field, the attempt to derive an "objective grammar of design capable of obviating the twin dangers of dependence on past styles on the one hand and merely personal taste on the other."[28]

The "artist-designer," at once claiming the name and the prerogatives of the artist and rejecting an older, shopworn image, embodies what Thierry de Duve describes as the central fantasy of the Bauhaus's teaching and its version of the modern artist: a "transfer of power from the former artist-artisan to the new conceiver-projector."[29]

> Throughout the length of their common modernist history, architects, even painters, and especially designers, vehemently denied that they were artists at the same time that they demanded for themselves the highest prerogatives of art: to create something new, to found a new language, to build a new culture. . . . From coffee spoons to urbanism and landscaping, the *Gestaltung* would diffuse through the whole of society artistic attitudes and requirements even as the specific trade and identity of the artist would have to disappear.[30]

I will return to the history suggested by the hyphenated "artist-artisan" in the coming pages. I want to turn first to de Duve's other hyphenation, "conceiver-projector," a term that situates both the fantasy he describes and its designer firmly in the field of the visual, as does his untranslated *Gestaltung*.

The word *Gestaltung* appears throughout the Bauhaus curriculum, particularly after the school's arrival at Dessau in 1925, where it was first granted the official title Hochschule für Gestaltung, a name most often translated as "Institute for Design."[31] Design is the most frequent translation of *Gestaltung*, although an earlier German institution, the *Gewerbeschule* (craft school) of the mid nineteenth century, had trained designers for factory work as *Musterzeichner* (pattern draftsmen),[32] and when, in 1899, the Dresden Technical School appointed a new professor of design in the fields of interior architecture and decoration, his title was "Professor für Entwerfen."[33] The word does not necessarily appear even now in German-English dictionaries among the possible translations of the English "design"; Nikolaus Pevsner has remarked, curiously, that in response to the new interest in industrial design and the machine aesthetic that surrounded the founding of the Werkbund in 1907, "the term *design* had in the end to be taken over by Germany because of the absence of a German word with the same meaning."[34] Perhaps if *Gestaltung* does not mean "design," it shares the historical and semantic space that word might have occupied in the early years of the century.

Some commentators have struggled over the translation of *Gestaltung*. Lionel Richard rewrites the title of the Dessau school in French as "Ecole supérieure de conception des formes,"[35] and the Gestalt psychologist Rudolph Arnheim translates the word as the Bauhaus used it, as "formation."[36] Just as frequently it is left, as de Duve leaves it, in the German, to stand for something more. In a translation of Conrad Fiedler's *On Judging Works of Visual Art*, the German émigré art educator Henry Schaefer-Simmern only half translates the word as "Gestalt-formation," a term that interestingly redoubles Arnheim's "formation." Form-formation, the formation of formations, the doubling, however inadvertent, suggests a rhyming at the center of *Gestaltung*, the act of seeing or forming—of holding together—forms that hold themselves together as "self-sustained unities," in which, as Schaefer-Simmern notes, paraphrasing Goethe and much of the German nineteenth-century aesthetic theory that descends from him, "all parts receive their artistic meaning only by their interfunctional relationship to the whole."[37]

Writing in 1960, and, like Schaefer-Simmern and Arnheim, in America, T. Lux Feininger, who grew up in Weimar (his father, Lyonel, was one of Gropius's first faculty colleagues) and studied at Dessau, found once again that *Gestaltung* was "so nearly untranslatable that it has found its way into English usage." He, too, gives the term a doubleness and, more than that, makes its seeming untranslatability a mirror of the ungraspable ideal: "Beyond the significance of shaping, forming, thinking through, it has the flavor underlining the totality of such fashioning, whether of an artifact or of an idea. . . . In its fullest philosophical meaning it expresses the Platonic *eidolon*, the *Urbild*, the pre-existing form."[38] Feininger imagines *Gestaltung* as classical *disegno*, but as *Gestaltung* design would be free of the academic drawing that *disegno* also means. Moreover, and more important, in the Bauhaus and even before it, *Gestaltung* is not the imagining and then finding of "preexisting" forms that carry the name and the likeness of objects, but the projection of form into the world; what preexists is the grid, the drive to form, the aesthetic as an a priori category. Art, wrote Conrad Fiedler in 1876, in a text that, as Philippe Junod puts it, the Bauhaus would inherit, "is free Gestalt-formation."

> Art has nothing to do with forms that are found ready-made prior to its activity and independent of it. Rather, the beginning and the end of artistic activity reside in the creation of forms which only thereby attain existence. What art creates is no second world . . . ; what art creates is the world, made by and for the artistic consciousness.[39]

As *Gestaltung*, design at the Bauhaus was situated firmly in the present; its name pointed consciously to the broad discourse on "psychological aesthetics" that had "by the end of the late nineteenth century become one of the dominant strands in German intellectual thought,"[40] and to the language of perceptual and experimental psychology that helped form and grew out of that discourse. At the beginning of the twentieth century, a number of Werkbund architects, including Fritz Schumacher, Dresden's Professor für Entwerfen, and Walter Gropius, criticized *Musterzeichner*, not only for their formulaic repetitions, but also for their merely arbitrary differences. As part of their argument, they held up *Gestaltung* as an ideal, and as a link to Goethe and Fiedler, who spoke of it as "a thought process in which the architectural forms themselves are the content."[41] *Gestaltung* evoked, not something learned or drilled like the pattern forms of the *Musterzeichner*, or even something planned out like *Entwerfen*, but an innate, necessary, and

expressive vision. For Hermann Muthesius in 1913, it was a fully psychological term, a universal human drive and an immanent process ("*Gehirntätigkeit immanent*") of the brain.[42]

The *Gestaltung* of the Werkbund's vision and the Bauhaus's name differed in both meaning and discourse from the Gestalt of German psychology, but both terms were clearly involved in a "psychological aesthetics," the experimental search for a psychological foundation of good forms. They shared roots that, at Weimar, ran through Klee and Kandinsky: "Diagrams and explanations in Klee's *Pedagogical Sketchbook* (1925) and Bauhaus teaching notes or in Kandinsky's *Point and Line to Plane* (1926) leave no doubt that they were fascinated by . . . the perceptual analyses of the immediate forerunners of the Gestalt school."[43] At the Dessau Bauhaus the ideas of Gestalt psychology proper were presented later, by visiting lecturers and, in 1930–31, at the request of students, in a course taught by a psychologist and professor at Leipzig and attended by Kandinsky and Albers. Pointing to the Dessau school's title as Hochschule für Gestaltung, Hannes Beckmann, who studied there from 1928 to 1932 and would later teach design at Cooper Union, recalled the Bauhaus as "a school in Gestalt psychology itself."[44] But he overstates the link. The practitioners of Bauhaus *Gestaltung* and Gestalt psychology had no contact with one another until quite late; as Junod remarks, in Germany their paths ran parallel. For an American audience in the 1950s and 1960s the untranslated German term would tie the work of the Bauhaus to that of Gestalt psychology; in the United States, in the work of émigrés such as Arnheim and Kepes the discourses and practitioners of art and Gestalt psychology have been far closer since World War II than they were in Germany before it.

In exile and in translation—in Hannes Beckmann's teaching and in his call, written in the United States in the 1960s, for a "visual education . . . based on Gestalt psychological insight,"[45] for example, or in passages from Kepes's *Language of Vision*—they are made a common language. Clearly, an image of the Bauhaus as a pedagogical and experimental project can be found in the terms of Gestalt psychology. When Max Wertheimer describes knowledge as an aesthetic object—"so round, so clean, so complete in itself. . . . This is not just any individual fact, but everywhere principles are at work"[46]—he could easily be describing the work of the Bauhaus, the object of *Gestaltung*. The psychological necessity of form and order, the will to good form that Muthesius imagined as a drive, would determine the pedagogical and

professional practice of the artist, or rather the designer, as "conceiver-projector."

Writing in the late 1920s for an English-speaking audience, the psychologist Wolfgang Kohler once again defined "Gestalt," rehearsing what it had meant in the German discourse on aesthetics and for the psychology of perception; he pointed to the site from which both a visual art and an experimental science could take the term:

> In the German language . . . —at least since the time of Goethe, and especially in his own papers on natural science—the noun "gestalt" has two meanings: besides the connotation of "shape" or "form" as a *property* of things, it has the meaning of a concrete individual and characteristic entity, existing as something detached and *having* a shape or form as one of its attributes. . . . the word "gestalt" means any segregated whole.[47]

A segregated whole, Kohler stressed, is formed actively by the eye out of, and in relation to, something else, an unformed ground against which it appears. "*Gestalt* psychology is said by some critics to repeat the word 'whole' continually, to neglect the existence of parts," but that whole is possible only in "the functional 'interwovenness' of a field."[48] *Gestaltung*, in its image, and in the image of the eye, insists on a coherent, forming vision, in Kepes's words, "the shaping of sensory impressions into unified, organic wholes."[49] For both Kepes and Kohler, whom Kepes cites, the structuring vision established by experimental psychology is made the model of the self and its relations to the field of the world: "Vision is not only orientation in physical spheres but also an orientation in human spheres," Kepes argued. "Man can no more bear chaos in his emotional and intellectual life than he can bear it in his biological existence."[50]

The spheres of self and world, the grounds within and against which forms are conceived, are laid one over the other in both the vision of *Gestaltung* and the language of Gestalt psychology. Kepes wrote in *Language of Vision* of "the visual field, the retinal field," "the three-dimensional field," and "the picture field," each marked by forces and tensions that organize the relationships of figure and figure, and of figure and ground.[51] Kohler insisted, too, on the mirrored ordering of fields: "All experienced order in space is a true representation of a corresponding order in the underlying dynamical context of physiological processes."[52] That order extends far beyond the physiology of vision, but vision remains its prototype: "the processes of learning, of reproduction, of striving, of emotional attitude, of thinking, acting, and so forth, may be included as subject matter of *Gestalttheorie* insofar as

they do not consist of independent elements, but are determined in a situation as a whole."[53] David Summers has recently noted the transformation I have outlined in the preceding paragraphs, writing that the shift from the Vasarian "arts of design" to the "visual arts" may be "described as the progressive perceptual psychologization of an artistic procedure, which was itself explained in psychological terms."[54]

The work of art as *Gestaltung* was both made and read as a record of vision, as the image of the constructedness of vision, and as a mold for it, a kind of training—an idea to which I will return in the coming pages. The passage from design to vision returns us to the transfer of power de Duve wrote of, from the "artist-artisan" to the "conceiver-projector." In that transfer the *work* of art is shifted from hand to eye, from making particular forms, "independent elements," to mapping the series of fields that Kepes offered. De Duve describes a field that not only runs from coffee spoons to urban planning but also links and interweaves such elements into a single vision, a period style made and corrected before the fact. ("Period style" itself is a construction of the discourse of "psychological aesthetics" out of which Bauhaus pedagogy and Gestalt psychology emerged.) Over and over again in the teaching of art at the Bauhaus and in its teaching in America, the re-creation of design as vision is represented by the field or, more familiarly, by the picture plane as the gridded, ordered, law-bound rectangle with which, and on which, art fundamentals begin. The rectangle marks the teaching of modernism as the visual arts, displacing and containing the human figure that stood at the center of the academic fine arts.

The Schools of Design

A great deal is written in de Duve's other hyphenation, the "artist-artisan"; the hyphen that joins, one might note, produces separation as well. The pedagogical separation of the artist and the artisan at the beginning of the nineteenth century and their provisional rejoining at the beginning of the twentieth shapes the goals of the Bauhaus, and that long history is encapsulated quite specifically in its founding: Staatliches Bauhaus was the name granted in the spring of 1919 to Gropius's combination of Weimar's existing fine art academy, the Hochschule für bildende Kunst, and its arts and crafts school, the Grand-Ducal Kunstgewerbeschule, which had closed in 1915. As the name suggests, *Kunstgewerbeschulen* were part of the late-nineteenth-century Arts and Crafts reform, established in an attempt to answer the problem of the *Musterzeichner* and,

like numerous nineteenth-century attempts, to raise the level of the arts of manufacture. The Bauhaus doubled that reform. Its project was to alleviate both the uselessness of the artist of *bildende Kunst* and to offer the student of the *Kunstgewerbeschule* the vision of the artist. Writing to the state ministry in 1916, Gropius recommended requiring of each applicant for his proposed institution at Weimar proof "that he has learned a craft or that he has worked . . . for a firm engaged in production"; in 1919 he addressed his first program—and his famous call to return to the crafts—to "architects, sculptors, painters." [55] The leaflet was distributed in art schools across Germany.

The segregation of training in the crafts and trades from that in the fine, representational arts—and the increasing institutionalization of both—were pivotal developments in nineteenth-century European art education. The division of training and the various attempts at reform—whether to regenerate an isolated high art or to elevate the crafts—resulted in the division of artistic training in the nineteenth century into particular practices enclosed almost completely within a school. Until the end of the eighteenth century, the fine artist as well as the artisan received craft training in the private studio of a master; only drawing was taught at the academy, and, as Nikolaus Pevsner has put it, the academy "usually operated on [the art student] only for a few hours a week." [56] By the mid nineteenth century most European academies taught the figure for many more hours, along with what had been considered mere métier—carving, engraving, painting directly from the model and or in various genres—in organized classes, segregated by medium or by subject. The art student, Pevsner wrote,

> was now much more at the mercy of the public art school imparting all available training. It is one of the most important developments of the nineteenth century that the "academization" of his instruction was completely or almost completely achieved. . . . Now only—or as artists said: now at last—art was really no longer a craft, no longer a trade. And even those who wished to work as humbly and as well as the Dutch still-life or landscape painters could only go to a central academy to learn the job. [57]

Pevsner offers the label "art school," a term I would use historically and technically to mark the expansion and increased articulation of schooling time and curriculum, and the formalization of art education that begins in the nineteenth century. Art school can serve, as well, to link the reforms of art education to the broader reformation of public education and a new vision of the student as the subject of pedagogy in the nineteenth century; this, in part, is the project of the chapter that follows.

The practices that now, in the aftermath of the Bauhaus, train studio artists in the United States have their origins in the nineteenth century not only in the drawing and painting of the full-time fine arts academy, but also in the exercises of state-run *Gewerbeschulen* and schools of design fashioned specifically for the trades and manufactures, exercises that in their moment reinforced the difference—the class difference—between the fine artist and the artisan of an increasingly industrialized workplace. A number of the pedagogical approaches and practices that we link to the Bauhaus's impact emerged first in nineteenth-century industrial education, among them the insistence on truth to materials, an insistence characteristic, even definitive, of the Bauhaus. According to Moholy-Nagy, "Every tool, every medium, every process, whether it is technological or organic, has its intrinsic quality which, to understand and employ, must be listed among the main duties of a designer."[58] This statement can be read by the mid nineteenth century in the writings of the Department of Science and Art at South Kensington, which was consciously modeled after the German craft school system. Richard Redgrave, who developed the National Course of Instruction in Practical Art from South Kensington in 1853, insisted, like Moholy-Nagy, that "each material has its own peculiar constructive qualities" and "each mode of execution has its characteristic qualities."[59]

Redgrave's insistence on the teaching of materials and processes might be read in contrast to Ingres's blanket dismissal of the French reforms of 1863, which brought practical workshops into the Ecole des Beaux-Arts for the first time: "The Ecole des Beaux-Arts, it is true, . . . teaches only drawing, but drawing is everything, it is the whole of art. The material processes of painting are very simple, and can be taught in eight hours."[60] Ingres's complaint was motivated by a fear of mistaken identity, of being taken for a teacher like Redgrave; the reforms, he said, treated Ecole masters like "*chefs d'ateliers industriels.*"[61] The academy insisted not only on the centrality of drawing but, as Ingres makes clear, on its separation from any specific application, the sense that it stands both before and clear of its materialization. As Pierre Subeyran, director of the academy at Geneva, explained a century before Ingres: "Drawing is representing the shape of objects; to engrave, to carve, to paint, is to represent the same shapes with a burin, or a chisel, or a brush, . . . so that hardly anything remains to be learnt but the use of those different tools."[62] Bauhaus education, indeed most twentieth-century art education, is based on that "hardly anything"; it is constructed in and out of the *procédés matériels*.

Another legacy of the nineteenth-century schools of design was the Bauhaus's marked ambivalence to the human figure, its almost literal displacement of the model. Drawing from the live model was not a part of the curriculum at Berlin's Gerwerbe Institut in the 1830s, and William Dyce, who visited *Gewerbeschulen* in Prussia and Bavaria in 1837 and was appointed the following year the first superintendent of Britain's Central School of Design at Somerset House, the predecessor of the South Kensington system, refused the figure model to his general students in the 1830s and 1840s.[63] If the human figure did not stand at the center of the design school studio during this period, it nonetheless occupied a central position in the debate in Britain about the teaching of design for manufacture and the relationship of art to industry. In 1837 Benjamin Haydon, an early and strong supporter of training in art for manufacture in England, proposed a craft training that followed, like that of the academy, from classical casts and anatomy to the human figure, insisting that without it "the very elements of taste and beauty in manufacture will be omitted in the basis."[64] Dyce's debate with Haydon and his rejection of representational drawing in favor of industrial plan were not yet the overarching critique of academy teaching methods or the recognition of "truths of design" they would become in the Bauhaus, but Dyce, in refusing the figure, used the same language those institutions would use, arguing for design—or at least ornamental design—as "a kind of practical science," grounded in geometry and the order of the machine.[65]

Gropius's earliest *Programm* for the Bauhaus, published in 1919, mentioned the live model, art history, and "anatomy—from the living model,"[66] continuing the curriculum of the old Hochschule für bildende Kunst, whose faculty and physical plant remained part of the Bauhaus in the early years. All of those references are gone in the January 1921 publication of the Bauhaus's instructional plan, as were most of the faculty inherited from the academy; when they complained, the state reestablished a separate school of fine art in April 1921. Figure drawing continued in the Weimar Bauhaus, but it was misplaced; like instruction in "free art," it was placed outside the curriculum of theory and the workshop. Moreover, and in contrast to painting as a "free art," the particular kind of knowledge the academic figure provided was dismissed: Kandinsky rejected the "very brief scientific 'bonus' " of figure drawing—"anatomy, perspective, and art history"—as "no longer viable."[67] When figure drawing reemerged in the published curriculum in 1928, it is posed differently and given a new knowledge.

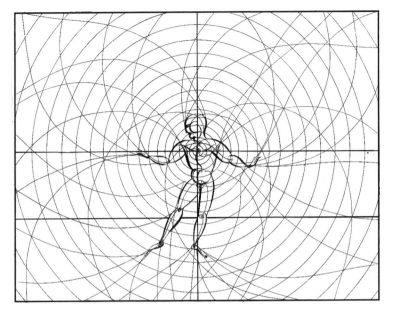

Figure 2. Oskar Schlemmer, *Egozentrische Raumlineatur* (Egocentric Space-Delineation), 1924. Pen and ink on paper, 8 ⅛ × 10 ⅝ inches. Oskar Schlemmer Theater Estate Collection © 1997 The Oskar Schlemmer Theater Estate, 79410 Badenweiler, Germany. Photo Archive C Raman Schlemmer, Oggebbio, Italy.

Figure drawing formed the first section of Oskar Schlemmer's three-part course, entitled "Man," but the figure he imagined differed from the academy's model. For Schlemmer, the address to the figure "deal[t] with schemata and systems of lines, planes, and body sculpture"; joined by studies in biology and philosophy, it would "unite finally into the totality of the term 'man.' "[68] Most of the images of the human figure at the Bauhaus come out of his workshops in theater and dance, where he posed student models onstage to change setting, sound, and light.[69] In image after image, the figure is marked by its relations; indeed, it is a map of its mechanics and its relations. "We shall observe the appearance of the human figure as an event . . . a space-bewitched creature" (Figure 2).[70] Both the broad Bauhaus discomfort and Schlemmer's re-creation of the solid, contoured academic figure as a spreading space-generating diagram have echoes across European modernist programs; they are both among the calls of the Futurists' "Technical Manifesto" of 1910: "To paint the human figure you must not paint it; you must

render the whole of its surrounding atmosphere." And, more stridently and famously: "*We demand, for ten years, the total suppression of the nude in painting.*"[71]

Despite attempts at workshops and training in conjunction with local manufactories, drawing and the copy were as central to the nineteenth-century industrial art school or the school of design as they were to the academy. As I have begun to suggest, however, what was copied differed; the human figure and its singular lessons—of anatomy, of the beautiful—were conspicuously absent in the British schools of design.[72] Their program of drawing and those in the American technical institutes and normal schools organized in their image frequently included both freehand and mechanical drawing. Such courses most often began with repeated drills in straight and curved lines. The student progressed to copies of geometric figures in plane and flat designs drawn from historical ornament, and then to geometric forms in orthographic projection and ornament in depicted relief. The student's principal three-dimensional models were simple still-life objects—buckets, bowls, vases—and plaster casts of historical ornament. Often after mid century, and well into the 1900s, still-life setups were composed of wooden, board, or plaster geometric "type solids," white-surfaced cones, cylinders, spheres, and cubes.

Design school models were not those of the academy; neither was the line they were drawn in. In the schools of design, at South Kensington, and in the numerous self-education manuals that forwarded variations of its program across the century—some 145 in America alone between 1820 and 1860[73]—students were taught "linear drawing." The redundant "linear drawing" signaled industrial art education's refusal of what it often termed "fancy drawing," the techniques and terms, central to academic training, of modeling, value, and the *demi-teinte,* as well as the body on which that modeling took place.[74] The firm, consistent line was not the outline of the body but a medium of measurement. A number of nineteenth-century drawing manuals promised to develop a "compass in the eye,"[75] a metaphor of Renaissance origins that served on those pages to link linear drawing to the needs of industry, or to an image of industrial practices. The line and the compass anticipate Kandinsky's course in analytical drawing at the Bauhaus, which aimed for "concise, exact expression" according to "the most precise possible schema"; even his enumerated choice of objects—"saw, grindstone, bucket"—repeated the still-life setups of industrial arts drawing.[76] "The compass in the eye" also forecasts the broad rhetoric of construc-

Figure 3. El Lissitzky, *The Constructor: Self Portrait*, 1924. Photo-montage and photogram, 4 ⅜ × 5 inches. Stedelijk Van Abbemuseum, Eindhoven. Photography: Peter Cox © 1998 Artists Rights Society (ARS), New York/VG Bild-Kunst, Bonn.

tivist modernism. Naum Gabo's "Realist Manifesto" of 1920 offers an image of the new artist as de Duve's "conceiver-projector"; equipped with "eyes as precise as a ruler, in a spirit as taut as a compass," he constructs his work "as the universe constructs its own, as the engineer constructs his bridges, as the mathematician his formula of the orbits."[77] The cybernetic metaphor is pictured, as well, in El Lissitzky's 1924 self-portrait photomontage *The Constructor* (Figure 3), which juxtaposes and layers the compass and the artist's eye.

Drawing manuals and the schools of design were not intended to make artists, or to meld the artist and the craftsman. Dyce's rejection of the human figure stemmed not only from a belief in the separate science of design, but also from a fear of the contaminations of the fine arts and their seduction to aspire beyond class boundaries. Life drawing at Somerset House, the central London school, was "not to be entered upon

unless the future prospect of the student needs it," a possibility that was severely limited by 1843, when Dyce decreed that "no person making Art his profession should be eligible for admission as a student."[78] By definition, those from whom he withheld the figure were not artists but designers for manufacture. When the projects and the language of the schools of design return as part of the *Formlehre* of modernist teaching, the class distinctions they reflected and reproduced are elided and subsumed, like the artisan in the passage from artist-artisan to conceiver-projector. Or perhaps the artisan is not so much elided as "displaced," as we now talk about displaced workers. As Peter Hahn has recently commented, "After starting with a clarion call for a 'return to crafts-manship,' the Bauhaus moved toward the industrialization of design and art, laying the foundations of modern industrial design," for a new professional practice. This recasting, or upscaling, of the applied and industrial arts "earned it the hostility of the same petit bourgeois elements that were the cradle of the Nazi movement," of the same lower middle classes whose sons would have been trained in *Gewerbeschulen* and would have found employment as *Musterzeichner.*[79]

By the Cylinder, Sphere, and Cone

Ernst Gombrich remarks in passing, but with remarkable assuredness, in *Art and Illusion* that "Cézanne's much-quoted advice to Bernard to look at nature in terms of simple shapes of known property, that is, in terms of cylinders, cones, and spheres. . . . surely has nothing to do with cubism but rather with the type of art teaching in French schools which was current at the time Cézanne was young and which he wished to pass on to his young admirer."[80] Gombrich's casual reduction of one of the great aphorisms of modernism to a studio shortcut or a public school convention is at best only half-right. It may have been offered by the master as a simple tool, a recollection of a lesson from the Ecole de Dessin at Aix, but it has been heard across the twentieth century as a foundational principle. As Richard Shiff writes, hedging Gombrich's "surely," if Cézanne's statement "perhaps merely reflects a device of studio practice, a manner of conceiving conventional modeling," it "becomes for Bernard an absolute law of nature or a mathematical truth."[81]

Cézanne's advice had been given before; one popular source would have been Charles Blanc's 1867 *Grammaire des arts du dessin*, which argued, well before Cézanne's letter of April 1904, that "the child who

shall have succeeded in putting a cube into perspective, and in representing the convexity of a sphere, will possess in abridgement, the whole science of design."[82] And even the Platonism Emile Bernard heard as though for the first time was conventional. Blanc, the librarian of the Ecole des Beaux-Arts, recalled Plato by name; the passage above continues: "The artist, in proceeding thus, will follow the path traced by him whom Plato calls the eternal geometrician."[83]

Why, then, did Cézanne imagine this piece of well-worn advice worth giving, and why did it appear so different and necessary to Bernard? If it was, as Gombrich has it, a teaching drawn from French schools, then Bernard should have learned it long before Cézanne's letter; it was current practice while Bernard was a student in the 1880s. A nationwide, mandatory drawing program that built from two-dimensional to three-dimensional geometric types was not introduced into public schools in France until 1883, as a way to provide "a means of communication and a practical instrument used by the worker-artist and the artisan."[84] Perhaps the "type of art teaching" Gombrich cited was not the one intended for the type of artist Cézanne and Bernard aspired to be, even if the education meant for them—or rather, for fine artists—that of the Ecole des Beaux-Arts, no longer fit. Insisting, like Gombrich, that Bernard had misinterpreted Cézanne's "purely pragmatic advice," Theodore Reff notes the appearance of Cézanne's advice in the "many manuals of self-instruction published in the first half of the 19th century."[85] But in citing manuals of "self-instruction," Reff suggests that their lessons and their students were different from those of an academician's atelier. Blanc's assignment was posed first to the child, and his book was offered, not to replace the Ecole, but to educate public taste.

Rooted or not in the conventions of a trade school drawing, Cézanne's advice to Bernard—to "treat nature by the cylinder, the sphere, the cone"[86]—was not, I would argue, offered as a drawing lesson, a lesson in how one might more easily produce an image of this or that object. Rather it was a lesson in vision. According to Bernard, Cézanne's geometry provided a way to "organize one's sensations,"[87] a way to ground, order, and even theorize perception, "in spite of," and here the words are Cézanne's, from another letter to Bernard, of July 1904, "the tremendous effect of light and shade and colourful sensations."[88] The forms concentrated vision, and they concentrated nature as well, pointing it toward, and composing it for, the eye. Cézanne's teaching was written for an individual act of seeing; it became the founding story of

modernism, and of design as *Gestaltung.* To do so, however, it had first to be heard differently from the lessons of ornament and craft training. The geometry lessons had to be sublimated, tied to the instance of the artist rather than the repetitions of the artisan, and severed from the markers of class and the utilitarian. That was Cézanne's job. (Or that was the job of this Cézanne-as-designer; there will be other Cézannes fashioned to meet other images of the artist.) In his advice what had been elementary training becomes elemental, foundational.

Nikolaus Pevsner, who quite literally wrote the book on the conventions of art teaching, saw, not the conventionality of Cézanne's teaching, but its primacy. Cézanne—and specifically the Cézanne of "the cylinder, the sphere, the cone"—is the first painter among Pevsner's "pioneers of modern design."[89] At the Bauhaus Moholy-Nagy cast Cézanne as the empirical pioneer of *"vision in relationships,"* making the lessons of his paintings precisely those of the Bauhaus foundation course. "Cézanne and the cubist painters organized their work through visual fundamentals." In listing those fundamentals, Moholy outlines the lessons of the Bauhaus *Vorkurs,* as if paraphrasing Johannes Itten's general theory of contrast: "The visual fundamentals emphasized by the cubists were based mainly on contrasts: black and white, light and dark, geometric and free shapes, complementary colors, positive and negative, full and empty, perforated and solid, curved and straight, convex and concave, distorted and unchanged."[90] Placing Cézanne at the origin not only of modern painting but also of modern design, making the advice and the geometry his, and casting them as discoveries—findings rather than teachings—all work to secure for the designer the prerogatives and the status of the artist. In Moholy's story, the twentieth-century designer no longer learns from the *Musterzeichner* or the applied artist of the mid nineteenth century; instead, on the model both of science and inspiration, he learns his lessons from the empirical research and individual discovery of the artist.

As Richard Shiff suggests, Cézanne offered his advice as a way of organizing particular sensations, individual moments of vision; but it was heard as a science of design, where design is a knowledge of the order of vision. In his July letter, Cézanne admonished Bernard that "to achieve progress nature alone counts, and the eye is trained through contact with her. It becomes concentric by looking and working."[91] Looking educates the eye and shapes it: the eye, given a new form, then forms the world in its image. Cézanne's figure of the trained eye, like

the metaphor of the compass, is a decisive one for a new design educa-
tion that can leave the manual exercises of the school of design, the
copying and recopying of tapestry patterns and historical ornament,
and turn to the world as a design problem, something that must be or-
dered. The trained eye—the eye as the site (and of course, the sight) of
art—continues in the twentieth century, when to teach art is to "give a
course in seeing" at Sarah Lawrence, to "train the eye to see" at the
University of Kentucky, to make "seeing . . . an aggressive act" at the
University of Georgia.[92] All these courses that have focused on the eye
ground the rules and orders of design teaching in vision, in what Kepes
called "the education of vision"; they mark the interiorization and the
psychologization of those rules, as well.

The Language of Vision

To start with Itten's "visual fundamentals" or Kandinsky's "construc-
tive elements"—to start with varieties of mark making, or the con-
strasts of shape and texture, or the tensions created between geometri-
cal or free forms across a surface—is to start, not with the body or the
world represented, but with the materiality and autonomy of represen-
tation, opaque marks matching the opacity of the world as a visual
image. The founding moment of the constructing, aggressive vision of
the visual arts opens up a space between vision and meaning, or be-
tween vision and the world, a space that makes possible the language of
art. Precisely when vision is stressed as primary and primordial, as the
object of art education, primers and grammars and ABCs of art dis-
cover and multiply language—or the image of language—from Blanc's
1867 *Grammaire des arts du dessin,*[93] through the Bauhaus, to Kepes's
Language of Vision.

Those who have read Gombrich might complain that the geometry I
have stressed as a method for schematizing the world has been available
to artists since at least the Middle Ages. It is reproduced in *Art and Illu-
sion* in the drawings and pages of Villard de Honnecourt, in Albrecht
Dürer's measured figures, and in Erhard Schön's "schematic heads and
bodies."[94] As early as the end of the sixteenth century, Carel van Man-
der had called for "an ABC book on the first elements of our art."[95] Cit-
ing van Mander, Gombrich continues: "As so often happens, the de-
mand elicited a supply. In 1608 there appeared in Venice what seems to
be the first book of a new type, Odoardo Fialetti's 'The true method and
order to draw all parts and limbs of the human body.' "[96] My insistence

on pedagogical reforms, on theory and its dissemination in the pages of primers also has a longer history. Barbara Stafford, for one, has noted the eighteenth century's "dedication to pedagogy, to the production of training manuals and corrected compendia outlining the proper procedures for the developing professions."[97] But Fialetti's is an alphabet of the body; it is the human figure that is dismembered into reassemblable parts: a page on eyes, another on ears. The academy's ABCs, its fundamentals, were constructed in the image of the body, a point made clearly, if curiously, by Giuseppe Maria Mitelli's *Fanciful Alphabet of Models for Drawing* (Figure 4), where bodies help to form each letter of the alphabet. Indeed, all knowledge, as Stafford notes, was imagined as a body: "For the age of encyclopedism, the human body represented the ultimate visual compendium, the comprehensive method of methods, the organizing structure of structures. As a visible, natural whole made up of invisible dissimilar parts, it was the organic paradigm or architectonic standard for all complex unions."[98]

The system of knowledge marked by the visual arts lies closer to what Heidegger describes in "The Age of the World Picture" than to the pre- and early-modern formulas and schemata for making that Gombrich disinters, or the Enlightenment body that Stafford reveals.[99] The "world picture," Heidegger explains, "does not mean a picture of the world but the world conceived and grasped as picture," each instance already emplotted and in relation.[100] The visual arts have removed the grid and the measure from the surfaces of bodies—from the human figure or horses or rhinoceroses—and plotted it on the surface of the work and in the field of vision. The coordinates and vectors are not those of things, but those of a mapped surface with its own laws and directions. In the Bauhaus course the material signifiers of drawing and painting are disassembled and taught; these are the subject matter of works of art. The narrative of the work of art, its *histoire*, is now, as in Kandinsky's title, the passage from point and line to plane or, in Klee's aphorism, the story of taking a line for a walk.[101] What is constructed with pictorial elements is pictorial space, a space built with and for the means of picturing. Plotted across this space are relations, contrasts, oppositions, tensions, depths, directions, forces, at once both pictorial and pictured—illustrated, demonstrated—but always internal.

In *Vision in Motion* Moholy-Nagy sums up the argument I have been pursuing, beginning, once again, with Cézanne: "The art of the postcubist period derived its first abstraction from nature, but later

freed itself from that departure and articulated the basic means of vi-
sual impact—shape, size, position, direction, point, line, plane, color,
rhythm—and built with them a completely new structure of vision."[102]
What Moholy has listed between his dashes are the fundamentals that
structure so many twentieth-century textbooks, the elements and gram-
matical rules of a language of vision. Positing abstraction as the theory
of the visual arts, he compares the artist to a linguist (Figure 5): "Like
the semanticist, who strives for logical cleanliness, a clearing away of
loosely trailing connective associations in the verbal sphere, the ab-
stract artist seeks to disengage the visual fundamentals from the welter
of traditional symbolism and inherited illusionistic expectations."[103]
The abstract artist works to disengage those fundamentals from any of
the particular practices and uses of representation, to discover and to
demonstrate the picture's interiority and its working. Not the semanti-
cist, I would argue, but the semiotician is the right linguist for the lan-
guage of art Moholy offers: the scientist, not of meanings, but of the
system of signs. Moholy-Nagy's description rehearses the terms of
structural linguistics: the separateness of the artistic sign from the
world represented, the integrated and necessarily internal relations
among the "basic means of visual impact," and the completeness of the
field they describe.

The followers of Cézanne after Bernard learned certain teachings of
industrial education, but as problems for artists and designers as artists,
as laws of vision and even of nature. The lessons of artisanal specificity
that had arisen in lower-middle-class trade schools were recast as a cri-
tique of a dying "aristocratic" academy, first in the image of the artist
as socialist craftsman and later in the artist as scientific researcher, an
image that worked to transcend—or to elide, in modernism—the ques-
tion of class. The exercises, repetitions, types, techniques, and shortcuts
of the trade school were transformed into Kandinsky's "constructive
elements," his "forces (= tensions)"[104] that must be discovered, a hid-
den order of art that, like Itten's paragraph-long list of contrasts, must
be "worked out singly and in combination."[105] The order thus envi-
sioned lay not only in the eye of the artist but also under the world that
flattened before him as a visual field; that order was reinscribed yet
again in the implicit grid of the paper or canvas rectangle that matched
that field. There the designer's vision ordered the vision of the viewer as
well; the work of art as design was itself the site (and once again,
the sight) of a further disciplining of the eye. Edward Rannells of the
University of Kentucky, who is quoted above on training the eye to see,

Del D non può far il Pittor mai senza ,
Se noi uogliam considerar, ch'ei dica .
Neceſsaria è al Pittor la Diligenza .

Figure 4. Giuseppe Maria Mitelli, "The Letter D," from *Alfabeto in Sogno Esemplare per Disegnare*, 1683. Etching, 10 ⅞ × 7 ⅝ inches. Print Collection, Miriam and Ira D. Wallach Division of Art, Prints and Photographs, The New York Public Library, Astor, Lenox and Tilden Foundations.

Figure 5. László Moholy-Nagy, *Wall Display for a Bauhaus Festival*, 1925. Photograph courtesy Museum of Modern Art, New York © 1998 Artists Rights Society (ARS), New York/VG Bild-Kunst, Bonn.

argued for this series of mirrored demands and disciplines in the mid 1940s, in terms directly indebted to Bauhaus teaching and Gestalt psychology:

> The work of art, in the process of its making, requires or demands an order appropriate to itself. . . . [and] what art requires of the artist as maker, it also requires of the observer: namely an awareness in himself of an order consonant with that in the object and thus an understanding of the form that makes it a work of art.[106]

The mirroring of the order of vision in the world and on canvas that marks Rannell's argument appears in a number of attempts to understand modernism's vision more critically. The vision of design is, in Rosalind Krauss's words, a "redoubled vision: of a seeing and a knowing that one sees, a kind of *cogito* of vision."[107] Krauss dates Mondrian's emblematic "entry into modernism"—and modernism itself—to a realization that "took place on the site of the rationalization of painting around the laws of color theory and psychological optics." There Mondrian found the parallel planes of the visual arts as a structural

language of vision: "the two planes—that of the retinal field and that of the picture—were understood now to be isomorphic with one another, the laws of the first generating both the logic and the harmonic of the order of the second; and both of these fields—the retinal and the pictorial—unquestionably organized as flat."[108] David Deitcher also writes of this mirroring, and he too positions the moment of its unveiling in the development of abstraction in the years before World War I. What generates pictorial order for Deitcher, and what arms and grids the artist's eye, are not the theorems of optics but the objects and processes of industrial education and manufacture as they are made to serve, or to allow for, the individual and interiorizing subject of the artist. "This generation," he writes, "internalized the industrial grid to map out a wholly imaginary pictorial space in which the individual subject could deploy a sovereign gaze and explore the limits, coordinates, and dynamic vectors of vision in an abstract, stable domain of pure, unobstructed visibility."[109]

In their descriptions of a gridded, knowledgeable, constructing vision, Deitcher and Krauss have stressed the kinship of visual modernism and structuralism, a link that has been forecast in the insistence throughout this chapter on an ordered language of vision. In *The Optical Unconscious* Krauss writes of Frank Stella's paintings of the early 1960s, paintings of a series of nested squares, that "the figure of the frame turn[s] the painting into a map of the logic of relations and the topology of self-containment. Whatever is *in* the field is there because it is already contained *by* the field, forecast, as it were, by its limits. It is thus a picture of pure immediacy, of complete self-enclosure."[110] Krauss gives those same attributes to a structuralist figure called the Klein Group (or, as it often appears in literary studies, the "semiotic square"), a rectangular graph on which can be plotted all the possible relations of any system structured by opposition; the upper corners bear the positive terms of opposition, the lower corners, their negation. She follows her reading of Stella's paintings with a single sentence, set alone as a paragraph two lines long: "And the graph itself is also a picture of pure immediacy, of complete self-enclosure."[111]

The graph lays out for us the workings of visual modernism because it operates on modernism's terms. "It captures the inner logic of modernist art on its own grounds—that of the terms of vision. It gives one the logic in the form of transparency, simultaneity, and containment of the frame. As a logic of operations it already accounts for its closure; has always already enframed it."[112] A rectangle that maps and orders

the universe that it bounds, the graph is both an image of modernism and a modernist image; functionally and, not coincidentally, iconically, it is the same as Stella's paintings. Throughout *The Optical Unconscious*, the graph is the image and example of modernism; it stands again and again for modernism's self-accounting, its urge to self-knowledge in the visual field. In the Klein Group, in Stella's paintings, and in the Bauhaus foundation course, knowledge is added to vision. The logic of this addition is a structural logic; the world with knowledge added is the structural world. "The goal of all structuralist activity," wrote Roland Barthes in 1963,

> is to reconstruct an "object" in such a way as to manifest thereby the rules of functioning (the "functions") of this object. Structure is therefore actually a *simulacrum* of the object, but a directed, *interested* simulacrum, since the imitated object makes something appear which remained invisible or, if one prefers, unintelligible in the natural object. . . . the simulacrum is intellect added to object.[113]

What is important for diagrams and modernist painting alike is to account for what had been unintelligible—here I reverse Barthes's preference—and to make it visible.

Barthes's "rules of functioning (the 'functions')" curiously echoes Kandinsky's goal for analytic drawing, to discover the "laws that govern the forces (= tensions)"; both Barthes and Kandinsky have foreseen Krauss's argument that structuralism is not only the language that explains modernism, but also the language in which it is made. For Barthes the work of visual modernism, work made not far from the Bauhaus, was the very model of structuralism.

> When Troubetskoy reconstructs the phonetic object as a system of variations; when Dumézil elaborates a functional mythology; when Propp constructs a folk tale resulting by structuration from all the Slavic tales he has previously decomposed; when Lévi-Strauss discovers the homologic functioning of totemic imagination . . . they are all doing nothing different from what Mondrian, Boulez, or Butor are doing when they articulate a certain object—what will be called, precisely, a *composition*—by the controlled manifestation of little units and certain associations of these units.[114]

The vision that Deitcher and Krauss described, gridded and mapped by science and technology, is an internal, individual vision; it belongs to the subject, but it is not the clouded, troubled, merely subjective vision of romanticism's artist as genius. Rather it is the clear, lucid, knowing vision of the kind of artist a place like Harvard needed. Before I can place artists on campus, however, I need to trace their nineteenth-century

childhood. If, as Moholy-Nagy wrote, the "objective" of the Bauhaus Foundation Course is to make the student "conscious of his creative power," its "method is to keep, in the work of the grown-up, the sincerity of emotion, the truth of observation, the fantasy, and the creativeness of the child."[115]

INNOCENCE

AND FORM 4

Modernist vision has two eyes. In addition to the shaped and strengthened eye of which Cézanne and so many others wrote, there is another, equally important: the innocent eye. Both take their attributes from the themes of pedagogy; they appear as goals and examples of teaching. The innocent eye, called first by name in John Ruskin's *Elements of Drawing*, is the eye that sees the world afresh. It sees nature, in Cézanne's words, "as no one has seen it before you";[1] moreover, it sees nature before the mind knows its names and its purposes.

> The perception of solid Form is only a matter of experience. We *see* nothing but flat colours; and it is only by a series of experiments that we find out that a stain of black or grey indicates the dark side of a solid substance, or that a faint hue indicates that the object in which it appears is far away. The whole technical power of painting depends on our recovery of what may be called the *innocence of the eye;* that is to say, a sort of childish perception of these flat stains of colour, merely as such, without consciousness of what they signify, as a blind man would see them if suddenly gifted with sight. . . . [T]he whole art of Painting consists merely in perceiving the shape and depth of those patches of colour, and putting patches of the same size, depth, and shape on the canvass.[2]

Ruskin's statement appears in a footnote in the first pages of the *Elements;* it is part of the author's justification for assigning a technical exercise that must precede his readers' turn toward nature, a practice in producing the flattened "patches" of which painting and Ruskin's drawing too are composed.

Jonathan Crary quotes the sentence that carries Ruskin's long foot-note: "Everything that you can see in the world around you presents it-self to your eyes only as an arrangement of patches of different colours variously shaded," and he juxtaposes to it a statement by Hermann von Helmholtz, written at the same moment: "Everything our eye sees it sees as an aggregate of coloured surfaces in the visual field."[3] Ruskin's innocent, it seems, already knows the mirroring, the isomorphism of the visible world and the picture plane; I noted Rosalind Krauss's and David Deitcher's recognition of it across modernism at the close of the preceding chapter. The vision that Ruskin and Helmholtz described constructs a visual world, a world of flattened color shapes and surfaces that have been peeled away from tactile objects and views we cannot see, a world whose primary attribute is depth. Innocent vision, what Crary calls a "primal opticality,"[4] sees before objects, before what is known, both spatially (this vision is a screen of patches) and develop-mentally (it is intrinsic to childhood). Ruskin wrote of the adult artist's ability to see innocently as a kind of developmental regression to that time before writing or before taking for granted the names and the order of things: "A highly accomplished artist has always reduced him-self as nearly as possible to the condition of infantine sight."[5] Not only is there a primal vision, but vision is also primary; the child sees before the world of things, certainly before their uses and practical values, be-fore what they are worth. The vision that Ruskin and Helmholtz describe makes Kantian disinterestedness, the aesthetic point of view, developmental and physiological.

Ruskin's innocent eye bears the marks of a century-long valorization of the child, along with the archaic and the naive, as both original in the present and proof of an origin lost in the past of the individual and of the race. What had been lost was a way of seeing; like Ruskin, Ralph Waldo Emerson linked childhood to vision and a special seeing of na-ture, as though in a mirror: "Few adult persons can see nature. . . . The lover of nature is he whose inward and outward senses are truly ad-justed to each other; who has retained the spirit of infancy even into the era of manhood."[6] Ruskin's eye continued, as well, a belief in the child as a natural artist, an image current by the mid nineteenth century among educational reformers; by the end of the century, essays bearing the title "The Child as Artist" had appeared in both the United States and Germany.[7] Earlier, Francis Wayland Parker, whom John Dewey called the father of progressive education, had argued that "every child has the artist element in him. . . . All modes of expression are simulta-

neously and persistently exercised by the child from the beginning ex-
cept writing. It sings, it makes moulds, it paints, it draws, it expresses
thought in all the forms of thought expression, except one."[8]

The innocent eye insists on the separation of image and thing, but
also, and perhaps more stridently in the writings of educational com-
mentators, on the separation of image and language. Ordinary adult vi-
sion is the equivalent of verbal apprehension, the reduction of the
world to a system of names and formulas. "At the very moment that
the seen thing is named," writes Philippe Junod of Ruskin's eye, or of
the nineteenth-century German aesthetician Conrad Fiedler "chez
Ruskin," "it loses its visual existence in order to acquire a linguistic
one."[9] Training the eye was, indeed, the educator's task. The intent of
such training, however, was not merely to teach the names of things,
crowding the eye and the mind with the stuff of the dictionary, but also
to engage the child's vision, to plot and prepare it. Using a metaphor
that is by now familiar to us as the language of vision, one American
kindergartner explained to the National Education Association in 1876
that the "A.B.C. of things must unquestionably precede the A.B.C. of
words, since the signs (the letters) presuppose the concrete to which
they refer."[10] Remarking the space between vision and representation
that Ruskin and Parker had begun to describe, she continued: "The
things and their properties are certainly there, and they are also per-
ceived by every child of sound senses, but they have not been set in
order so as to be irresistibly impressed in their original and simplest el-
ements on the still blank tablet of the child's soul."[11] The retinal tabula
rasa and the spiritual one must be constructed, traced with the order of
foundations.

A Primary Art School

The innocent eye, which sees before the name, and the child who bears
it—the child discovered in the nineteenth century as the subject of
kindergartens and of educational reformers, who embodies the sincer-
ity of emotion and the truth of observation of which Moholy-Nagy
wrote—give the methods and techniques of design training a psycho-
logical interiority, a necessity that is ontogenetic rather than eco-
nomic.[12] "To instruct men," wrote the Swiss educational reformer Jo-
hann Pestalozzi, "is nothing more than to help human nature develop
in its own way, and the art of instruction depends primarily on harmo-
nizing our message and the demands we make upon the child with his

powers at the moment."[13] Pestalozzi was one of the central figures of
the broad early-nineteenth-century German educational reform, and a
number of American educators helped to import his methods into
American classsrooms and drawing manuals. The author of an 1843 re-
port to the American Institute of Instruction explained that Pestalozzi's
"object teaching" brought "minerals, flowers, and other natural objects
into the schoolroom." There, "amidst the sensations of the hardness
and weight of the one and the beauty of the other, . . . the little learner
[was] taught the words by which they are so called. The child would
thus learn the alphabet of letters in the alphabet of things."[14] The pur-
pose of those lessons in the Pestalozzian schoolroom was not to pro-
duce artists, or even artisans, but rather children.

Pestalozzi promoted drawing as part of the general, rather than vo-
cational, education of the child, an integral part of the child's ability to
observe and then name the world. In 1803 he published *A.B.C. der An-
schauung oder Anschauungs-Lehre der Massverhältniße* (The ABC of
Sense Impression; or, the Sensory Lessons of Proportion), a book of
fundamental drawing lessons suggesting a mapping of perception that
precedes both an ABC of things and an ABC of words. The straight line
and its measure, its division and multiplication, were Pestalozzi's foun-
dational forms of understanding. The child was asked first to draw
straight lines and then later to divide them, by eye, into halves or quar-
ters or eighths, to learn to measure visually (Figure 6). "Then we begin
to name the straight lines as horizontal, vertical and oblique; describing
the oblique lines as rising or falling, then as rising or falling to the right
or left. . . . In the same way we teach them to know and name the pro-
totype of all measure—forms, the square which rises from joining to-
gether two angles and its division in half, quarters, sixths, and so on"
(Figure 7).[15] Pestalozzi's child learned to draw as a surveyor—measur-
ing and dividing—rather than as an antiquarian or an iconographer.
The further uses of drawing's tools, of line and shape as they are tied to
bodies, as they round the figure or shade into relief the artisan's histor-
ical ornament, were left unspoken, even as the child learned the names
by which the world was called.

Pestalozzi's exercises in drawing and dividing lines, in dividing and
redividing squares, in constructing right angles appear in a number of
nineteenth-century technical manuals in Europe and the United States.
In the illustrations to Pestalozzi's *A.B.C.* they look and even sound like
nothing so much as works of minimal art. His assignment of "straight
lines, unconnected each by itself. . . in different arbitrary directions,"[16]

reads like the title (and the enacted instructions) of one of Sol LeWitt's wall drawings: *Short straight lines, not touching, drawn at random, and evenly distributed over the area* (1972).[17] The engraved freehand horizontals, divided in halves, fourths, and so on, recall the handmade tentatively penciled and divided grids of Agnes Martin, which have most often been read as records of her isolated working in the landscape of the desert Southwest. They might also be the traces of a history of art education, one she might have known as a graduate of Western Washington College of Education and a frequently returning student at Columbia Teachers College (Figure 8). Still, I do not need to argue that Martin knew Pestalozzi's exercises as his, for they turn up anonymously throughout modern training, which is predicated on the parallel plotting of the grid on paper and in the eye.

Between the early nineteenth century and LeWitt and Martin, Pestalozzi's exercises, dividing lines and building angles, appear at the Bauhaus as the opening lessons for Josef Albers's three-semester course in *gegenständliches Zeichnen* (representational or, more literally, objective drawing), offered at Dessau in 1931–32:

> Divide lines up at equal distances according to your own computation. Draw parallel lines freehand. Divide up lines drawn freehand into approx. equal distances using only your eye (check afterwards). Use your eye to divide circles drawn freehand into quarters and thirds. Use your eye to arrange dots in a square and then connect them. Repeat forms symmetrically [Figure 9].[18]

Wolfgang Wangler, who collected Albers's course assignments and the drawings Katja Rose, a Bauhaus student, made to fulfill them, repeats the now familiar protestation: "It was not painting or drawing that he taught, but seeing."[19] Perhaps one of Albers's lessons—certainly the one learned by his students in America—was to see the results of those assignments as art, to see the grid as the order the work of art would demand.[20] The grid structured a number of Bauhaus exercises, and not only flat work; tactile, material, and tool studies were organized across a compartmentalized rectilinear surface. "If the same methodology were used generally in all fields," wrote Moholy-Nagy, "we would have *the* key to our age—*seeing everything in relationship.*"[21] Across the grid, materials, surfaces, textures are held in relation—rough to smooth, hard to soft, heavy to light; each is typed and categorized according to its "intrinsic qualities," in Moholy-Nagy's words, or, in Pestalozzi's, according to those "sensations of hardness and weight" that the child felt as the necessary and telling difference between rocks and flowers.

Figure 6. Johann Heinrich Pestalozzi, Table 2 of *A.B.C. der Anschau-
ung oder Anschauungs-Lehre der Massverhältniße*, 1803. Reproduced
from the Collections of the Library of Congress.

Figure 7. Johann Heinrich Pestalozzi, Table 1 of *A.B.C. der Anschauung oder Anschauungs-Lehre der Massverhältniße*, 1803. Reproduced from the Collections of the Library of Congress.

Here, then, is another lineage for Bauhaus teaching, one that might parallel its sources in the schools of design as the innocent eye parallels the trained one—although one could argue that, rather than parallel the trained eye, the child and innocent eye precede it as its prerequisites. The ordering of vision descends not only from industrial education and the technical art course at South Kensington, but also from the schoolroom and the kindergarten, a name introduced by Friedrich Froebel, a follower of Pestalozzi, who established the first kindergarten in Germany in 1837. The goal of the Froebelian classroom, like that of Pestalozzi's drawing, was not to make artists but to order an innocent

Figure 8. Agnes Martin, *White Flower,* 1960. Oil on canvas,
71 ⅛ × 72 inches. Anonymous Gift, 1963, Guggenheim Museum,
New York. Photography: Robert E. Mates © Solomon R. Guggenheim
Foundation, New York (FN63.1653).

vision and to produce the world as a world of forms. The plane figures
that design students learned to render as the building blocks of histori-
cal ornament, the geometric solids that art students received as prob-
lems in hatching and modeling, kindergarten students learned to see as
types, permanent, intelligible organizing forms that lay beneath stove-
pipes and apples and oranges. The child who compares the forms of a
sphere and a cube, explained an American Froebelian in 1891,

> then discovers something like the type, an apple, an orange, and any of the
> pleasant objects which are beautiful to him. From one type form he passes to
> another; the group of three given by Froebel, the sphere, cube and cylinder,
> are followed by other groups. . . . As he studies his type form he studies all
> the forms about him, and in his mind are stored the images of these forms
> made perfect by the study of types.[22]

Figure 9. Katja Rose, page from Josef Albers's drawing course *gegenständliches Zeichnen,* at the Bauhaus in Dessau, 1931. Assignment: Divide Lines at Equal Distances according to Your Own Computation; Draw Parallel Lines Freehand. Pencil and red pencil on paper, 16 ½ × 22 ⅜ inches. Bauhaus-Archiv, Berlin (Inv.-Nr. 1997/32.2). Photography: Markus Hawlik.

Froebel's gifts to each child—a progression from yarn balls and wooden blocks to a gridded board—were intended to provide entertaining, manipulable, and above all visual models for the child's development of concepts. They offered a clear "percept" within which the particulars and specifics of objects could be ordered and compared: "In order to gain clear knowledge the child must not be confused by too many forms."[23] This explanation, from 1876, of Froebel's second gift—a wooden ball, cube, and cylinder—precedes Cézanne's advice to Bernard to take refuge in the geometric solid against the confusions of "light and shade and colorful sensations." In the kindergarten, too, the cylinder, the cube, and the cone offer a solid point of visual and conceptual contact.

Child Art and Composition

"Froebel's kindergarten," wrote the American reformer Elizabeth Peabody in 1870, "is a primary art school," and it influenced the development

of the art school and art training in Germany and the United States well beyond the primary years.[24] The exercises and ideologies of elementary education enter professional training in a number of ways, many of which cross through the Bauhaus. Noting that Kandinsky's mother was an enthusiast of Froebel's kindergarten, Frederick Logan in 1950 posited a connection between Froebel's education of the senses and his kindergarten gifts and the Bauhaus's "learning by doing" realized in geometric form. More recently, Marcel Franciscono has linked early child education to the Bauhaus through Johannes Itten. There was an intense struggle within the Bauhaus over the meanings and merits of individual expression, over whether an individual creativity could be fostered that was not the same as an arbitrary and isolating "artistic subjectivity." Franciscono argues that Itten's association with prewar progressive child education was part of what alienated him from an increasingly functionalist Bauhaus and led to his resignation in 1923.

> The most original aspect of Itten's pedagogy—the foundation on which the *Vorkurs* was built, and as far as the Bauhaus was concerned its most problematic aspect—did not come primarily from orthodox sources of professional art education but rather from the liberal Rousseau-Pestalozzi-Froebel-Montessori reform tradition of child education, which had as a basic tenet that education is essentially the bringing out and developing of the inherent gifts through a guided process of free and even playful activity and self-learning.[25]

Itten's "improvisatory exercises in self-expression," exercises in breathing, body movement, and humming, and in rhythmic and two-handed drawing, do disappear in the preliminary courses that Albers and Moholy-Nagy offer after his departure. But his use of children's investigations as models for artistic experimentation and of the child as a model for both perception before language and creativity without preconception were shared across the Bauhaus. The large lesson Itten drew from educational reform—"that education is essentially the bringing out and developing of the inherent gifts through a guided process of free and even playful activity and self-learning"—was learned across the Bauhaus. It remained influential, even after his departure, on the very teachers who replaced him. Gropius's "Theory and Organization of the Bauhaus," a position paper written just after Itten's departure and in the midst of this shift, invokes Maria Montessori, praising her not only for her "practical exercises"—praise that would fit the image of a new functionalist Bauhaus—but also for her education of "the entire human organism." "The education of children when they are

young and still unspoiled is of great importance," Gropius continued; "the Bauhaus keeps in touch with new experiments in education."[26] Certainly it continued to use the older parts of the progressive tradition; Albers used Pestalozzi's lessons and Moholy-Nagy invoked the child's creativity and sincerity as essential elements even in the Bauhaus-trained designer.

Still, there is an important difference between the sincere child Moholy-Nagy embraced and the child artist that influenced Itten. The sources of Itten's improvisatory situations and his idea of teaching as a "bringing out" lie at the twentieth-century end of the long reform tradition that Franciscono's list of names represents. He ties them to Maria Montessori and the Austrian art educator Franz Cizek, both of whom contributed to the language of expressionism that the Bauhaus would reject after 1922. The idea of self-expression, a now familiar term, was central to Cizek's conception of Child Art, and he cast his teaching as subtraction, the removal of method and model. Teaching was deschooling, uncovering, taking off the lid or peeling off the veneer: "The slightest thing which is produced as a result of inner experience, is worth more than the cleverest copying. . . . The teacher must avoid every form of compulsion."[27] Art emerges from an individual interior, not arbitrarily, merely subjectively, but necessarily and naturally: "Nothing here is made, it has grown like flowers."[28] Cizek's botanical description repositions the child's "nature" from outside to interior, from the Ruskinian or Emersonian innocent who revels in the natural, sensuous world, to a Freudian child, closer to the urgings of the unconscious and driven to express its desires and imaginings—to what Cizek called "the kernel of creative barbarism."[29]

The art of children had been the object of the Child Study movement, an almost ethnographic survey of childhood begun in the 1880s, and exhibitions of arts and crafts by children had been included in various fairs and expositions since the Crystal Palace exposition of 1851 as proof of the success of various methods of teaching drawing or crafts or kindergartners. Indeed, such exhibitions were important to internationalizing a variety of teachings, from South Kensington drawing to the Froebelian kindergarten, and art by Cizek's students was included in an International Art Congress exhibition in London in 1908. Child Art announced a shift in how and where the work of children was seen; Cizek insisted that he offered no method but reveled in his lack of one, and he rejected the idea of children's art as embodied psychology. He insisted that Child Art be seen as art, precisely because it was unskilled, because

its practitioners took images from their imaginations and struggled with the medium to give them form—a struggle necessary for any creative art, for keeping the scent of creative barbarism.

Cizek's view of children's work marked an intersection of the arguments of progressive education and the discourse—and look—of progressive professional art practice; as the Bauhaus evoked the values of the childlike, the innocence and the interiority of the child, Child Art drew on the values of modern art, on the demiurgic individual. In 1912, when Alfred Stieglitz mounted one of the earliest exhibitions of children's art in a professional context, between exhibitions of Picasso and African sculpture at 291, Sadakichi Hartmann suggested that the exhibition was "like a commentary on modern art ideas."[30] That is, the exhibition and its reception grew from and pointed toward the ideas and goals of modern art practice. By 1926 Hughes Mearns, the editor of *Progressive Education,* would insist that only the child was a real artist in the terms that modern art offered, and no longer metaphorically: "Adults are in the main wingless; . . . long years of schooling, something has stilled the spirit within or walled it securely. It is to children we must go to see the creative spirit at its best; and only to those children who are in some measure uncoerced."[31] Mearns's child artist makes real work; he or she is a professional, or at least a model and a goal for the modern artist.

Although until these last citations I tied the ideas and exercises of children's classroom reformers to the training of adult artists through the Bauhaus in Germany, they were well understood and in wide circulation in the United States as well. The American Pestalozzian Edward Sheldon, founder of the progressive normal school at Oswego, New York, in the 1860s, preached basic tenets that sound very much like those Itten learned: "Begin with the senses [and] never tell a child what he can discover for himself."[32] Sheldon's institution, now the State University of New York College at Oswego, suggests an important, if pragmatic, link between school art and professional training in the United States. Most American art training from around 1880 through the 1920s was offered as teacher training. "No other work of the art department is more vitally important than the training of competent teachers in art," wrote a commentator on the new Pratt Institute in 1893.[33] Pratt's art training was intended not only for art teachers but also for teachers of young children, as part of an avowedly Froebelian course in kindergarten teaching. "The pupils of the regular kindergarten training course of two years are brought much under the influ-

ence of the art department, that they may drink in as much of the artistic atmosphere as possible."[34]

The most influential American art educator of the first half of the twentieth century was Arthur Wesley Dow. Hired by Pratt in 1895, he published his remarkably successful *Composition* in 1899. Dow defined composition variously as design, "synthesis," and "art structure" and positioned its lessons in opposition to academic teaching, which had been since Leonardo—whom he singled out for criticism by name—an instruction in imitation. Against the copy and the drawing, Dow championed the construction of the work of art, the plotting of the rectangle according to fundamental principles of art structure: opposition, transition, subordination, repetition, symmetry. Dow's principles and the exercises that realized them articulated the relation of form to frame; "painting," he wrote to a student, "is merely the cutting up of space by line, and then adding color. . . . Draw little squares or rather rectangles and sketch into them some scenes."[35] The American modernist Max Weber, who studied in Paris with Matisse but was first a student of Dow's at Pratt, recounted an assignment that imagines the drawn or imitative image as a readymade; the students' creative task was to place that image: to "enclose it in a rectangle, to make a horizontal picture or a vertical, as they chose, and to make whatever changes necessary to fit the drawing to the frame."[36]

Dow's work on the frame ties it to a long project of modernist teaching, to Hans Hofmann's, for example, or to that of the Bauhaus, which insisted with Moholy-Nagy that the "key to our age" was "seeing everything in relationship." Dow's list of fundamentals, moreover, ties *Composition* to a number of other late-nineteenth- and early-twentieth-century teachings, including Itten's introductory course at the Bauhaus, that assume there are "objective principles, forms, or fundamentals of design lying behind all works of art and therefore conceptually—and even historically—prior to any particular stylistic embodiment."[37] The insistence that there are fundamental orders that govern the work of art before its drawing or its subject—and various enumerations of them— had been forwarded from the mid nineteenth century, earliest and most influentially in Charles Blanc's *Grammaires* of the decorative arts and the arts of design, but also in Ruskin's *Elements of Drawing*. Blanc's five "inevitable elements," offered in 1882 as "general laws of ornament"—repetition, alteration, symmetry, progression, and confusion— are quite close to Dow's principles of composition.[38] But Dow and Itten and other twentieth-century authors of primers and foundations and

grammars depart from Blanc's teaching in erasing the difference be-
tween the decorative arts and the representational *arts du dessin,* or in
recasting the hierarchy. Whereas Blanc wrote two different grammars,
Dow offered his *Composition* as the "basis of all work in drawing,
painting, designing and modeling—of home decoration and industrial
arts—of normal courses and of art training for children."[39]

Dow's course was not Itten's; like Cizek's, its terms and examples re-
mained tied to the models of the Arts and Crafts and the Jugendstil. But
it differed from Cizek's course in insisting on the stepped teaching of
principles and in drawing examples from a variety of trained arts. Al-
though works by Dow's students at the Horace Mann School of Co-
lumbia Teachers College hung alongside those of Cizek's Child Art
course at the International Congress for the Advancement of Drawing
and Art Teaching of 1908—and Cizek was reportedly impressed—Dow
said little in his writing about the specifics or the specialness of child-
hood, or the separateness of children's art. His language in *Composi-
tion* and elsewhere, however, makes an important connection between
the fundamentals of art and self-expression. The purpose of art instruc-
tion is "the development of *power,*" a creative or critical force that is
"the natural endowment of every human soul."[40] Dow's power be-
longed to the individual; innate and interior, it was a drive to form quite
distinct from talent or skill and rather like the Bauhaus's *Gestaltung.* (It
is worth recalling that Dow troubled over the word "composition" in
ways that push it close to the Bauhaus ideal: "Design, understood in its
broad sense, is a better word, but popular usage has restricted it to dec-
oration."[41]) In both Dow's course and Cizek's the internal drive
matched the elements and principles of art. Cizek's course may have
been more structured and more fundamental than its initial apologists
suggested; one former student recalled, in precisely modern terms, its
"rigorous and demanding exploration of design elements and princi-
ples."[42] Even if they were not taught, they emerged, intrinsic, like
Dow's power, to both art student and art work: children's work, Cizek
insisted, "contains in itself eternal laws of form."[43]

From the late nineteenth century on, the fundamentals of art, its
"eternal laws," are founded in the individual as he realizes and ex-
presses himself. Composition, the term Dow chose for his lessons,
points toward a long history that conjoins the individual work of art—
the rectangle in specific opposition to the figure—and its maker as a
particular creator. "By the end of the eighteenth century," Albert Boime
argues, "originality in art became identified primarily with composi-

tion," and composition, in turn, "is synonymous with 'sketch,' " with first indications of the overall conception of the work.[44] Indeed, the Ecole des Beaux-Arts established the link between composition and artistic singularity architecturally: where drawing was taught, after Leonardo's famous dictum, "in company," students participating in the academy's *concours de composition,* begun in 1816, were housed enfilade, in a long row of separate cubicles that opened, not onto the world, but onto a corridor—an intimation of the private studio and private vision. While composition was tested, it was not taught; it belonged to, and was the mark of, the individual artist.

Ruskin, who was no academician, also argued for the likeness of representational drawing and the difference of pictorial composition. While he offered rules for pictorial arrangement at the end of *Elements of Drawing,* he insisted, like the academy, that composition was unteachable. It belonged to the individual and to God: "The essence of composition lies precisely in the fact of its being unteachable, in its being the operation of an individual mind." At the same time, because it always operated and confirmed an order, it was, for Ruskin, the evidence "in the arts of mankind, of the Providential government of the world."[45] Composition is at once more and less than drawing; it surrounds academic training and the visual world it represents. Composition, both bound by universal law and bound to the individual, underlies representation, plotting the visual field in each instance for each viewer, and hovers above it, proving the presence of providential government.

For Ruskin and Blanc, the rules of composition were merely conventions, crutches for those who were not inspired, who could therefore be taught. In the twentieth century the rules of composition, no longer simply suggestions, were instead fundamental and necessary, precisely as they were tied to the self, as they marked the individual artist—or marked every individual as an artist—and became the language in which individuality was spoken. "The art of composition is the art of putting ideas into color, mass and line," wrote R. L. Duffus, describing the methods of the Yale School of Fine Arts in the 1920s, in language borrowed from Dow. He continues his definition with an equation: "Composition is merely another name for self-expression."[46] The same conflation appeared in the 1913–14 bulletin of Syracuse's Crouse College of Fine Arts; the faculty of painting, stressing the human figure as the basis of all study, also insisted on composition, "being in reality self-expression." Imitation and drawing made students alike; composition insisted on

their difference and the difference of their objects, a difference tied to the generative moment and to the interior. This discussion of composition and self-expression has taken us too far from the Bauhaus and Gropius's problem with the artist's subjectivity, that problem with the artist that marked the discourse of American art education as well. But the goal of *Composition,* and of Itten's Bauhaus foundation course, was to map and measure the terms of art, to build an objective language of expression in which the individual could speak. In describing the *Vorlehre* in "Theory and Organization," Gropius gave the Bauhaus's preliminary course the same purpose that Dow offered for *Composition,* using similar language: "to release the creative powers of the student, to help him grasp the physical nature of materials and the basic laws of design."[47] Gropius too insisted on the relation between visual form and the interior self: "No longer can anything exist in isolation," he begins, as though critiquing the academy figure isolated on the page. "We perceive every form as the embodiment of an idea, every piece of work as a manifestation of our innermost selves." In transit through the work of art as a structured whole, as a composition, "the laws of the physical world, the intellectual world, and the world of the spirit function and are expressed simultaneously."[48]

"Theory and Organization," the central essay in the Museum of Modern Art's 1938 Bauhaus exhibition catalogue, along with illustrations of work from the preliminary courses at Weimar and Dessau— illustrations that tended to reduce the differences between Itten's "expressionist" course and the constructive courses of Albers and Moholy-Nagy—was a formative statement for the reception of the Bauhaus in America. I now want to trace one strand of the Bauhaus's transformation on these shores, the afterlife of the foundation course, which, as Frederick Logan noted in the 1950s, was the "activity from the Bauhaus best known to America."[49]

Everyone Is Talented

In Ruskin's innocent eye, everyone is born seeing as an artist; in Froebel's kindergarten gifts, everyone is born playing as one. Insisting in bold type in *The New Vision* that "everyone is talented," László Moholy-Nagy rewrote those lessons in the clear language of the Bauhaus. In his rewriting he checks off the themes of this chapter: childhood, vision, language, and everyone. Citing "the work of children and of primitive

peoples" as evidence, he appeals to a physiology that Ruskin only hinted at.

Everyone is equipped by nature to receive and assimilate sensory experiences. Everyone is sensitive to tones and colors, everyone has a sure "touch" and space reactions, and so on. . . . In art education at present we are striving toward those timeless biological fundamentals of expression which are meaningful to everyone. This is the first step to creative production before the meaning of any culture (the values of an historical development) can be introduced. We are not, therefore, immediately interested in the personal quality of expression which is usually called "art," but in its primordial, basic elements, the ABC of expression itself.[50]

In the opening years of this century both Dow and Cizek had insisted that the chief purpose of art teaching was, in Cizek's words, "to educate a generation of the public, which will have acquired artistic tastes and a sense of aesthetics, through work of its own."[51] Moholy-Nagy argued with them, and with many other art educators from the end of the nineteenth century on, that art education's primary target was the nonprofessional, the audience of appreciators and clients. What needs to be taught is not the difference of being an artist but the sameness and the sharedness of seeing and expressing as an artist. It is taught in ABCs, as the language of art.

Moholy-Nagy's *New Vision,* written in 1928, was published in English translation in 1930 and revised in 1938 and 1947. In 1956 a College Art Association survey suggested that its arguments had been taken seriously. Charting "current trends" in art on campus, David Manzella noted a marked expansion in the number of introductory courses in studio art, from fifteen in 1940 to sixty-five, at twenty-nine colleges. "An effective characterization of much of what was new in the approach to work in the studio," he wrote, "can be found in the statistics relating to the introductory course, sometimes called the 'grammar of art' or the 'language of art.' "[52] The titles Manzella singled out as characteristic are familiar: they belong to a line that might run from Blanc to Dow's *Composition* to the Bauhaus. Although they named courses in studio art, they did not name a set of studio skills or techniques; they did not promise training in drawing or painting or sculpture. The skills these courses promised rested elsewhere and earlier: once again, in the eye and in childhood. The explanation Manzella had for the trend in grammars and languages suggests that the lessons of progressive education had been learned. Colleges increasingly understood the need for an art appreciation gained "through direct participation in the creative

process," as well as the importance of providing every student with new opportunities for "personal, unique expression"; these opportunities, he continued, had been available to the child, but "during the process of growing up" had formed "an ever decreasing part of his education."[53] Thus, Manzella noted, the courses were often open to everyone, and offered with the "awareness that [they] might constitute the student's first and only contact with the practice of art while at college."[54]

Despite the growth in numbers, the value of such courses, and of any training in the studio arts in college, was heatedly disputed; Manzella acknowledged voices on both sides, but took up the cause of studio art. Neither recreation nor professional training, these courses were part of a program of general education, aligned with the values of the liberal arts, and often part of the same program. Among the educators he cited was Columbia's Peppino Mangravite, whose remarks begin with a now familiar construction, "the language of visual forms is an aesthetic language," and end by tying that language to the other language of the university and to the project of general education: "Columbia University introduced courses in creative design (the grammar of art) as liberal arts courses. These courses in drawing and painting during the freshman and sophomore years are recognized as liberal arts; as English, History, Social Science, Philosophy, etc."[55]

Mangravite, a well-known artist, was also one of the authors of the College Art Association's 1944 "Statement on the Practice of Art Courses," a paper Manzella cited. Proposing the continuous study of art from elementary school through college, the 1944 report fashions art practice as a practice in vision, and as essential to, and even a model for, general education. "Through analysis and *practice* of the elements that compose a work of art, with emphasis on the structural principles by which the arts are formulated," the student's

> ability to acquire general knowledge through the eye and by practice would be heightened and expanded. In other words, instruction by word would be broadened to include instruction by sight—a broadening which is bound to have its effect not only on the student while in school but afterwards as a fully functioning member of society.[56]

"The aim of this process of education," they concluded, "would be to concentrate on *seeing* and doing as a two-way means of intelligent communication."[57] This argument for experiments in art making is more sober and circumspect than others Manzella offered—personal creativ

ity and self-expression—but its terms are again those of language. It recalls the training and ordering of vision that links the design school and the Pestalozzian classroom. With its appeal to "general knowledge," to full functions and intelligent communication, the report is clearly written for the undergraduate college and against the stereotype of artist and art student. Its coupling of seeing and doing bears the marks of John Dewey's pairings of gerunds, his "learning by doing" and "doing and undergoing." Dewey, who had been Arthur Wesley Dow's colleague at Columbia Teachers College, was among the most frequently cited voices in arguments for art practice in general education. And his writings were acknowledged, as well, in the Bauhaus's educational reforms and foundation teaching: Learning by Doing was the name of Albers's first-semester Compulsory Basic Design Course at Dessau, and he took Dewey's famous title, *Art as Experience,* for an essay he published shortly after arriving in the United States.

The most influential and widely circulated proposal for general education in the American college was the 1945 Harvard Committee report, *General Education in a Free Society,* but in it, as supporters of the visual arts at Harvard would remark a decade later, the visual arts "were conspicuous by their absence."[58] The authors of the report, known as the Redbook, had stated flatly that they did "not believe that training in the technique of the arts should be part of general education."[59] At the same time, the Redbook authors called for precisely what Moholy-Nagy offered: vision. Important for those involved in intradepartmental battles with programs in art history—battles such as those recorded in Manzella's survey—vision was needed as an antidote to too much history:

> The remedy is not more knowledge about the past. That has been piled up as such knowledge never was for any former generation. Its sudden, all but overwhelming, increase is one of our chief difficulties. The humanities. . . . have thereby ceased to be the bond and covenant between men that they once were. Not even the great scholar can any longer see the human story steadily or whole.[60]

The whole was the product of seeing, the province of vision.

Dewey had argued in the thirties that bringing intellectual material to a coherent culmination was precisely an aesthetic process: "No intellectual activity is an integral event (is *an* experience), unless it is rounded out with this quality."[61] Like Gestalt psychology in German cultural circles, Dewey placed vision, as the production of coherence

and closure, at the center of psychic and social experience: in contrast to the flow of everyday material and against its background, "*an* experience" was self-sufficient and individual.[62] Like the segregated whole of Gestalt psychology, it is "integrated within and demarcated in the general stream of experience from other experiences."[63] Within that frame, as though across a tautly constructed pictorial field, "there are no holes, mechanical junctions, and dead centers when we have *an* experience. There are pauses, places of rest, but they punctuate and define the quality of movement. . . . The *form* of the whole is therefore present in every member."[64] Once again, and particularly important for art educators, the work of visual art was understood as a privileged record of, and a necessary training in, seeing whole.

At the same time, and for just that reason, art was neither useless nor otherworldly. Rather Dewey's work of art was both continuous with the everyday world and a necessary organization of it. "The work of art has a unique *quality,* but it is that of clarifying and concentrating meanings contained in scattered and weakened ways in the material of other experiences."[65] What separates a work of art from experience is intensity and intention. The details and the closure of experience are transformed into a work of art when they are "lifted high above the threshold of perception and are made manifest for their own sake"; the work both demonstrates and embodies its coherence.[66] In Dewey's argument the lessons and fundamentals of art are cast as the organizing principles of intellectual endeavor, of the sciences and the professions.[67] Thus the visual artist had important and, more to the point, general, foundational lessons to teach the scholar and the student. "A beholder must *create* his own experience" before the work, Dewey wrote, re-creating the work of art for him- or herself by experiencing and ordering as the artist has done. "The artist," he concludes, "selected, simplified, clarified, abridged and condensed according to his interest. The beholder must go through these operations according to his point of view and interest."[68]

The normality of the artist was a necessary counterpart to the continuity of art and the world. Numerous commentators cited Dewey's insistence on art as a rigorous mode of thought, and the artist as a rigorous thinker, to support the presence of art and the artist in college:

> [T]he idea that the artist does not think as intently and penetratingly as a scientific inquirer is patently absurd. . . . [H]e has to see each particular connection of doing and undergoing in relation to the whole that he desires to produce. To apprehend such relations is to think, and this is one of the most exacting modes of thought.[69]

The crusade to make the practice of art a necessary and organizing part of everyone's experience worked as well—at least in writing—to demystify the artist. The difference or the drive of the artist did not need to be pathology or genius; it could be a career choice. As Dan Flavin would insist in the early 1960s, to become an artist is a "mature decision for intelligent individuals with a prerequisite of sound personally construed education."[70]

Continuing from his postulate that "everyone is talented" and "equipped by nature to receive and assimilate sensory experiences," Moholy-Nagy concluded that "any healthy man can become a musician, painter, sculptor, or architect." The professional artist's difference from a broad and talented public was one of intensity and involvement, the same qualities that raised a work of art above an experience. A professional artist, through "daily work with his material," gained "a superior understanding of his means"; the artist's differences and intensities were those of any other professional.[71] Kandinsky too tied the psychological normalcy of the artist to the question of general education for the art student and of art itself as a mode of general education: he formulated as synonymous the psychological excess of the romantic artist and the overspecialization of an older professional. "Specialist training without a general, human basis ought to be no longer possible," Kandinsky wrote in "Kunstpädagogik," complaining against the same evils as the Harvard Redbook authors.[72] Kandinsky's essay was published in 1927 alongside a description of his course in Analytical Drawing; its goals were precisely those he gave to general education: "training in analytical-synthetic observation, thought, and action."[73] In the image of art as the *Vorkurs*, the ground for a new professional training, "the artist works like every other man, on the basis of his knowledge, and with the aid of his capacity for thought and his intuitive impulse. . . . The artist is indistinguishable from every other creative person. His work is law-governed and purposive."[74]

The artist is like every other man, perhaps, only more so. This version of the artist was the model for the new professional. "*The future needs the whole man,*" wrote Moholy-Nagy.[75] What each individual needs, what society needs, what the future needs, are the objects and the outcome of *Gestaltung*. Indeed, the whole man is one of the definitions of "gestalt"; tracing the history of the word in German thought, Mitchell Ash cites its appearance as the object of Wilhelm Dilthey's historical psychology: "The teleological end of Dilthey's psychology, then, was not a monadic individual but a socially and culturally formed or

organized personality, which he called 'character,' or, in one place, *Gestalt.*[76] Unity, the whole man and the whole society built in his image, was the goal of general education in the United States as well, particularly after World War II. Proponents of general education in the university saw the divisions and isolations enforced by specialization as mirrors of the divisions of society at large in postwar America, the divisions of race, class, ethnicity, and region. In response to those divisions and the lures of specialization, wrote Ernest Ziegfeld in *Art in the College Program of General Education,* general education's task was to develop "the individual's total personality,"[77] to make active thinkers, active family members, active members of culture, active citizens, and thereby to remake a whole society. As an earlier America had been imagined in the Jeffersonian figure of the autonomous and unbound citizen-farmer, in the post–World War II United States a whole society was imagined in the figure of the citizen-professional, balanced, educated, whole, and rounded—and, like the citizen-farmer, outside and above the divisions of the factory wage system.[78] The new professional and the coherent society fashioned in his image, a society without hidden corners or separate, private motivations—without an unconscious, perhaps—would find its artistic language in the language of vision and in the modern work of art.[79]

What He Can Discover for Himself

A good deal of simple pragmatism may have led to offering languages and grammars of art as general education; those offerings answered serious questions about the status and economic standing of art practice in the university. They insisted that undergraduate training in the arts had a place on campus, that it deserved funding, that it could put any student at an easel and provide each with something more than atmosphere or recreation. The arguments posed for such a course insisted, as well, on the employability and the professional responsibility of artists as teachers and colleagues, as equals in the university, in meetings and on committees. They asserted, moreover, that art, at least in its fundamentals, in precisely the basic theories that general education courses were intended to address, was demonstrable and teachable.

Art as a language was neither pure inspiration nor unbridled expressionism, nor was it pure technique; neither unteachable nor protracted and manual, it could be taught within the academic calendar, along with other studies. The Bauhaus preliminary course filled a demand

that had already been voiced for speeding and rationalizing the teaching of art to artists in college. Moreover, art as a language could be taught as a studio practice, as at least one supporter commented, even to those who could not draw a straight line. It obviated the question of straight lines, or rather of representational drawing, by making drawing a métier and by placing its practice, not at the beginning and at the center of training, but in a class with its name. Studio art could be general education only if it was available to everyone regardless of dexterity, if everyone could demonstrate its laws, and if, finally, everyone is talented.

"Make a drawing in which solid forms, rectangular and curvilinear, move against each other and establish a pressure relationship."[80] "Take a series of fixed points in space and align an intensive series of point thrusts to each."[81] Assignments that allow students to discover for themselves the order of vision, the forces and relations of two-dimensional design and three-dimensional space, and the properties of materials—at least of paint, perhaps of paper and clay—mark the presence and the difference of Bauhaus education in the United States, its difference from the sameness and repetition of the academy and its resemblance to the goals of the modern research university. Bauhaus research and development began in individual and different demonstrations of the principles and problems that structured the work of art, a discovery on one's own that insisted on those principles as critical and integral to the self. Each formal discovery was a self-discovery; this is why modernism can be, or rather has been, simultaneously formalist and expressionist: formal innovation is a discovering and an instantiation of the self.[82]

Certainly, this double discovery is critical to design education and the idea of art as problem solving. It is built into the very format of the design problem: spoken or written "experiments" or "creative problems" intended to elicit a visual answer, a work that is both an image and a demonstration. "While the problems can be verbalized and communicated," writes the author of *Visual Design: A Problem-Solving Approach,* "the perceptual awareness and sensibility to visual relations that result must be developed within the individual."[83] Not *by* but *within* the individual, precisely in the translation, in the difference between the verbal assignment and the visual answer. Johannes Itten's program for the Bauhaus's first basic course performed this conflation of form and self, of laws and discovery: "Finding and enumerating the various possibilities of contrast was always one of the most exciting lessons because the students realized that a whole new world was opening

up for them. . . . All these had to be worked out singly and in combina-
tions."[84] Working through Itten's oppositions, each student finds a new
world, but it is a world precisely because it has already been founded
and principled.

In a letter to a university committee on general education reprinted
in the *College Art Journal,* Thomas Folds of Northwestern argued for
the inclusion of a course in studio art in Northwestern's program in
general education. "No previous training or special 'talent' is required
of students. . . . [E]ven students who cannot draw well in the orthodox
art school academic manner can still do excellent work in the course."[85]
The fundamental principle, the illustrative problem, and the student so-
lution provided the format of Northwestern's Art A20; thus, Folds
noted, the course was classified as a laboratory, a classification that re-
calls the arguments of the Committee on the Visual Arts at Harvard
and the kinship of the artist and the scientist against the speech of the
university. "In both art and science the instructor establishes a series of
given factors and a goal," he explained to the committee, but there is an
important difference. "Whatever 'discoveries' the student makes in a
science laboratory at the introductory level are already known in ad-
vance to the instructor."[86] But, Folds continued, in an art class,

> the main purpose of applying controls in a problem . . . is to bring out as
> much as possible the *individuality* of different solutions. This means that al-
> though the instructor in a studio class may know in a general way what to
> expect from his students, he is also in for a number of surprises, because the
> solutions to the class problems will contain not only revelations of individ-
> ual aptitudes but also demonstrations by the students of genuine *discoveries*
> they have made.[87]

The language of vision, its order and demonstration, makes possible
and founds the work of art, but the work of art as "genuine discovery"
is precisely what escapes.

Moholy-Nagy has already introduced this formulation; it is written
in the difference between "those timeless biological fundamentals of ex-
pression," on the one side, and the "values of an historical develop-
ment" and the "personal quality of expression which is usually called
'art,' " on the other. The differences of art and the artist are both per-
sonal and historical; that is their excess, the field of their individuality—
a field we might label the art world. Folds's Art A20 instructors know
that; his text continues: "Much of the subsequent class discussion,
therefore, centers on a comparative analysis of various solutions, on
questions as to their validity, and on relationships between what has

happened in the studio and what has happened in the world of art out-side."[88] Genuine discoveries need to be different from the assignment, different from what the instructor expects in advance and what he has seen before or around him, and yet like something in the art world.

In textbooks whose titles are marked by vision—*Visual Design; Form, Space, and Vision; Vision in Motion; The Language of Vision*—the work of modern artists and designers, from Cézanne and Picasso to Herbert Bayer, Moholy-Nagy, and Kepes, appears with works by older masters, Turner or Tintoretto, or the anonymous artist of a German woodcut or a Russian icon. Alongside them are photographs and pho-tograms from nature, taken under the microscope or in X ray. These images form a heterogeneous collection, and their assembly together was once new, even if it is quite familiar to us now. Their links, connec-tions, permanent truths, and enacted Platonisms were beyond the purview of the academy, which had, after all, only to explain the classi-cal tradition, and not yet "the windows at Chartres, Mexican sculpture, a Persian bowl, Chinese carpets, Giotto's frescoes at Padua," along with "the masterpieces of Poussin, Piero della Francesca, and Cézanne."[89] This list could be the list of illustrations for a course in vi-sual design; indeed a similar list of objects is illustrated in Dow's 1899 *Composition*. It comes, however, from Clive Bell's *Art* and from the question that he poses to summon the answer "significant form," the form promised by the innocent eye.

Every work of art employed to illustrate a principle becomes the so-lution to a problem, a demonstration of its workings. Dow himself promised this recasting of works of art as design problem illustrations as early as 1924: "Historic styles will now serve as examples of har-mony, and not mere models."[90] They will serve, that is, as prototypes, rather than paragons, as demonstrable instances of the principles of art structure or composition. A 1960s rewrite of the lessons of Dow's *Composition*, entitled *Notan: The Light-Dark Principle of Design*, ex-emplifies this new history of art as example; its authors promise "many illustrations of the principles of Notan," a Japanese word Dow had introduced to designate the massed areas and sharp contrasts of light and dark he preferred to academic chiaroscuro, "among them im-ages as diverse as a sculpture by David Smith, a Samoan tapa cloth, a Museum of Modern Art shopping bag, New England gravestone rub-bings, Japanese wrapping paper, a painting by Robert Motherwell, a psychedelic poster and a carved and dyed Nigerian calabash."[91] Moth-erwell and Smith and all the others are made equivalent as they are

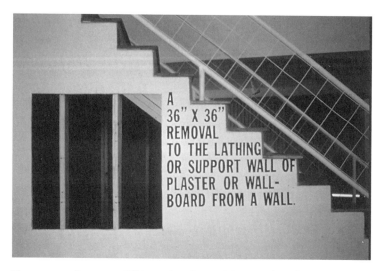

Figure 10. Lawrence Weiner, *A 36" × 36" Removal to the Lathing or
Support Wall of Plaster or Wallboard from a Wall*, 1968. Pictured as
installed in *The Presence of Absence*, 1989–90. The Seth Siegelaub
Collection and Archives © 1998 Lawrence Weiner/Artists Rights Society
(ARS), New York.

made illustrations of principles, provisional and merely individual an-
swers to a design problem.

There is one further inclusion to the list of illustrations and equiva-
lents, student work. The work of workshop students is reproduced
prominently in most postwar art fundamentals and design texts, and in
Moholy-Nagy and Itten as well. The principles of line, direction, force,
tension, opposition, spacing, and the massing of light and dark not only
join Motherwell and Smith, and Giotto and Picasso, but also link the
student to that chain of artists: they all speak the same language. More-
over, student work in reproduction embodies the promise of the assign-
ment as the possibility for making work, or rather for making art, a
guarantee similar to that offered by Northwestern's Thomas Folds. Ed-
ucation in the language of art lies some distance from the *bottega;*
rather than a master's work to copy from, the student is offered a fellow
student's work—not to copy, but to strike a difference from. The in-
structor presents the design problem in writing in a text, or in spoken
form; the student determines the particular appearance of the result.
The textbook's illustrations and the professor's examples—works of
nature or of art history or works by students—provide both a demon-

strable solution and the implicit demand to solve the problem differently, with a difference that can be measured and recuperated in the world of art.

Student work from the outset, precisely as it embodies and demonstrates the basic and primordial laws of art, is art. This is the project of modernist teaching as a mode of general education that has "everyone" as its subject. Yet it is Art, a genuine discovery, and the student is an artist, only through excess and difference; that difference becomes the object of the graduate programs in studio art that emerge with remarkable rapidity in the 1950s and 1960s. In the chapter that follows I trace the internalization of formal difference, its transformation into a difference at once deeply psychological and aggressively professional: what defines an artist at a certain moment is a real difference constructed in relation to, and demarcated within, a disciplinary field.

In this and the preceding chapter I have insisted on a language of vision, and on the link between that language and the rectilinear grid. According to Rosalind Krauss, the grid figures, not a link, but the absolute separateness of visual art and language: "The grid announces . . . modern art's will to silence, its hostility to literature, to narrative, to discourse."[92] Clearly, Krauss's language—linear, discursive, writerly—is different from the language of vision. In school and in this chapter, the separateness she describes is reinforced by the myriad references to vision as a language prior to any written one, and by the spoken assignment that wants to see something different. In Chapter 7 the written or spoken language that has set the work in motion as though in flight from it, the language of the assignment and the explanation, will catch up (Figure 10). It will always already know the work.

SUBJECTS OF THE ARTIST

5

According to legend, the first of Douglas MacAgy's acts as the new director of the California School of Fine Arts in 1945 was to cover over Diego Rivera's mural *The Making of a Fresco Showing the Building of a City*. Painted for the California school in 1931 and covered, at least intermittently, with a false wall beginning in 1947, it portrayed the artist and his assistants on a scaffold, their backs to viewers, at work on a mural of a towering factory worker (see Figure 1). Both the muralists and the looming worker they paint are surrounded by the builders of a modern industrial society: planners and developers, architects and drafters, steelworkers and machinists, all rendered in the same scale as the working painters. Rivera's equation of art work with industrial and intellectual labor—his insistence on making the art worker part of the field of constructive labor—seems clear. It was clear to the painter Hassel Smith, who studied at the school in the 1930s and taught there in the 1940s, that something significant was at issue not only in Rivera's conception but in its covering over, whether by MacAgy or his successor, the Bauhäusler Ernest Mundt. In an interview that may be the source for the legend of MacAgy's precipitousness, Smith recalled that the mural had "Rivera's big fat bottom hanging out over the scaffolding and it's really not too edifying so one of the first things MacAgy did was to put a false ceiling in the gallery which effectively blocked out Rivera. I guess there was something symbolic about it. That sort of rang down the curtain on some earlier periods."[1] A text by Ad Reinhardt, whom

MacAgy brought to the school as a visiting artist in the summer of
1950, sketches those earlier periods and provides a tendentious guide to
what was symbolized in their displacement.

Reinhardt wrote on the issue of "public and publicized artist im-
ages"; Rivera's mural was an image of the artist, a portrait, albeit of his
backside. Artists, or their recent images, Reinhardt explained in the
College Art Journal in 1953, fit certain general types: "It's important to
pin down these characters because of the pressure everywhere to con-
form to these standard portraits."[2] The image of Rivera in *The Making
of a Fresco* was an artistic possibility "still left over from the thirties":
the "honest artist-worker and atomic age reporter."[3] By 1953 Rein-
hardt had a category, or rather a caricature, for an artist like Hassel
Smith, as well: "a contribution of the forties": the "café-and-club prim-
itive and neo-Zen bohemian, the Vogue magazine cold-water-flat fauve
and Harpers Bazaar bum, the Eighth Street existentialist and East-
hampton aesthete."[4] This is Reinhardt's version of the public abstract
expressionist as "romantic ham," exemplified by Mark Rothko and
Clyfford Still, both of whom MacAgy hired to teach with Smith in San
Francisco.

But the New York school painter need not be uneducated; he can be
philosophically and psychologically literate, an existentialist, perhaps,
or a "Kootzenjammer Kid Jungian"; for this artist there is yet another
category. A product of the early fifties, this final and "latest up-to-date
popular image" is "the artist-professor and traveling design salesman,
the *Art Digest* philosopher-poet and Bauhaus exerciser, the avant-garde
huckster-handicraftsman and educational shopkeeper, the holy-roller
explainer-entertainer-in-residence."[5] In his final category, artist-professor,
Reinhardt conflates the Bauhaus designer and the "philosopher-poet."
His list of examples includes not only Josef Albers and Robert Jay
Wolff of Moholy-Nagy's New Bauhaus (and Reinhardt's chair in the art
department at Brooklyn College), but also Robert Motherwell and Bar-
nett Newman. In the preceding chapter I traced the impact of the
Bauhaus and design in America; in this chapter I focus on the artist as
liberal artist, and the claims of that category to an "up-to-date" fifties
vision of the professional man. MacAgy's covering of Rivera's mural re-
sembles other Cold War era rejections of the activist artist of the 1930s
and of art in service of cause or future. Here, with Reinhardt's help,
I want it to measure the proximity of a revised romantic artist and a
college-educated one.

Perhaps the best place to begin is on campus, with a letter Mark Rothko wrote from the University of Colorado at Boulder, where he had been hired as a visiting artist in the summer of 1955, to the sculptor Herbert Ferber:

> The University . . . is on the hill. At its base are the faculty apartments which are shells around appliances facing a court into which the children are emptied. Two hundred yards away is Vetsville, in which the present faculty itself had lived only four or five years ago when they were preparing to be faculty. Vetsville itself is occupied by graduates from army headquarters, already married and breeding who will be faculty in faculty quarters three or four years hence. They breed furiously guaranteeing the expansion which will perpetuate the process into the future. . . .
>
> Here is a self-perpetuating peonage, schooled in mass communal living, which will become a formidable sixth estate within a decade. It will have a cast of features, a shape of head, and a dialect as yet unknown, and will propagate a culture so distorted and removed from its origins, that its image is unpredictable.[6]

How did Rothko—the New York school—come to be in Boulder? And now, four decades later, what image has the university and its replications and packagings of culture-at-a-distance produced? At Boulder, Rothko complained to Ferber, the students "want me to teach them how to paint abstract expressionism."[7]

Despite Rothko's palpable alienation and the lonely distance between Boulder and New York inscribed in the letter, Rothko was far from alone on the campus in 1955. A decade after Pollock "broke the ice," William Baziotes and Robert Motherwell were on the faculty at Hunter College, James Brooks was a visiting critic at Yale, Adolph Gottlieb and Franz Kline had taught sessions at Pratt, Kline and de Kooning at Black Mountain, and Gottlieb at UCLA. Reinhardt was teaching at Brooklyn College; Rothko had already done a hitch at Brooklyn, and in 1957 he would be a visiting faculty member at Sophie Newcomb College of Tulane University. Bradley Walker Tomlin, Clyfford Still, and Philip Guston were university teachers even before the icebreaking. Tomlin taught at Sarah Lawrence from the early thirties to his death in 1953. Still taught at Washington State University in the mid thirties and at what is now Virginia Commonwealth University in the early forties; in the early fifties he would teach in New York at both Hunter and Brooklyn. Guston was a well-known and influential teacher throughout the forties, first at the University of Iowa and then at Washington University in Saint Louis.

Whatever distaste one might read in Rothko's complaint that his students wanted him to teach them to paint abstract expressionism, they learned rapidly, and they too were far from alone. In the closing paragraphs of his 1955 Princeton dissertation, "Abstract Expressionist Painting in America," William Seitz proclaimed that "little painting remains which is 'modern' and not in some way affected by 'Abstract Expressionist' characteristics," drawing his proof from the exhibitions mounted by a New York gallery devoted solely to the work from college and university art departments.[8] "A valuable service has been performed by Robert D. Kaufmann, at his New York Forum Gallery, in exhibiting student work from college and university art departments of the Far West, Midwest, South, and East. Approximately 80 percent of the work shown so far, he estimates, is Abstract Expressionist in character."[9] Reviewing Forum's 1954 exhibition of student art from the University of California at Berkeley, Hilton Kramer credited the artists with "a very professional look" and "a knowledgeability of current abstract idioms which is breath-taking."[10] Student artists represented in the Forum's other group shows in 1954 and 1955 received similar grades. The *Art Digest*'s reviewers stressed the spread of abstraction and the canniness of the young artists' professional knowledge: "a sophisticated exhibition" from Hunter College "indicates a familiarity with and an understanding of current abstract idioms";[11] more surprising, the exhibition of student artists from Mississippi offered "interesting indications in the spread of non-representational expressionism; most of the pieces are abstract, with some excellent examples."[12] Even before Rothko's arrival, the students of the University of Colorado— Forum's debut exhibition in October 1954—had exhibited "an awareness of contemporary art forms that places them in the vortex of advanced abstract painting."[13]

Abstract expressionism's emergence as a public movement through the 1950s coincides with the remarkable physical and demographic expansion of the university that Rothko noted so dyspeptically, an expansion spurred by G.I. Bill students whose college and art school costs were paid for by the government. The G.I. Bill funneled money into educational settings, accompanied by the demand that they professionalize and accredit themselves and credential their graduates. In art schools and departments filled with nondegree students and adjunct faculty, the call to professionalize was heard in relation to earlier attempts to formalize the teaching of art, and to masculinize its academic image and its student body. The average age of G.I. Bill returnees was

twenty-five, and 90 percent of the student veterans were men. The gen-
der of the veterans coupled with the career demands that they—or their
age and gender—were seen to embody insisted, along with the federal
government, on the streamlining of art teaching and a professionaliza-
tion of its goals. Hassel Smith recalled the difference of the late forties
at the California School of Fine Arts with just this conflation of mas-
culinity and professionalism: "The GI's were the big thing. They were
working artists. To a large extent when I was a student at the school, it
was a debutant kind of place. It was just crawling with socialites. Of
course, the GI Bill was a godsend to institutions of that sort."[14] It was
also a godsend to their competition, the college and university art de-
partments that through the 1950s encroached on the art school's terri-
tory.

In 1957, two years after Rothko's stint at Boulder and the year the
Metropolitan Museum of Art acquired Pollock's *Autumn Rhythm*—an
acquisition that signals a breakthrough, one of "the first signs of Ab-
stract Expressionist market success"[15]—the College Art Association,
noting twenty-three different projects, announced that "the most signif-
icant college art news of 1957 is to be found in the large number of art
buildings currently in construction or on drawing boards."[16] At the
same time the G.I. Bill and its provisions pushed independent art
schools into academic admission requirements, humanities courses,
core requirements, and degrees. "It is not whimsy but metamorphosis
that has been operating to produce such new titles as *Philadelphia Mu-
seum College of Art, College of the San Francisco Art Institute, Cali-
fornia College of Arts and Crafts,*" wrote Norman Rice of the National
Association of Schools of Design; "the pressures on the independent
schools have made them all conscious of the competition of the col-
leges."[17] Pointing to the same sprawl that Rothko saw from his hillside,
Rice noted that "the substantial reasons for this transformation are not
hard to find: after the war and during the flood of subsidized students,
'being on a list' was a passport to G.I. Bill participation and, hence,
survival. The lists were lists of schools the Office of Education had
heard about; and its sources were the accrediting agencies, state, re-
gional, and professional."[18] Rice's own organization, founded in 1948
to improve "educational practices and raise professional standards in
design," was one of the responses to the G.I. Bill's call and the colleges'
threat.[19]

The formalization of art training and the prospect of professional-
ism in the university represented by students returning on the G.I. Bill

combined with the critical visibility of an emergent abstract expressionism to integrate the university with an enlarged professional art world in New York. The contemporary art world discussed in an increasingly gallery-focused art press, shaped the issues of the discipline and offered professional models to growing numbers of students and faculty. An examination of the development of the art departments at the Universities of Iowa and Indiana in the postwar years notes as "characteristic of veterans . . . their admiration for teachers whose work they had seen in exhibitions and magazines and whose articles and books they had read."[20] Accompanied by artist statements, new critical writing, and, often, the presence of visiting artists, abstract expressionism was more than just one of an eclectic set of possible choices of style and subject for those who would be artists. Rather it provided a national image of what art looked like and dealt with, and what artists did. Writing in the early 1960s of the recent transformations in art education, the artist and Rutgers professor Allan Kaprow praised Hans Hofmann's school for "its historicity, its systematic discipline, its awareness of and insistence on modern art, its professionalism." But the key to Hofmann's teaching that Kaprow singled out was "not so much 'modernity' . . . but *a sense of the issues at stake* which 'modernity' provokes."[21] Abstract expressionism in the university— often taught by Hofmann school students—provided a professional charge, an arena within which the young artist had to act in order that his work could be seen as serious.

As the presence of the art world in the university, abstract expressionism served both to cement and to streamline the career path for artists, the single one that exists today: a B.F.A., or less frequently a B.A., from a university art department or degree-granting art school, followed by an M.F.A., involvement with art in New York, the "national recognition" called for in most CAA studio job listings, and a teaching job in the university, or, for some, a studio in New York or Los Angeles or Chicago. The irony in this outcome is sounded in the first article the art historian Stanley Meltzoff published after being discharged in 1946. Noting that the sculptor David Smith had dropped out of both Ohio State and Notre Dame, he surmised that Smith had been "unaware of the methods of becoming an artist."[22] Meltzoff's words fit the majority of the artists of the New York school; this chapter posits that the problem of becoming an artist—an educational problem at once intensely psychological and absolutely professional—is the subject matter of abstract expressionism.

Curriculum Vitae

The claim that abstract expressionism has a subject matter has been built more than once (most often against Clement Greenberg's formalism) on the name of a failed art school founded in New York in 1948 by William Baziotes, David Hare, Robert Motherwell, and Mark Rothko: Subjects of the Artist. Indeed, the name was fashioned, according to the painter Robert Goodnough, "to emphasize that abstract art, too, had a subject."[23] Clyfford Still participated in the school's earliest planning, as did Douglas MacAgy, the director of the California School of Fine Arts, where Still taught and Rothko was a visiting lecturer in the summer of 1947. Barnett Newman, who named the school, was added to the list of teachers in its second term in January 1949. The first advertisement for Subjects of the Artist appeared, along with ads for seventy-one other art schools, in the education pages of the *Art Digest* of September 15, 1948, the same issue and page, as it happens, that had announced the formation of the National Association of Schools of Design. Tucked between an advertisement for "The Workshop School," which promised, "not theoretical instruction, but really practical training and experience," and one for the Ozenfant School, "the leading school of modern art," the Subjects of the Artist ad listed the surnames Baziotes, Motherwell, Hare, and Rothko and promised, as an advertisement should, "A New Kind of Art School." Located at 35 East Eighth Street in New York, the school ran for three ten-week terms before closing in May 1949 and had about seventeen regular students.

Ozenfant's ad and the even larger advertisement for the well-known Hans Hofmann School of Fine Art across the page raises the questions, what was new in Subjects of the Artist, what was promised in a "new kind of art school"? The styles of modern art had been part of the curriculum for art historians and studio students in art schools and college departments for some time. In 1928 R. L. Duffus reported for the Carnegie Foundation that in Seattle at the University of Washington—across the state from Spokane University, where Clyfford Still, at the same moment, was studying for his bachelor's degree in public school art—a visitor could find "the modern atmosphere and the modern method."

The absence of tradition makes it easy for an instructor to be as modernistic as he likes, just as it makes it easy for all of Seattle to have electric lights when certain portions of New York City get along with gas. For instance, a class in design is taught by the use of abstract forms—cubes, cones, cylinders, prisms, planes. It produces, with immense enthusiasm, drawings which

would have been quite at home in almost any modernistic gallery during the cubistic furor of some years ago.[24]

Until just the last phrase, the Washington student was up-to-date, caught up with New York—to paraphrase one of Clement Greenberg's accounts of the birth of abstract expressionism, and of New York's relation to Paris—as New York had not yet caught up with itself.

The look of art schools in the 1930s and up to World War II was relatively modern and up-to-date; in most places by the mid 1930s it was quite consciously antiacademic. Most programs would feature at least some version of Cézannism alongside or combined with regional realism, which, although it retreated from modernist abstraction, was more contemporary, more in tune with painting nationally, for doing so. Hassel Smith recalled the pervasive influence of Diego Rivera and José Orozco on students in the late 1930s, and the sculptor Seymour Locks, who studied at San Jose State College in the mid 1930s and then at Stanford about the same time as Robert Motherwell, remembered the choices in northern California in the thirties and early forties as "either a kind of watered-down social realism or this kind of effete French school through Cézanne."[25] Locks's Cézanne—like the Cézanne of most college departments from the late twenties on—was not Moholy-Nagy's constructor or Nikolaus Pevsner's pioneer of modern design but the Cézanne of the modern studio problem: the re-creation of three-dimensional space "architecturally, plastically, in relation to the picture plane."[26] This Cézanne was passed through departments in books by Albert Barnes and Sheldon Cheney.[27] In northern California, it was elaborated and combined with Matisse's color and Kandinsky's writings through Hans Hofmann's influential teaching at the University of California at Berkeley in 1930 and 1931, and through his followers there. Locks mentions UC Berkeley's Erle Loran, whose words I have chosen to describe Cézanne's studio problem; he could have added Glenn Wessels of the California College of Arts and Crafts, and Worth Ryder, chair of Berkeley's studio art department, both students at Hofmann's school in Munich in the 1920s and both instrumental in bringing Hofmann to the United States.[28]

After 1933, when Hofmann established his own school in New York, one could learn the pictorial lessons of European modernism from the master himself. By the end of the thirties the Bauhaus too had made its presence felt in the United States: Albers had been at Black Mountain since 1933; Moholy-Nagy founded his New Bauhaus in

Chicago in 1939, and in 1940 he and other members of the New Bauhaus faculty, including Gyorgy Kepes and Robert Jay Wolff, taught the summer session at Oakland's Mills College.[29] Brooklyn College's Bauhaus-influenced department of design was established in 1942 by the architect and designer Serge Chermayeff, and led for many years by Robert Jay Wolff after his departure from the New Bauhaus in 1946. It would employ Reinhardt for twenty years, beginning in 1947, and Rothko and Still for much shorter and more difficult periods in the early 1950s.

Perhaps Subjects of the Artist differed, not in style, but in its founders' own educations, marked at once by a peculiar modernity and a familiar old-fashioned romanticism. An odd group of artists to decide to teach, or to elect to study with, the founders of Subjects of the Artist, like David Smith, were "unaware of the methods of becoming an artist." And unlike Hans Hofmann, whose school is never absent from discussions of the success of American painting after World War II, none of these founding artists had trained in the atelier of a European master, much less run one, as Hofmann had in Munich in the 1920s. Not only did they lack Hofmann's extensive organized training, but in public statements and comments to their students they also denied its value. About a year before Subjects opened, Rothko, quoted in an article by Oscar Collier, insisted that he was a self-taught artist, that he had "learned painting from his contemporaries in their studios."[30] Rothko was exaggerating—he was not entirely self-taught—but his organized, institution-based training amounted to eight months at the Art Students League between 1924 and 1926: two months studying anatomy with George Bridgeman, the remaining six painting the still life with Max Weber. His two years as a liberal arts student at Yale in the early 1920s included neither studio art nor art history. Hired by Brooklyn College in 1951 after the demise of Subjects of the Artist, Rothko returned to the Art Students League for one more week, taking Will Barnet's printmaking class in order to teach the Graphic Workshop he had been assigned at Brooklyn.[31]

This last story is telling; it speaks of Rothko's lack of the professional knowledge expected of a certain kind of artist, and like Rothko's own declaration that he was self-taught, it models an image of a different artist. A number of other anecdotes and remembrances repeat its lessons. Sally Avery recalled as significant, descriptive of his difference, that Rothko read incessantly and spoke of getting a Ph.D.; the painter Ben-Zion remarked that he liked to work "like a professor."[32] Stanley

Kunitz's recollection that Rothko was "clumsy," that "his hands were not an artist's hands,"[33] separates him clearly, and indeed harshly, from the manual skills and craft techniques of the workshop and the art school to fashion him even more an artist. At Brooklyn, Rothko himself consciously constructed his difference from what he described for his students as the scientism and utilitarianism of Bauhaus teaching: "It is only by the circumvention of the real intent of the Bauhaus ideology of the courses in Basic Design, Drawing, Color 1 & 2 that I have been able to lay before my students what I really felt had to be said."[34]

Rothko's dismissal from Brooklyn College in 1954 restaged the Bauhaus's own battle between artistic subjectivity and aesthetic functionalism, between Itten and Gropius, not only in the name of the individual artist—"I was not brought into the department because I am primarily a teacher or an advertising man or a textile man. I was asked to join the department because I am Mark Rothko and the lifelong integrity and intensity which my work represents"[35]—but also on behalf of the goals of a liberal education. In one of the drafts of a 1954 letter to the dean protesting the design department's vote not to renew his contract, Rothko insisted that "the philosophy of the Bauhaus . . . [is] invalid to the proper ideas of the liberal arts."[36] Rothko's claim to have been self-taught and his expressed support of the liberal arts link the romantic and the liberal artist and separate both from the trained professional artist.

Education is important because it prepares artists and provides them with the skills and languages of art, but more than that it profiles and positions artists for themselves and others. Robert Motherwell's training as a liberal artist can be drawn even more clearly than Rothko's. His art school instruction amounted to parts of years at Otis Art Institute in 1926, at age eleven, and at the California School of Fine Arts in 1932, where Motherwell encountered the Cézannism Seymour Locks described. As an undergraduate in Stanford's art department in the early thirties, Motherwell "was told by one instructor that his work was 'too blunt and coarse,' " the art historian H. H. Arnason recounts. "Nevertheless, he is grateful to that same instructor for advising him to read Proust."[37] Motherwell graduated from Stanford in philosophy and pursued a graduate degree in philosophy at Harvard before leaving to study art history at Columbia with Meyer Schapiro. Like Rothko, Motherwell became a regular art student only as a teacher; he "began finally to paint daily with absolute regularity" after a family friend had helped him secure a one-year teaching position at the University of Oregon in 1939. His teaching load reflects the up-to-dateness of the studio

art program in the university as well as its credit-hour and disciplinary divisions and discursivity. It included a lecture course on modern art, a seminar in aesthetics for architecture students, and a drawing class.[38] In 1940, at the urging of Meyer Schapiro, Motherwell became a private student, studying etching in the studio of the surrealist Kurt Seligmann.

Looking back from the 1960s at Motherwell's early work, Arnason remarked that the artist's "college experience would seem to have been a series of false starts not particularly designed to further his career as an artist."[39] Arnason's comment on the would-be artist's false starts recalls David Smith's not knowing how; it also recalls the novel the Germans named the bildungsroman. Emerging at the end of the eighteenth century with the passing away of the apprenticeship system and its clear path from youth to adulthood, the bildungsroman told the story of education by trial and error—in Hegel's words, "the education of the individual at the hands of the given reality," where each individual fashions and is fashioned by his wrong turns and false starts.[40] Motherwell's story, like that of Goethe's Wilhelm Meister—like that of all bildungsroman heroes—turns out all right. The lessons the artist learned as though accidentally, his introduction to Proust by the teacher who dismissed him, for example, were just those he required to become an artist, albeit a new and different kind of artist.

> The last fifteen years in American art have been marked not only by the emergence of the most significant and original painting and sculpture in the history of the country, but also by the emergence of the artist as a chief critic and historian of the art which he himself is producing.
>
> The outstanding instance of this new American artist-critic-historian is unquestionably Robert Motherwell.[41]

Arnason proposes Motherwell as a model for a new artist, perhaps the kind who would teach in a new kind of art school. Curiously, his hyphenated list of occupations paraphrases Ad Reinhardt's description of the artist of the fifties, and of Motherwell: "the artist-professor . . . the *Art Digest* philosopher-poet . . . the holy-roller explainer-entertainer-in-residence."

Like Motherwell and Rothko, the sculptor David Hare, the third teacher listed in the *Art Digest* ad for Subjects of the Artist, had attended college in pursuit of a career other than art. A premed, Hare majored in chemistry at Bard, and worked as a commercial photographer after graduation, photographing surgical operations and making portraits of the Pueblo Indians for the American Museum of Natural History. He had no formal training as a sculptor, and his first exhibited

works, in 1939, were photographs; Hare began to exhibit sculpture only in 1944, in a solo exhibition at Art of This Century. William Baziotes, the last of Subjects of the Artist's first-term teachers, in contrast to his fellow faculty members, had a traditional and formal art education. He attended the venerable National Academy of Design from 1933 to 1936, where he studied anatomy and drew after casts, after the masters, and after the model. Yet Baziotes's academic training, for all its familiarity, can be read in relation to that of other artists of the New York school as simply another way, another instance of the heterogeneous formation of the artist, another example of not knowing how to go about becoming an artist.

The names of two other well-known artists associated with the school did not appear in its initial announcement: Clyfford Still, who had proposed the idea but had withdrawn before the school opened to return to teaching at the California School of Fine Arts, and Barnett Newman, who coined the name Subjects of the Artist before joining the school as a teacher. Clyfford Still's educational passage sounds familiar, more like Baziotes's story than like Motherwell's or Rothko's or Hare's. At least it seems so now. Still received a B.A. in art from Spokane University in 1933 and an M.A. from the Washington State University at Pullman in 1935. Still's path at the time he took it, however, was hardly common; it was, if anything, prophetic: in 1936, the year after Still received his M.A., only 18 of the 483 art schools, college departments, and independent studios listed in *American Art Annual* offered any graduate degree in art or art education.[42] Moreover, Still's education was not yet fully contemporary; his undergraduate degree was in public school art, and his graduate degree was an M.A. in art rather than the Master of Fine Arts that Washington State began to offer relatively early on, in 1941.

The official biography composed for Still's 1979 retrospective at the Metropolitan Museum of Art dismisses Still's M.A. as an accidental perk of the time he spent at Pullman, first as a student and then as a teacher: "A master's degree in 1935 was a required concomitant of the hours spent in school: he did not work for the degree. His presence there was based on the fact that the school provided him the means and time to continue his personal work in art."[43] This account was written by Patricia Still, perhaps with her husband's collaboration and certainly with his approval.[44] As an account of Still's discomfort not only with his degree, but also with having been schooled in art at all, it might stand as evidence of the relative newness of the graduate degree in art

practice, and even of the presence of professional art practice in the university. A review in 1957 of the work of another member of the first generation of the New York school, Bradley Walker Tomlin, offers another example of the strangeness of the college-trained artist and the professional pitfalls of such training. After receiving his bachelor's degree in painting from Syracuse University in 1921, Tomlin studied at the Académie Colarossi and the Académie de la Grande Chaumière in Paris. Ignoring his French sojourn and his academic training, the note begins by asserting that Tomlin "is particularly interesting because he learned how to paint in a university. . . . [where he] specialized in painting rather than an academic subject."[45] The reviewer distinguishes Tomlin as both a college-educated artist and a different version of such an artist, but this piece of biography determines his verdict on Tomlin, who suffers the taint of academe or, more correctly, of the collegiate. This, perhaps, is what Patricia Still was attempting to avoid. "Tomlin," the posthumous piece concludes, "was basically too restrained and too much of an intellectual to be a truly great painter."[46]

Despite his wife's assertion that he did not work for the degree, Still did produce a master's thesis, which, ironically but by now also expectedly, is marked by a distrust for the artist as an educational product. For all his own schooling and teaching, Still's thesis, "Cézanne: A Study in Evaluation," lauded the French artist's unschooledness and, beyond that, his inability to be schooled. For Still, writing and painting at a land-grant college in the Far West, in a place similar to Rothko's Boulder and even Cézanne's Aix, what mattered was the French master's ruralness and crudeness. A number of art historians have noted, as April Kingsley writes, that "everything he wrote about Cézanne was true of himself. . . . Still seems to identify completely with Cézanne and his struggle."[47] Still's thesis makes over and over again the point that Cézanne was a failure—bodily, systemically—and that his very failure was critical to his success.

> In his every move we see the maladjustment of the crude, groping Provincial. . . . His lack of facility, his sensitiveness, his isolation—these and a hundred other qualities that singly would have defeated innumerable other painters were but useful links in the chain of coincidences that made Cézanne possible.[48]

Still's Cézanne did not refuse his facility or his talent—a case that might be made for Picasso—but became an artist by virtue of that very inability and redefined the terms of artistic success. Still's thesis is, as its title

says, "a study in evaluation." The model of Cézanne as a failure under-
writes Still's work and his identity; it makes possible his being an artist,
even in Pullman, perhaps even without facility: "An appreciation of his
contribution involves an inversion of popular concepts of art. . . .
Histrionic talent, imagination, fancy, interest in the habits and ways of
men, knowledge of life or the ecstasy of the prophet are in him conspic-
uous by their absence."[49]

Still's romantic Cézanne seems the polar opposite of Moholy-Nagy's
master of design, and he lies some distance from the college Cézanne of
Hofmann and Erle Loran as well. Of the three images, Still's, perhaps
the most hackneyed, was certainly the most popular. Cézanne as a
driven failure was a recurring theme across the first half of the century,
in the writings of not only the enemies of modern art, but also its apol-
ogists. One of his earliest proponents and publicizers, the artist Mau-
rice Denis, also described a Cézanne who could not learn correctly:
what learning he accomplished embodied a rupture. "His spiritual con-
formation, his *genius,* did not allow him to profit directly from the old
masters. . . . His originality grows in his contact with those whom he
imitates or is impressed by; thence comes his persistent *gaucherie,* his
happy *naïveté,* and thence also the incredible clumsiness into which his
sincerity forced him."[50] Like Still's Cézanne (even like Kunitz's
Rothko), Denis's cannot do what the masters had done before him; he
and the artists to follow are left with only part of, indeed less and less
of, what artists of the past had done and could do.

Cézanne's failure as an artist and an individual allows him to be an
individual artist, to be precisely *just* an artist. In Clive Bell's ringing as-
sessment of modernism's debt to Cézanne, being just an artist is
Cézanne's difference—and the legacy he bequeaths to modernism: "The
painters of this movement are consciously determined to be artists.
How many men of talent, of genius have tried to do more than this and
failed at being even an artist. To be an artist . . . suffices."[51] For Still,
for Denis, and for Bell, Cézanne embodies modernism's *Kunstwollen.*
The will to art that Alois Riegl had assigned to races of people, to na-
tionalities, to history becomes, particularly through Wilhelm Wor-
ringer's *Abstraction and Empathy,* the private attribute of the individ-
ual artist, the opposite of skill and, in Still's declaration, present in
inverse proportion to it. For an older generation, Worringer wrote fa-
mously after Riegl, the "history of art was, in the last analysis, the his-
tory of *ability.* The new approach, on the contrary, regards the history
of the evolution of art as a history of *volition,* proceeding from the psy-

chological pre-assumption that ability is only a secondary consequence of volition."[52] From the figure of Cézanne on, that volition rests—or rather ferments—in the artist himself: it is his will to be an artist, despite the obstacles, despite his inability to perform those feats of talent, interest, knowledge, and ecstasy that form, in Still's words, the "popular concepts of art." This desire gives the artist's life the character of the bildungsroman. The literary Cézanne may not be able to fulfill the popular concepts of art, but he goes a long way toward fulfilling the popular concept of the artist. Lisa Tickner reminds us that the *Kunstlerroman,* or artist's novel, a version of the bildungsroman, "reached the zenith of its popularity between 1895 and the first world war. . . . [T]o become an artist at the turn of the century was not only a social matter of training and opportunity, but also a question of aspiration, of *imagining* oneself as an artist."[53]

If I seem to have followed Cézanne and his image too far from Clyfford Still's master's thesis, they figure again in the educational biography of Barnett Newman, who joined the Subjects of the Artist faculty in January 1949. Like many would-be artists in New York in the 1920s and 1930s, including Rothko and Adolph Gottlieb, Newman studied at the Art Students League, and he did so for a good deal longer than Rothko. He attended as a high school student from 1922 to 1926 and returned in 1929 and 1930 after graduating in philosophy from City College. He drew from casts with Duncan Smith and later painted, like many American artists, with John Sloan. None of Newman's paintings and few of his drawings from the period survive; in the early 1940s he destroyed as much of his earlier work as he could locate. Like Rothko, who claimed to be self-taught, and Still, whose master's degree was accidental, Newman attempted to start from scratch as an artist without a school, or from a different course of study at a different school—from philosophy at the City College of New York or, in the early forties, from botany at Cornell.

The critic Thomas Hess invoked a familiar model in the early seventies for Newman's destroyed works, his failures: "Piecing together Newman's own accounts, one is reminded of Cézanne's early, all-thumbs drawings."[54] Newman and Still, and Motherwell too with his blunt, coarse drawings, all worked under the sign of Cézanne as the artist who could not draw, the artist of will. According to David Hare, Newman would assure his Subjects of the Artist students, "I can't draw at all."[55] Clement Greenberg once noted that "like Rothko and Still, Newman happens to be a conventionally skilled artist—need I say it?

But if he uses his skill, it is to suppress the evidence of it."[56] Clearly, Greenberg needed to say it, for the evidence had been suppressed not only in individual works but also in the story of the New York school. At some point, not drawing—being not only unschooled but unable to be schooled—seems to have been crucial to abstract expressionism. It is part of the promise of Subjects of the Artist.

Students, Faculty, and Curriculum in Quotes

Mirroring its founders' refusals, the Subjects of the Artist's one-page catalogue insisted that "there are no formal courses" and "no technical requirements; beginners and those who paint for themselves are welcome."[57] According to April Kingsley's account, "The 'faculty' taught no techniques, set no problems for the students to solve or projects for them to execute, and gave no specific, how-to-fix-it critiques of their work."[58] She puts the word faculty in quotation marks to distance the artists from different, more usual teachers; the Subjects catalogue, written by Robert Motherwell, had already set off the word students: "Those attending the classes will not be treated as 'students' in the conventional manner, but as collaborators with the artists in the investigation of the artistic process, its modern conditions, possibilities, and extreme nature, through discussions and practice."[59] A number of students at Subjects had been trained as circuitously and incidentally as their artist teachers. Before enrolling in the school at age thirty-five, Yvonne Thomas had attended Cooper Union, where she studied with Buckminster Fuller; the Art Students League; and the Ozenfant School. Following the close of Subjects of the Artist, she would attend Motherwell's school in 1949 and the Hofmann School in the summer of 1950.[60]

Motherwell's promise that students would be treated as artistic collaborators became increasingly common in the 1960s and 1970s; it differs significantly from the promise made by the University of Washington in the late twenties. In discussing cones and cubes, Duffus praised Washington's pledge to "teach the student to 'work as the artist works,' regardless of whether or not he will be an artist after he graduates."[61] When the California Institute of the Arts opened in 1971, it did not put off the question of being an artist until after graduation; its initial catalogue, like Motherwell's, pledged that "from the day he enters, the student is an artist."[62] The question was no longer one of practice, of "practical courses in an eminently practical way," to continue Duffus's

letter from Washington, but of *being* an artist in the eyes of one's teach-
ers, and in the mirror—that sight of identification—provided there. The
Subjects catalogue listed only two regulations: "Smoking will be regu-
lated according to the fire laws; anyone who does not fit in the school
will be asked to withdraw."[63]

In March 1949, two months before Subjects closed, Motherwell de-
scribed the "little school of art at 35 East Eighth Street" in a talk to the
Seventh Annual Conference of the Committee on Art Education.

> The way to learn to paint—to begin one's orientation, I mean—is to hang
> around artists. We have made a place where young people can do so. . . . We
> talk to students as we do to one another, trying to break down ignorance
> and clichés, encouraging each individual to find his own expression of his
> inner life. This kind of teaching must be done by artists. . . . Still, in a basic
> sense art cannot be taught, and we do not try to. Yet paradoxically it can be
> learned—in the beginning from other artists, and then from oneself. We try
> to provide a congenial atmosphere for novices to enter the arena. . . . On
> Friday evenings we invite other artists to talk about whatever they like.[64]

In Motherwell's description, Subjects of the Artist was primarily a place
to be with artists—a place to hang out with them, to talk with them, to
see what they are like. The program emphasized speaking, and the sub-
jects spoken of concerned artists, what they worried over or were ex-
cited about, what recent art looked like. As Robert Goodnough so
clearly put it shortly after the school's close, "The 'curriculum' con-
sisted of the subjects that interest advanced artists."[65] It is worth re-
marking that Goodnough placed yet another pedagogical term, curricu-
lum, in quotation marks.

The insistence that art emerges out of an intellectual and emotional
ground and that artists have a sense of the present—this was what
Motherwell understood as the difference and the newness of Subjects
of the Artist. It led after January 1949 to the establishment of the series
of Friday lectures to which Motherwell refers. By April 1949 the list of
artists who had been invited to talk included Adolph Gottlieb, Willem
de Kooning, Hans Arp, Ad Reinhardt, Fritz Glarner, John Cage on In-
dian sand painting, Richard Huelsenbeck on the origins of dada, and
Joseph Cornell, who introduced his collection of early cinema. Mother-
well stressed talk and proximity, the sense of milieu and of hanging
around, in the school's catalogue. "Those who are in the learning stage
benefit most by associating with working artists," for only then can
they learn "what his subjects are, how they are arrived at, methods of
inspiration and transformation, moral attitudes, possibilities for further

explorations, what is being done now and what might be done and so on."[66]

Students and faculty both recall at Subjects of the Artist the artist's presence and his speech and, curiously—as though conversely—the absence of the artist's touch. These characteristics signify the difference of a different kind of art school. "Unlike a truly professional teacher such as Hans Hofmann," David Hare recounted, Barnett Newman "never drew or painted on a student's work to correct it. Newman was content to talk about art in a general theoretical way."[67] Across the continent at the California School of Fine Arts, Douglas MacAgy characterized Still's teaching by noting the same difference: "He didn't take over people's brushes and say do it this way or that way."[68] In not working on student work, the artists of Subjects of the Artist not only separated themselves from Hofmann, who was well known, even infamous, for tearing up and repositioning student work to illustrate the plastic production of space, but also refused a long tradition formalized in the nineteenth-century French atelier of the *séance de correction,* a term that names both the master's visit and his touch. The nineteenth-century master, seldom in his atelier, did not lecture or teach or pose problems. Instead, during his weekly or semiweekly visits he traced the correct line, the right proportion, onto and over individual student work, a practice that, as Albert Boime remarks, "denoted perfection," the possibility of mastery.[69]

In contrast to the nineteenth-century master, the Subjects of the Artist faculty talked, and in the recollections of students and colleagues their speech is marked by excess, an imbalance of form and meaning. "The painters walked around us as we worked," Florence Weinstein recalled, "and made remarks to individuals, often contradictory. The idea was that you didn't get influenced by one artist."[70] These remarks denote, if I can follow Boime, not perfection but the impossibility of a single line or single answer. They suggest an extension, the continuing of the work of art elsewhere. The link between speech and extension, the afterward of the finished work, is written as well in Clyfford Still's response to a friend's request to sit in on his painting classes at Colorado-Boulder, where the artist would follow Rothko to teach the summer session of 1960.

> My "teaching of painting" consists of conversations with the painter after he has executed his work. There is just no sitting in at a class, for a class in the conventional sense does not exist. The private conversations are in the direction of getting the painter to see what he has done and to establish a

worthy basis for further execution and clarification. Almost no one, I have found, can read more than superficially the real content of today's paintings. . . . It is an effort to bring some honesty into a confused—even sordid—situation, that I assign myself the discipline of speaking, call it what one will.[71]

Still's method, his reading of a finished painting back to its maker so that the student-artist's project might be refined and extended, is the teaching of painting by "crit." Opposed both to training in specific techniques and to the corrections in situ of the academy master, this speech after the painting is now taken for granted. My point here is not to give Still credit for its invention, or even to suggest him as a particularly early practitioner. Rather it is to insist on the form's historicity: that Still had to explain it, that he was unsure even what to call it, suggests that its difference as a way of teaching was not yet invisible. He does, after all, put the phrase "teaching of painting" in quotes; by the end of his paragraph he has substituted for it the "discipline of speaking."

Often the painters' comments were not addressed to the paintings at all. They were not attached to the concrete presence of the work, but rather were spoken in its vicinity. They hung about the work in the way that Motherwell suggested would-be artists should hang around. Newman, we have already heard, was content to talk generally about art. Similarly, Yvonne Thomas recalled Rothko as "more interested in talking about life in a way than in criticizing paintings."[72] Teaching at the California School of Fine Arts in the summer of 1947, Rothko insisted, in response to a question posed by another member of the faculty, that painting "can be simultaneous with philosophic thought . . . it can be a philosophic expression." Asked how art students might prepare to produce such painting, Rothko looked to a liberal arts curriculum: "some general understanding of psychology, philosophy, physics, literature, the other arts, and writings of mystics, etc."[73] A number of students and faculty at the California school recall both Rothko's own version of mysticism and their confusion about it. The painter Ernest Briggs, a student of Rothko's in the late forties, remarked that he "could talk endlessly and very brilliantly and poetically and metaphorically and mysteriously."[74] MacAgy compared Rothko's language to his chain-smoking: "The curling smoke [was] almost a symbol of how he talked: very elusive talk."[75]

Still's presence in San Francisco was no less marked by his speech. "A lot of what he did at the beginning and even right through was talk," recounted MacAgy. "What he would do is go in and talk about

baseball and then he would read something of Clement Greenberg's from the *Nation.* . . . Something about Jackson Pollock maybe and then criticize it or give his opinion of it to the kids. And then he would talk about all kinds of things."[76] Ernest Briggs, who remembered Rothko's mystery and metaphors, recalled Still's teaching as equally elusive. Still had

> these radical ideas and seemed to have a very definite philosophy, though it is difficult to put it together in any consecutive manner. He became a problem to me at least, in terms of, what does it mean? What does he mean? The relationship in one of his classes was that he would come in for twenty or thirty minutes and talk about something he had read or something that had happened on the art scene either locally or in New York or in Europe and that became your problem, to figure out what it meant in relation to your situation.[77]

The artist's speech in the teaching of art—precisely in its ambiguous, excessive relation to the work of art and the task of instruction—called on students to position themselves. It demanded that they place themselves in professional relation to the position of the speaker. What does this mean to me, to my being an artist?

Before venturing something like an answer to Briggs's question, I want to turn to another way the same question is raised. As I have already suggested, the history of teaching art by assignment goes back only to the nineteenth century. The separation of art into discrete, repeatable lessons, each demonstrating for the student who completes it a fundamental principle of art or design, each giving the student a separable technical skill, is an innovation that arose outside the academy and in a different approach to education. In the academy, assignment and product are given in the same language. Students' copies from the flat and later their drawings from the cast and from life all carry the same instruction: make a similar object. Both the question and the answer address the realm of the visual, the realm of likeness. The art school project, in contrast, is spoken, and often written. Posed in a language other than its result, it is directed, not toward the exterior world, but toward the surface of the work as it reveals a language of art that can be split into sections and themes, each of which becomes the possibility of an assignment. The teachings of abstract expressionism, like those of the Bauhaus and its precursors, were posed in spoken language, and sometimes even posed as assignments, but the lessons learned in New York and at the California School of Fine Arts in the late 1940s and early 1950s were yet again different.

What Does He Mean?

Ad Reinhardt, teaching at Brooklyn College in the fifties, instructed his drawing students to produce self-portraits in pencil and charcoal on fine paper. When a drawing was finished, he would have the student erase it and begin again, a process repeated with the same sheet of paper throughout the term.[78] Hassel Smith, teaching with Rothko and Still in California, asked his students to spend some three hours drawing a six-foot mound of wadded newspapers; with a sardonic nod to the possibility of teaching another kind of painting, he requested that they paint in homemade egg tempera while he read aloud from the Bible. There is now a history of such assignments, and a collection of them in practice worldwide. In 1967 in a British college of art course that continued the trappings of life drawing, students arrayed before the posed nude model were instructed to

> make as many marks as possible with brush and black paint, starting from the least obvious ways of using the brush end—sideways, etc.—without repeating each type of effect and without conscious control or intent. Hands, noses, hair are also to be used to produce marks. The sheets will then be assessed according to the impact the sheet of marks makes on the tutor.[79]

Perhaps I should remark that I have chosen these assignments, not for their ludicrousness, even if their practitioners would argue that they are ludic, involved in the openness of play. Rather, I have chosen them for their normalcy. Often they are fitted in and around more traditional classes in drawing and painting, or at least, as in my British example, in classes that continue to wear those names.

The assignments of Reinhardt and Smith and the British art school tutors do not demonstrate the elements of drawing or art fundamentals. They do not allow the student mastery over image or material; rather they promote unmastery. The art college tutors "did not spell out what exactly it was they expected or wanted from students. . . . [and] quite deliberately did not explain their criticisms."[80] By the late 1960s in Britain, and certainly by the time I encountered such assignments in the early 1970s, their different goal was well understood: to get students to loosen up, open up, and relax and, more deeply, to get them to leave what they know and draw on or draw out something they do not know. One of the British instructors designed his teaching program to "disconcert the student, thereby breaking down his preconceptions," to "open students' minds to the numerous possibilities contained within any given image."[81] A California School of Fine Arts student remarks

about similar assignments that "the main thing I remember was the opening up."[82] The open-ended assignment, the assignment against mastery or closure, psychologizes the work of art, or rather the workings of art. It produces "intrasubjectives," as the title of a well-known early group exhibition of abstract expressionism had it, a type of artist who, in Harold Rosenberg's words, is "not inspired by anything visible, but only by something that he hasn't seen yet."[83]

The students of Subjects of the Artist internalized that teaching. They corrected themselves more harshly than either Hofmann or the nineteenth-century master corrected his students' work: it is the student here who is worked on. "They changed me completely," recalled Mary Abbott in 1988. "Now I had to destroy the object, get rid of horizon, and not use any literary subject either. The point was to get you so you weren't putting down marks deliberately, but also not arbitrarily either. So you really felt it. Then it began to be real. . . . you'd know it was real and you weren't translating an object."[84] The teaching of abstract expressionism was founded on the teaching of refusal, on a demand for what could not be recognized. Rothko, according to Fred Martin, who studied with him in California, pushed his students "to find something unknown . . . the word was 'unknown,' and working on a painting if you associate to something in the painting or if you recognize something in the painting, take it out."[85] The modern artist "begins with nothingness," wrote Rosenberg, but he continues with an odd turn of phrase: "*That is the only thing he copies.*"[86]

The work of art in the assignment of unmastery is psychologized in another scene as well, this time intersubjective rather than intrasubjective, set, that is, not within the artist-student, but in the relationship between student and teacher. Unfulfillable, opaque, the assignment constitutes a demand; its question—that is, the question it raises in the student—is, what does he want? In this scenario the assignment does not help the student access his or her subjectivity, a deep, personal inner well; rather it *produces* a subjectivity, or at least the effects and the emptiness of one. "Desire begins to take shape in the margin in which demand becomes separated from need: this margin being that which is opened up by demand."[87] This is Jacques Lacan's formula for the birth of desire in the child, but it might also describe the scene of professional desire. The student's desire—the wanting-to-be an artist that echoes like the *Kunstwollen*—is born in the difference the student glimpses between what the teacher asks for and what he wants for. "A lack is encountered by the subject in the Other, in the very intimation that the

Other makes to him by his discourse. In the intervals of the discourse of the Other," the child says, *"He is saying this to me, but what does he want? . . . Why are you telling me this?"*[88] For Lacan, it is the child's unvoiced question to the parent and to the "enigma of the adult's desire,"[89] but it is also Ernest Briggs's question to Clyfford Still: "He became a problem to me . . . in terms of, what does it mean? What does he mean?"

Students at Subjects of the Artist struggled not only for the unrecognizable, but for recognition as the thing that once and for all fills and completes the Other. The student desires to be recognized as an artist, as *the* artist, to make the object Rothko has never seen, to make that something unlike anything else that would stop the series and the repetitions of art school painting and the teacher's endless desire for something else: Have you thought about trying it this way? Have you done that? Have you looked at this artist or at that one? The teacher desires, perhaps, to be the eyes, the knowledge, the reputation through which the student will be seen as an artist, an artist of his school. Even more, the artist, whichever artist—to be an artist—wants not to desire, not to want for anything. Only by disavowing this professional desire, this need for recognition—this want-to-be an artist (*manque à être,* in a Lacanian turn of phrase that assumes a lack of being at the center of the subject)—can the artist be an artist, uninfluenced, whole, without likeness. Only in this way can the artist be like the paintings that Yvonne Thomas and Mary Abbott described, paintings that refused to recognize their need for any other thing.

"I fight in myself any tendency to accept a fixed, sensuously appealing, recognizable style," wrote Clyfford Still in 1961, repeating the struggle of the Subjects students. Marking his place as a teacher, issuing his demand for recognition and withdrawing it in the same breath, he continued, "I do not want other artists to imitate my work—they do even when I tell them not to—but only my example of freedom and independence from all external, decadent and corrupting influences."[90] Patricia Still's biography of her husband, published at the back of his Metropolitan Museum of Art retrospective catalogue of 1979, is marked by this same dialectic of desire and disavowal. It carefully records each entreaty to him and each of his refusals: from 1957, "invited to show in an exhibition at the Kunsthalle Basel . . . refused for ideological reasons" and "invited to exhibit in the American Pavilion of the Venice Biennale . . . the first of at least four invitations to show at the Biennale, all . . . refused"; from 1967, "met with Gerald Nordland

to discuss retrospective exhibition at the San Francisco Museum of Art. Still refused the terms offered"; and from 1968, "received invitation from Charles Parkhurst, director of the Baltimore Museum of Art. . . . Still refused the terms."[91] These are, Lacan might explain, the "mortal negations that fix [the ego] in its formalism. 'I am nothing of what happens to me. You are nothing of value.' "[92]

Finding the dialectic of psychoanalytic desire written in the back of a catalogue from the Metropolitan Museum allows me to turn another corner and to insist that the intensely personal struggle of becoming and being, and of believing oneself to be, gets played out in, and is nurtured as, professional life. Rothko's advice to a student at Brooklyn College makes it clear that the intense search for a real and personal image—an image of oneself—is the same as professional ambition: Art, Rothko cautioned, is about "somebody getting territory, this is your territory, you develop something and it's yours, it's your territory. And to emulate one by imitations would be ridiculous."[93] Rothko's paintings, or Newman's or Still's, tell much the same story, as the breakthrough image, that image of the artist's becoming different, is repeated insistently and demandingly in painting after painting across two and a half decades—constructing, building, reinforcing the self as an artist.

In a paper delivered in 1948 Lacan postulated the relation between "aggressivity in man" and the "formalism of his ego and his objects."[94] Newman forecast the repetitions of abstract expressionism in nearly Lacanian terms that same year when he wrote of those artists in America who had begun "making *cathedrals* . . . out of ourselves, out of our own feelings."[95] His architectural self-imaging is kin to Lacan's statue man, clad in the "orthopaedic . . . armour of an alienating identity," figured "in dreams by a fortress or a stadium."[96] The subject constructs this architectural unity as an image over a division that has itself been structured by an image. The individual, Lacan explains, "fixes upon himself an image that alienates him from himself," and it is there, in the splitting of the subject in the image and over it, that the "organization of the passions that he will call his ego is based."[97] Certainly the New York school's alienated artist, and perhaps even Lacan's figure of another self within the self, descends from romanticism. But the abstract expressionist's self-alienation, his demand to be recognized precisely as an image, cast him in the very image of a professional. Across the writings of the New York school in the forties and fifties, the name of that other self is the artist.

In his very well known, if not very well read essay "The American Action Painters," Harold Rosenberg wrote that "a painting that is an

act is inseparable from the biography of the artist."[98] I have read this sentence many, many times and have only recently noticed what it does not say: that a "painting that is an act is inseparable from the *auto*biography of the artist." Who else, then, is writing that painting? from where is it written? Rosenberg offered the terms for an answer six years later: action painting, he wrote in 1958 in a clarification that is now included as a footnote to "American Action Painters," "has to do with self-creation or self-definition or self-transcendence; but this dissociates it from self-expression, which assumes the acceptance of the ego as it is."[99] Action painting is a way of making someone else, or—Rosenberg makes this clear numerous times—of making oneself an artist. "What gives the canvas its meaning is not psychological data but *rôle*."[100]

In his 1963 discussion of the painter Arshile Gorky, Rosenberg named that role explicitly: "In the art of our time, the identity of the artist is a paramount theme."[101] This is not a simple statement, or simply the statement of a very late romanticism; at least it need not be read as one. The word "artist" is not a substitute for a particular proper name, for Gorky's or anyone else's. The phrase "identity of the artist" should be read rather as a single term, strung together with hyphens, and the definition of identity should lean away from *Webster's* "unity and persistence of personality" toward "the condition of being the same with something described or asserted." In the mid fifties, Rosenberg's "Everyman a Professional" suggested just such a reading. Writing on the modern artist, advertising man, and lawyer, he equated all identity—its very possibility—with professional identity: "Having no identity other than the one he creates for himself through his métier, he is compelled to regard the rank of his profession, and of himself in it, as the final measure of his existence."[102] I leave it to Ad Reinhardt to name that identity, and to situate its existence both in and outside the self as *rôle* one last time: "An artist . . . is a separate person. Even as an artist, he is separate from himself as a human being. I never go anywhere except as an artist."[103] Cézanne, as Bell and Denis said, was *just* an artist; abstract expressionism made just that professional identity the psychological—and pedagogical—subject of the artist.

The Subject of Teaching

There remains the task of making the artist the subject that is taught in the teaching of abstract expressionism in the university. This is the overlay promised in the process of professionalization; the university is

its privileged site: "The core of the professionalization project is the production of professional producers; this project tends to be centered in and allied with the modern university."[104] Not long after closing Subjects of the Artist, Motherwell and Baziotes were both uptown at Hunter, teaching the artist. In the fall of 1955 Motherwell offered a series of five lectures on the modern artist as an ethical individual; Baziotes's course, repeated each semester of the later 1950s and into the early 1960s, was entitled the Artist in Modern Society. Recasting Ernest Briggs's question to Clyfford Still for the final exam in the fall semester of 1962, he offered his students two lapidary quotations—Vasari's "Painters make other painters" and Picasso's "Why question the song of the birds?"—asking, "What does each of these statements mean?"[105]

Hassel Smith, as senior lecturer in painting at the West of England College of Art in the late 1960s, offered a second-year course for degree students in the fine arts that was devoted to the artist and to the questions of being one: economics, the painting experience, youth and professional maturity. Under the heading "the role of the artist in society," Smith asked his students, "As an artist do you identify yourself as," a question completed by a numbered list: intellectual, entertainer, craftsman, mystic, ball player.[106] Smith's list immediately recalls Ad Reinhardt's, but Smith consciously patterned his teaching on Still's: "I think I teach today very much in the way that Clyff preferred to teach," he told an interviewer. "I hardly ever speak directly to a student about his or her painting. It's a question of sitting down from time to time and examining certain propositions which in due course, then have some meaning in relation to a painting or various paintings."[107] Language in excess of painting—even as the elision of painting—has marked Still's teaching in the pages above; in the debates over where and how art should be taught in the 1950s and 1960s, language is the shared attribute of the university and of abstract expressionism. Among the materials held in storage at the Archives of American Art is a box of blue books, midterms and finals from Baziotes's course. One answer on a final from spring 1960 reads, "In this course I became aware of the fact that the great artists are as much dedicated to their profession as any college professor."

Both its critics and its supporters maintained that the teaching of abstract expressionism took place and took hold on campuses rather than in the art schools. The claim is exaggerated, but abstract expressionism was understood early on as a university style. In the closing paragraphs of his 1955 dissertation, William Seitz placed the future of

art in America, a particularly abstract expressionist future, securely in the college and the university, precisely as they were different from art schools. Summoning Hans Hofmann's comment that America, despite its material riches, was "poor in ideal goods,"[108] Seitz claimed that the nation could now look forward to

> a surge of talent, intelligence, knowledge, and seriousness which, on such a scale, has never before existed in America. The lack of awareness of spiritual values which Hofmann noted in 1930 has been altered, and it has been mainly the universities and colleges, rather than private art academies, which, in their rejection of localism, have provided the nuclei for a greater interest in the practice of art on the part of a whole nation.[109]

Seitz might have chosen any number of words to characterize the private art schools he dismissed. His choice of the term "localism" suggests the ideals of postwar professionalization. Particularly in the university, proponents of a new professionalism stressed the national man who shared the theoretical concerns and disciplinary identity—and the college education—of his professional peers rather than the particular practices and prejudices of his geographic neighbors.[110]

As early as the late 1930s Talcott Parsons insisted that professional knowledge "transcends the immediate practical exigencies of the particular professional function." Attempting to cohere a definition of the term "profession" in the early 1950s, the Harvard educator Morris Cogan cited Parsons in arguing that "the great attributes of profession arise not from their specialism"—not from whatever singular skill they bring to serve a particular client—but "from the fact that the specialism is grounded in the liberal tradition."[111] That tradition, imparted by the college rather than the special school, perhaps allows Seitz's and Hofmann's spiritual values. Certainly Cogan's description of the professional as "the conservator and representative of the values that modern society seeks to preserve" echoes in Seitz's very last words on the New York school.[112] In its concern for "humanism and naturalism over mechanism, freedom over regimentation . . . and commitment over pragmatism," abstract expressionism offers a dramatized image of the new professional; it "*portrays* the searcher and idealist among contemporary men, whatever his field of endeavor may be."[113] Seitz's description of the artist as a picture expands, far from coincidentally, to cover other professionals, those other serious men defined by an identity constructed in relation to a field, who share abstract expressionism's aspiration to advanced research guided by the liberal tradition.

Addressing the annual meeting of the National Association of Schools of Design in 1955—and speaking for the other side—Kenneth Hudson of Washington University, one of the earliest freestanding, university-based professional art schools in the country, noted that "college art departments offer little in the fields of the commercial arts or industrial design." He suggested two reasons why: "first, that these fields carry the taint of professionalism and are therefore inconsistent with liberal arts ideals; but more importantly, in these fields the absence of highly developed technical skills and understanding cannot be disguised—and these demands the college department cannot meet."[114] College art departments cannot produce designers or illustrators; they can only make painters, and only of a certain kind. Students who have to spread their interest and energy across the breadth of college departments, and faculty who have to teach the merely interested or simply required cannot devote the time and intensity of focus required for technical mastery—or, in Cogan's word, specialism. Hudson too lays claim to the professional, but his "professionalism," a term he uses both bitingly and proudly, is linked to a specific, intensive training and to particular tasks.

Like Parsons and Cogan and numerous other midcentury commentators, Hudson uses the word "professional" to lift his endeavor above the merely vocational or manual, and he too appeals in the final instance to the values of liberal humanism. Professional artists are formed by finding their place in the traditions held in and imparted by the professional school: dedication, sincere creation, the "mastery of materials," and the "disciplines requisite" to that mastery.[115] Listing the industrial designer and the commercial artist among the heirs to these lofty traditions, Hudson notes, as a telling marker of the difference inculcated by the professional art school, that his professional artist is made, his identifications forged, in the specific practices of art; professionalism is grounded in a material knowledge and technical ability that secure results. Seitz offers a different model of the artist as a university professional, whose expertise is grounded, not in a particular technical practice, but in a discipline and whose relations are not those of practitioner to client but of researcher to field. The final product of Seitz's "searcher" is not the specific artwork as it fulfills a function or answers a particular need, but research, the production of new knowledge, in the discipline of art practice as art historical culture.

That last element is part of Hudson's criticism. College art departments cannot make professional artists, Hudson complained; for the

artists the colleges produce, "painting and sculpture and the crafts are purely cultural activities." Arguing as though he had read Still's master's thesis or listened to Newman talk to his students, Hudson suggested that college departments and their pretensions had benefited from "abstract painting and sculpture, expressionism, and abstract expressionism. . . . for in these contemporary idioms, *the absence of a command of techniques can be made to seem a virtue.*"[116] Hudson's recourse to the phrase "cultural activities" recalls—deliberately, it seems—the history of college fine arts: its place in the nineteenth-century "ornamental course" and its early-twentieth-century position in schools such as Wellesley or Smith as a subsidiary of art history and the humanities. In 1948 Barnett Newman described a group of painters "free from the weight of European culture," free from "memory, association, nostalgia, legend, myth."[117] In Hudson's dismissive "cultural activities," the painters of the New York school, or at least those educated in their image, have ended up painting culture, painting pictures of painting and its historied image. Or one might argue that the students of the New York school have ended up painting their position in that history, and on the work of art. In that field of positions the artist's identity is formed: Motherwell insisted both that "every artist's problem is to invent himself" and, famously, that "every intelligent painter carries the whole culture of modern painting in his head. It is his real subject, of which anything he paints is both a homage and a critique, and anything he says is a gloss."[118] The culturedness that Hudson dismissed is part of the constellation that allowed the artist in the university to be a liberal artist, and a learned one, and to become the professional subject of his or her own work.

For Seitz and for Hudson, too, albeit with different ramifications, the skills of the college artist are not manual and visual skills but academic proficiencies or perhaps research skills: theoretical, historical, and verbal. Whether or not they can paint, Hudson worried, the student artists "have developed verbal skills and are often convincing in their justifications."[119] Writing at the end of the 1960s, the minimal sculptor Dan Flavin, who, like Motherwell, had studied art history at Columbia, revisited the distinction between the art school and the university in a long complaint on the problems of American art education. Like Hudson, he railed against the teaching of those media guaranteed by art history—the "formal art historical media indoctrination"—but had little patience for any "institutionalized technical vocational training" and listed the "new mediumism" among his targets as well.[120] Like

Seitz, Flavin suggests that the future of an effective art education lies in the university: his essay offers "some procedures through which colleges and universities and, to a much lesser extent if at all, the educationally restricted non-university connected professional schools could participate in appropriately accommodating both artist and art."[121]

In the chapter that follows I address some of Flavin's specific proposals for educational reform. Here I want to note both that the reforms seemed possible to him only in the university and that they are predicated on the artist's self-education: "Remember that discipline in art is bred of self-regard for self-development."[122] Artists, as I insist throughout this chapter, construct themselves as artists; they do so, Flavin argues, by pursuing their "self-induced research" in the "educational center of the college or the university," a site that reaches well beyond the studio.[123] Finally, Flavin's proposals, and his artist, are marked by language. For him, and for a number of other commentators I turn to in Chapter 6, speech characterizes the artist in the university. As Flavin says of one graduate student, "As he knows, he talks."[124] Perhaps he has learned to speak like Rothko, or to answer Clyfford Still.

PROFESSING

POSTMODERNISM **6**

In the debates surrounding the rapid expansion of university-based graduate education in the arts from the late 1940s through the mid 1960s, language was the defining attribute of the university. The spread of language—indeed, language as spread, a spreading thin of time and energy and commitment to craft—encapsulated the threat of university training both to artists, imagined as incapable of, and even damaged by, the "abstract reasoning and manipulation of words and symbols demanded by the usual academic tests of aptitude and achievement,"[1] and to works of art, envisioned as "so all-embracing that [they] can't be split up into separate words."[2] The two sides of this debate reemerge in the late 1970s and early 1980s as the chronological categories "modernism" and "postmodernism." In the writings of Rosalind Krauss, Douglas Crimp, and Craig Owens, among the most influential theoreticians of postmodernism in the visual arts, language remains the central actor in the debate. Deployed as the power to fissure and evacuate the whole and singular work of art, language—or its image and its effects: absence, difference, repetition—dictates the attributes of a critical, knowing postmodernist art as it unravels the blindnesses and fictions of modernism.

Certainly the university demands language; it insists, for example, that I publish or perish. Less punitively, it professes a commitment to the advancement of knowledge or, according to the name of the program in conceptual and performance art at UCLA, to the development

of "new forms and concepts." But the university's demand for the production of knowledge—indeed, its takeover of the training of artists, its fashioning of art as research and art criticism as science—belongs to the specialization, administrative rationalization, and "professionalized treatment of the cultural tradition"[3] that are not so much postmodern as characteristically and familiarly modern. The university's challenge elicits a reproducible and certifiable knowledge—a language at once theoretical and esoteric—on which to found and consolidate the exclusivity of a discipline or profession and to guarantee its members' status as experts. The university in which both the theory and the practice of postmodernism in the visual arts emerge is a fully modern institution. And the language postmodernism imagines as critique and as method is the agent of modernization.

Even, perhaps especially, at their most critical, the artists and theorists of postmodernism repeat the demands of the university: a "demythologizing criticism and a truly postmodernist art [that would] void the basic propositions of modernism [and] liquidate them by exposing their fictitious condition" requires the production of ever clearer and more knowing works of art and the development of ever more effective methodologies to place and determine them.[4] As Rosalind Krauss insisted in 1983, "Postmodernist art enters this terrain (the theoretical domain of structuralist and poststructuralist analysis) openly. And it is this phenomenon, born of the last two decades, that has opened critical practice, overtly, onto method."[5] The terrain Krauss sketches—whatever else it might be—is that of the university, and the phenomenon, that of a professionalized disciplinary practice. Postmodernism here is a practice that necessarily modernizes: it enlightens; it demands a future already determined by the past and insists that we know it and name it even as we act it out. Perhaps here I can mention that the term "postmodernism," when it reappears in this text later on, should be read as if embedded in quotation marks.

But first I want to assert the university's crucial role as both patron and scene for the art of the sixties and seventies that could not travel without the artist from studio to gallery to museum, could not be simply bought and sold, but instead needed to be read or screened or installed, and attended. The artist who accompanies the event, the visiting artist, figures large in my argument. Recalling an essay I wrote some twenty years ago, shortly after my own graduation as an artist, I cast the visiting artist as the artist who speaks, or at least as the figure who stands here for the issue of language in the university.

The Visiting Artist

Unlike many student artists, I discovered a use for my M.F.A. a few weeks after graduation. If nothing else, the degree held a certain explanatory value; it defined who was an artist and where artists appear. I insisted that "most artists are not self-made but graduated. They are graduated from art schools across the country, versed in the methodologies of contemporary art."[6] That claim appeared in an essay on the emergence of alternative spaces, as part of an argument about the relationship of these new spaces to New York and to a roster of artists published in the national art press and visible in the market. Outside the gallery-based art markets, I argued, universities were graduating contemporary artists with market-driven tastes and oeuvres, but with neither the jobs nor the space to indulge them. They were, that is, producing the constituency for alternative spaces and often graduating their operating personnel. The spaces that grew out of graduate programs and student-run galleries—or in lieu of such galleries—continued the forums that in school had suggested or simulated an art world: lectures and meetings and visiting artists. These had led me, and I imagine many others, to enter a graduate art program, and I imagined that they existed in some "realer" form somewhere else.

Besides local links between alternative spaces and the university art department, I argued, the nontraditional media that these spaces exhibited also owed their emergence to the university. "Video, film and performance share with the spaces themselves certain roots within the university structure. All three of these art media/situations require a space, a technology, and a community audience. The university art department provides all of these, and it has become the desire of alternative spaces to provide and create these same situations."[7] The art department provides equipment, pays a salary to artists who make work that cannot be sold, and offers a place to exhibit—or screen or read or install such work. Most important, it seems to me now, through stipends and fees for visiting artists and lecturers, it gives artists a venue to exhibit themselves. It has helped to create a figure I referred to in the article as the journeyman artist, whose work must be made on site, whose presence is demanded, and who travels from installation to lecture, "supported by a network of grants, alternative spaces and universities."[8]

Although I would like to claim originality for these observations on the connections between the traveling artist, technology, and the university, they only suggest that I was already well versed in the new

forms and markets of contemporary art. Andrew Menard had noted in
1974 that the increase in the number of art students and graduate de-
gree programs was accompanied by "an increase in expensive kinds of
art." "In fact," he wrote, "I think the current popularity of film and
video at least has a lot to do with schools."[9] Artists and critics from the
1950s on had commented on the traveling, or at least visiting, artist.
Dan Flavin placed the visiting artist and the temporary exhibition at the
center of his program for a new art education in 1968, calling for "a
continuous schedule of one man or one team expositions" accompa-
nied by "an open, continuous visiting artist, lecturer and demonstrator
program."[10] Earlier in the decade, Allan Kaprow too, writing of the
new artist as "a man of the world," suggested that the artist escort the
work of art as its expert, translating the work and the art world it rep-
resents for his audience. "Essentially, the task is an educational one,"
he wrote in 1964; the artist's "job is to place at the disposal of a recep-
tive audience those new thoughts, new words, the new stances even,
which will enable his work to be better understood. If he does not, the
public's alternative is its old thoughts and attitudes, loaded as they are
with hostilities and stereotyped misunderstandings."[11] The artist must
be present, both on the art scene and at the scene of education; for
Kaprow, those sites are the same: "Art politics is not only possible but
necessary. It is the new means of persuasion. And persuasion leads to a
verification of the artist's contact with the world."[12]

A decade before Kaprow, the abstract painter and veteran teacher
Raymond Parker had pointed to the school as a significant site of art
world politics, which he too tied to the artist's presence in the new
post–World War II art departments. Beginning with a popular, and by
now familiar, position in the debate over whether and where artists
should be taught, Parker argued that art cannot be taught, indeed, that
art is precisely what escapes teaching: "Schools can teach all about
art. . . . [yet] art matches neither preparation nor expectation."[13] In lieu
of art, "the art-world can be understood and taught as a subject."[14] But
"the art-world idea, taken for granted in schools, inflates the value of
the artist as a figure."[15] The taught art world determines the status of
teachers in the eyes of the students: "The teacher distinguishes himself
from the student by the authority with which he acts as a part of the
art-world."[16] But it also determines that the visiting artist will be seen
as special, even excessive: "It must be fatuous and embarrassing to the
visiting artist whose mere presence is expected to spice local culture."[17]
Both Parker's "spice" and Kaprow's "persuasion" are terms of excess,

something added. Lucy Lippard too, in her 1973 survey of performance, video, installation, and conceptual art, cited the traveling artist; she fashioned the phenomenon as something added to, but also necessary for, the new art. "The artist is traveling a lot more, not to sightsee, but to get his work out. . . . Even if we get the art *works* out of New York, even if the objects alone do travel, they alone don't offer the stimulus that they do combined with the milieu."[18]

Lippard and those who preceded her all noticed the artist alongside or before the work of art and remarked a surplus in that presence, one that is written as "spice" or "milieu." Writing in 1977 on the work Lippard had chronicled, Rosalind Krauss offered a theory of that excessive presence. The seemingly diverse "post-movement" art of the 1970s, she argued, was united by its substitution of "the registration of sheer physical presence for the more highly articulated language of aesthetic conventions."[19] "Again and again," artists working through the decade in a variety of media, video or performance or body art or earthworks, "chose the terminology of the index."[20] Krauss draws her emblematic case of this choice from a performance, or rather a refusal to perform, by the dancer Deborah Hay. Instead of choreographing a work that would create meanings outside her self and her presence in a particular space on a particular evening—a recognizably separate and bounded dance whose movements would be understood, in Krauss's words, "with relation to one another, and in correlation to a tradition of other possible signs"—Hay told her audience that "she wished to talk."[21] What she said "was that she was there, presenting herself to them."[22] Krauss designates this insistence on presence—on the message "I am here," at this moment, in this situation—the index, but that presence, she suggests, must always be doubled, as Hay doubled hers, with "a spoken text, one that repeats the message of pure presence in an articulated language."[23]

Krauss takes the term "index" from Charles Sanders Peirce, for whom it named signs that are physically inscribed by their referent and thus tied to it existentially. Indexes—a fingerprint, a lipstick smudge— signify what has caused them; they testify to its presence, or its having been present. Krauss derives her index carefully, using as examples those personal and demonstrative pronouns called shifters as well as photographs. Peirce had classed photographs not only as icons, signs that refer by resemblance, but also as indexes, explaining that photographs have been "physically forced to correspond point by point to nature."[24] The shifter and the photograph allow Krauss to theorize the

index as hollow, as needing to be doubled and filled by language. Words like "this" and "that," "you" and "I," have no fixed object; rather, as Emile Benveniste wrote in a text Krauss leads us to, they are "empty" signs, "available [to] become 'full' as soon as a speaker introduces them into each instance of his discourse."[25] They mean without having meanings, without referring, except "to the utterance, unique each time, that contains them."[26] By turning to the photograph, Krauss inhabits and doubles that emptiness with a text, and places it always in the past. "It is the order of the natural world that imprints itself on the photographic emulsion," but for that imprint to mean, or even be described, Krauss suggests, it must be repeated in another language—more precisely, in a conventional one.[27] She quotes Roland Barthes's observation that photographs are "almost always duplicated by articulated speech . . . which endows them with the discontinuous aspect which they do not have."[28] Krauss relies on Barthes to move the index into the past tense as well, to make it, as she says, "physically present but temporally remote."[29] "Photography produces an illogical conjunction of the *here* and the *formerly*. . . . Its reality is that of a *having-been-there*."[30] Like tire tracks and cigarette burns taken as clues, it is an absence, a withdrawal, that secures the photograph's indexical meaning and makes it significant—indeed, exaggerates its significance and makes it "meaningful."

The physical presence of the artist and the redoubling, representational absence carved within it by language is the subject Krauss offers to Hay's performance, a scenario, I would argue, very much like that of the visiting artist. Chris Burden has already made that argument for me: the play of physical presence and representational absence is clearly the project of Burden's *Shadow*, a performance constructed around a visiting artist's appearance at Ohio State University in 1976 (Figure 11). In *Shadow* Burden appears as the visiting artist, costumed as "an avantgarde artist [in] a fatigue jacket, pockets stuffed with notebooks, film, and a tape recorder, opaque dark glasses with chrome rims, a black cap, levis, and a striped T-shirt."[31] Burden's scheduled performance consisted of a recitation of performances completed elsewhere, pronounced in monotone by the artist from behind a backlit scrim. During the scheduled question-and-answer period the following day, his replies were limited to yeses and noes. "My intention throughout the piece was to make my personal presence almost superfluous by revealing little or no information about myself that was not already available publicly."[32] Burden's refusal both to perform the work of art on the first day and to converse on the second—to be off duty as the artist—insists on the logic of the

Figure 11. Chris Burden, *Shadow,* April 26, 1976. Performance, Ohio State University, Columbus, Ohio. Courtesy Chris Burden.

The piece began the moment I arrived at the airport and lasted the entire time I was in Columbus. I was dressed in clothes which I thought would fit people's preconceptions of an avant-garde artist, i.e., a fatigue jacket, pockets stuffed with notebooks, film, and a tape recorder, opaque dark glasses with chrome rims, a black cap, levis, and a striped T-shirt. These clothes were in no way characteristic of my normal attire. During the course of the piece, I acted distant and aloof, and had as little interaction with students and faculty as possible. The University had scheduled a particular time in the gallery for what they believed to be the performance. I had them erect a translucent screen to separate me from the audience. I sat on a chair behind the screen, and a strong light illuminated my profile. I read the audience descriptions of the pieces I had done in the last six years. I allowed 30 seconds between each description for the audience to visualize the piece. The following day I was supposed to have a question-and-answer period with students. But I remained elusive, answering elaborate speculations with a simple "yes" or "no." My intention throughout the piece was to make my personal presence almost superfluous by revealing little or no information about myself that was not already available publicly.

index, the framing and representation of presence through its double. Indeed, sitting behind the scrim and cast as a shadow upon it, Burden produced himself quite emphatically as an index: shadows are exemplary indexes. I would suggest, moreover, that he produced himself as a photograph, not only in his self-production as the public representation of his career, but also in his flat light-cast image. "Every photograph," as Krauss writes, "is the result of a physical imprint transferred by light reflections onto a sensitive surface."[33]

Perhaps now, with the index and the absence that haunts it, that constructs it as a sign, we can link the visiting artist to language—although we could have seen it coming. Kaprow's persuasion, Lippard's milieu, Parker's spice, all suggest that the artist's presence is too much, that it is marked by an excess. That presence supplements the work of art, at once completing and substituting for it. In Deborah Hay's plea and Burden's recitation, language redoubles and represents even that presence. "The supplement adds itself," Derrida explains; "it is a surplus, a plenitude enriching another plenitude."[34] It is both more and less. The supplement is superfluous—"embarrassing," as Parker said—yet it renders the once full work of art and the "sheer physical presence" of the artist wanting and incomplete, at once no longer present and "the *fullest measure* of presence."[35] With Derrida's supplement we mark, in Craig Owens's words, "the eruption of language into the field of the visual arts."[36] This chapter makes the visiting artist a figure for that language: the presence of the artist, "in order to be presence and self-presence, has always already begun to represent itself, has always already been penetrated," hollowed out from within and from the outset as a sign.[37]

Language in the University

I am insisting on the particular significance of the visiting artist and, with Krauss's indexical sign and its supplement, on his or her signification. But there is an easier way to link the visiting artist to language in the university. I can say simply that the visiting artist speaks. Before the performance, as the performance, or after it, in the gallery before an installation or with a slide carousel in a nearby classroom, the visiting artist discusses his or her work, puts it in the context of older work, answers questions about its relation to art by other artists or to current issues and concerns. Of course, speech is not the sole province of the visiting artist. In art schools and departments, faculty speak in front of slides and other artists' works, in crit sessions and graduate reviews.

Students too speak in front of work and double it as they enumerate the critical issues and contents it would address. Speech is now a requirement for the M.F.A. According to the College Art Association's current statement of standards, the young artist needs "self-criticism and external comparison"; "a large part of criticism of self and others is verbal," and thus "verbal skills must not be ignored. The need for continual writing, criticism, and self-explication in the careers of most artists is self-evident."[38]

In Irving Sandler's reminiscences of teaching at Yale in the 1960s, speech is not merely a helpful offshoot of art school practice but characteristically—and early on—the central product of graduate education in studio art. "Like most other graduate programs, Yale's was based on individual work done by a student in his or her private or semi-private space. The basic instruction was criticism of ongoing work by resident and visiting faculty. . . . Work was the proof of seriousness and it permitted students to enter into a verbal discourse with other serious colleagues."[39] Work, specifically work in series, becomes the opportunity for speech, first by faculty and then by students. In both its ongoingness and its guarantee of the right to speak, Sandler's serious work performs a function significantly different from that of the chef d'oeuvre, the masterpiece, that resulted from an earlier education. It neither demonstrates the acquisition of certain manual skills and techniques nor marks the culmination of a period of training. Rather it insists both on going on and on the ongoing production of language.

Much of the debate about training artists in the university, a debate spurred from the late 1940s by the increasing popularity of the M.F.A. degree and the possibilities offered by the G.I. Bill—the debate to which Raymond Parker spoke—was a debate about language, about whether artists speak or should speak. For its supporters as well as its detractors, the university was the source and site of language. "In the university, for better or worse," wrote the Harvard biologist George Wald, who cast the artist at Harvard in the image of the scientist, "it is talking about knowing that is enshrined."[40] The university mediates and administers knowledge, and within its gates the artist was a stranger, even a trespasser, at least according to the editors of the journal *Arts in Society* in 1963.

The intensities of the artist are quite different from—and at times seemingly at odds with—the intensities of the scholar. In outlook, temperament, and even language, the artist is inherently alienated from the traditional concerns and values of higher education, and at times his passions, unorthodoxies and irreverences make him seem a dangerous intruder.[41]

Marked by their excesses, and perhaps by the lack of a certain kind of language, artists pose a threat to the university, but they are also its potential victims. On campus, artists are threatened with disappearance: "Encouraged to present themselves as both artists and scholars," they have ended up as "confused hybrids, not fully acceptable to either species."[42] They have become, that is, what used to be called artist-teachers, a phrase in which the supplement "-teacher" designates the presence of language and the absence of a certain presence, as even those who argued in favor of artists on campus were forced to admit.

Artist-teachers, wrote Gibson Byrd of the University of Wisconsin, "are concerned with words and explanations much more than are professional artists as a group."[43] But if they "tend to be at least semi-reasonable men," he reluctantly adds, "perhaps they are less the artist for it." Byrd may overdraw the portraits of the artist-teacher and his opposite, but the debate he enters might be considered precisely a debate about reasonableness. On one side stands the "unreasonable" artist, traced in Chapter 1 as a visionary whose vision is both marked and made by silence. On the other stands Kaprow's professional "man of the world," or Dan Flavin's "public man, trusting his own intelligence, confirming his own informed ideas."[44] Against the silence of the studio, Flavin insisted that the artist take "overt verbal responsibility" for his or her work;[45] against the idea of art as a birthright or a calling, he argued that art making was a "mature decision for intelligent individuals with a prerequisite of sound personally construed education."[46]

In contrast to Flavin's informed, speaking artist and the art student cast in that image—"as he knows, he talks"[47]—David Smith insisted on silence: "To serious students I would not teach the analysis of art or art history—I would first teach drawing; teach the student to become so fluent that drawing becomes the language to replace words. Art is made without words. It doesn't need words to explain it or encourage its making."[48] Smith demanded drawing as a language to replace words because in the classes taught by the art educators he addressed words had already threatened to replace drawing. For the painter Mercedes Matter, who founded the New York Studio School, the rout was complete; words had already won. Matter, like Raymond Parker, castigated art schools and departments for teaching the art world in lieu of art, in lieu of the drawing that Smith advised. The student is

> cast into the arena to deal with art and history, at best, on an intellectual level. Today, it is possible for a student to go through art school and gain an acute perception of "what is going on," a fairly intelligent grasp of the situ-

ation, and yet have never departed a single step from his original naïveté of vision. In old-fashioned language, he will never have "learned to draw."[49]

Art education as practiced in the university, Matter complained, cannot teach drawing—indeed, cannot teach art—because it has "eliminated . . . the continuity of work in a studio. Take this away and the art has been taken out of the education, and the art school becomes ready-made for the Ready Made."[50] What has replaced continuity—"the monotony of day after day irrevocably devoted to drawing, painting, sculpture"[51]—is language; the readymade is the work that must be talked into existence.

Language and the readymade are Matter's figures—her cause and effect—for the chopping and subdividing of art that she deplored. Language articulates, and it does so in the image of the university: Matter complained that students' time in the studio had been taken up and divided by lecture series and humanities classes. Worse, art itself had been fragmented—split into theory and practice, two-dimensional and three-, color and space composition—by the demands of the academic calendar and credit hours: "for the good of the catalogue."[52] Even in the studio and in front of the model, language intrudes. Employing, like Smith, the figure of substitution, Matter fashioned speech as an unnecessary and threatening supplement: "Silence is rare. Even a relatively quiet room is never without the intrusion of the instructor—for instruction no longer punctuates the student's work, it replaces it."[53]

Matter's conjoining of silence, duration, and representation, on the one hand, and of the articulations of speech, the rationalization of time, and the readymade, on the other, returns in, and as part of, the theorization of postmodernism. Duchamp himself had forecast Matter's joining of the readymade, language, and the "grasp of the situation" that art schools taught. Early on, he compared the readymade to a speech delivered—like Hay's and Burden's—to a particular audience at a particular time.

> The important thing is just
> this matter of timing, this snapshot effect,
> like
> a speech delivered on no matter
> what occasion but at *such and such an hour.*[54]

Like the snapshot and the index—here the insistence is Rosalind Krauss's—the readymade is "inherently 'empty,' its signification a function of only this one instance, guaranteed by the existential presence of

just this object."[55] This bottlerack, this urinal signify—gain their particular meaning—only inside the institutions and discourses that constitute what is abbreviated as the art world.

Readymade Knowledge

In her 1978 study of the California Institute of the Arts, the sociologist Judith Adler repeated the terms of misplacement and ill-fittedness that the editors of *Arts in Society* had offered in the early sixties; she, too, imagined artists as different from university professors, a difference written in the obvious irony of her title: *Artists in Offices*. However adapted to, or accepting of, the arts any campus may be—even if that campus is, like CalArts, an art school—"the college and university milieu jars with the mores of the bohemian subculture in which many artists still participate." She described the collision:

> A subculture which grows out of highly atomized, "loose" occupational structures and exalts qualities of anarchistic individualism (eccentricity, the apostasy and advertisement of personality through flamboyant, spontaneous, and outrageous behavior) confronts the culture and imperatives of a bureaucratic work organization with its stress on certified and universalistic credentials, routinized procedure, formally designated domains of authority and expertise, the subordination of person to office, and the use of formal and hierarchically significant titles. People who may have been drawn to the arts in the first place because, like Marcel Duchamp, they "did not want to go to the office," now squirm slightly in their university offices.[56]

Adler's authority on the habits of an artistic subculture is no less an expert than Duchamp, perhaps the most important historical source for the art of the 1960s and 1970s. But the very terms she uses to differentiate the practices of the university from those of the artist—words such as "bureaucratic" and "routinized"—are those the theorist Benjamin Buchloh has understood as Duchamp's crucial lesson to recent art, particularly to the practice of conceptual art. Adler presumes a special relationship between the university and conceptual art, a link she imagines historically and houses in the word "academic":

> From the time of the earliest academies of the Renaissance, the cultivation of theory and criticism, of intellectual over manual dexterity, has been the hallmark of art academicians. The Conceptual art of the 1960s—with its treatises and its theses, its substitutions of publications for exhibitions, and its redefinition of works *of* art to include esoteric criticism and speculation *about* art—appears to be a genre of academic art finely adapted to the pressures of the new university habitat.[57]

Adler's italicized prepositions repeat both Raymond Parker's observation that "schools can teach all *about* art" and George Wald's description of the university as "talking *about* knowing"; her definition of academic art continues the opposition between word and image that structures so much of the debate I have rehearsed on the teaching of art, and on which much of this chapter depends. Certainly, it recalls the image of the learned artist that I described as the university's goal in my earlier chapters.

The university and its practices appear in the work of a number of conceptual artists in the late 1960s and through the 1970s. David Askevold's game theory demonstrations, Donald Burgy's tests and assignments, Dan Graham's charts and schema, Alain Kirili's exercises in sociology, Joseph Kosuth's seminar rooms with chairs drawn up to open three-ring binders, all these projects and many others partake of what Donald Kuspit has termed "the look of thought."[58] Bernar Venet initiated a four-year pedagogical art project that included studies in nuclear physics and space science, meteorology and mathematics, sociology and politics; his exhibitions during the period consisted of live and tape-recorded lectures by specialists and wall-size photographs of textbook pages accompanied by the recommended volumes (Figure 12). Insisting that he was not presenting "Mathematics as Art; but Mathematics as Mathematics" and, further on, as "pure knowledge as such," Venet fashioned his work as a "manifesto against sensibility, against the expression of the personality of an individual."[59] The university's research and its disciplines offered a body of knowledge and a way of knowing that were—or were imagined to be—disinterested and objective, free from the whims of taste and the traffic in objects. Most important for Venet's project, that knowledge was free from the subjectivity and otherness that had characterized the artist, David Smith's or Mercedes Matter's at any rate, and had caricatured the artist for the university. Here, oddly, the Bauhaus dream of a principled and objective art practice is realized as pure theory.

Venet's presentations recall the research university, the demand for expertise, the urge toward specialization and separate technical languages; James Lee Byars cast his work of the early 1970s in the image of the liberal university and wrote in the language of the humanities. In contrast to Venet's disciplinary researches, Byars's ironically proposed but earnestly pursued projects of the period—to earn a fictional doctorate (a "PhD-fic.") from the University of California and to establish a World Question Center—imagined the artist as a Socratic seeker in the

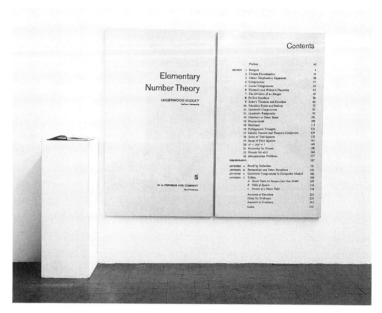

Figure 12. Bernar Venet, *Elementary Number Theory*, 1970. Photographic enlargement, dimensions variable. Collection of the artist, New York.

high research university. Byars asked experts across the disciplines at Berkeley, MIT, and elsewhere for the single central question of their course of study, in language that "would be intelligible to an eighteen-year-old student."[60] His goal was not the particulars of high research but the character-forming roundedness of general education. The questions were intended to locate the trace of a liberally educated personality, the organized residue of subjectivity, in professional knowledge: "I began to wonder if I asked someone for a question that was pertinent to them in regard to the evolution of their knowledge of their own discipline, if that would be a sensible sort of synthesis of that personality."[61]

Finally, Byars asked his scholars to propose the single question, the one to which all the others could be reduced: "total informational synthesis."[62] His vision of the question as singular, a synthesis of discipline and practitioner, and eventually the essence of all language, suggests the project of art and artists in the liberal arts: the arts as a synthetic, inseparable knowledge, and the artist as a sort of outlaw in the university, crossing and mixing disciplines, searching for their shared essence, for the big picture. This was one of the roles proposed

for the newly emergent art department in the university. Byars's World Question Center echoes the Fluxus artist Robert Watts's more serious, or at least officially requested, proposal for a new arts program on the campus of the University of California at Santa Cruz. In his 1970 report, Watts, then teaching at Rutgers, imagined Santa Cruz's art department as an interdisciplinary think tank, where the artist could join with "a biologist, a psychologist, a sociologist, and a philosopher . . . to generate ideas."[63] The point was the same as that of Byars's project, to raise questions "which are not being asked and not being dealt with."[64]

The idea of art as a search for knowledge, and of the artist as teacher, Socratic in Byars's case, rather more modern and distracted in Venet's, was forwarded in numerous writings on conceptual art and, earlier in the 1960s, on minimal art envisioned as a Platonic geometry. Like the sciences, like the objective disciplines of the university, and against the pessimistic subjectivity that had characterized abstract expressionism through the 1950s, the new art was read as a "triumphant illustration of the powers of human reason. . . . [W]hat else could conceptual art be?"[65] Rosalind Krauss asks the question ironically, for what she finds in the serial works of Sol LeWitt—the artist who led Kuspit to coin the phrase "the look of thought"—is not the triumph of Cartesianism and the restoration of the Renaissance humanist artist, but rather an art marked by a numbing and absurd repetition. An art of "almost identical details, connected by 'and,' "[66] LeWitt's art and his quite literally minimal systems refuse the synthesizing and generalizing and extrapolating that characterize thought—at least, those thoughts that would be contemplated in Byars's question center or Watts's art department. The 122 units of LeWitt's *Incomplete Open Cubes* offer, not knowledge or applicable law, but simply exhaustion (Figure 13). The order, as Donald Judd famously pointed out about minimalism's refusal of composition, is simply order, "one thing after another."[67]

Thus against a reading that would tie LeWitt's sculpture to a tradition of geometry as knowledge, and the minimal or conceptual artist to the Albertian one, Krauss insists on the work's absurdity. Benjamin Buchloh has linked conceptual art to the same aesthetics of "simply order." His reading can also tie conceptual art to the university, not along the paths to knowledge that Byars and Venet pursue or against the campus backdrop they present, but through his suggestion that conceptual art operated an "aesthetic of administration,"[68] an aesthetic that might feel at home in the offices Adler described, marked by routinized procedure and formally designated domains of expertise. One

Figure 13. Sol LeWitt, *Schematic Drawing for Incomplete Open Cubes, 1974,* 1976. Ink over graphite on paper, 13 × 12 $^{15}/_{16}$ inches. © Sol LeWitt, Courtesy of the New Britain Museum of American Art, Connecticut. Photography: Michael Agee.

might point to number twenty-five of Frederick Barthelme's 1970 series *Substitution Works* (Figure 14): a dated sheet of copy paper bearing the typeset words "Instead of making art I," followed by the typed-in conclusion, "filled out this form."

If in its inability to synthesize or summarize LeWitt's *Incomplete Open Cubes* is not finally a learned work of art, then perhaps in its absurd and exhausting repetitions it is at least a didactic one—the word "didactic" often carries such negative connotations. "Didactic Art" was among the names given to conceptualism at the end of the sixties; the French critic Catherine Millet used the term to describe Venet's project. Venet's use of lectures and books, even of whole disciplines, can be seen as a form of "unassisted readymade," she argued, but the lessons of

DATE: February 22, 1970

SUBSTITUTION: 25

INSTEAD OF MAKING ART I filled
out this form.

Figure 14. Frederick Barthelme, *Substitution 25*, February 22, 1970.
Xerox paper, 8 ½ × 11 inches. Collection of the artist. Photography:
Jonathan Durham.

Venet's work, unlike Duchamp's readymade, lay neither in its gesture
nor in the art world: judging Venet's work consists in asking, not why he
has done it, but whether the information is accurate.[69] Barbara Rose
also wrote at the end of the 1960s of "the value of Didactic Art," and
she too found its model in Duchamp's unassisted readymade: "Pure di-
dactic art includes that whole class of found objects which Duchamp
termed 'unassisted readymades,'" objects that cannot be art, but can
only be seen as or, better, called art.[70] The lesson of Rose's didactic art

was precisely an art world lesson: only there does this object or that teaching from somewhere else matter. In the art world, Venet's title pages and lectures are "illustrations of theoretical aesthetic positions condensed into a single object, which stands for the entire argument."[71] The positions Rose notes are those of the art politics that Allan Kaprow wrote about, which sent the visiting and lecturing artist on the road and into schools. Rose's didactic art is precisely professional and disciplining: its value is "not as art but as dialogue," and, she argued, "it is made . . . for internal consumption within the art world."[72]

Conceptual art on the model of the readymade is probably not what George Wald had in mind when he championed art at Harvard and united the studio artist and the laboratory scientist—active producers of the very material of their fields—against the professors of the old humanities. "Other departments in the university are concerned for the most part with contemplating, ordering, and evaluating the activities of others," and in them "great emphasis is laid upon classification, description, explication."[73] For Buchloh, this very ordering characterizes conceptual art and the works that exemplify his aesthetic of administration. He quotes Sol LeWitt on the "serial artist," who differs from Wald's productive researcher and Byars's philosopher. The serial artist, writes LeWitt, "does not attempt to produce a beautiful or mysterious object but functions merely as a clerk cataloguing the results of his premise."[74] His project is to administer and organize information, to shuffle papers and list facts that gain validity—like Venet's mathematics as art in the art world—solely from being facts: all facts are equal. Using as examples Ed Ruscha's books of parking lots and apartment buildings and "every building on the Sunset Strip," Buchloh describes the lists that characterize much conceptual art (and could include Venet's list of disciplines) as the "antihierarchical organization of a universally valid facticity, operating as total affirmation."[75] This, according to Buchloh, characterizes conceptual art and its inheritance from the Duchampian aesthetic, read as minimalism's "one thing after another."

The readymade, the work that refuses the difference between art and its other, that is presented as a fact, as "total affirmation," is crucially involved in the project of conceptual art. It seems to have waited for us at every turn. A variety of the figures I have introduced have connected the readymade to the university, or at least to schooling and the speaking of art as language. Buchloh's version of conceptual art is founded, in no small part, on a theorization of the readymade, and on a reading

of how conceptual artists have understood its implications. Certain conceptual artists have understood the readymade as Barbara Rose and Mercedes Matter understand it, as an excess of speaking—specifically as a speech act. The model is Robert Rauschenberg's telegraphed submission to a 1961 exhibition of portraits at the Galerie Iris Clert, "This is a portrait of Iris Clert if I say so." The idea that the readymade speaks about art rather than does it—the readymade, in Buchloh's words, as "willful artistic declaration"[76]—echoes the familiar criticisms of the artists in the university: that they are too verbal, too theoretical, and finally too careerist.

Buchloh would like the readymade to be more than that. Not only does it operate, as Matter suggested, in the absence of figurative representation and authenticity but it also, he argues, negates them. The readymade "replace[s] the studio aesthetic of the handcrafted original" with "repetition and the series," forms that link it to the "law of industrial production" and—as I argue below—to the production of art in graduate school. Moreover, according to Buchloh, the readymade, as retheorized by conceptual art, comes to replace an aesthetic of production and consumption—of canvases that can be shipped off, for example—with "an aesthetic of administrative and legal organization and institutional validation."[77] Conceptual art's readymade suggests that the institution's pronouncement, not the artist's, allows an object to be read as art.

> In the absence of any specifically visual qualities and due to the manifest lack of any (artistic) manual competence as a criterion of distinction, all the traditional criteria of aesthetic judgement—of taste and of connoisseurship—have been programmatically voided. The result is that the definition of the aesthetic becomes on the one hand a matter of linguistic convention and on the other the function of both a legal contract and an institutional discourse (a discourse of power rather than taste).[78]

In graduate programs in art, particularly the most successful ones, manual competence no longer plays a central role in judging works or makers. No longer is the criterion, as it was in Matter's academy, the matching of a rendered figure to a figure in the world, to the model on the modeling stand or the plaster cast on the table: the artist need not demonstrate the traditional manual skills and techniques of representation but instead must possess certain kinds of knowledge and occupy a certain position. It is precisely a convention that we call our practitioners "artists"; the modifiers and combinations shackled to the word in the 1950s and 1960s—as in "teaching artist" or "artist-teacher"—marked a struggle to keep an ontological difference in the name "artist," a refusal

to surrender it outright to those who merely hold the degree, and to a simply legal or institutional definition. The M.F.A. makes artists in the same way the artist makes art in the image of the readymade, as a matter of linguistic convention, according to a legal contract—or approaching one—and certainly within an institutional discourse.

Theorizing Postmodernism

"Can there be any doubt that training in the University has contributed to the cool, impersonal wave in the art of the sixties?" Harold Rosenberg asked in 1970, charting the distance between David Smith and Dan Flavin in tracing the path from atelier to university classroom. "In the classroom—in contrast to the studio, which has tended to be dominated by metaphor—it is normal to formulate consciously what one is doing and to be able to explain it to others."[79] Metaphor, an apt figure for the language of the studio, "opens an eye . . . at the center of language," writes Derrida, and "draws its energy from the visible."[80] Through its appeal to the eye, metaphor makes present and whole: Paul de Man described the "inference of identity and totality that is constitutive of metaphor," tying it to necessity against metonymy's contingency.[81] Lacan, too, linked metaphor to "the question of being"— what the subject once was—"and metonymy to [the subject's] lack," to the always temporary and contingent *"something else"* that might make it whole, that seems like its return.[82] Following Lacan and the other theorists I have cited, we might use Rosenberg's metaphor to describe not only the studio but the work made inside it that aspired, in Clement Greenberg's well-known words, to be "something *given,* increate."[83]

Michael Fried's statement in the early 1960s of modernism's desire builds on Greenberg's phrase, but de Man's linkage of metaphor to necessity and metonymy to chance echoes in it as well: modernism seeks the work that makes us accept the conventions of painting as "essential, and even natural . . . in the face of our awareness of their precariousness, circularity and arbitrariness."[84] The successful modernist work makes us see metaphorically. The path Rosenberg charts from studio to classroom, then, might be charted as the passage from metaphor to metonymy; the texts to which I now turn map it as the transformation from modernism to postmodernism. I want to claim that the writing on postmodernism that emerges as a critique of Greenbergian modernism in the late 1970s continued and repeated the debate about where and how to educate artists—a debate with the troubling matter of language at its center.

I have argued that in the 1970s the university, because it offered economic and technological support for an artistic practice that often produced no salable object, enabled the development of a new art. It offered a room and an audience for work that was in one way or another transitory. For performances and film and video screenings one must assemble an audience, often a student audience; for site installations, image projections, and light chambers one must be there—because, as Robert Morris said of minimal sculpture, "the experience of the work necessarily exists in time."[85] The experiential nature of minimal art, the viewer's sense of temporal duration, was Michael Fried's focus in his influential critique of minimal (he called it literalist) art, which he opposed in the name of modernism.

Minimal sculpture, according to Fried, constructs the viewer as an "audience of one": it "*depends on* the beholder, is *incomplete* without him, it *has* been waiting for him."[86] The viewer's being there, self-consciously experiencing his own presence with the work, completes the work and provides its experience: the time of that experience becomes the time of the work. The model for this experience of the needing, incomplete object is theater. "Theatre *has* an audience—it *exists for* one."[87] Like the work of minimal art and the art made in its wake, theater requires a specific site, one that might be located once again in what the college campus offers: "The concept of a room is, mostly clandestinely, important to literalist art and theory. In fact, it can often be substituted for the word 'space' in the latter: something is said to be in my space if it is in the same *room* with me."[88]

Read differently, Fried's theatricality would become an important term for theorizing postmodernism in the visual arts; the negative attributes of his minimalism would come to characterize the art of the 1970s and in the late 1970s and early 1980s would become the defining and critical attributes of postmodernism. "The success, even the survival, of the arts," Fried declared, "has come increasingly to depend on their ability to defeat theatre."[89] Writing in 1979 in support of the art that Fried had pledged to defeat, and indeed marking its ascendancy, Douglas Crimp suggested that "Fried's fears were well founded. For if temporality was implicit in the way minimal sculpture was experienced, then it would be made thoroughly explicit—in fact the only possible manner of experience—for much of the art that followed."[90] Crimp's remark that duration now forms "the only possible manner of experience" specifically addresses Fried's description of—or dream for—the experience of the modernist work, the sense that "*at every moment the*

work itself is wholly manifest."[91] That combination of immediacy and wholeness was central to Fried's modernism, and to its future: "I want to claim that it is by virtue of their presentness and instantaneousness that modernist painting and sculpture defeat theatre."[92] Against the "presentness" of the modernist work, its existence always in, or even as, "a continuous and perpetual present," minimalism offered merely a "*stage* presence," an exaggerated presence that was a function of "the special complicity that the work extorts from the viewer" by asking that we notice and credit our experience to it.[93] "Something is said to have presence when it demands that the beholder take it into account, that he take it *seriously.*"[94] Minimalism, in Fried's scenario, asks only that we take it as though it were art, that is to say, as something like art.

First in "Pictures" in 1979 and then, a year later, in "The Photographic Activity of Postmodernism," Crimp began to name the art that followed minimalism as postmodern and to construct it as minimalism come true, the realization of Fried's fears. "It can be said quite literally of the art of the seventies that 'you had to be there,' " Crimp wrote in the earlier essay.[95] Performance literalized the terms with which Fried had critiqued literalist art: it required the physical presence of artist and audience at a certain place for the actual running time of the work—in Fried's terms, it staged theater. In the later essay, Crimp cast minimalist presence once again as stage presence, linking the hollowness, the neediness, and the theatricality that Fried had criticized in minimalism to the absence that representation stages, tying the "*being there* necessitated by performance—to the kind of presence that is possible only through the absence that we know to be a condition of representation."[96] What Fried labeled theatrical "presence," Crimp argued, is a presence marked by absence, already held in representation. This exaggerated, hollowed presence is what Krauss described with the index and what I have attempted to include in the figure of the visiting artist; Crimp, too, characterizes this marked presence with the supplement: it is "a kind of increment to being there, a ghostly aspect of presence that is its excess, its supplement."[97] His example for this "more than there" that hollows out and haunts presence even as it represents it, is the stage presence of the performer Laurie Anderson, but he could be describing Chris Burden in *Shadow* or the performance of any visiting artist, the figure, as we have already seen, that functions as milieu, as spice, as supplement.

The late Craig Owens turned to the descriptions and forecasts of Fried's "Art and Objecthood" to ground postmodernism in the writings of Robert Smithson and other artists associated with minimal art. In his

early essay "Earthwords," the very presence of language in the work of visual art and between its métiers inaugurates the rupture with modernism in the 1960s. "When late in that decade it was recognized that a break with modernist practice had taken place, the late modernist critic Michael Fried diagnosed it as the invasion of the static art of sculpture by duration, temporality. What his postmortem actually discloses, however, is the emergence of *discourse*."[98] As Owens points out, Fried begins his critique of minimalism with an address, not to its objects, but to its writing—the writing of its practitioners and its objects as a kind of writing. Minimalism, Fried complains, is "largely ideological. It seeks to declare and occupy a position—one that can be formulated in words, and has in fact been formulated by some of its leading practitioners."[99] The problem of minimalism is serious; it cannot be dismissed like pop or op, Fried suggests, because minimalism's ideological posturing threatens to render even silent works positional and discursive. Minimalism depends on other, less "written" forms, specifically on modernist painting and sculpture; it characterizes them as positions—as though they too were written—to occupy its own: "Its seriousness is vouched for by the fact that it is in relation to modernist painting and modernist sculpture that literalist art defines or locates the position it aspires to occupy. (This, I suggest, is what makes what it declares something that deserves to be called a position.)"[100]

Minimalism cannot suspend the knowledge of an art world or of a professional discussion of art; rather it requires us to hold that discourse to make it present. Once again, it needs us to take it as though it were art. Minimalism cannot perform the task of modernism, to be, or seem to be, "essential and even natural." The goal of modernist painting was to so include the moment in which it was made both physically and philosophically, to make it so much a part of its image, that it could temporarily suspend the knowledge of its determinations, the sense that it had been made out of and within the limits of a conventional historical practice. This is the source of the presentness that Fried grants to the modernist work and opposes to the theatrical presence of minimal art. Theater suspends time, he argues; "expectation, dread, anxiety, presentiment, memory, nostalgia, stasis" are its versions of temporality, and time in those words promises its deliverance elsewhere. In stark contrast, the modernist work compresses its past, includes it within itself as vital and present:[101] "as though if only one were infinitely more acute, a single infinitely brief instant would be long enough to see everything, to experience the work in all its depth and fullness, to be forever

convinced by it."[102] In the words of Fried's friend and mentor Stanley Cavell, "Each instance of the medium is an absolute realization of it; each totally eclipses the others."[103]

If the goal of modernist painting was, as Rosalind Krauss rehearses Fried and Cavell, "to summarize and culminate parts of the past . . . to make the past part of its present," at some point "this felt transparency between past and present silted up."[104] The image no longer contained its past as an integral and present part of itself. "Rather, both the past and the problem are felt to reside outside it, and access to them can only be achieved by a long chain of explanation that characteristically takes the form of narrative."[105] In graduate school, the realization and eclipse that Cavell imagined are impossible—and what makes them so is not an issue of quality or artistic maturity. For graduate work depends on making visible, and making verbal, its determinations; its maker must know and insist on its contingency and its position, must always reexplain and paint over the top of the relation between past and present. In the student critique or the visiting artist's lecture, the work is always presented in the narrative that Krauss notes. In the slide carousel, no image can be *given* because every image is framed and positioned by—is a position *on*—what is not there and on what it is not: the slide next to it on the screen, before it or behind it in the tray. Each work is linked to a past made narrative and presented to the students as part of a discourse within which they must situate themselves. Or, perhaps, about which they must take a position.

The work of art, at any rate the student work of art, is never allowed to culminate its past, to summarize or end it. Like Fried's work of minimal art, "it is endless the way a road might be."[106] Unlike work in the academy, which was corrected against the model or the cast and against the perfection realized in the work of acknowledged masters, and far from the guild idea of the chef d'oeuvre, there is no end to the production of work in graduate school that can be seen or proved in the work and its meanings, that can be related to the work's transparent address to its own history or to the visible world. The time of graduate school is determined by the demands of the degree and the university: two years and sixty credit hours. The work of students in the program never culminates as proof of mastery over either materials or histories. At no point in the program's progress—indeed, at no point in the progress of the student's work—can the faculty say, "This is fine, you may go." At the end of two years, in the fourth semester, this culmination is not realized but staged as a show.

The student work is always an open work; it is always on its way to somewhere else, to being something else. It exists as a place marker, and only in relation to another work produced offstage, or rather, off a number of stages. Each presentation must begin from the last work and from where the discussions around it paused. It must be significantly and narratively different from, but still like, the last. But that is only one of the narrative relations from which student work takes its meaning. In addition to this plotting along the diachronic axis, each work is positioned by the student and then by the faculty according to their maps of the art world. In the stock questions of the student crit—"Have you seen? Have you read? Have you tried?"—work is not corrected; it is not made whole and more like itself. Rather, it is continued, extended, and completed elsewhere according to what is recognized in it—and what it can, therefore, be positioned against. There will always be a position for it.

Following Owens's suggestion that the break with modernism is marked by "the eruption of language into the field of the visual arts," I have in the preceding pages linked the art department and the production of postmodernism in the visual arts by placing language at their shared center. The language I have situated there has admittedly been broadly drawn. Along with the literal speech of artists and teachers and students, and as a function of that speech, it has included a narrativization—or a structural emplotment—of the individual artist's relationship to the past and to a present viewed as outcome. It has included, as well, the fissuring of presence by the absence of representation, the redoubling of presence by the supplement, and the extension of presence in that series "one thing after another." For a number of critics writing in the 1980s, these decenterings by and in the name of language came to characterize the critique of modernism mounted by "a demythologizing criticism and a truly postmodernist art." Understood as new knowledge, as what now must be taken into account, they became the criteria for that "postmodernist work [which] speaks of itself."[107] Yet the impossibility of fullness and self-presence that language has stood for here—whether that self is imagined as a speaker, a subject, or an agent in history—is a fully modern condition: the theoretical terms are Saussure's, Freud's, and Marx's, and they are both taught in and enacted by the university in which postmodernism emerges as the professional language of artistic production, a language whose task it is to produce a discipline and project itself into and as the future. Thus, when postmodernism "speaks of itself," even if it speaks, as Owens continues, only "to narrate its own contingency, insufficiency, lack of

transcendence,"[108] it names itself as a project of the university, a specu-
lative project. In Jean-François Lyotard's phrase, it "expound[s] for it-
self what it knows."[109] Postmodernism here proclaims its self-knowledge,
its knowing better, and its knowing what must be done. "In that act of
self-recognition," Owens writes, "there is a challenge to both art and
criticism, a challenge which may now be squarely faced."[110] In its self-
naming and in its demands on the future, this postmodernism is only
Lyotard's modernism once again: it "guarantees that there is a meaning
to know and thus confers legitimacy upon history (and especially the
history of learning)."[111] It insists on and is driven by the knowledge
or the fear that "something remains to be determined, something that
hasn't yet been determined."[112]

The Model

Readers of earlier drafts of these ideas have suggested that the acade-
mies of the seventeenth and eighteenth centuries might offer some
precedent for the place of language and the role of theory in the art de-
partment. Just for starters, one might note a resemblance between the
contemporary art department chair and Norman Bryson's description
of the first director of the French academy, Charles Le Brun, as the site
where "two great forces" converged: "bureaucracy, and the text. Al-
most before he is a painter he is a bureaucrat, and the profile of his ca-
reer (career is the operative word) is that of the eminent civil ser-
vant."[113] There are, of course, more important resemblances.

The presence of language characterized the academy; the teaching
and theorizing that took place there distinguished it from an older sys-
tem of apprenticeship, and academicians from the organized artisans of
the guild. By the 1570s lectures in geometry, perspective, physics, and
anatomy were part of the sequenced educational program—at least on
paper—of Vasari's Accademia del Disegno. The Accademia di San
Luca, which opened in Rome in 1577, proposed to devote an hour each
day to theoretical debates and disputations on such issues as the prece-
dence of painting or sculpture, or the definition of *disegno* or of *decoro*.
To Federico Zuccari, elected the academy's *principe* in 1593, such
"learned conversation" was "the mother of knowledge and the true
font of all science."[114] As early as 1653, the fledgling French academy
had proposed a series of regularly scheduled public lectures on issues of
theory and painting, in no small part as a political maneuver to shore
up its status and to demonstrate the difference of its members from

those who still belonged to Paris's medieval artists' guild, the *Maîtrise*.[115] When they were finally realized by Le Brun in 1667, the monthly *conférences* placed individual works from the royal collection before the public and the assembled academy for discussion, "focus[ing] the word on the image with an intensity that is without precedent."[116]

Like professional training in the post–World War II university, the academy was dedicated to the production of theory, and founded on the primacy of theory over practice. The French academy's definition of painting and sculpture, submitted in a legal brief in 1775 on behalf of those unfortunate artists still incorporated in the *Maîtrise* with "ornament and wood Sculptors, or masonry Sculptors or Heraldic Painters or House-Painters, or Gilders, or Monumental Masons, or Varnishers, or Colour Merchants," echoes the twentieth-century definition of a profession, also drawn from the courts.[117] Painting and sculpture grounded in academic training were entitled to "the same liberties enjoyed by the other liberal arts" because, the academicians argued, they pertained "more to the impulses of genius and the labour of Intellect than to that of the Body."[118] At the height of the academy in the eighteenth century the manual elements of an artist's education, the grinding of paint, the preparing of canvas or panel, and the casting of plaster or bronze, took place elsewhere; these remained the province of associated workshops or ateliers. Apprentices began their training with the material base of the work of art, with such grindings and preparings, but the young academic *élève* proceeded by drawing first from engravings, then from casts, and finally from the nude model: the work of art in the academy was solely representational, and drawing was its theory of representation. "Drawing alone was taught at the Academy and the Academy emphasized it as the theoretical element uniting all the branches of art. This separation of the artist's instruction into the practical and the theoretical was retained intact [from the 1650s] until 1863."[119]

If the academy was marked throughout its reign by the presence of language and the production of theory, it would also be defined by the representation of the nude figure. Nikolaus Pevsner speaks of the "coincidence of the term academy and the fact of life-drawing" as early as the academy of the Carracci in Bologna in the late 1500s.[120] And Albert Boime notes that "as early as the seventeenth century, drawings and paintings after the model were called *académies*."[121] The academy's insistence on both language and the figure seems contradictory.[122] How can the study from life coexist with the schematic and the formulaic,

the intense focusing of words on the image of which Bryson speaks? How exactly, to reach back to the generation that provided the models for Vasari's academy, do Albrecht Dürer's painstaking studies of a rabbit or a chunk of earth relate to his numerous pages of preordained proportions, mapped down to the fingertips, for men, women, and children? The same question might be asked of the empirical specifics of Leonardo's anatomies and the universals of his Vetruvian man.

Perhaps there was no contradiction between anatomy and schematics for Dürer and Leonardo, or for the artists of the academies: to observe nature would be to discover its order or, later, to place it in order. Drawing can equal theory, as Boime suggests, because theory as *disegno* underlies the world; it is given in the order of nature and the (pre)vision of God. Painting, sculpture, architecture become the workshop clothing of drawing as theory, as the particulars of the world clothe the order God has made with his vision, the projection of his design. The artist, in marble or on canvas, makes images of an "inner intellectual Design," an interior vision granted by God that is itself a copy of his creation: "To act externally [God] necessarily looks at and regards the internal Design in which He perceives all things that He has made, is making, will make, and can make with a single glance."[123] Thus, in Zuccari's etymological formulation, "*disegno = segno di dio in noi* (design = the sign of God in us)."[124]

Theory lies at the center of the world because the visible world is already a representation, a visual image—"a single glance"—of God's vision. "This Idea," wrote Giovanni Pietro Bellori, Annibale Carracci's biographer and Poussin's champion in the French academy, "is revealed to us and enters the marble and the canvases. Born of nature, it overcomes its origin and becomes the model of art; measured with the compass of the intellect it becomes the measure of the hand."[125] The academician then, armed with the intellect that would measure the accidents and specifics of nature and draw from them the image of a greater similarity, retrieves and represents the design that has preceded him, God's drawing or nature's. The nude model on which academic training was based coexisted with another, ideal, model, of which the world was already a picture. The goal in drawing from the model, the real if prosaic one that sat at the center of the studio, was to find the model, to find what Sir Joshua Reynolds called the "central form . . . from which every deviation is a deformity."[126] Thus if the model at the center of the room is not the model of art that lies at the center of the academy and of the world, he or she instanced and imaged it; Reynolds's "central form" comprises the cosmology of the academy and the topography of

the studio. I would note here that the custom that emerged in art schools at the dawn of photography of posing a nude model at the center of studio class portraits might be read, not (or not only) as the artists' challenge to bourgeois morality or as the secular reappearance of the allegorical Veritas, but as the image of—the model for—a representational paradigm based on the picture and on plenitude, on the presence of the model.

Harold Rosenberg's description of the studio as the site of metaphor now seems particularly apt, for metaphor is the figure of likeness, of painting and fullness. "When representation is conceived as imitation," writes Paul de Man, "in the classical sense of eighteenth-century aesthetic theory, it confirms rather than undermines the plenitude of the represented entity. . . . The model for this idea of representation is the painted image, restoring the object to view as if it were present and thus assuring the continuation of its presence."[127] In the academy both image and language were tied to likeness and the reproduction of the object present; both image and language were imagined as pictures. The language that marks the contemporary graduate school and models its images, however, is not the full language of the academy; it cannot make present. Rather it is the language that structuralism describes, a system of negative differences. In this language and the images made in its image, there is "no more resemblance or lack of resemblance, of God, or human being, but an immanent logic of the operational principle."[128] At least, this is the story I want to tell with the model and the visiting artist. In *Simulations*, Jean Baudrillard discusses two mechanical figures, the baroque automaton and the modern robot: "A whole world separates these two artificial beings. One . . . submits entirely to *analogy* and to the effect of semblance. The other is dominated by the technical principle."[129] Like the baroque automaton, the model is marked by likeness, tied to the world and its order by analogy. The visiting artist works like the modern robot, along a line demarcated by difference in repetition.

Postmodernism as the Knowledge of Modernism

In 1963 Henry Raleigh, an artist and teacher at the State University of New York at New Paltz, described the teaching of art as the teaching of "visual differences." "In the broadest sense the art instructor acts the role of critic who continually corrects the work of the student against a given standard," even when the standard is, as he says it is now, "newness."[130] Teaching, he argued, is the "process of eliminating error

against an ideal model," an explanation that allowed him to link even the most current teaching to "the master-apprenticeship system [and] the art academies of the 18th and 19th centuries."[131] But there is a difference between a present model—the model at the center of the room—and an absent one. Raleigh offers a model of structural language, of negative difference, not of pictorial imitation, and he is forced to introduce temporality, series, into his description.

> The judgement of what is or is not creative depends on the degree of difference that may be noted between any two given objects. The creative form exhibits visible, physical differences from forms that have preceded it or are contemporary to it. The creative man or the creative artist produces objects that are not like the objects that other men or other artists . . . produce.[132]

The goal of Raleigh's student artist is to produce the not-like, but that difference can be seen only in series, only in relation to a temporal order of like objects that it can be different from. In series, works take their meaning from not being some other. Moreover, they represent neither that other nor any other but lie next to, and mark a distance from, it.

In the academy, the validity of a student artist's drawing was based on its connection with and its likeness to the model. The relationship between the drawings of different students was a limited and spatial one, always subordinate to and routed through the center, through a relationship to the model. In contrast, the teaching of differences in the modern university is continuous, even endless; Raleigh himself worried that his definition of creativity as difference might lead to sheer contiguity, "an endless race."[133] His worry recalls Michael Fried's description of minimalism as an endless road: "It is always of further interest; one never feels that one has come to the end of it; it is inexhaustible . . . not because of any fullness . . . but because there is nothing there to exhaust. It is endless the way a road might be."[134] The shift from academy to university enacts a transformation that Baudrillard has theorized, from representation—the "redoubling of the world in space"—to repetition, the "indefinable redoubling of the act in time."[135] Artistic practice is now "committed to an implicit seriality," necessarily, if inadvertently, "dedicated to homologically illustrating the seriality of all other objects and the systematic of an increasingly well integrated world."[136]

Produced and consumed as differences within a series, the objects of modern art are like everything else, or as Baudrillard more judiciously puts it, they "signify in the same mode as objects do in their everydayness, according to their latent systematic."[137] In graduate school serial-

ity and the production of meaning "according to the play of successive differences" are explicit;[138] they must be acknowledged, be part of what is known, to perform the integration that the rationale of the series—indeed, of the discipline—demands. Each work is made from the outset as precisely what the discourse of art education makes each work on its arrival: the story of when and where it entered. Each is constructed to be taken into the very narrative of which it is made. The form of this story in the university is different from that of the stories of artists told in the academy; the academy offered, not art history, but a picture of art and a model of perfection. In 1708 the French academician Roger de Piles fashioned the order of "the most noted painters" from the Renaissance forward, not as a story of progress or even of decline, but as a scale or, in his word, a "balance." The merit of each painter on the alphabetical list of names was determined by—and his relation to other artists, routed through—his approach to, or fall from, a "sovereign perfection."[139]

The student artist's delivery into the story of the progress of modern art is a graduation requirement for the M.F.A. The College Art Association asks for "a critical statement, in writing, on the student's work, its development, and its cultural and historical references"; all but nine of the nation's 184 graduate studio art programs require an oral defense of a thesis project, and over a hundred list an additional written defense.[140] Some require public lectures or published catalogues, monographs on oneself as an artist. Norwich University in Vermont proposes "an extended self-evaluation in [the] final semester where the students examine their work within an art-historical and social context."[141] The artist Mark Stahl, who received his M.F.A. from CalArts in 1981, has credited that school's success in the late seventies and early eighties to a similar teaching.

> Students are endowed with a sense of how history works on and through their work. They are encouraged to understand their placement within the flux of history and the relation of their work to the continually evolving state of art theory. [They] quite consciously adop[t] certain procedures, strategies and practices which, taken as a whole, create a critical distance in the artworks [through] an emphasis on the use of form that tends to betray its historically determined status and its culturally conditioned reception. This critical distance is a manifestation of the acute awareness of history and theory that CalArts promotes.[142]

In Vermont and in southern California, students must produce themselves as part of, and as an already narrativized position on, art history

as a professional discourse. As Stahl suggests, CalArts's version of that history is particularly up-to-date, but the task of art schools across the country is to provide a language that we can speak together as professionals, and to ensure that its concerns will be the student's concerns. The student's task, like that of his works, is to take—and to mark—his or her place. All art in the university, then, might be described as Fried described minimalism, as an ideological art. Or even a political art: according to Hal Foster's maxim, for political art, "historical specificity, cultural positioning is all."[143] The task of my final chapter will be to plot and edge the field in which that positioning takes place.

TOWARD

A THEORY 7

OF THE M.F.A.

I began this project by asking why, if I held an M.F.A. in sculpture, I could not carve or cast. Why had I not been taught the traditional material practices of sculpture? Why was any specific material practice in some sense optional? What did my M.F.A. certify or enable me to do? My questions about the degree turn out to be old questions. Through the 1950s and into the 1960s, most critics, and even level-headed supporters, of degrees in the practice of art argued that no certification could measure creative success, indeed that any degree was a deception. Carnegie's Norman Rice, who chaired the national agency that accredited degree-granting programs in the studio arts, derisively acknowledged the obvious, that "a degree is a by-product of art education, not a warranty that artistic euphoria has been achieved."[1] Rice wrote in 1963, in a special number of *Arts in Society* entitled "The Creative Artist Invades the University"; at the time, some seventy-two art schools and universities offered the M.F.A., more than double the number in 1951. By 1978, the year I received my M.F.A., there were 118 accredited graduate studio art programs, but the value of the degree remained a question, as did what exactly it certified. Unlike law or medicine, wrote the sociologist Judith Adler, there are "no legal licensing requirements for the practice of art [and] a formal degree gives only minute competitive advantages to its holder in any marketplace other than that of teaching (the claim to being a 'certified sculptor' or a 'qualified poet' being fruitless)."[2]

Like many, Adler located the market for the M.F.A. in college- or university-level art education, as did a resolution approved by the 1959 Midwest College Art Conference, which recommended that the M.F.A. "be considered the terminal degree for teachers of studio courses."[3] The College Art Association adopted this recommendation at its annual meeting in 1960, but the CAA's report on the status of the degree in 1965 included the caveat that although holders of the M.F.A. use the degree "in large part . . . as an entry into the teaching field," it is "evidently not generally designed in a specific way to prepare the student for this."[4] By 1977, the year the College Art Association's current guidelines were adopted, the M.F.A. was explicitly not a teaching degree. Rather, it guarantees that one is—or at the very least has the ability to be—an artist.

Currently, according to the CAA, the degree Master of Fine Arts is to be "used as a *guarantee* of a high level of professional competence in the visual arts"; it promises not only a "certifiable level of technical proficiency" but also, and without equivocation, "the ability to make art."[5] The guidelines hedge on, and the degree cannot certify, teaching: "Having earned the degree does not necessarily guarantee an ability to teach this proficiency to others."[6] College and university art teachers are hired as artists rather than as educators; that is, they are hired as other university educators are, for their research and their careers, like historians or biologists. Again, the CAA's 1977 guidelines: "Not every good teacher needs to be a recognized star, but the CAA is concerned that all graduate faculty be fully competent professionally." In a revision approved in 1991, the sentence continues, "and that they be professionally active in their respective disciplines and fields."[7] Those fields lie in what is loosely termed the art world, in one or another of the particular communities intricately intertwined with the art practiced and taught in the art department and linked to it through magazine subscriptions, programs of visiting artists and exhibitions, internships, and friendships.

The CAA's document repeats the word "professional" a number of times, insisting that the degree is precisely what Adler suggested it had not yet become: the terminal professional degree in the practice of art.[8] Perhaps it involves no particular revelation on my part to argue that graduate programs in art schools and art departments are professional programs or, then, that artists are professionals. But what "professional" means is far from clear. The word was contested in the histories and sociologies of the professions written in the years after World

War II, spurred by the rapid expansion of the professional-managerial class and by the emergence of "professional" as an important symbolic marker in the broad culture. It was not obvious to the art critic Harold Rosenberg, writing in 1956, where the boundaries of the professions stopped, whether they included artists and poets as well as doctors and architects—or what it meant that they already did. Rosenberg's essay was called, perhaps in alarm, "Everyman a Professional";[9] the same misuse and overuse of the term troubled the sociologist Harold Wilensky in his 1964 *American Journal of Sociology* essay "The Professionalization of Everyone?"[10]

Professionalism was among the topics raised by the artists of the New York school at the Artists' Sessions at Studio 35, a roundtable discussion held in 1950 at the site of Subjects of the Artist. Ad Reinhardt submitted written questions to his fellow artists: "What is your work (of art)? Do you consider the production of it a professional activity?" Reinhardt himself defined a professional artist as one who considered art a way to make a living, a meaning that for him disqualified professionals as artists: "All of us exhibit in large exhibitions alongside of artists who consider themselves 'professional' or commercial artists and businessmen, such as members of the Artists' Equity."[11] Reinhardt's fellow artists responded, not by discussing morals, but by entering the debate over the meaning of the word "professional," as though that term rather than art or artists was at stake. Willem de Kooning offered what might be called a "credentialist" definition: "You can't call yourself 'professional' unless you have a license, such as an architect has. . . . You must be a 'professional' to someone else—not to yourself."[12] James Brooks suggested that this being-for-someone-else described a relationship not only economic but, more important, symbolic: " 'Professional' conveys, to the outside world that people spend a great deal of time in what they are doing," to which Barnett Newman appended his own simple and important definition: " 'Professional' for me means 'serious.' "[13]

What Is a Professional and Why Is the University the Place to Be One?

The artists of the New York school have mapped for me the sites at which sociologists have examined the professions since the 1930s, and with increasing energy in the postwar years. Most recent work in the sociology of the professions begins, at least rhetorically, with the same

problem of definition that faced the artists at Studio 35; a review of the literature is a review of definitions and of the processes and problems of defining.[14] Across the period, "profession" has described an economic relation of expert to client, of organized individual actors to markets, and of one group of organized actors to another claiming a similar name or market. It has also described a social relationship: the status for a public of a named occupation in a system of occupations. The earliest attempts to understand and apply the label professional began by extrapolating from occupations traditionally identified as professions: medicine, law, and the clergy. Other occupations earned the label as they approached the formal organization, the particularized training, practical autonomy, and peer associations, of the old "learned professions." In their mold a profession was distinguished by the practice of a particular problem-solving skill based on esoteric and theoretical knowledge imparted through an elaborate and separate system of training.

The historical process of professionalization depends on the organization of freestanding schools that offer the specific formalized knowledge and broader institutional culture of the profession. Harold Wilensky notes a point important to the story I have told about the practice of art: whether or not professions *"begin* within universities, . . . they always eventually seek contact with universities, and there is a steady development of standard terms of study, academic degrees, and research programs."[15] Autonomous practitioners are bound together both by a shared professional language—the esoteric language they learned in school—and by formal, occupation-based associations and a peer-enforced code of ethics or behavior. World War II–era sociologists stressed ethics and the commitment to the service ideal of the professions, describing them as an emergent modern meritocracy, a remedy for the regimentation and materialism of bureaucratic capitalism, and a bulwark against the particular, local interests of class or ethnicity.

Recent revisionist descriptions of the professions have rewritten the developmental "sequence of structures"—the founding of associations and the establishment of schools—as a "sequence of functions they served" in the formation of individual professions and their individual practitioners.[16] Theoretical knowledge, controlled higher education, national associations, and peer-driven codes of conduct are now read as ways to limit membership, to police borders in relation to other professions and would-be professions, and to secure a public image as expert or, in Barnett Newman's term, "serious." That image is at stake in both

original and revisionist analyses: because professionals are autonomous individual practitioners at once enacting a profession and represented by its name, professions are the site of an intense self-fashioning. As Magali Sarfatti Larson notes in *The Rise of Professionalism*, often cited as the starting point for a critical reexamination of the professions (and of previous work in the sociology of professions): "The image or model of profession which we commonly hold today, and which we find as well in social science, emerged both from social practice and from an ideological representation of social practice."[17]

Like a number of earlier sociologists, Larson remarks on the link between professional status, the university, and the liberal arts, but she describes the relation between professionalization and the university in language rather different from that of Morris Cogan, whose arguments for the grounding of professional expertise in the broad liberal tradition I discussed in Chapter 5. "Entry into the university gives any profession a core of educators," Larson argues, and "because of the university's apparent universalism and independence from lay demands and private interests, these educators are in the best position to defend the universalistic guarantees of professional competence and to legitimize the professionals' claim of autonomy and monopoly."[18] Professionalism for Larson is an economic strategy, its goal a twofold monopoly: "of expertise in the market" and "of status in a system of stratification."[19]

For both individual practitioners and professional groups, market share and even expertise arise through the visible markings of separation and distinction. Formal theoretical knowledge—and its parade—are among the most important of those distinctions. Defining characteristics, they function to differentiate the professions from manual practice and vocational experience. Indeed, in recent writings on the professions, the value of formal professional knowledge is primarily symbolic; its learned terms allow the "ritualistic and ceremonial moments in practicing [that] impress the laymen."[20] Randall Collins has argued that after a certain point—often very early on—"academic training does not usually enhance practical effectiveness very much" because "the content of typical schooling does not provide direct practical skills."[21] Certainly, the skills I learned in my own professional training in the practice of art lay elsewhere. "This does not mean," Collins continues, that "there is no such thing as 'professional' knowledge," or that the doctor or lawyer or even the artist is a fraud. "But it does tell us that the academic organizational structure has a social rather than a technical impact."[22]

Professional training, and the professional language it teaches, structures a relationship between professional and client and among professionals; it excludes and includes. Collins defines professions at their broadest as "socially idealized occupations organized as closed associational communities."[23] One might add that the closure is performed by both the liberal arts education so important to Cogan—and to so many of the commentators on artists' education I have cited in these pages—and the further professional training that initiates the practitioner. The shared ground that the undergraduate college provides allows professionals to talk to one another, to have dinner together, to extend to one another "professional courtesy." It produces and cultivates the marks of distinction that, as Pierre Bourdieu has theorized, reproduce economic class distinctions and conflicts in the symbolic realm, an arena that has its own quite real effects.

Was I a Professional?

In the vernacular, artists are professionals if they are paid for or make a living from their work as artists, or perhaps if they work at it seriously and full time. When Jimmy Ernst asked the artists' roundtable, "Can we say that no one here is an amateur?" the answer was obvious.[24] But whether or not contemporary artists are professionals according to any sociological definition is a different matter. The practice of art does not, as it should according to one model of the professions, construct an effective monopoly. Those who hold the M.F.A. and their representative and accrediting organizations, the College Art Association and the National Association of Schools of Art and Design, do not control training in or a market for a particular skill; any number of people can draw or paint, and can learn to do so in a number of different places. Moreover, they do not control the rights to "artist" as a title. Anyone can be an artist; as Bourdieu has remarked, "The fate of groups is bound up with the words that designate them: the power to impose recognition depends on the capacity to mobilize around a name."[25] Indeed, Ernst formulated his urgent question against the backdrop of an unprecedented interest in the arts and their amateur practice in America during the forties and fifties: Jacques Barzun wrote in 1956 that "the most salient fact of artistic culture in this country since 1930 is the rise of the amateur. . . . Our reality is symbolized by the fact we have a President who paints."[26] One could argue that the eighteenth- and nineteenth-century European state academies performed much better as professional or-

ganizations than the present-day CAA and NASAD, for they controlled the site and the means of teaching; the theoretical discourse on paintings, past and present; and access to exhibitions, commissions, and pensions.

Perhaps the practice of art belongs, not to the professions, but to what Cogan lumped together as the "chaos of pseudo-, semi-, quasi-, and sub-professions" cast in the model of, and at the site of, the traditional professions.[27] The lack of a "common and clearly defined basis of training" that, for Larson, characterizes a would-be profession recalls certain disapproving descriptions of recent art and its practice. "Those professions that do not have such a solid support tend . . . to create and emphasize pure mannerisms (including cognitive ones, such as unnecessary jargon or unjustifiably esoteric techniques or 'pseudo-paradigmatic' changes)."[28]

My goal, however, is not to reach a conclusion, to match the practice of art to a model "real" profession and then use a metanarrative of "professionalization" to explain or motivate a particular history. Rather I want to acknowledge the functional effectiveness of particular practices—to insist, for example, that university-based or -modeled training and certification are related to and reiterated by the production of a certain kind of language. In the preceding chapters I have pointed to the uses of "professional" in a number of period debates about art and artist in the university, noting how the demands of the university and the discourse of professionalism shape images of the artist and the practices of art education. But the meaning of "professional," far from being coherent and continuous, is contested and often contradictory; the attributes and functions assigned to it have ideological effects: they serve specific audiences and institutions.

At the close of Chapter 5, I began to construct opposing versions of the professional artist from the discourse of the artist in the university. One, the slightly older version, emphasizes the relation between professional and client: the professional puts to use a deep knowledge and a specific set of skills to solve a client's problems, to produce a particular outcome. The model is medicine or, closer to the tradition of the visual arts, architecture. The other emphasizes, not the client relationship—and the client's judgment—but the ideal of independent research within the field defined by a formal, theoretical discourse. It is modeled after the laboratory scientist or university professor, who formulates problems in relation to the discipline's present and whose performance is judged by colleagues. Values attach to these positions: skill, service, and

quality to the first, intellectual autonomy and disciplinary progress to
the second.

Each also argues for a specific kind of training; it would be easy to
place client-driven professionals in freestanding art schools and re-
searchers in university departments. But they do not always map so
neatly; the conflict exists inside departments as well as between schools.
The attraction of the *bottega* artist, offered as an antidote to the acade-
mician and the isolated avant-gardist by both university art depart-
ments and the independent art schools, was based on both a collegiate
humanism and a local practice. ("Regional" was one of the terms Gib-
son Danes used to characterize the important and effective practice of
the architect against the useless cosmopolitanism of the painter.)[29] Con-
versely, the artist as an independent researcher in materials, perception,
and the visual history of art practice was central to design teaching in
the freestanding professional schools after the Bauhaus; it was one of
the German school's most powerful legacies. The question these figures
pose is not, where should the artist be trained (as their supporters or de-
tractors might have construed it), but whether the artist is a profes-
sional trained at the university (or at an art school that builds on a lib-
eral education) or a university professional—that is, whether art is an
academic discipline—a word I have perhaps used as often as "profes-
sional," but have thus far paid less attention to.

In the university, theoretical discourses are developed and particular-
ized training takes place within the discipline, which seeks its legitimacy
and claims its status through the university's recognition of it as an area
of study, as a department, perhaps. Roger Geiger writes of the prag-
matic, professionalizing relationship of the scholarly discipline to the
academic department—of the field of knowledge to the area of admin-
istration:

> Instead of appealing to the state to protect their services with legal restric-
> tions [like law or medicine or architecture], the disciplines have sought the
> aegis of the university. The creation of departments at important universities
> effectively guaranteed the practice of a discipline, even though it may have
> been necessary over the long run for disciplines to prove themselves through
> intellectual growth and the attraction of students.[30]

The disciplines differ from the professions, not only in the role the uni-
versity plays in legitimation, but also in the system that polices and
judges them: "The need of consumer-oriented professions to place con-
straints on member conduct through codes of ethics was expressed
quite differently in the disciplines. Once the institutions were in place to

operate the reward system of science, the scientific ethos could be ex-
pected to constrain the behavior of academics."[31] I return to studio
art's relation to the system of the sciences begun in Chapter 3, with the
sociologist Max Weber's discussion of the distinction between science
and art. Here, briefly, I will insist that for art practice, both in and out
of the university, the system of rewards depends almost entirely on dis-
ciplinary procedures, on the rereading and reshaping of historicized po-
sitions and practices as they inform the field in the present; that is, the
system of rewards in art is that of most of the humanities in the univer-
sity as they are cast in the image of science.

Other Stories

The discipline of studio art in the university has been shaped in partic-
ular ways by the model and the proximity of the academic humanities,
particularly as they themselves have been remodeled after the research
sciences in the postwar American university. But that was not the only
possible outcome. All the arts, as Harold Wilensky wrote of all the pro-
fessions, have sought "contact with universities," subsequently experi-
encing "a steady development of standard terms of study, academic de-
grees, and research programs."[32] This they share, but the particular
story of each of the arts in the university—its allegiances and transfor-
mations—is bound by its performance both on and off campus. I want
at least to note the positional differences between creative writing,
dance, filmmaking, music, and theater in the university, and to compare
their histories to the one I have constructed for studio art.

The material demands and traditional practices of each art mark its
individual history in the university and its departmental organization.
The private practices of painting and writing, historically imagined as
interior and individual endeavors, were more readily adaptable to the
causes of general education and universal creative expression than were
those of the collaborative—and more expensive and technically and ar-
chitecturally demanding—arts of music, film, and theater.[33] Creative
writing owes its place in the university to the same synthetic impulse of
general education that transformed the teaching of studio art; the earli-
est programs, at the Universities of North Carolina and Iowa, were
founded by the New Humanist critic Norman Foerster to wrest the
study of literature from the separatism and sophism of philology and
"pure research" and place it at the center of the humanities. The origin
of creative writing as a humanist practice—as both a critique and a

continuation of the academic English department—situates the pro-
gram in English and in the general college. In contrast, film history and
theory, commonly housed in English or comparative literature depart-
ments, remain separate from filmmaking in schools of art or communi-
cation or film. A similar division takes place in theater studies, where
the practice of theater and its history belong to the school of drama and
the scripts to English or comp lit. The separate M.F.A.s in acting, light-
ing, set design, screenwriting, and costume design offered in theater and
film are specifically craft-based and professionally oriented, repeating
the skilled divisions of production established by guild organizations
and professional practices.

The graduate degree in theater came late to the university, perhaps
because of a long history of student and amateur productions on cam-
pus that took the place of a general education in theater. Music comes
into the university much earlier, often alongside studio art, and like stu-
dio, it has a gendered history on campus; it was one of the offerings of
Syracuse's College of Fine Arts in 1873, and of its College for Women
after 1889. Among the oldest and largest university-based music pro-
grams are those at Oberlin and Rochester, schools founded as coeduca-
tional institutions that were among the first to offer a course in draw-
ing. The University of North Texas at Denton and the University of
North Carolina at Greensboro—the former founded as a teachers col-
lege and the latter as the state's college for women—house much larger
and more comprehensive music performance programs than the states'
primary research schools at Austin and Chapel Hill. Not only size but
also focus separates Greensboro from UNC–Chapel Hill; across the
state music is divided between theory and practice along gendered lines.
Greensboro offers the Master of Music and the Doctor of Musical Arts
in performance, theory, composition, and education, and a Ph.D. in
music education; Chapel Hill offers the M.A. and Ph.D. degrees of the
liberal arts in musicology, music history, literature, and theory.

If music and studio art enter the university in much the same way,
their teaching differs, with music hewing more to the conservatory than
art to the *école*. Music performance in the university has continued to
emphasize classical instrumentation and tonality and the collabora-
tively testable, usable craft skills determined by those historical forms
and by a pooled or static concept of history, that is, more accurately,
tradition. Music's separateness on campus, or its specificity, might be
read in the name of the degrees that Greensboro offers, the Master of
Music and the Doctor of Musical Arts. Offered by some 130 universi-

ties, the M.M. is usually recognized as the terminal degree for profes-
sional performance, with additional theoretical and performance stud-
ies leading to the Doctor of Musical Arts, or of Music; stressing the
Master of Music's emphasis on technical expertise, most schools that
offer it also offer an M.A. that substitutes a written thesis or musico-
logical emphasis for part of the practice requirement.[34] A handful of
schools offer an M.F.A., rather than the M.M., in music performance.
At the University of Iowa or at UCLA (where the M.F.A. has been dis-
continued recently in favor of the M.M.) the difference might be one of
the decade in which the program was instituted or refashioned, a rem-
nant of the attempt to understand the arts together. But at a school such
as Bennington or Mills College, where, as its publicity insists, John
Cage and Henry Cowell once taught, the distinction seems to signal a
keener interest in an individual and consciously innovative music prac-
tice. The degree, or the catalogue prose that surrounds it, fashions a
musician whose individual creative activity allows him or her to be a
historical and professional actor—that is, a musician written in the
terms of the studio artist in the university: "Music is evolving. Musical
societies in the coming millennium will require young musicians to be
increasingly flexible, original, and to have an ever broadening range of
skills enabling them to make meaningful contributions to a rapidly
changing, global culture," write the authors of the CalArts catalogue.
Marking their place at the end of the present, they project their students
into the future: "Each and every young musician today should be fo-
cusing on developing her or his original, musical voice as a complete
musician for the emerging world."[35]
 The total musician of CalArts is an exception; the terms of individu-
ality for the applicant or graduate of most music schools are those of
talent as it matches the specific performances and expectations of pro-
fessional practice rather than of creativity as it differentiates each indi-
vidual actor in a professional field. In contrast, creative writing in the
university—and in its very name—has come to insist strongly on an in-
tensely exaggerated individuality, an acute examination and operation
of the self. The skills learned are taught as "critical" rather than techni-
cal skills, even if they are taught in writing "workshops" or address the
"craft of writing." They are learned in relation to—and at the cost of—
completed and deeply invested work. As in the studio crit, each work of
writing is extended and finished elsewhere by a working on and work-
ing out of the writer. As I suggested above, studio art and creative writ-
ing were shaped in the university by a shared relationship to the ideal of

the humanities and the goals of general education across mid century; they are united as well by their increasing professionalization, despite that origin. Like programs in studio art in the years after the war, and in histories that parallel the one I recount in this book, "creative writing programs would quickly become detached from their initial synthesizing purposes," as Gerald Graff has noted, "and become autonomous enterprises."[36] The fields into which student artists and writers project themselves, however, differ significantly, as does the construction of disciplinary history and the professional present. While both studio art and creative writing work to instantiate the difference of each individual practitioner, the practice of writing in the university aims at the "content," or perhaps the peculiarity, of the individual student writer. In contrast, studio work requires the student to construct his or her difference historically or positionally; the field and its recent past, and particularly the sense of its movement, the urgency of its present, mark the art department—and mark its product as university research.

Disciplinary Practices

On campus, studio art cannot be a calling or a vocation. To be included among the disciplines, art can no longer bear definition as a craft or technique, the fully trainable manual skill of the guild or apprenticeship. At the same time, it cannot be purely inspirational or simply expressive: the work of genius cannot be taught or self-expression tutored. Studio art must not only differentiate itself from public knowledge and practices but also constitute itself within the university. There must be an object of knowledge, a field carved out or claimed in relation to other fields. There must be something called Art for a department to be called after it.

A department of art might seem a simple thing and an innocent title, but when the University of Iowa's Lester Longman, a pioneer of the M.F.A. in studio art, proposed that name for a university program, it was an integral part of his argument for an autonomous and comprehensive study of art. A program named Art would secure creative work in the university from the smattering of technical and handicrafts courses taught in departments of home economics or education and wrest courses in the history of that work from departments of archaeology and classics.

> It is simple to pronounce that ideally art should be taught in art departments, but to consummate the ideal will require protracted effort. . . . One

finds it sheltered under the wing of classics, archaeology, philosophy, education, home economics, architecture, and engineering. Thus art is not regularly taught for the sake of art, but is often a suffix to the dominion of some other department.[37]

Even when "on occasion" some version of art has been allowed as a separate entity in the college, Longman complained, "it is accepted for a special purpose that restricts its potential function. Then one finds it in the catalogue in departments labelled Applied Arts, Industrial Arts, History of Art, Art Appreciation, Graphic Art, Design, Commercial Art, and the like."[38] Art taught under archaeology or engineering or home economics, or as applied or industrial art, would always be a collection of objects or tools and techniques, always an art about or in relation to something else—as Longman wrote, a suffix.

Longman called, not for art-for-art's-sake—or perhaps, not only for it—but for an art department for art's sake: art "taught for the sake of art." His reworking of the aestheticist creed fashions the art department's autonomy, the self-sufficiency of art as a discipline in the university, in the image of the modernist work of art. The subject of an art department, what it teaches and what its works will mean, is Art; it assumes both the unity and the bounded, internal coherence of art. A department of art can include the graphic, commercial, and industrial arts; as Longman remarked, they are within "the scope of art." At the same time the values and order of art are independent of and separate from any particular instance. In this century, those values are most often written in the language of formalist aesthetics—line, shape, color, space, and design—but the pairing of the "useful" arts and the terms of formalism is not contradictory: indeed, as I have argued, it is foundational.

Longman's department of art declares art a discipline. Writing some four decades later for the place of film and video in an art department, Edward Levine of the Minneapolis College of Art and Design argued that the new media too must become disciplines, a process that in his description recalls the formation of professional knowledge: "It is through the development of theoretical issues that a medium becomes a discipline."

Theoretical questions raised by a discipline become important sources of ideas which can extend and enlarge the medium because they provide a metacritical viewpoint. There is a sense in which the discipline is larger than any of its manifestations as a medium, where it can direct the attention of the artist as well as being directed by the artist.[39]

A disciplined medium is precisely not a medium for the artist's pecu-
liarly individual speech but a field that demands and contains each in-
dividual practice as research, as a proposal within that field. Each tech-
nical practice of art, Levine concludes, "ultimately must develop this
theoretical thrust, otherwise it will be relegated to the status of
craft"[40]—to something that need not be learned in the university, that
does not have its identity and history as a professional stake.

In both art schools and university departments, the disciplined arts
most often comprise painting and sculpture,[41] and those newer forms
cast in their image as individual and autonomous practices and theo-
rized in direct reference to the history of painting and sculpture: instal-
lation art, conceptual art, performance art, video art. Art, as Thierry de
Duve has remarked, names the discipline that takes place where paint-
ing and sculpture were, on the site of—and in lieu of—their craft: "The
general word *art,* flanked by some qualifying adjective, . . . substitute[s]
for the words *painting* or *sculpture.*"[42] Whether it is painting and sculp-
ture made within the project of modernism, or that art constructed as
its "postmodernist" critique, work in the discipline—or the disciplined
work—is doubly articulated, constructed out of and plotted onto a past
read as historical demand and a present articulated as a field. Certain
individually practiced and historically bound media—printmaking, for
example, or ceramics—have functioned less well as disciplines: as *art* in
general or as criticism in the place painting once was. There is, perhaps,
too much to teach, too specific and material a body of knowledge to
learn to produce an image and, it seems, the more teacherly the
medium, the less readily its technical practices transform into theoreti-
cal questions, and the less historical difference is written in them. But
even painting, under a certain definition or at certain locations, is di-
vided between its craft practice and the positions offered it by the his-
toricized field of recent art, between its undergraduate teaching and its
graduate research.

The split between the disciplined and the teacherly arts mirrors the
division between research and teaching that, as Roger Geiger notes,
characterizes especially the humanities in the modern university but ap-
pears as well in mathematics and other fields of the exact sciences.
"There is considerable intellectual distance between the few who labor
on the rarified frontiers of research and the many who are engaged in
routine classroom instruction."[43] Teaching specific, repeatable, estab-
lished knowledge to students "had to remain a distinctly subordinate
concern, because the overriding goals of legitimacy and professionaliza-

tion could be attained only through the development of recognized scholarship," through work on and about the boundaries of the discipline itself.[44] Certainly the practice of art in the high research universities—where departments in every discipline are expected to be nationally ranked and focused—and in art schools that imagine themselves research institutions (CalArts, for example, or the Art Center College of Design in Pasadena) differs from art making in smaller state and private college programs. But as I argue in the pages that follow, those smaller schools too must take into account, and teach, the field of research.

In *To Advance Knowledge,* Geiger defines a discipline, quite simply, as a "community based on inquiry and centered on competent investigators."[45] His definition might be too simple, but it points to the organization of identifications and exclusions the discipline performs, how it determines speakers and validates knowledge. According to Michel Foucault's *Discourse on Language,* an examination of the procedures that select, organize, and distribute the production of discourse, disciplines limit and bind discourse by stipulating a "specific range of objects," which are examined with "conceptual instruments and techniques of a well-defined type," according to the questions raised within a "certain type of theoretical field."[46] There must, of course, be "the possibility of formulating . . . fresh propositions," and each proposition in the field moves the discipline's knowledge forward, but only as it reinstates and recertifies the objects, methods, and definitions of the discipline.[47] Disciplines fix their "limits through an action of identity taking the form of a permanent reactivation of its rules."[48]

Professions as associations of individual members order and control at the level of practitioners; their rules of credentialing and certification govern who can speak, even as they assume that practitioners will have learned the rules of professional discourse. A discipline, in contrast, orders and controls at the level of discursive practice; its rules concern what can be said, and in what form. I want to use the concept of the discipline as it constrains and structures discourse to keep from having to judge whether or not art is a profession, and, once again, to keep from saying "as a profession." At the same time, Foucault's description of the functions of a discipline allows me to reintroduce the system of inclusion and exclusion at work within the particularity of professional vocabularies, and to place that system firmly in the university—or in a network that includes both the university and the art world defined and united by that language.

The language one learns to speak in graduate school provides a crucial internal tie that links artists, dealers, curators, critics, and departments as they address common issues and concerns. Indeed, "issues" and "concerns" are important words in that language. While the "concerns" may change, from the integrity of the picture plane or the specificity of perceptual experience to representation and gender, they change and are demanded of artists and critics and curators—they matter—as part of a disciplinary discourse. A network of discursive and professional practices by artists, critics, teachers, and students raises some questions as credible and pressing, as the legitimate objects of disciplinary research; as those issues construct the field of practice, they have real effects in and on the community of makers. As feminism, for example, has become part of the professional discourse of recent art, and gender an "issue" around which art can be made and critical writing be done, reading lists have changed, and so too have rosters of visiting artists and, more slowly, the hiring practices of university departments as they seek to be at the forefront of disciplinary change, of advancing disciplinary knowledge.

Griselda Pollock, reflecting on her travels to British art schools in the mid 1980s, wrote of the difficulty of working as a woman art student with an all-male faculty, particularly when the very image of the artist is constructed with "exclusively masculine attributes": alone, silent, sovereign, "man is an artist *tout court.*"[49] Alongside that difficulty, and critically clarifying it, Pollock recorded the emergence of

> a certain kind of art practice. It is usually photo-text, scripto-visual or some such form; it is often sustained by reference to a body of cultural theories; it generally handles questions of gender, representation, sexuality. The students offering such work are well thought-of intellectually and produce theoretically developed work in complementary studies and art history.[50]

The work Pollock describes, which she sees "regularly" as a visiting lecturer, marks the entrance of feminism into what she terms "the community of knowledges and expectations that constitute the social practice"—into what I have been calling the discipline.[51] That the work and its practitioners function so well in complementary studies in theory and history—the particular sites that produce disciplinary knowledge and professional language in the university—speaks to their already having been disciplined in the university. Pollock, like many other commentators I have cited, argues that "the rationale of art schools is to train rather than educate artists,"[52] a distinction that insists, as it has

throughout this book, on the university as the optimal site for the contemporary artist's education and that calls for reconstructing artistic practice as an academic discipline.

While any of the languages of explanation or assignment taught in school—formalist, phenomenological, psychological, or "critical"—can perform the integrative and exclusionary functions of professional knowledge, the relationship between specialized language and professional acceptance and practice has particular implications for the recent role of "theory" in the art world. The broad body of semiotic, psychoanalytic, and critical theory housed under the term "poststructuralism" has become, in Thomas Crow's description, the "patois" of the art world. Understood or not, its vocabulary

> has become part of the everyday, informal processes by which artists explain their work to others and to themselves; it is part of the dealer's helpful explanations and the collector's proud accounts of his acquisitions. It knits the art village together on all levels. . . . The language of high theory has come to serve a genuinely integrative function for the art community as it actually exists, gathering a wide variety of practices under its wings.[53]

Theory's "integrative function" makes its critical and political promises at least ambiguous; theory—including feminist theory—continues to mark and produce professional distinctions. The boundaries of Crow's village—despite his pastoral language—are those of a disciplined art practice rather than those of a simpler physical geography.

Much work by black, Latino, and feminist-identified artists and theorists involved with the political questions of race and gender has proposed working locally, in a community constructed in the image of political, rather than professional, identity. Proponents of a politically active art have long argued for work made for and with specific local audiences, who embody its criteria and who judge it outside disciplinary concerns. Wherever the work is staged, however, the arguments over its success—over the authenticity of its appeal or even its rootedness in the local—increasingly take place nationally, and in the discipline. As the work emerges in *Artforum* or *October* and is taught as art history or in studio seminars as exemplary work that must be responded to, the judgment of its effectiveness becomes a disciplinary one. Its politics become an issue that opens further professional opportunities and allows for other works. The site where feminism, identity politics, and ideology critique have become concerns, where they raise issues, is the university as it reproduces artists.[54]

Serious and Dedicated

In a critique of the hegemony of the New York art world as it presents it-
self to itself and its far-flung constituents in the pages of *Artforum* and
Art in America, the artist Andrew Menard argued in 1975 that "New
York Ideology is taught *nationwide* . . . it's not only the student Techni-
cians in Los Angeles Houston Boston, the large metropolitan areas, but
those in Missoula Santa Fe Dayton yes even in Peoria . . . who are indoc-
trinated into the ways of New York Ideology."[55] In 1978, the year I grad-
uated and three years after Menard's observation, 101 colleges and uni-
versities nationwide listed conceptual art among their offerings, schools
not only in New York and California, but also in Arizona and Colorado,
Georgia and South Carolina, Iowa and Kansas.[56] There are, of course,
different versions of the disciplinary language of studio art, or rather
different readings or inflections. Each member of the graduate faculty
offers particular objects and interpretations of recent art and its issues.
Programs, or individual teachers, teach against New York, against "art
world maneuvers" or "postmodernism" or Marcel Duchamp; others
teach against "formalism" or "expressionism" or Clement Greenberg.
The critical interests of the graduate program at the University of Cali-
fornia at San Diego may be at odds with those of the University of
Iowa. Still, the set of images and articles programs are compelled to ex-
plain, the professional arena they describe to their students, and to which
they direct them, is in most respects identical, linked to a decidedly simi-
lar set of locations, institutions, and publications. That arena provides
the terms of inclusion, the terms of the conversations artists have.

 The art department provides its students with a disciplinary knowl-
edge, with "issues," as well as a tacit knowledge of the rules and orders
of practice. It is part of a network of institutions—galleries, museums,
granting agencies, journals, and the like—that define the boundaries of
the field, construct the concerns or shared values of the community, and
circulate its discourse—the language that marks its speakers as mem-
bers of a community. Having insisted on the disciplinary coherence of
the art world toward which graduate student artists are pointed, I must
note that a number of other art worlds, other communities, identify
their members as artists. One task of a degree-granting art school is to
define for its constituents and institutions who is an artist, to separate
its graduates from cowboy artists or community art center artists or
shopping mall or state fair artists or portrait painters, landscapists, wa-
tercolorists, maritime painters, and so on. These distinctions are con-

structed locally as well as nationally. The graduate art department and its credential structure local art worlds, regulating contacts, opening up opportunities, and determining the shape and membership of communities in cities across the United States.

In a sociological study of women artists in the Saint Louis area published in 1978, Michael McCall noted the importance of the M.F.A. and the local university in shaping and delimiting the art world. When the artists she interviewed "discuss one another as artists and express judgments of one another's work, [they] seldom speak of how good the work is, or how talented the individual; rather they speak of seriousness and dedication." She constructed her model for the status positions of women artists in the community in those terms. In her model, "degrees are credentials which help establish the individual's claims to seriousness and dedication. Indeed, individuals trained as artists are serious almost by definition; they have learned to make things that look like art and to treat the things they make as art is treated."[57] Among artists in Saint Louis, the M.F.A. and a college or university teaching job, for which the degree is a requirement, fully guarantee artistic status. "B.F.A. mothers" are serious but not dedicated; those McCall terms "picture painters"— women artists without a professional degree who exhibit for the most part at fairs and in hospital lobbies (among the artists in McCall's survey these painters actually make the most money from the sale of their work locally)—are dedicated but not serious. "Nonfaculty M.F.A.s" are serious and dedicated but isolated; "faculty M.F.A.s" are finally full artists: "No respondent questioned their dedication or seriousness."[58]

McCall's categories do not finally measure status within a homogeneous community; rather they define separate communities that share and struggle for the same title. The groups were identified with different exhibition sites, for example, and were divided even on the value of exhibiting, at least locally. Credentialed teaching artists, artists whose status was not in doubt in the community, considered showing in Saint Louis unimportant. They were trained in another discipline and their community was located elsewhere. As Allan Kaprow noted early on, their "actual social life is usually elsewhere," and in this "they resemble the personnel in other specialized disciplines and industries in America."[59]

Artistic Ability

In this chapter I have discussed some implicit functions of the M.F.A. but have not yet answered the question I opened with, the question of

skill: why I cannot cast or carve or weld. "Let us begin," writes Peter Burke of the recruitment and training of artists in Renaissance Italy, "by assuming that artistic and other creative abilities are randomly distributed among the population."[60] It is not clear at the end of the twentieth century what artistic ability might be; from this vantage, it seems a concept that must be historically derived. There is no necessary link between the ability to draw from life (to offer the most pervasive definition of artistic ability in post-Renaissance Europe) and the work of recent art. Indeed, in the preceding chapters I have often noted the decentering of representational drawing as the core and foundation of the artist's training. It is now a particular and often optional skill, something one might use, like the ability to cast fiberglass resin or to weld. Even those undergraduate departments that require figure drawing as an introductory course frequently offer it in tandem with a required course in design or problem solving or "art" fundamentals. It is taught, not as a way of remaking the world as *disegno* or as the "probity of art," in Ingres's words, but as a way of seeing. Introductory Drawing trains the artist to perceive, but perception on a professional level takes place far from the ability to render. As my undergraduate drawing teacher said, "So you can draw. What are you going to *do?*"

The meaning of the phrase "artistic ability," at least in common usage, is tied to practiced manual dexterity and a mastery of techniques, a definition I have adapted from a discussion of the word "skill" by the sociologist Harry Braverman, who lamented the twentieth-century division of work and traditional craft skills into formalized knowledge on the one hand and machine-regulated manual labor—"a specific dexterity"—on the other.[61] The late Australian artist and critic Ian Burn turned to the concept of "deskilling" that Braverman introduced—the dissecting of whole skills into pure theory and mere labor—to describe what happens in art schools or university departments that teach art as the field of contemporary art practices. "The growth period for Australian art schools (as elsewhere) was during the 1960s and early 1970s, a time when American influence reached its peak," Burn wrote, marking from the outset a link between practice in Australian art schools and an international professional discourse centered in New York.

> During the 1970s, the tendency was for students of art to be taught traditional skills (e.g. figure drawing, composition, perspective, colour theory, knowledge of materials and techniques) on an ever-decreasing scale. . . . [Thus] it has not been uncommon during the past decade for students to experience an avant-

garde context during their art school years, but to find difficulty in sustaining such attitudes outside of the school and to then discover that they have not been taught skills to allow them to work in any other way.[62]

Burn implies what he does not say outright, that the teaching of and about the current art practice in lieu of traditional studio art training, enforces professional membership by depriving the student, not so much of traditional skills, but of usable ones—the skills that might be put to work by a public artist. The lessons of the "avant-garde context," and of the disciplinary practice of art in the university, Burn argues, are founded on the "separation of mental or intellectual work from manual work, with a revaluing of the intellectual and a devaluing of the manual."[63] This is, in fact, Burn's critical description of seventies conceptual art, but "it is hard," he continues, "to avoid the analogy with the role of management in industry,"[64] or, I would add, the goals of the university.

The deskilling that Burn describes, and the segregation that it institutes, are visible in any number of places; they are inscribed, to take a very public, if mundane, example, on the covers of magazines. The "teaser" on the front cover of the July 1995 *Art in America* consists of the words "Whitman, Kandinsky, Heizer, Jonas, Whiteread, Report from Berkeley." The cover of the September 1995 *American Artist* promises articles on "Interior & Landscapes in Oil," "Getting the Most from Gouache," and " 'Painting' with Fabric." This is a cursory sampling, yet in these covers and the knowledge they promise, art has been divided between a set of craft skills, learnable and teachable on the job, and a theory of the cultural history of those crafts as it is continuously retheorized and reauthorized by its practitioners. The surnames on the cover of *Art in America* promise readings and positions within the field, but only to other practitioners, those with the community knowledge to recognize them and fill in the first names, those who understand that art is much more difficult to make, and to read, than it seems at first glance.

Pierre Bourdieu has written of the assumptions embedded in the idea of " 'reading' the work of art": the insistence on reading not only implicitly admits the class-based knowledge required to recognize and place a work, but also speaks to the difficulty and the special practices of understanding.[65] To imagine a painting as something that *must* be read away from the surface and the visible—from what it looks like or what it depicts—separates the work of art from what it pictures and from the skill with which it is made; that is, it separates the work of art from its broad and amateur definition. The necessary difficulty of reading insists

that the practice of art is something other than picturing and, more to the point, something both more and less than the simply operated skills and pleasures of making. Bourdieu writes, "The whole language of aesthetics is contained in a fundamental refusal of the *facile.*"[66] A translator's note remarks that the French *facile* is intended to carry the sense of both accomplishment and shallowness. The university makes the same conjunction.

The goal of an artist's training cannot be facility, that ease with one's métier that cannot be challenged and need not be pushed. If painting or drawing are "simply" the repeatable techniques of picture making, then there is only a question of what to represent or what to make. If art is a set of tools with which to do something else, there is no discipline; there is no demand for further research, no question raised by the medium or by its historical uses and appearances, no "issues" raised by its contemporary practice that plot a future and a direction. Each work is a separate, complete, and finished instance; it has no stake, because it has no field in which to strike one. It is merely professional.

Progress, both the idea and the ideal, is written into the university discipline; the goal of the university, in Roger Geiger's perfect title, is to advance knowledge. I have cited the science laboratories of the modern research university as the model for studio art's presence there a number of times in these pages. Perhaps I can invoke it one more time, with Lester Longman, who worked so hard to wrest the discipline of art from its particular skills and practices. In 1946 Longman wrote to the New York art critic Emily Genauer of his hope to institute at Iowa "experimental work on a more advanced level so that we may contribute new ideas to the field of art as freely as New York or Paris. . . . In the sciences it is generally expected that universities will be in the vanguard of experimentation. I want to be the first to do this in the field of art."[67] Here, as though in capsule, Longman produces the artist as scientist of a disciplinary field, one that looks to the cosmopolitan art world as though it were its scholarly journal, or its think tank, or its annual meeting. In borrowing the language of progress and new research for the practice of art, Longman might stand as an example of what Sande Cohen has recently called the "bureaucratization of the concept of research in the nonscientific disciplines of the high university."[68] The administrative forms of the sciences have left their mark on the university—it is in their image that disciplines are created and that literary critics, art historians, and studio artists imagine what they do as new and productive research when they fill out research reports.

In 1919, when perhaps it was still possible, Max Weber distinguished science from art by placing science on a path of progress that "in principle . . . goes on *ad infinitum.*" The ad infinitum of science differs from the *longa* of *ars longa*—the timelessness and tradition of art. "Scientific work," Weber wrote, "postulates the progress of knowledge. In art, on the contrary, there is—in this sense—no progress."[69] Writing as though of the presentness Fried sought in the modernist work (and against the "endlessness, being able to go on and on, even having to go on and on," that Fried criticized in minimalism),[70] Weber argued that "a work of art is really a 'fulfillment' in an artistic sense and is never rendered obsolete by a subsequent work of art."[71] In contrast to the work of art, "every scientific 'fulfillment' raises new 'problems' and should be 'surpassed' and rendered obsolete."[72] It *should* be, Weber insisted: its goal as an object of science is to be unfulfilled, emptied out; it lies in wait like a work of minimal art, for a completion endlessly deferred. Fried and Clement Greenberg had, of course, already imagined modernism as problem solving, and as progress, but they imagined as well that the work of art could be at least momentarily full, that it could, in Fried's description, produce or constitute a present. It is the innovation of postmodernism in the university to take the address to history, not as a personal project, an ethical stake, but as a disciplinary and institutional demand. One could say that postmodernism anticipates its not yet being filled; it settles in for the wait. It imagines itself only as a projection into the future, and still more of the same. In all this, it is remarkably modern.

This university science precludes the otherness of the work of art. The work delivered up as always already its own narrative erases whatever resistance and moment the work of art had in Fried's modernism or in the modernism Adorno imagined, where the work of art marked the refusal of commensurability. The distance Adorno and Marcuse promised is no longer available. The space of the aesthetic can no longer be a critical space; the work of art cannot escape to be somewhere or something else. Marcuse's thesis that art's radical possibilities—"its indictment of the established reality and its invocation of the beautiful image of liberation"—lie "precisely in the dimensions where art *transcends* its social determination and emancipates itself from the given universe of discourse and behavior" becomes not just unbelievable but also, and more damningly in the modern university, terribly naive.[73] That version of transcendence has been replaced by another one. The works of postmodernism in the university thematize their positions and reflect their

knowing better, letting those of us who know, know that they too are vigilant. They will not be unknowing victims of history or theory, just necessarily, historically, victims. This thinking, or outthinking, the end of each attempt operates now as transcendence.

Conclusion

I want to pull back from my argument here, or rather from the tone of coherence and finality in which I have written it. I do not want to argue that the university has caused the self-criticality and historical aware-ness of modernism, or even the "arch" and interdisciplinary, but no less professional, knowledge of postmodernism. Neither do I want to be synopsized as suggesting that the university is responsible for a new academicism, or for some putative decline of recent art. Rather what I have tried to describe is a functional relationship—and perhaps a com-pelling analogy—between the practices of modern and contemporary art and the development and scientization of knowledge and its concre-tion in the departments and schools of the university; between the "his-tory of art" and the narrative of the professionalization of academic disciplines in the university. Clement Greenberg's internal history of modernist art, for example, might be seen to parallel, to run according to the same logic as, a history of university-based knowledge; it is al-ready written in the language of the disciplines: "The essence of Mod-ernism lies . . . in the use of characteristic methods of a discipline to criticize the discipline itself, not in order to subvert it but to entrench it more firmly in its area of competence."[74] Certainly the university has worked to shape a certain version of art as a discipline; it has not caused, but it has helped to model and select and enable.

I want to insist on the university as a crucial structuring site where artists and art worlds are mapped and reproduced, and which is, there-fore, a place to be looked at. It is, to borrow Daniel Buren's list, one of "the frames, envelopes, and limits—usually not perceived and certainly never questioned—which enclose and constitute the work of art."[75] The extended project, the series, the work addressed to a problem or ques-tion, the work as visual research or as critical uncovering—these are some of the lessons and forms of the university; both the regularized per-formance of "straight painting" and the scattered, decentered practices of conceptual art or of installation bear the marks of the university and its discipline. And yet I do not want to offer it as a final or necessary cause for a number of reasons, the strongest of which is that I do not

know how to value its effects. My goal in writing has not been to decry the fate of art and artists in the university, or to find the cause and then place the blame for postmodernism at its feet. I do not intend to join my voice to those who would blame the university for the fall of art (or of poetry or the novel). Indeed, the work that compels me is work made—like its artists—in and out of the discipline of art in the university.

I cannot, however, let the cruelty of current art training go unremarked; I want to return to Mary Abbott's comment that her abstract expressionist teachers at Subjects of the Artist "changed me completely. . . . now I had to destroy the object," and to take it seriously.[76] Positioning the artist as both the object and the subject of graduate training in art (and of much undergraduate teaching) necessarily psychologizes and personalizes critique; it is always ad hominem, always directed at the person, precisely to change and to discipline her rather than her "object" or her skills.[77] This harshness adds to, and is layered upon, the everyday cruelty of the crit, of cliques of students and sometimes faculty who control the local circulation of discourse, wielding it as a weapon. And then there is simple neglect: those students who just are not "interesting" enough, who do not quite understand the questions being asked or cannot perform the identifications and transferences necessary to install the discipline and its demands at the site of the superego, fall through the cracks of teaching. To return to a word I broached in my introduction, the failure of the M.F.A. lies, not in any decline of art or crisis of culture, but in the lives of individual students who are neither disciplined nor skilled, in the same waste that the CAA's first commentators decried.

Still, as Anthony Giddens has suggested, each deskilling is also a retooling,[78] and as Bruce Robbins has argued concerning the humanities in the university, the professionalization of intellectuals in the university must be understood outside a narrative of loss and decline.[79] I have, over these last pages, described a flattened landscape for, and an impossibility at the center of, contemporary art practice; perhaps I have written a narrative of decline, but I want to distance it from those arguments that fall back—with remarkable frequency—on the figure of the ivory tower. They continue to imagine that the problem lies in the retreat of artists and poets and writers in the university from the "real" world, in their taking refuge where they need no longer paint pictures that people want or write about common trials in common language. I have tried to make the point, which the flattened surface of recent art and theory have described for me, that the university and its practices

are woven into the economic, social, and signifying structures of the "real" world. The university is a site in the world, in New York and California and Kansas and Nebraska, and telling the story of the artist in it has been for me one way of insisting precisely on the worldliness of recent art practice, its shaping by, and belonging to, social and economic and institutional histories.

I have written of the artist in the university as particularly aware of his or her place in the narrative of recent art and have argued that awareness itself as a specifically professional knowledge. Crafting a history of the discipline or mapping its contemporary shape and producing work in relation to it are skills—skills we admire in the university humanities. And these are the skills that have increasingly come to replace the workshop crafts and academy techniques of the objects the university teaches as art history. I remarked in the introduction on the failure of my program to teach me my métier, or to make it central to my formation. I noted that they taught me about it only as a set of demands and problems, situating whatever work I would do outside it and along its frame, as a gloss. In contemporary art and art schools, the frame and the field of work have become precisely the métier, the craft skills with which work is made, as well as the site where it is produced.

"In the present stage of the artistic field, there is no room for naivety," writes Bourdieu. "Never has the very structure of the field been present so practically in every act of production."[80] I have argued throughout that this consciousness of the field is what is now taught as art, and that this teaching has allowed for the production of a critical and self-aware art practice; here the flattened bounded visual field of the Bauhaus has become the professional field, the field in which one positions oneself in relation. The practice of art is now a historical and historicized practice, but it cannot be dismissed as just a marking of professional place. Rather it is precisely a "reading" of that place, sometimes with a particularly effective self-consciousness. The work of art as a historical practice can be what Thierry de Duve has called an " 'interpretant,' filled with all the historical meanings of the field of conditions in which the fact of its existence resonates."[81] The field that has been formed by the past in its relation to the conditions of work in the present insists upon the artist; it both makes demands on and creates him: "Reinterpret[ing] the past as an artist," de Duve insists, means "creating oneself."[82] Or, as Bourdieu casts the same observation: "The production of a work which is always in part its own commentary" is also always the artist *"working on himself* as an artist."[83]

The field of which Bourdieu and de Duve write, with quite different politics, is the field of the artist's responsibility to both past and future, within which the artist is made as a figure, a historical stake. Perhaps now we can return to Barnett Newman's definition of "professional" as "serious" and to the seriousness that Michael McCall's respondents ascribed to the artists among them. Bourdieu notes that for the French bourgeois, *le sérieux* marks a "reciprocal appropriation" in which "the inheritance inherits the heir."[84] In assuming the name of the artist as a professional name, one assumes a responsibility, an obligation to that name's past as well as its future. Seriousness is, Bourdieu explains, "that aptitude to be what one is: the social form of the principle of identity."[85] That is why the artist is both the object and the subject of university training, why what the university makes is artists, for identity—the identity of the artist—is what is constructed in and by and through the discipline.

NOTES

Introduction

1. The question was not local to my college or to the early 1970s; rather it is endemic and, I argue below, defines the education of the artist. "What kind of work should I be making, anyway?" is the way the question was put by one student at the University of Illinois to a 1990 panel on social responsibility and the role of the artist in society, reported by Carol Becker, Speakeasy, *New Art Examiner* 18, no. 6 (February 1991): 15.

2. Walter Benjamin, "The Work of Art in the Age of Mechanical Reproduction," in *Illuminations,* ed. Hannah Arendt, trans. Harry Zohn (New York: Schocken Books, 1969), 218.

3. Thierry de Duve writes of these two histories: "It is as if at a certain moment in history, the specificity of painting reached the limits of its 'essential conditions' stripped bare and, from this point on, the aesthetic judgement 'This is painting' could no longer be uttered. Then two clans appeared": the first insisted still on the historicity and specificity of at least the name of painting; the second, "faced with an object that it is impossible to call painting," named its "object *art* while attaching to it an epithet that tries to respecify it." De Duve insists that there "are not two histories of modern art," that we misunderstood. But then we were only students (Thierry de Duve, *Pictorial Nominalism: On Marcel Duchamp's Passage from Painting to the Readymade,* trans. Dana Polan with the author [Minneapolis: University of Minnesota Press, 1991], 189–90).

4. Jacques Derrida, *The Truth in Painting,* trans. Geoff Bennington and Ian McLeod (Chicago: University of Chicago Press, 1987), 63–64.

5. In Cynthia Goodman, "The Hans Hofmann School and Hofmann's Transmission of European Modernist Aesthetics to America," Ph.D. diss., University of Pennsylvania, 1982, 76.

6. Raymond Parker, "Student, Teacher, Artist," *College Art Journal* 13, no. 1 (fall 1953): 28–29.

7. Derrida, *Truth in Painting,* 59.

8. Howard Risatti, "Protesting Professionalism," *New Art Examiner* 18, no. 6 (February 1991): 23.

9. Of the 184 graduate programs in studio art nationwide, only eight make no mention of a visiting artist or lecture series in the CAA's most recent *Directory of M.F.A. Programs in the Visual Arts,* rev. ed. (New York: College Art Association, 1996). The offerings range from two or three lectures a year to over forty at the Claremont Graduate School and the Universities of Connecticut and New Mexico, and eighty at Yale and the School of Visual Arts in New York City.

10. Both labels were used to describe and differentiate the California Institute of the Arts in its early days. See Judith Adler, *Artists in Offices* (New Brunswick, N.J.: Transaction Books, 1979), 1.

11. E. H. Gombrich, *Art and Illusion: A Study in the Psychology of Pictorial Representation,* 2d ed., rev. (1961; reprint, Princeton, N.J.: Princeton University Press, Bollingen Paperback Edition, 1969), 156.

12. Probably the earliest M.F.A. was that awarded by the University of Washington in 1924 to Mabel Lisle Ducasse. The University of Oregon awarded its first M.F.A. the following year. The 1928 edition of *American Universities and Colleges,* ed. David Allan Robertson (Washington, D.C.: American Council on Education; New York: Charles Scribner's Sons), lists only three M.F.A.s, at Yale, Syracuse, and Princeton. Princeton awarded the degree in the 1920s and 1930s, not as a studio art degree, but as its master's in art history. Clearly the meaning of the M.F.A. had not yet been formalized, and indeed the degree was so new in 1928 that it was not included in the *American Universities and Colleges* extensive list of degrees and abbreviations.

13. "The Present Status of the M.F.A. Degree: A Report to the Midwest College Art Conference," *College Art Journal* 24, no. 3 (spring 1965): 244.

14. These statistics are drawn from individual program descriptions submitted by departments to the CAA's 1996 *Directory of M.F.A. Programs in the Visual Arts.* For comparison, the 1992 edition listed 6,100 full-time students and more than 8,040 degrees awarded in the five years from 1987 to 1992.

15. Walter Gropius, "The Theory and Organization of the Bauhaus," in *Bauhaus, 1919–1928,* ed. Herbert Bayer, Walter Gropius, and Ise Gropius (New York: Museum of Modern Art, 1938), 23.

16. Leo Steppat, "Can Creative Art Be Taught in College?" *College Art Journal* 10, no. 4 (summer 1951): 385.

17. Stefan Hirsch, "An Appraisal of Contemporary Art Education," *College Art Journal* 10, no. 2 (winter 1950–51): 154.

18. Kenneth E. Hudson, in response to Allen S. Weller, "The Ph.D. for the Creative Artist," *College Art Journal* 19, no. 4 (summer 1960): 351.

19. Since the academy reserved the title artist for those who could draw, those whose work was the representation of the human figure, teaching art was teaching the figure: as Ingres insisted, drawing was "art *tout entier.*" Or as Katie Scott has written, "The representational product distinguished the artist

utterly from the artisan" ("Hierarchy, Liberty, and Order: Languages of Art and Institutional Conflict in Paris [1766–1776]," *Oxford Art Journal* 12, no. 2 [1989]: 65). Art, as representation, could indeed be taught in the academy, which reserved the word "genius" for that act of god or the heavens that lifted Raphael above other artists.

20. Walter Gropius, "Teaching the Arts of Design," *College Art Journal* 7, no. 3 (spring 1948): 160–61.

21. Ernst Kris and Otto Kurz, *Legend, Myth, and Magic in the Image of the Artist: A Historical Experiment* (New Haven, Conn.: Yale University Press, 1979), 15, 50. I refer throughout to the image of the artist in the university, and at times, too, to the image of the art department: held in these phrases are questions of identification and of status, of appearing for someone else. In "Writing Artists onto Campuses" (Chapter 1) and "Subjects of the Artist" (Chapter 5), in particular, I write of the *Künstlerroman*, the textual production of the artist, and the art student's capture in an image: the artist as a likeness. My choice of the word "image" acknowledges Kris and Kurz's *Legend, Myth, and Magic*, a book that has been important to me for some time. But it speaks as well to a process of identification, the decentering and refinding of oneself in the image of another, described in—and now abbreviated by—Lacan's Mirror stage. Lacan's description of identification as the process of re-restoring a unity that was at once constructed and lost in that initial visual displacement insists on the continuing "predominance of the visual. If the search for his affective unity promotes within the subject the forms by which he represents his identity with himself, its most intuitive form is provided, at this stage, by the specular image" (Mikkel Borch-Jacobsen, *Lacan: The Absolute Master*, trans. Douglas Brick [Stanford, Calif.: Stanford University Press, 1991], 49). I could, perhaps, have used "ideology," and written of the "ideology of the artist," but most recent readings of ideology have argued its pellucidness and pervasiveness. The image of the artist is a thickened and readily visible sight.

22. Walter Gropius, "First Proclamation of the Weimar Bauhaus," in Bayer, W. Gropius, and I. Gropius, *Bauhaus, 1919–1928* (as in note 15), 18.

Chapter 1

1. Roger L. Geiger, *To Advance Knowledge: The Growth of the American Research Universities, 1900–1940* (New York: Oxford University Press, 1986), 22.

2. Frederick M. Logan, *Growth of Art in American Schools* (New York: Harper and Brothers, 1955), 144.

3. Holmes Smith, "Problems of the College Art Association," *Art Bulletin* 1, no. 1 (1913): 6–10.

4. John Pickard, "President's Address (April 21, 1916)," *Art Bulletin* 1, no. 2 (1917): 15.

5. Ibid., 14.

6. Ibid., 13.

7. John Pickard, "The Future of the College Art Association," *Art Bulletin* 2, no. 1 (1919): 8.

8. Pickard, "President's Address (April 21, 1916)," 13–14.

9. Richard F. Bach, "Schools, Colleges, and the Industrial Arts," *Art Bulletin* 2, no. 3 (1920): 171.

10. Frederick Rudolph, *The American College and University: A History* (Athens: University of Georgia Press, 1990), 339.

11. Statistics are drawn from individual listings in the *American Art Annual* 14 (New York: American Federation of Arts, 1917), 284–318.

12. Ellsworth Woodward, "Supply and Demand," *Art Bulletin* 2, no. 2 (1919): 71.

13. In Richard Hofstadter and Wilson Smith, eds., *American Higher Education: A Documentary History* (Chicago: University of Chicago Press, 1961), 2:568.

14. Laurence Veysey, *The Emergence of the American University* (Chicago: University of Chicago Press, 1965), 113.

15. Ibid.

16. Alexander Meiklejohn, "What the Liberal College Is," in Hofstadter and Smith, *American Higher Education*, 2:902.

17. Ibid., 903.

18. Alice V. V. Brown, "Standardization of Art Courses," *Art Bulletin* 1, no. 4 (1918): 111.

19. Gertrude S. Hyde, "Ways and Means of Securing Proper Recognition for Art Teaching in Our Colleges and Universities," *Art Bulletin* 1, no. 4 (1918): 58–59, 61.

20. *American Art Annual* 11 (New York: American Federation of Arts, 1914), 38.

21. Pickard, "President's Address" (as in note 4), 14.

22. Lura Beam, "The Place of Art in the Liberal College," *Association of American Colleges Bulletin* 13, no. 3 (May 1927): 272.

23. *American Art Annual* 14:301.

24. While "by 1890 a distinctive Midwestern educational spirit was coming into being," characterized by "action, practicality, realism, and progress," Veysey writes, "only after 1909, when Harvard moved closer in its outlook to Yale and Princeton, did the contrast between the future Ivy League and Big Ten begin to take on a clear-cut significance." Those same years, "1908, 1909, and 1910 witnessed the widest flurry of debate about the aims of higher education ever to occur so far in the United States" (Veysey, *Emergence of the American University* [as in note 14], 109, 111, 252).

25. Robert Goldwater, "The Teaching of Art in the Colleges of the United States," *College Art Journal* 2, no. 4, supplement (May 1943): 23.

26. Ibid.

27. Committee of the College Art Association, "The Practice of Art in a Liberal Education," *College Art Journal* 6, no. 2 (winter 1946): 96, 95.

28. Ibid., 95.

29. Edward W. Rannells, "The Midwestern College Art Conference," *College Art Journal* 3, no. 2 (January 1944): 67.

30. Virginia Le Noir Van Duzer Fitzpatrick, "Changes in Curricula, Students, Faculty, and Teaching Styles in the Art Departments of the University of

Iowa and Indiana University, 1940 to 1949," Ph.D. diss., School of Education, Indiana University, 1989, 62–63.

31. John Alford, "Practice Courses in College Art Departments: A Survey," *Parnassus* 12, no. 7 (November 1940): 13.

32. In Fitzpatrick, "Changes in Curricula," 62.

33. Alford, "Practice Courses," 13 (emphasis in original).

34. Ibid.

35. "The Creative Artist Invades the University," *Arts in Society* 2, no. 3 (1963): 4.

36. Raymond Parker, "Student, Teacher, Artist," *College Art Journal* 13, no. 1 (fall 1953): 29.

37. Harold Taylor, "Symposium Statement: The Role of the University as a Cultural Leader," *Arts in Society* 3, no. 4 (1965–66): 462.

38. "Comment by Norman Rice," in ibid., 476.

39. Norman Rice, "Art in Academe," *Arts in Society* 2, no. 3 (1963): 40.

40. Ibid.

41. Ibid.

42. Walter Gropius, "The Theory and Organization of the Bauhaus," in *Bauhaus, 1919–1928,* ed. Herbert Bayer, Walter Gropius, and Ise Gropius (New York: Museum of Modern Art, 1938), 23.

43. As late as 1941, twenty years after the publication of this number of the *Art Student,* correspondence schools in art remained a large enough industry to earn a chapter in *The Fortieth Yearbook of the National Society for the Study of Education: Art in American Life and Education,* ed. Guy Montrose Whipple (Chicago: University of Chicago Press, 1941). The chapter's author, Arthur Pelikan, director of art in the Milwaukee public schools and of the city's art institute, mounted a scathing critique of the correspondence schools' "easy lessons" to defend the profession and the name of the artist. "The word *artist* is used to denote a person properly trained and qualified to take his place in the community on a par with men in other professions . . . whose right to practice in their chosen field depends on meeting definite requirements." Pelikan implored recognized art schools and colleges "to conduct an educational campaign that will help protect young people from falling prey to false promises" (663–64).

44. Fanny Kendall, "Lowly Artist Now Earns Big Sums," *Art Student,* School of Applied Art, Battle Creek, Mich. (1920): 9.

45. Ibid.

46. Ibid.

47. R. L. Duffus, *The American Renaissance* (New York: Alfred A. Knopf, 1928), 165.

48. Ibid.

49. Ibid., 97.

50. Ibid., 318.

51. Ibid., 165.

52. Ibid.

53. Ibid.

54. Cecilia Beaux, "What Should the College A.B. Course Offer to the Future Artist?" *American Magazine of Art* 7, no. 12 (October 1916): 480.

55. Duffus, *American Renaissance,* 166.

56. Ibid., 187.

57. Ibid., 48.

58. Ibid., 104.

59. Ellsworth Woodward, "What Instruction in Art Should the College A.B. Course Offer to the Future Artist?" *Art Bulletin* 1, no. 2 (1917): 20.

60. Duffus, *American Renaissance,* 49.

61. Ibid., 187–88.

62. Florence N. Levy, "Art Education: A Brief Statistical Survey Made by the American Federation of Arts," *Art and Progress* 6, no. 8 (June 1915): 281.

63. Ibid.

64. John Pickard, "President's Address (April 6, 1917)," *Art Bulletin* 1, no. 3 (1917): 43.

65. Duffus, *American Renaissance,* 167.

66. Pickard, "President's Address (April 6, 1917)," 42.

67. Ibid., 44.

68. Duffus, *American Renaissance,* 167.

69. Ibid., 186–87.

70. Beaux, "What Should the College A.B. Course Offer" (as in note 54), 480.

71. Woodward, "What Instruction in Art Should the College A.B. Course Offer" (as in note 59), 19.

72. Piet Mondrian, "Neo-Plasticism: The General Principle of Plastic Experience," in *Art in Theory, 1900–1990: An Anthology of Changing Ideas,* ed. Charles Harrison and Paul Wood (Oxford: Blackwell, 1992), 287.

73. Georges Braque, quoted in William Rubin, "Cézannisme and the Beginnings of Cubism," in *Cézanne: The Late Work,* ed. William Rubin (New York: Museum of Modern Art, 1977), 198 n. 88.

74. Arshile Gorky, "Cubism and Space, 1931," in Herschel B. Chipp, *Theories of Modern Art: A Source Book by Artists and Critics* (Berkeley and Los Angeles: University of California Press, 1968), 532, 534.

75. Hans Hofmann, quoted in Cynthia Goodman, "The Hans Hofmann School and Hofmann's Transmission of European Modernist Aesthetics to America," Ph.D. diss., University of Pennsylvania, 1982, 76.

76. Ibid., 106.

77. Walter S. Perry, "The Art School: Its Relation to the Arts and Crafts," *Craftsman* 2, no. 4 (July 1902): 197–98.

78. Duffus, *American Renaissance,* 48–49.

79. John Dewey, "Experience, Nature, and Art," in Dewey et al., *Art and Education* (Merion, Pa.: Barnes Foundation Press, 1929), 6.

80. Ibid.

81. Ibid., 11.

82. Quoted in Duffus, *American Renaissance,* 169. Michael Leja has written of the role such terms of exaggerated individualism played in the reception of modernism in America at the turn of the century; "egotism" and "over-individualization" were used by both sides of the critical debate over modern art as early as Royal Cortissoz's essay "Egotism in Contemporary Art" (1894). Leja reaches a conclusion quite like my own, albeit from a different direction, that

there was a "profound similarity between academicism and modernism . . . at the turn of the century in the United States. . . . [A]cademic art and modernist art appear not as antitheses but as different sides of a coin" (Leja, "Modernism's Subjects in the United States," *Art Journal* 55, no. 2 [summer 1996]: 71–72).

83. Dewey, "Experience, Nature, and Art," 6.

84. Writing of a portrait by Léon Cogniet in the Salon of 1845, Baudelaire characterized the *juste milieu* as a conscious and rational center, a choice driven by neither history nor inspiration so much as the public: "If he does not aspire to the level of genius, his is one of those talents which defy criticism by their very completeness within their own moderation. M. Cogniet is as unacquainted with the reckless flights of fantasy as with the rigid systems of the absolutists. To fuse, to mix and to combine, while exercising choice, have always been his role and aim; and he has perfectly fulfilled them" (Charles Baudelaire, *Art in Paris, 1845–1862: Salons and Other Exhibitions,* ed. and trans. Jonathan Mayne [Ithaca, N.Y.: Cornell University Press, 1981], 18). I have touched on and will return to the mistrust of the excesses of individualism that character- izes the discourse of art education in the university, a suspicion that might match the doubts of Baudelaire's Cogniet. First, I want to note the choices Co- gniet is allowed to make in lieu of recklessness or rigidity. Writing in 1917, Har- vard's Arthur Pope linked just such choices to the reasonable study of art, argu- ing that "the art of the future must be based on thorough understanding—call it Rational Eclecticism, or simply Rationalism, if you choose; and I believe that in rational teaching in the schools, continued in the colleges and universities, lies our chief hope for the art of the future" (Pope, "The Teaching of Drawing and Design in Secondary Schools," *Art Bulletin* 1, no. 3 [1917]: 51). Lester Longman, in his role as editor of the CAA's *Parnassus,* would argue, on the eve of World War II, for the humanist artist, the artist in the university, as a middle ground between a finished European abstraction ("by about 1933 it became ap- parent that highly subjective art had run its course") and an overbearing Amer- ican regionalism—between, in his wartime rhetoric, "the influence of the school of Paris . . . [and] the principles of Berlin, disguised as native American" (Long- man, "Better American Art," *Parnassus* 12, no. 6 [October 1940]: 4, 5). "It is not so difficult," Longman insisted, "for intelligent educators to strike a rea- sonable balance between 'progressive' and conservative principles of teaching" (4). Longman's middle ground is, like Baudelaire's and Pope's, the place of in- telligent choice, based on citizenship and necessity, on social efficiency.

85. Caroline Jones, *Machine in the Studio: Constructing the Postwar Amer- ican Artist* (Chicago: University of Chicago Press, 1996), 1. Jones's book stresses the romance of the studio for American abstract expressionism and its transformations in subsequent American art. Her decision to emphasize Euro- pean precedents because, as she says, they were most important to the painters of the New York school (19) necessarily elides the critique of the studio posed by American artists and critics in the 1920s and 1930s. Thus she also comes to a different conclusion about the gender of the studio and its occupant.

86. Meyer Schapiro, "The Social Bases of Art," in *First American Artists' Congress* (New York: American Artists' Congress against War and Fascism, 1936), 33.

87. Thomas Craven, "Men of Art: American Style," *American Mercury* 6, no. 24 (December 1925): 427.

88. Schapiro, "Social Bases of Art," 37.

89. Craven, "Men of Art," 432.

90. Ibid.

91. Kenyon Cox, *The Classic Point of View* (1911; reprint, with introductory notes by Henry Hope Reed and Pierce Rice, New York: W. W. Norton, 1980), 19.

92. Charles M. Shean, "Mural Painting from the American Point of View," *Craftsman* 7, no. 1 (October 1904): 21, quoted in David Adams, "Frederick S. Lamb's Opalescent Vision of 'A Broader Art,' " in *The Substance of Style: Perspectives on the American Arts and Crafts Movement,* ed. Bert Denker (Winterthur, Del.: Henry Francis du Pont Winterthur Museum, 1996), 328.

93. Peyton Boswell, quoted in Anthony W. Lee, "Diego Rivera's *The Making of a Fresco* and Its San Francisco Public," *Oxford Art Journal* 19, no. 2 (1996): 76.

94. Stefan Hirsch, "An Appraisal of Contemporary Art Education," *College Art Journal* 10, no. 2 (winter 1950–51): 150.

95. Albert I. Dickerson, *The Orozco Frescoes at Dartmouth* (Hanover, N.H.: Dartmouth College Publications, 1934), n.p.

96. Ibid.

97. Diego Rivera, *Portrait of America,* with an explanatory text by Bertram D. Wolfe (New York: Covici, Friede, 1934), 16.

98. Ibid., 17.

99. In Laurance P. Hurlburt, *The Mexican Muralists in the United States* (Albuquerque: University of New Mexico Press, 1989), 114.

100. Anthony W. Lee, "Diego Rivera's *The Making of a Fresco*" (as in note 93), passim. I am indebted to Lee for this reading and, more broadly, for his discussion of how the public is imagined and imaginary in the discourse of the mural.

101. Diego Rivera, "The Revolution in Painting," *Creative Art* 4, no. 1 (January 1929): 27.

102. Frank J. Roos, "Art Department: The University of Georgia," *Parnassus* 12, no. 8 (December 1940): 22.

103. Walter Gropius, "First Proclamation of the Weimar Bauhaus," in Bayer, W. Gropius, and I. Gropius, *Bauhaus, 1919–1928* (as in note 42), 18.

104. Walter Gropius, "Theory and Organization," in ibid., 23.

105. Duffus, *American Renaissance* (as in note 47), 318.

106. As one of the administrative agencies for the Federal Arts Project in New York, the College Art Association itself was picketed by the Artists' Union, later the CIO-affiliated United American Artists (Gerald M. Monroe, "The Artists Union of New York," Ph.D. diss., New York University, 1971, 63, 104).

107. Art historians from Rensselaer Lee on have critically examined the image of the Renaissance master and the unity of the workshop. Lee, followed by many others, questioned that artist's status as a learned humanist, a "renaissance man." More recently, historians examining workshop practices have suggested that there were both class divisions between workers in the shop—be-

tween *giovani* and *garzone,* those who learned as pupils and those who were employed to perform manual labor with little or no chance of leaving the shop as a master—and divisions into technical specialties quite early on. The educators' Renaissance was in many ways wishful thinking. See Rensselaer Lee, *Ut Pictura Poesis: The Humanistic Theory of Painting* (New York: W. W. Norton, 1967), as well as two anthologies on the education of artists: Laurie Rubin et al., *Children of Mercury: The Education of Artists in the Sixteenth and Seventeenth Centuries* (Providence, R.I.: Department of Art, Brown University, 1984); and Peter M. Lukehart, ed., *The Artist's Workshop* (Washington, D.C.: National Gallery of Art, 1993).

108. Eugene Savage, "On Art Education," in *Methods of Teaching the Fine Arts,* ed. William Sener Rusk (Chapel Hill: University of North Carolina Press, 1935), 133–34. Savage's essay, "slightly enlarged," was issued as a pamphlet by the Carnegie Corporation in New York in 1929.

109. Ibid.

110. Ibid., 127.

111. Ibid.

112. Ibid., 136.

113. Gibson Danes, "The Education of the Artist," *College Art Journal* 2, no. 3 (March 1943): 71.

114. Ibid., 72.

115. Ibid.

116. Ralph L. Wickiser, "The Artist as a Teacher," *College Art Journal* 11, no. 2 (winter 1951–52): 122.

117. Ibid.

118. Craven, "Men of Art" (as in note 87), 432.

119. Schapiro, "Social Bases of Art" (as in note 86), 35.

Chapter 2

1. Diego Rivera, "The Revolution in Painting," *Creative Art* 4, no. 1 (January 1929): 30.

2. Mary Hubbard Foote, quoted in Betsy Fahlman, "Women Art Students at Yale, 1869–1913: Never True Sons of the University," *Woman's Art Journal* 12, no. 1 (spring–summer 1991): 19.

3. Ann Bermingham, "The Aesthetics of Ignorance: The Accomplished Woman in the Culture of Connoisseurship," *Oxford Art Journal* 16, no. 2 (1993): 7.

4. June Wayne, "The Male Artist as a Stereotypical Female," *Art Journal* 32, no. 4 (summer 1973): 414–15.

5. Mary D. Garrard, " 'Of Men, Women and Art': Some Historical Reflections," *Art Journal* 35, no. 4 (summer 1976): 325.

6. James Jackson Jarves, *The Art-Idea: Part Second of Confessions of an Inquirer* (New York: Hurd and Houghton, 1864), 5–6.

7. Garrard, " 'Of Men, Women and Art,' " 325.

8. Ibid., 326.

9. Jarves, *Art-Idea,* 14.

10. Meyer Schapiro, "The Social Bases of Art," in *First American Artists'
Congress* (New York: American Artists' Congress against War and Fascism,
1936), 35. Thomas Craven's portrayal of the American artist as "an effeminate
creature who paints still-life, tepid landscapes, and incomprehensible abstrac-
tions purporting to express the aesthetic states of his wounded soul" is from
"Men of Art: American Style," *American Mercury* 6, no. 24 (December 1925):
432.

11. Marius de Zayas, quoted in Barbara Rose, ed., *Readings in American
Art, 1900–1973* (New York: Holt, Rinehart and Winston, 1975), 5.

12. Jonathan Weinberg cites de Zayas's declaration in analyzing how ho-
mosexuality was figured and homosexual artists placed in the first American
avant-garde (Weinberg, *Speaking for Vice: Homosexuality in the Art of Charles
Demuth. Marsden Hartley, and the First American Avant-Garde* [New Haven,
Conn.: Yale University Press, 1993]). The visibility of homosexuality in both
the communities and the literature of the avant-garde was used as a figure of
bohemian New York's openness. But the homosexual could image the modern
artist only in his isolated, closeted self-hatred; "homophobia pervaded the
avant-garde novel of the 1920s and 1930s," and it marked de Zayas's state-
ment as well—it is what made his metaphor possible, believable (204). The
avant-garde internalized the homophobic stereotypes of the broader culture,
perhaps because only the "unhappy homosexual" matched the avant-garde's
self-image, precisely because that sad figure, however visible, "does not neces-
sarily add up to a rebellion against the value system that marginalizes homo-
sexuality. . . . [and] may even end up reaffirming that marginalization" (205).
Reaffirmed for both general culture and the avant-garde, the stereotype could
signify the artist as outsider, and it could also, once again, imagine the artist as
a type. "Since the mid nineteenth century, *homosexuality* . . . defined not only a
set of physical attributes or perverse pleasures but a variety of persons—almost
a species" (5).

13. Michel Foucault, *The History of Sexuality* (New York: Vintage Books,
1980), 1:42–43.

14. Lewis M. Terman and Catharine Cox Miles, *Sex and Personality: Stud-
ies in Masculinity and Femininity* (New York: McGraw-Hill, 1936), 176.

15. Ibid.

16. Ibid., 177.

17. Ibid., 192.

18. Ibid., 572–73.

19. Ibid., 162, 167.

20. Wayne, "Male Artist as Stereotypical Female" (as in note 4), 415.

21. Lisa Tickner, "Men's Work? Masculinity and Modernism," *Differences*
4, no. 3 (1992): 11, 12.

22. Stephanie Z. Dudek, "Portrait of the Artist as a Rorschach Reader,"
Psychology Today, May 1971, 82.

23. Ibid., 47.

24. Ibid., 82.

25. Ibid., 78.

26. Foucault, *History of Sexuality* (as in note 13), 43.

27. Terman and Miles, *Sex and Personality* (as in note 14), 222, 221.

28. Georgia C. Collins, "Women and Art: The Problem of Status," *Studies in Art Education* 21, no. 1 (1979): 58. I am indebted to Collins's bibliography for leading me to Dudek's *Psychology Today* essay and, less directly, to Terman and Miles.

29. Ibid., 59.

30. Ibid. The Berkeley social psychologist Frank Barron offers ample support for Collins's contention that the circularity of psychological testing offers different positions to men and women. In surveying the traits of originality among men at the Air Force Academy in 1957, he imagines a relationship between originality and femininity, but the creative effects of that relationship matter only to men: "More original men would permit themselves to be more aware of tabooed interests and impulses." It is not surprising, perhaps, but still shocking that he goes on to remark what seems to him obvious: "Nature has literally arranged a division of labor. Men bring forth ideas, paintings, literary and musical compositions . . . while women bring forth the new generation" (Barron, "Originality in Relation to Personality and Intellect," *Journal of Personality* 25, no. 6 [December 1957]: 737). Surveying students at the San Francisco Art Institute a decade later, Barron again found that for male art students "the usual aggressive go-getter male role is left behind, its place taken by an emphasis on internal complexity, sensitivity, and a differentiated response to life (high *Mf*)." From these results, he fashioned a "portrait" of the male art student "that might be called the 'gentleman pirate' motif." In the mirror of that dashing image, Barron offered a "female pattern," a "slightly less flamboyant, more naive, more introverted version of the male." Her pattern does not become a portrait or an identity, only a difference that is marked and reinforced by biological difference (Barron, *Artists in the Making* [New York: Seminar Press, 1972], 45).

31. Terman and Miles, *Sex and Personality* (as in note 14), 222.

32. Dudek, "Portrait of the Artist" (as in note 22), 78.

33. Ibid., 82.

34. Wayne, "Male Artist as Stereotypical Female" (as in note 4), 415.

35. Rosi Braidotti, quoted in Teresa de Lauretis, *Technologies of Gender: Essays on Theory, Film, and Fiction* (Bloomington: Indiana University Press, 1987), 24.

36. Bermingham, "Aesthetics of Ignorance" (as in note 3), 5.

37. Pierre Macheray, *A Theory of Literary Production*, trans. Geoffrey Wall (London: Routledge and Kegan Paul, 1978), 85–101.

38. Frederick P. Keppel and R. L. Duffus, *The Arts in American Life* (New York: McGraw-Hill, 1933), 19.

39. Ibid., 41.

40. R. L. Duffus, *The American Renaissance* (New York: Alfred A. Knopf, 1928), 107–8.

41. Ibid., 127.

42. Ibid., 129.

43. Fahlman, "Women Art Students" (as in note 2), 17.

44. Ibid., 15. Students at Yale's Sheffield Scientific Institute—like the art school, a three-year, presumably vocational course for which Latin and Greek

were not required and for which the Bachelor of Arts was not awarded—were also barred from dining halls and chapel. Sheffield, founded in 1854 and funded between the 1860s and the turn of the century as a land-grant college, accounted for the majority of the male students' enrollments in the art school, which offered the drawing classes required for students of botany, geology, or anatomy. See Frederick Rudolph, *The American College and University: A History* (Athens: University of Georgia Press, 1990), 232.

45. Duffus, *American Renaissance*, 37.

46. Ibid., 44.

47. Thomas Woody, *A History of Women's Education in the United States* (New York: Science Press, 1929), 1:151.

48. Guy Albert Hubbard, "The Development of the Visual Arts in the Curriculums of American Colleges and Universities," Ph.D. diss., School of Education, Stanford University, 1962, 102.

49. Catharine Beecher, quoted in *Pioneers of Women's Education in the United States*, ed. Willystine Goodsell (New York: McGraw-Hill, 1931), 137.

50. Louise Boas, quoted in Hubbard, "Development of the Visual Arts," 125.

51. James Monroe Taylor and Elizabeth Hazelton Haight, *Vassar* (New York: Oxford University Press, 1915), 7.

52. Hubbard, "Development of the Visual Arts," 121.

53. Margaret Fuller, quoted in Woody, *History of Women's Education,* 1:109, 443.

54. Woody, ibid., 442.

55. Ibid., 394.

56. Taylor and Haight, *Vassar,* 51, 86.

57. Eleanor Wolf Thompson, *Education for Ladies, 1830–1860: Ideas on Education in Magazines for Women* (New York: King's Crown Press, 1947), 71–72.

58. Woody, *History of Women's Education,* 2:182.

59. Laurenus Seelye, quoted in Hubbard, "Development of the Visual Arts," 153–54.

60. Seelye, quoted in ibid., 193.

61. Ibid., 153.

62. Carey Thomas, quoted in Joyce Antler, *The Educated Woman and Professionalization: The Struggle for a New Feminine Identity, 1890–1920* (New York: Garland, 1987), 100.

63. Ibid.

64. Taylor and Haight, *Vassar,* 160.

65. *American Art Annual* 11 (New York: American Federation of Arts, 1914), 38.

66. Gertrude S. Hyde, "Ways and Means of Securing Proper Recognition for Art Teaching in Our Colleges and Universities," *Art Bulletin* 1, no. 4 (1918): 61.

67. See Mary Ann Stankiewicz, " 'The Eye is a Nobler Organ': Ruskin and American Art Education," *Journal of Aesthetic Education* 18, no. 2 (summer 1984): 51–64; and Roger B. Stein, *John Ruskin and Aesthetic Thought in America, 1840–1900* (Cambridge: Harvard University Press, 1967). On

Ruskin's influence on art education in Great Britain, see Stuart Macdonald, *The History and Philosophy of Art Education* (New York: American Elsevier, 1970). Macdonald's short passage on Ruskin bears the heading "Ruskin's Lack of Influence" (265).

68. Jarves, *Art-Idea* (as in note 6), 12.

69. C. J. Little, quoted in Mary Ann Stankiewicz, "The Creative Sister: An Historical Look at Women, the Arts, and Higher Education," *Studies in Art Education* 24, no. 1 (1982): 53–54.

70. Ibid., 52.

71. John Ruskin, *Sesame and Lilies* (New York: John Wiley and Sons, 1889), 93.

72. Ibid., 101.

73. Ibid., 110.

74. Ibid., 107.

75. Stankiewicz, "Eye is a Nobler Organ," 61.

76. John L. Rury, *Education and Women's Work: Female Schooling and the Division of Labor in Urban America, 1870–1930* (Albany: State University of New York Press, 1991), 21.

77. Arthur D. Efland, *A History of Art Education: Intellectual and Social Currents in Teaching the Visual Arts* (New York: Teachers College Press, 1990), 172. From 1888 to 1903 Bailey was also an examiner for the Massachusetts State Board of Education, writing annual reports on art education.

78. Henry Turner Bailey, *Art Education* (Boston: Houghton Mifflin, 1914), 32. Only when Bailey turns to the question of the art teacher as such, in his final chapter, "The Teacher the Chief Factor," does the pronoun's gender change; it does so without comment.

79. Ibid., 27.

80. Royal Bailey Farnum, "Professional Opportunities in Art," in *Art Professions in the United States*, ed. and comp. Elizabeth McCausland, Royal Bailey Farnum, and Dana P. Vaughan (New York: Cooper Union Art School, 1950), 87.

81. Ibid.

82. For two examples of this steering, from authors who do not question it, and indeed seem to share the assumptions that undergird it, see Barron, *Artists in the Making* (as in note 30); and Anselm Strauss, "The Art School and Its Students: A Study and an Interpretation," in *The Sociology of Art and Literature: A Reader*, ed. Milton C. Albrecht, James H. Barnett, and Mason Griff (New York: Praeger, 1970), 159–77. As Strauss writes, "The school can be conceived of as functioning as a huge sorting device" (175).

83. On statistics for women faculty in college and university art departments, see Ann Sutherland Harris, "Women in College Art Departments and Museums," *Art Journal* 32, no. 4 (summer 1973): 417–19; and Barbara Erlich White, "A 1974 Perspective: Why Women's Studies in Art and Art History?" *Art Journal* 35, no. 4 (summer 1976): 340–44. For statistics on graduate programs in art education, see Jessie Lovano-Kerr, Vicki Semler, and Enid Zimmerman, "A Profile of Art Educators in Higher Education: Male/Female Comparative Data," *Studies in Art Education* 18, no. 2 (1977): 21–37.

84. White, "A 1974 Perspective," 341.

85. Figures drawn from individual university listings in the CAA's *Directory of M.F.A. Programs in the Visual Arts* (New York: College Art Association, 1992).

86. Barbara Ehrlich White and Leon S. White, "Survey on the Status of Women in College Art Departments," *Art Journal* 32, no. 4 (summer 1973): 420.

87. Figures for 1996 are drawn from individual listings in the most recent *Directory of M.F.A. Programs in the Visual Arts,* rev. ed (New York: College Art Association, 1996). The CAA subsequently has reported that the percentage of women teaching in art and art history departments tripled between 1970 and 1995–96, and that women currently hold 33 percent of full-time studio art teaching positions. See *CAA News: Newsletter of the College Art Association* 23, no. 2 (March 1998).

88. McCausland, Farnum, and Vaughan, *Art Professions* (as in note 80), 52.

89. Ibid., 52–53.

90. Ibid., 53.

91. Ibid., 73.

92. Ibid., 88.

93. Duffus, *American Renaissance* (as in note 40), 108.

94. Ibid., 38. Betsy Fahlman's recent monograph on Weir makes clear the inaccuracy, or the viciousness, of Duffus's comment with its detailed discussion of the academic focus of the Yale school (Fahlman, *John Ferguson Weir: The Labor of Art* [Newark: University of Delaware Press, 1997], 124–42).

95. Walter Smith, quoted in Anthea Callen, *Angel in the Studio: Women in the Arts and Crafts Movement, 1870–1914* (London: Astragal Books, 1979), 44.

96. Oscar Lovell Triggs, *Chapters in the History of the Arts and Crafts Movement* (1902; reprint, New York: Arno Press, 1979), 159.

97. Sally Irvine, quoted in Isabelle Anscombe, *A Woman's Touch: Women in Design from 1860 to the Present Day* (New York: Elisabeth Sifton Books, 1984), 48.

98. Mary Sheerer, quoted in Callen, *Angel in the Studio,* 89.

99. Ibid.

100. Candace Wheeler, "Art Education for Women," *Outlook,* no. 55 (January 2, 1897): 82, 81.

101. Ibid., 87.

102. Ibid., 82.

103. Duffus, *American Renaissance* (as in note 40), 70.

104. Irene Sargent, "A Revival of the Old Arts and Crafts," lecture notes dated January 13, 1901, Syracuse University Archives.

105. "Useful Work versus Useless Toil," in *William Morris: Stories in Prose, Stories in Verse, Shorter Poems, Lectures, and Essays,* ed. G. D. H. Cole (London: Nonesuch Press, 1948), 603.

106. Lura Beam, "The Place of Art in the Liberal College," *Association of American Colleges Bulletin* 13, no. 3 (May 1927): 266.

107. Ibid.

108. Ibid.

109. Keppel and Duffus, *Arts in American Life* (as in note 38), 41.

110. Jane Addams, quoted in Eileen Boris, *Art and Labor: Ruskin, Morris, and the Craftsman Ideal in America* (Philadelphia: Temple University Press, 1986), 132.

111. Thorstein Veblen, *The Theory of the Leisure Class: An Economic Study of Institutions* (New York: Macmillan Company, 1905), 159.

112. Wassily Kandinsky, "Point and Line to Plane," in *Kandinsky: Complete Writings on Art*, ed. Kenneth C. Lindsay and Peter Vergo (Boston: G. K. Hall, 1982), 2:593.

113. On the gendering of the senses of touch and sight along the lines of proximity and distance, see, among many others, Craig Owens, "The Discourse of Others: Feminists and Postmodernism," in *The Anti-Aesthetic: Essays on Postmodern Culture*, ed. Hal Foster (Port Townsend, Wash.: Bay Press, 1983).

114. Edward W. Rannells, "Training the Eye to See," *College Art Journal* 5, no. 2 (January 1946): 113.

115. Erwin M. Breihaupt, "The Basic Art Course at Georgia," *College Art Journal* 17, no. 1 (fall 1957): 29.

Chapter 3

1. C. J. Little, quoted in Mary Ann Stankiewicz, "The Creative Sister: An Historical Look at Women, the Arts, and Higher Education," *Studies in Art Education* 24, no. 1 (1982): 54.

2. Ibid., 52.

3. *Report of the Committee on the Visual Arts at Harvard University* (Cambridge: Harvard University, 1956), 4.

4. At the time of the committee report a Graduate School of Design at Harvard trained architects, landscape architects, and urban designers. The school was known as the School of Architecture until 1936, when Dean Joseph Hudnut changed its name to the School of Design. He invited Walter Gropius to Harvard that same year. See Klaus Herdeg, *The Decorated Diagram: Harvard Architecture and the Failure of the Bauhaus Legacy* (Cambridge: MIT Press, 1983). For much of the first part of the twentieth century, Harvard had an active program in the "practice and theory of art." Its demise was lamented by the Committee on the Visual Arts, which credited Charles Moore, Denman Ross, and Arthur Pope with teaching "generations of Harvard men how to look at a work of art and how to analyze it. They also succeeded in establishing a common language and terminology within the department" (*Report of the Committee on the Visual Arts*, 50). Ross, author of *A Theory of Pure Design* (1907), the only citation in Roger Fry's "Essay in Aesthetics," and Pope, who had studied under Ross at Harvard, were committed to rationalizing and theorizing the teaching of art for an undergraduate liberal arts student body. The language of their science is not yet that of progressive research, as in the *Report of the Committee on the Visual Arts*, but it is clearly the language of theory as a university product. In his 1949 preface to *The Language of Drawing and Painting*, first published in 1929, Pope insisted that "there is no reason why a prospective artist should not know something definite about the terms of the art

with which he is going to express his ideas so that his paintings may be conducted on an intelligent and sensible basis," a basis that might be formed by the "studies concerning the art of drawing and painting which have been carried out by a succession of teachers and students in the Department of Fine Arts of Harvard University. It has been the aim of these studies to build up a knowledge to form the basis for a genuine theory of the visual arts comparable to theory in music" (Pope, *The Language of Drawing and Painting* [Cambridge: Harvard University Press, 1949], viii–ix). As a practical study in the theory of color relations and their particular "tone sequences," Ross and Pope taught a set of historically periodized palettes and methods. Pope, in a letter to the *College Art Journal* in support of training artists in colleges, argued that students armed with such a "systematic instruction"—even those "not at all especially talented or planning to become artists—have, in the time allotted to one or two courses, been able to produce work in tempera and in a variation of the Flemish oil technique, altogether comparable to the good school work of the fifteenth century" (Pope, Letters to the Editor: "On Training Artists," *College Art Journal* 6, no. 3 [spring 1947]: 226–27).

5. *Report of the Committee on the Visual Arts,* 52–53.

6. Ibid., 5.

7. Dagobert D. Runes and Harry G. Schrickel, *Encyclopedia of the Arts* (New York: Philosophical Library, 1946), 1051. This history is not completely convincing, or at least not complete. The few questions or comments on the term "Visual Arts" assume it is a translation or at least an extension of Lessing's *bildende Künste,* which "distinguish[ed] sharply the figurative and plastic arts from poetry . . . reduc[ing] their scope to the visible world," but it becomes current only around the time of World War I. Prior to that, Lessing's term was translated (as Giulio Carlo Argan translates it in the text above) as "figurative arts" (*Encyclopedia of World Art* [New York: McGraw-Hill, 1959], 1:769–70). One of the earliest appearances of "visual arts" is, quite fittingly, in Clive Bell's essay "The Aesthetic Hypothesis," in the same paragraph that introduces "significant form" (in Bell, *Art* [1913; reprint, New York: G. P. Putnam's Sons, Capricorn Books, 1958], 17).

8. *Report of the Committee on the Visual Arts,* 58.

9. S. David Deitcher, "Teaching the Late Modern Artist: From Mnemonics to the Technology of Gestalt," Ph.D. diss., City University of New York, 1989, 303.

10. Royal Bailey Farnum, "The General and Technical Education of the Artist," in *Fortieth Yearbook of the National Society for the Study of Education: Art in American Life and Education,* ed. Guy Montrose Whipple (Chicago: University of Chicago Press, 1941), 619. The art teacher is conspicuously absent from Farnum's list of the professions of the artist as designer. For a discussion of Farnum, art education, and gender, see Chapter 2.

11. Ibid., 623.

12. Abbé Charles Batteux, quoted in Paul Oskar Kristeller, "The Modern System of the Arts: A Study in the History of Aesthetics," in *Studies in Renaissance Thought and Letters* (Rome: Edizioni di Storia e di Letteratura, 1993), 3:587.

13. Katie Scott, "Hierarchy, Liberty, and Order: Languages of Art and Institutional Conflict in Paris (1766–1776)," *Oxford Art Journal* 12, no. 2 (1989): 65.

14. Thierry de Duve, "Das Ende des Bauhaus-Modells," in *Akademie zwischen Kunst und Lehre: Künstlerische Praxis und Ausbildung—eine kritische Untersuchung,* ed. Denys Zacharopoulos (Vienna: Akademie der bildenden Künste Wien, 1992), 25. (I translate from de Duve's French text, which to my knowledge has not been published.)

15. *Report of the Committee on the Visual Arts,* 51.

16. Ibid.

17. De Duve makes a similar case for the shift from past to present, and the presentness insisted upon in the conflation of art and science. I have quoted above his description of the métier of the academy as "received from the past . . . situated upstream in history—in *antiquity.*" He contrasts academic métier to Bauhaus medium: "the métier is practiced, the medium is questioned; the métier is transmitted, the medium communicates; the métier is learned, the medium is discovered; the métier is a tradition, the medium is a language" (de Duve, "Das Ende des Bauhaus-Modells," 25; my translation from unpublished French text). De Duve's essay was written in French and published in German; the word chosen to translate métier was *Gewerbe,* which is usually translated into English as "craft." The transformation of art from a continuation of the past to a practice for the future can be seen in the crafts and language of the Bauhaus weaving workshop. Jane Addams of Hull-House wrote in 1900 of "mistresses of an old and honored craft" and "the whirl of wheels [that] recalls many a reminiscence and story of the old country" (in Eileen Boris, *Art and Labor: Ruskin, Morris, and the Craftsman Ideal in America* [Philadelphia: Temple University Press, 1986], 132; for a fuller discussion of this citation, see Chapter 2). Gunta Stolzl, a student in the weaving workshop at Bauhaus-Weimar and its director in Dessau, wrote in quite different terms in 1926. "Woven fabric constitutes an aesthetic entity, a composition of color, form, and material as a whole. Today in all fields of design there is a quest for law and order. Thus, we in the weaving workshop have set ourselves the task of investigating the basic elements of our particular field" (quoted in Hans M. Wingler, *The Bauhaus: Weimar, Dessau, Berlin, Chicago* [Cambridge: MIT Press, 1969], 116).

18. George Wald, "The Artist in the University," in *Report of the Committee on the Visual Arts,* 43.

19. Ibid., 47–48.

20. David Durst, "Artists and College Art Teaching," *College Art Journal* 16, no. 3 (spring 1957): 229.

21. Harold Rosenberg, "Educating Artists," in *New Ideas in Art Education,* ed. Gregory Battcock (New York: E. P. Dutton, 1973), 93.

22. National Association of Schools of Art and Design, *Handbook: 93–94* (Reston, Va.: National Association of Schools of Art and Design, 1993), 76. Also on the list of B.F.A. painting guidelines is the "encouragement to develop a consistent, personal direction and style." The chapter that follows addresses this construction of difference and the insistent linkage of consistency and personality, the repetition necessary for building the self as an artist.

23. Ibid., 91.

24. Frederick M. Logan, *Growth of Art in American Schools* (New York: Harper and Brothers, 1955), 255.

25. Gyorgy Kepes, *Language of Vision* (Chicago: Paul Theobald and Company, 1944), 201.

26. The phrase "artist-designer" was coined in 1937 by Robert Lepper, one of Andy Warhol's teachers at Carnegie Tech, on the occasion of the establishment of the nation's first B.F.A. degree in Industrial Design. See Deitcher, "Teaching the Late Modern Artist" (as in note 9), 298–99.

27. Marcel Franciscono, *Walter Gropius and the Creation of the Bauhaus in Weimar: The Ideals and Artistic Theories of Its Founding Years* (Urbana: University of Illinois Press, 1971), 166.

28. Ibid., 171.

29. Thierry de Duve, "Resonances of Duchamp's Visit to Munich," in *Marcel Duchamp: Artist of the Century*, ed. Rudolf E. Kuenzli and Francis M. Naumann (Cambridge: MIT Press, 1990), 57.

30. Ibid., 56.

31. See, for example, Frank Whitford's text for the "World of Art" series: *Bauhaus* (London: Thames and Hudson, 1984), 156; or Walter Gropius's own translation, "High School for Design," in *The New Architecture and the Bauhaus*, trans. P. Morton Shand, with an introduction by Frank Pick (Cambridge: MIT Press, 1965), 52. In his memoir Gropius uses the name to describe the school from the moment of its founding at Weimar, but the name is granted to the Bauhaus only after 1925.

32. Nikolaus Pevsner, *Academies of Art, Past and Present* (1940; reprint, New York: Da Capo Press, 1973), 272.

33. The professor was Fritz Schumacher, a teacher important to the Brücke painters Ernst Ludwig Kirchner and Erich Heckel, who, it might be noted, gained their training, not in an art *Akademie*, but at the *Kunstgewerbeschule*. See Peter Lasko, "The Student Years of the *Brücke* and Their Teachers," *Art History* 20, no. 1 (March 1997): 83, 99 n. 74.

34. Nikolaus Pevsner, *The Sources of Modern Architecture and Design* (New York: Praeger, 1968), 170.

35. Lionel Richard, *Encyclopédie du Bauhaus* (Paris: Editions Somogy, 1985), 92. De Duve does not translate *Gestaltung*, but elsewhere in "Resonances of Duchamp's Visit" he translates *Gestalter* (in terms similar to Richard's) as a "conceiver of forms" (52).

36. Arnheim offers a quick translation in presenting Gropius's outline for the Bauhaus's preliminary course, as published in *The New Architecture and the Bauhaus*. Criticizing the school's division of the artist's education between *Werklehre* and *Formlehre*, Arnheim notes that "formation (*Gestaltung*) . . . dealt with color, space, and composition: it was thought of as the teaching of visual grammar." In his synopsis Gropius translates that very same *Gestaltung* as "design" (Rudolf Arnheim, *Toward a Psychology of Art: Collected Essays* [Berkeley and Los Angeles: University of California Press, 1966], 200).

37. Henry Schaefer-Simmern, preface to the second edition of Conrad Fiedler, *On Judging Works of Visual Art*, trans. Henry Schaefer-Simmern and Fulmer Mood (Berkeley and Los Angeles: University of California Press, 1957), vii.

38. T. Lux Feininger, "The Bauhaus: Evolution of an Idea," in *Bauhaus and Bauhaus People*, rev. ed., ed. Eckhard Neumann (New York: Van Nostrand Reinhold, 1993), 184.

39. Fiedler, *On Judging Works of Visual Art*, 46, 48. See also Philippe Junod, *Transparence et Opacité: Essai sur les fondements théoriques de l'Art Moderne* (Lausanne: Editions L'Age d'Homme, 1976), 181 n. 82.

40. Mark Jarzombek, "De-Scribing the Language of Looking: Wölfflin and the History of Aesthetic Experientialism," *Assemblage*, no. 23 (April 1994): 41.

41. Conrad Fiedler, "Observations on the Nature and History of Architecture," in *Empathy, Form, and Space: Problems in German Aesthetics, 1873–1893*, trans. Henry Francis Mallgrave and Eleftherios Ikonomou (Santa Monica, Calif.: Getty Center for the History of Art and the Humanities, 1994; distributed by the University of Chicago Press), 130.

42. Hermann Muthesius, quoted in Franciscono, *Walter Gropius* (as in note 27), 67 n. 89.

43. Marianne L. Teuber, "*Blue Night* by Paul Klee," in *Vision and Artifact*, ed. Mary Henle (New York: Springer, 1976), 143.

44. Hannes Beckmann, "Formative Years," in Neumann, *Bauhaus and Bauhaus People*, 209.

45. Ibid., 199.

46. Max Wertheimer, quoted in Mitchell G. Ash, *Gestalt Psychology in German Culture, 1890–1967: Holism and the Quest for Objectivity* (Cambridge: Cambridge University Press, 1995), 41.

47. Wolfgang Kohler, *Gestalt Psychology* (New York: Horace Liveright, 1929), 192.

48. Ibid., 182–83.

49. Kepes, *Language of Vision* (as in note 25), 15.

50. Ibid., 14.

51. Ibid., 17, 19.

52. Kohler, *Gestalt Psychology*, 64.

53. Ibid., 193.

54. David Summers, "The 'Visual Arts' and the Problem of Art Historical Description," *Art Journal* 42, no. 4 (winter 1982): 309.

55. Wingler, *Bauhaus* (as in note 17), 23, 31.

56. Pevsner, *Academies of Art* (as in note 32), 223–24.

57. Ibid., 224.

58. László Moholy-Nagy, *Vision in Motion* (Chicago: Paul Theobald and Company, 1956), 36.

59. Richard Redgrave, quoted in Stuart Macdonald, *The History and Philosophy of Art Education* (New York: American Elsevier, 1970), 235.

60. Jean-Auguste-Dominique Ingres, quoted in Albert Boime, "The Teaching Reforms of 1863 and the Origins of Modernism in France," *Art Quarterly* 1, n.s. (1977): 20.

61. Ingres, quoted in ibid.

62. Pierre Subeyran, quoted in Pevsner, *Academies of Art* (as in note 32), 172.

63. On the Berlin Gewerbe Institut, see Arthur D. Efland, *A History of Art Education: Intellectual and Social Currents in Teaching the Visual Arts* (New York: Teachers College Press, 1990), 56.

64. Banjamin Haydon, quoted in Macdonald, *History and Philosophy*, 116–17.

65. William Dyce, quoted in ibid., 121.

66. Gropius's "Program of the Staatliche Bauhaus in Weimar" and "The Statutes of the Staatliche Bauhaus in Weimar" are included in Wingler, *Bauhaus* (as in note 17), 31–33, 44–45.

67. Wassily Kandinsky, "The Value of Theoretical Instruction in Painting," in *Kandinsky: Complete Writings on Art*, ed. Kenneth C. Lindsay and Peter Vergo (Boston: G. K. Hall, 1982), 2:703.

68. Oskar Schlemmer, quoted in Wingler, *Bauhaus*, 523.

69. Ibid., 145. At Dessau, Oskar Schlemmer's course was the third segment of a three-part compulsory design program, following Albers's "Learning by Doing," Kandinsky's "Analytic Drawing," and Klee's "Elementary Design Theory of the Plane." Schlemmer, who was form master for dance and theater, taught the model on the stage or in the auditorium, often posing the students themselves, a presentation that might be read as a decentering, a fictionalizing or at least ironizing, of the figure as the center and theory of art (see Wingler, *Bauhaus*, 144–45).

70. Ibid., 474.

71. In Herschel B. Chipp, *Theories of Modern Art: A Source Book by Artists and Critics* (Berkeley and Los Angeles: University of California Press, 1968), 292–93.

72. This absence continued until the 1870s, when the schools of design were renamed schools of art, but even then "drawing and painting the human figure, which was the only recognized training for fine artists at the time, made up only five of the twenty-three stages of which the course consisted" (Jeanne Sheehy, "The Flight from South Kensington: British Artists at the Antwerp Academy," *Art History* 20, no. 1 [March 1997]: 124).

73. Peter C. Marzio, *The Art Crusade: An Analysis of American Drawing Manuals, 1820–1860* (Washington, D.C.: Smithsonian Institution Press, 1976), 1.

74. Albert Boime, *The Academy and French Painting in the Nineteenth Century* (London: Phaidon Press, 1971), 24–29.

75. Marzio, *The Art Crusade*, 31.

76. Kandinsky, *Complete Writings*, 2:728–29.

77. Naum Gabo, "Realist Manifesto," in Chipp, *Theories of Modern Art*, 328.

78. William Dyce, quoted in Macdonald, *History and Philosophy* (as in note 59), 82, 151.

79. Peter Hahn, "Bauhaus and Exile: Bauhaus Architects and Designers between the Old World and the New," in *Exiles and Emigrés: The Flight of European Artists from Hitler*, ed. Stephanie Barron with Sabine Eckmann (Los Angeles: Los Angeles County Museum of Art, 1997), 213.

80. E. H. Gombrich, *Art and Illusion: A Study in the Psychology of Pictorial Representation*, 2d ed., rev. (1961; reprint, Princeton, N.J.: Princeton University Press, Bollingen Paperback Edition, 1969), 306.

81. Richard Shiff, *Cézanne and the End of Impressionism: A Study of the Theory, Technique, and Critical Evaluation of Modern Art* (Chicago: University of Chicago Press, 1984), 129.

82. Charles Blanc, *The Grammar of Painting and Engraving*, trans. Kate Newell Doggett (New York: Hurd and Houghton, 1875), 104–5. On the following page, Blanc argues against teaching by type solids, or against starting with them, and in support of the academic practice of beginning by drawing after engravings: "It seems to us that the drawing of objects already drawn or engraved ought to precede drawing directly from a model, geometrical or not; and that before putting one's self face to face with reality, it is well to learn the conventional proceedings by which it is interpreted." This mention, indeed this reasoned discussion, suggests the prevalent use of the geometric solid. See also Christopher Gray, "Cézanne's Use of Perspective," *College Art Journal* 19, no. 1 (fall 1959): 55.

83. Blanc, *Grammar of Painting*, 104.

84. Molly Nesbit, "Ready-Made Originals: The Duchamp Model," *October* 37 (summer 1986): 54–55.

85. Theodore Reff, "Cézanne on Solids and Spaces," *Artforum* 16, no. 2 (October 1977): 35. As further proof of the ubiquity of cylinders, cones, and spheres, in two dimensions and three, he quotes Ingres's complaint of 1840: "What purpose do these cubes, these cones and polygons serve? . . . Unhappy pupils, you are placed before your tombs and forced to copy them." Reff enlists Ingres's statement to underscore the spread and the obviousness of Cézanne's teaching, but it insists as well on a distinction that the academician wished to continue.

86. *Paul Cézanne Letters*, ed. John Rewald (London: Bruno Cassirer, 1941), 234.

87. Emile Bernard, quoted in Shiff, *Cézanne and the End of Impressionism*, 130.

88. Cézanne, *Letters*, 239.

89. Nikolaus Pevsner, *Pioneers of Modern Design from William Morris to Walter Gropius* (New York: Museum of Modern Art, 1949), 40.

90. Moholy-Nagy, *Vision in Motion* (as in note 58), 123. For Itten's "general theory of contrast," see Johannes Itten, *Design and Form: The Basic Course at the Bauhaus*, trans. John Maass (New York: Reinhold, 1964), 12. Reyner Banham, Marcel Franciscono, and others have linked Itten's "general theory of contrast" to pre–World War I German aesthetics and, like Cézanne's cones and cylinders, to Charles Blanc's *Grammaire*. See Franciscono, *Walter Gropius and the Creation of the Bauhaus* (as in note 27), 199–213.

91. Cézanne, *Letters*, 239.

92. Kurt Roesch in Anne Carter Ely, "The Artist: Learning," *Mademoiselle*, July 1952, 114; Edward W. Rannells, "Training the Eye to See," *College Art Journal* 5, no. 2 (January 1946): 113; Erwin M. Breihaupt, "The Basic Art Course at Georgia," *College Art Journal* 17, no. 1 (fall 1957): 29.

93. When Blanc's *Grammaire* was published in English in 1875, the translator's preface avidly continued the title's linguistic metaphor: "What we especially need is the A B C of Art." Such a teaching must come, not "from its history or its philosophy, but its grammar" (Blanc, *Grammar of Painting* [as in note 82], translator's preface, xiv).

94. Gombrich, *Art and Illusion* (as in note 80), 156–72.

95. Carel van Mander, quoted in ibid., 160.

96. Ibid., 161.

97. Barbara Maria Stafford, *Body Criticism: Imaging the Unseen in En-
lightenment Art and Medicine* (Cambridge: MIT Press, 1991), 9.

98. Ibid., 12.

99. Gombrich does not, after all, come to composition—to a set of pictorial
relations arranged across a gridded, rectilinear surface—in *Art and Illusion*
until Constable's *Wivenhoe Park,* in a chapter appropriately enough entitled
"The Analysis of Vision in Art." He locates the first conjunction of art and vi-
sion as a field at the same mid-nineteenth-century moment with which I began;
before he lays the grid over Constable's painting, there are only figures and
parts (see 303–5).

100. Martin Heidegger, "The Age of the World Picture," in *The Question
concerning Technology and Other Essays,* trans. William Lovitt (New York:
Garland, 1977), 129. Perhaps not coincidentally, one of Heidegger's markers of
the modern world picture is "art's moving into the purview of aesthetics," a
field Charles Blanc, in his *Grammaire,* had already declared a "modern sci-
ence."

101. That these forces were, or were not far from, narratives can be seen in
Klee's transcriptions of stories into lines in his "Creative Credo" (reprinted in
Chipp, *Theories of Modern Art* [as in note 71], 182–86) and in El Lissitzky's
Suprematist Story of Two Squares in Six Constructions (1924).

102. Moholy-Nagy, *Vision in Motion* (as in note 58), 150.

103. Ibid.

104. Kandinsky, *Complete Writings* (as in note 67), 2: 729.

105. Itten, *Design and Form* (as in note 90), 12.

106. Edward W. Rannells, "The Theory of Requiredness in the Understand-
ing of Art," *College Art Journal* 5, no. 1 (November 1945): 15–16.

107. Rosalind E. Krauss, *The Optical Unconscious* (Cambridge: MIT Press,
1993), 19.

108. Ibid., 11. For Krauss, the paintings that mark Mondrian's entry into
modernism are the *Plus and Minus* paintings of 1914–18, which record "a mo-
ment not of sensation but of cognition, the moment, that is, of pure relation-
ship. His field would thus be structured by these signals—black on white—
these signs for plus and minus, these fragments of an abstract grid that would
intend to throw its net over the whole of the external world in order to enter it
into consciousness. To think it" (12). This plotting of both visual and pictorial
fields with the remarking of horizontal and vertical axes is an exercise that ap-
pears in 1852 in the Boston public schools. William Bartholomew's "elemen-
tary drawing exercises consisted of putting dots in horizontal and vertical lines.
The first dot was placed in the center of the drawing slate. And successive dots
were marked in equal spaces from the center. During the exercises the teacher
explained basic terms: 'right and left,' 'equal distances,' 'between,' and 'mid-
dle.' In subsequent lessons tiny crosses were substituted for the dots, and the
same proportion exercises were repeated." I have not attempted to trace the ex-
ercise or the use of pluses to grid the picture plane (or in Bartholomew's case,
the surface of an industrial drawing slate) to Europe, but Peter Marzio, whose

synopsis I have just quoted, has suggested its roots in Pestalozzi. (Marzio, *The Art Crusade* [as in note 73], 62.)

109. Deitcher, "Teaching the Late Modern Artist" (as in note 9), 42.

110. Krauss, *Optical Unconscious,* 16, 19.

111. Ibid., 19.

112. Ibid.

113. Roland Barthes, "The Structuralist Activity," in *Critical Essays,* trans. Richard Howard (Evanston, Ill.: Northwestern University Press, 1972), 214–15.

114. Ibid., 215.

115. László Moholy-Nagy, *The New Vision* (1928), 4th rev. ed., and *Abstract of an Artist* (New York: Wittenborn, Schultz, 1947), 21.

Chapter 4

1. Paul Cézanne, in Herschel B. Chipp, *Theories of Modern Art: A Source Book by Artists and Critics* (Berkeley and Los Angeles: University of California Press, 1968), 12.

2. John Ruskin, *The Elements of Drawing: Three Letters to Beginners* (New York: John Wiley and Sons, 1886), 22.

3. Jonathan Crary, *Techniques of the Observer: On Vision and Modernity in the Nineteenth Century* (Cambridge: MIT Press, 1992), 95.

4. Ibid.

5. Ruskin, *Elements of Drawing,* 23.

6. Ralph Waldo Emerson, quoted in Hugh Honour, *Romanticism* (New York: Harper and Row, 1979), 313–14. For the long history of the child as Cicero's *specula naturae,* see George Boas, *The Cult of Childhood* (London: Warburg Institute, 1966).

7. In the United States, James Sully, "The Child as Artist," in *Studies of Childhood* (1895); see Boas, *Cult of Childhood,* 83–86. In Germany, Karl Gotze, *Das Kind als Künstler* (1898); see Sterling Fishman, *The Struggle for German Youth: The Search for Educational Reform in Imperial Germany* (New York: Revisionist Press, 1976), 23–24.

8. Francis Wayland Parker, quoted in Diana Korzenik, "The Artist as the Model Learner," in *The Educational Legacy of Romanticism,* ed. John Willinsky (Waterloo, Ontario: Wilfred Laurier University Press, 1990), 146. For Parker, in Diana Korzenik's words, "The learning child was the working artist"; his title for the ideal classroom educator is one subsequently used through the 1950s and 1960s in places like the University of Iowa, the "artist-teacher."

9. Philippe Junod, *Transparence et Opacité: Essai sur les fondements théoriques de l'Art Moderne* (Lausanne: Editions L'Age d'Homme, 1976), 160.

10. Mrs. John Kraus-Boelte, "Characteristics of Froebel's Method, Kindergarten Training," in Foster Wygant, *Art in American Schools in the Nineteenth Century* (Cincinnati, Ohio: Interwood Press, 1983), 243; a facsimile reproduction of *NEA Proceedings* (1879) appears as appendix N.

11. Ibid.

12. Or more ontogenetic—more involved with a theory of the development of the child as the mirror of the development of the race—than economic. Neither Pestalozzi's teaching nor Ruskin's (divided as it was between the Working Men's College and Oxford) was free from economics. Pestalozzi's "object teaching" began as a method for those unable to afford schools or private tutors to teach their own children readily graspable basics with the objects at hand.

13. In Boas, *Cult of Childhood* (as in note 6), 38.

14. In Wygant, *Art in American Schools* (as in note 10), 79.

15. Pestalozzi, quoted in Arthur D. Efland, *A History of Art Education: Intellectual and Social Currents in Teaching the Visual Arts* (New York: Teachers College Press, 1990), 80.

16. Ibid.

17. *Sol LeWitt Drawings, 1958–1992*, ed. Susanna Singer (The Hague: Haags Gemeentemuseum, 1992), plate 141. The possibility of LeWitt's drawing-by-instruction is given in the design problem, in the posing of a problem in writing to be solved in and as a visual image, a work.

18. Wolfgang Wangler and Katja Rose, *Bauhaus—gegenständliches Zeichnen bei Josef Albers* (Cologne: Verlag der Zeitschrift "Symbol," 1987), n.p.

19. Ibid.

20. See Carl Goldstein, "Teaching Modernism: What Albers Learned in the Bauhaus and Taught to Rauschenberg, Noland, and Hesse," *Arts Magazine* 54, no. 4 (December 1979): 108–16.

21. László Moholy-Nagy, *Vision in Motion* (Chicago: Paul Theobald and Company, 1956), 68.

22. Mary Dana Hicks, quoted in Efland, *History of Art Education*, 129.

23. Kraus-Boelte, "Characteristics of Froebel's Method," in Wygant, *Art in American Schools* (as in note 11), 246.

24. Elizabeth Peabody, quoted in Frederick M. Logan, *Growth of Art in American Schools* (New York: Harper and Brothers, 1955), 75. Froebelianism and the kindergarten were initially much more successful in post–Civil War America than in Europe, and their success gave rise to art book publishers and supplies makers as well as to the burgeoning teaching of art and art practice in normal schools. As I remarked in my opening chapters, normal school training and school teaching were the initial goals of many of the country's college and university art departments.

It has often been noted that as young children both Frank Lloyd Wright, whose mother was a kindergarten teacher in the United States, and Kandinsky in Russia received sets of Froebel's gifts and occupations. For an early discussion of Froebel and modernism, see Frederick Logan, "Kindergarten and Bauhaus," *College Art Journal* 10, no. 1 (fall 1950); and Sibyl Moholy-Nagy's response in a letter to the editor, *College Art Journal* 10, no. 3 (spring 1951): 270–72. More recently, see Jeanne S. Rubin, "The Froebel-Wright Kindergarten Connection: A New Perspective," *Journal of the Society of Architectural Historians* 48 (March 1989): 24–37; and Norman Brosterman's extensive examination, *Inventing Kindergarten* (New York: Harry N. Abrams, 1997).

25. Marcel Franciscono, *Walter Gropius and the Creation of the Bauhaus in Weimar: The Ideals and Artistic Theories of Its Founding Years* (Urbana: University of Illinois Press, 1971), 180.

26. Walter Gropius, "The Theory and Organization of the Bauhaus," in *Bauhaus, 1919–1928,* ed. Herbert Bayer, Walter Gropius, and Ise Gropius (New York: Museum of Modern Art, 1938), 31. As the opening statement in the Museum of Modern Art's 1938 exhibition catalogue, Gropius's "Theory and Organization" helped form the reception of the Bauhaus in America.

27. Wilhelm Viola, *Child Art and Franz Cizek* (Vienna: Austrian Junior Red Cross, 1936), 37.

28. Franz Cizek, quoted in Stuart Macdonald, *The History and Philosophy of Art Education* (New York: American Elsevier, 1970), 343.

29. Cizek, quoted in S. B. Malvern, "Inventing 'Child Art': Franz Cizek and Modernism," *British Journal of Aesthetics* 35, no. 3 (July 1995): 268.

30. Sadakichi Hartmann, "The Exhibition of Children's Drawings," *Camera Work,* no. 39 (July 1912): 45.

31. Hughes Mearns, quoted in Logan, *Growth of Art* (as in note 24), 157, 159.

32. Edward Sheldon, quoted in Wygant, *Art in American Schools* (as in note 11), 80.

33. James R. Campbell, "The Pratt Institute," *Century Illustrated Monthly Magazine* 46, no. 6 (October 1893): 871.

34. Ibid., 879–80.

35. Quoted in Frederick C. Moffatt, *Arthur Wesley Dow (1857–1922)* (Washington, D.C.: Smithsonian Institution Press, 1977), 59.

36. Ibid., 82. Dow's teaching had an important, and until recently unsung, impact on the development of American modernism. Among the well-known artists who learned his lessons firsthand were several associated with Stieglitz's 291: Weber, Georgia O'Keeffe, and the photographer Alvin Langdon Coburn. Dow's teaching was particularly influential in the Midwest and West, where the greatest expansion in college art and art education programs took place. The American modernist painter Raymond Jonson, who founded the art department at the University of New Mexico, studied with a Dow-trained teacher at the Museum Art School in Portland, Oregon. Dow's teaching was central to the program at the Los Angeles Normal School, which became the UCLA art department, and it remained important to the UCLA curriculum through the 1940s. Its impact was also felt at the Cleveland Museum School, where it influenced the American painter Charles Burchfield. Perhaps here is the place to note Cizek's influence as well. Oskar Kokoschka was a young art student with Cizek at the Vienna Kunstgewerbeschule. At a much greater distance, Mark Rothko, who was Max Weber's student at the Art Students League, wrote notes toward a new curriculum for teaching art in the United States in the late 1930s, based on Wilhelm Viola's influential *Child Art and Franz Cizek* of 1936 (see James E. B. Breslin, *Mark Rothko: A Biography* [Chicago: University of Chicago Press, 1993], 130–37).

37. Franciscono, *Walter Gropius* (as in note 25), 197.

38. Ibid., 212.

39. Arthur Wesley Dow, *Composition: A Series of Exercises in Art Structure for the Use of Students and Teachers*, 13th ed. (1913; reprint, Garden City, N.Y.: Doubleday, Doran and Company, 1931), 5.

40. Arthur Wesley Dow, "Training in the Theory and Practice of Teaching Art," *Teachers College Record* 9, no. 3 (May 1908): 136, 133.

41. Dow, *Composition*, 3.

42. Arthur D. Efland, "Changing Views of Children's Artistic Development: Their Impact on Curriculum and Instruction," in *The Arts, Human Development, and Education*, ed. Elliot W. Eisner (Berkeley, Calif.: McCutchan Publishing, 1976), 73. Eisner links the description of Cizek's teaching directly to Dow's "synthetic approach."

43. Franz Cizek, quoted in Malvern, "Inventing 'Child Art' " (as in note 29), 267.

44. Albert Boime, *The Academy and French Painting in the Nineteenth Century* (London: Phaidon Press, 1971), 175, 43.

45. Ruskin, *Elements of Drawing* (as in note 2), 169, 167.

46. R. L. Duffus, *The American Renaissance* (New York: Alfred A. Knopf, 1928), 48.

47. Gropius, "Theory and Organization of the Bauhaus" (as in note 26), 26. Dow had argued that it was "the individual's right to have full control of these powers" in "Training in the Theory and Practice of Teaching Art," 133.

48. Gropius, ibid., 22, 24. "Form," here, is once again *Gestaltung*.

49. Logan, *Growth of Art* (as in note 24), 174.

50. László Moholy-Nagy, *The New Vision* (1928), 4th rev. ed., and *Abstract of an Artist* (New York: Wittenborn, Schultz, 1947), 17–18, 13.

51. Franz Cizek, *Children's Coloured Paper Work* (Vienna: Anton Schroll, 1927), 4. Dow's "Training in the Theory and Practice of Teaching Art" (1908) begins by proclaiming, "The true purpose of art teaching is the education of the whole people for appreciation."

52. David Manzella, "The Teaching of Art in the Colleges of the United States," *College Art Journal* 15, no. 3 (spring 1956): 244–45.

53. Ibid.

54. Ibid., 245.

55. In ibid., 250–51.

56. Committee of the College Art Association, "A Statement on the Practice of Art Courses," *College Art Journal* 4, no. 1 (November 1944): 35.

57. Ibid.

58. *Report of the Committee on the Visual Arts at Harvard University* (Cambridge: Harvard University, 1956), 8.

59. *General Education in a Free Society, Report of the Harvard Committee* (Cambridge: Harvard University Press, 1945), 212.

60. Ibid., 108.

61. John Dewey, *Art as Experience* (New York: Minton, Balch and Company, 1934), 38.

62. Ernest Ziegfeld performs this connection of Dewey, Gestalt psychology, general education, and the visual arts in *Art in the College Program of General Education* (New York: Teachers College, 1953), 66–71.

63. Dewey, *Art as Experience,* 35.
64. Ibid., 36, 56.
65. Ibid., 84.
66. Ibid., 57.
67. Compare Dewey's statement with that of the American Froebelian Mrs. John Kraus-Boelte to the National Education Association in 1876:

> To be able to work productively, one must learn the A.B.C. of matter, and also the A.B.C. of things, since all things are of a material nature. . . . This A.B.C. of things consists in their common properties, for example: form, color, size, number, sound, etc. Whether we mean artistic or industrial work, it always has to do with *form,* color dimension, etc. . . . But the discovery of such a plastic A.B.C. is not only the beginning, the knowledge, and the mastery of the material; it also brings the free methodical management of every work, by means of which the workman arrives at the comprehension of its theory, and thus only is labor to be raised to science, when it becomes an intellectual and individual product.
> (Quoted in Wygant, *Art in American Schools* [as in note 11], 243)

The very possibility of professionalization is grounded on that "plastic A.B.C."; Kraus-Boelte's next paragraph addresses the disciplinary and moral problems of the professions, of medicine, law, and teaching, taught without foundations. Visual form lies both at the beginning of education, in the kindergarten classroom, and at its end, in the science and theory that can be developed because vision is ordered according to the order that underlies the world. What is taught through types and gifts, in grammars and languages, is neither drawing nor how to make art; rather, the production of art is afterward, only one of a number of modes of conceiving and arranging, one profession among others that might be taught over and bettered by the apprehension of form.

68. Dewey, *Art as Experience,* 57.
69. Ibid., 45.
70. Dan Flavin, "On an American Artist's Education," *Artforum* 6, no. 7 (March 1968): 31.
71. Moholy-Nagy, *New Vision* (as in note 50), 67.
72. "Kunstpädagogik," in *Kandinsky: Complete Writings on Art,* ed. Kenneth C. Lindsay and Peter Vergo (Boston: G. K. Hall, 1982), 2:723. General education, or *allgemeine Bildung,* was a hotly debated issue for post–World War I Germany, as it would be for post–World War II America. Kandinsky insisted on a course of education that would allow the phrase to be written without irony, or as he put it, without quotes around *allgemeine.*
73. Ibid., 725.
74. Ibid.
75. Moholy-Nagy, *New Vision,* 15.
76. Mitchell G. Ash, *Gestalt Psychology in German Culture, 1890–1967: Holism and the Quest for Objectivity* (Cambridge: Cambridge University Press, 1995), 73.
77. Ziegfeld, *Art in the College Program* (as in note 62), 59.
78. Both Thomas Jefferson's farmer and the postwar American professional were fashioned outside class divisions; they elided or, better, sublimated those

divisions. What defined the farmer for Jefferson was that he was not a factory worker, that he was (somehow) outside the wage system; that was the source of his autonomy. The attributes of the professional in essays on the professions in the 1950s include not only technical expertise and theoretical knowledge but also—in pointed opposition to the businessman and his workforce—service, altruism, and broad, enlightened interest. After noting theory and expertise, Morris Cogan of Harvard's School of Education continued, "This understanding and these abilities are applied to the vital practical affairs of man. The practices of the professions are modified by a knowledge of a generalized nature and by the accumulated wisdom and experience of mankind, which serve to correct the errors of specialism. The profession, serving the vital needs of man, considers its first ethical imperative to be altruistic service to the client" (Cogan, "Toward a Definition of Profession," *Harvard Educational Review* 23, no. 1 [winter 1953]: 49).

79. Gianni Vattimo, too, has commented on the relationship between modern design, psychical transparency, and social coherence, arguing that the modernist belief in design is a continuation of social utopianism, the bourgeois form of Marxism's new world. "The most explicit and radical form of utopia is obviously to be found in Marxism, but it also has a bourgeois form in the ideology of *design,* which has been widely influential, most especially via the popularity of Dewey in European philosophy and critique in the fifties." He could have dated the conjunction of Dewey and European design earlier, for he points to the Bauhaus as one of the sites of the transformation of utopia from Marxian to designed (Vattimo, *The Transparent Society,* trans. David Webb [Baltimore: Johns Hopkins University Press, 1992], 62–64).

80. Graham Collier, *Form, Space, and Vision: Discovering Design through Drawing* (Englewood Cliffs, N.J.: Prentice Hall, 1967), 104.

81. Ibid., 107.

82. I am indebted to Sande Cohen for phrasing this point so clearly.

83. Lillian Garrett, *Visual Design: A Problem-Solving Approach* (New York: Reinhold, 1967), 153.

84. Johannes Itten, *Design and Form: The Basic Course at the Bauhaus,* trans. John Maass (New York: Reinhold, 1964), 11.

85. Thomas M. Folds, "Letter to a College Committee," *College Art Journal* 16, no. 1 (fall 1956): 59.

86. Ibid., 61.

87. Ibid., 62.

88. Ibid.

89. Clive Bell, *Art* (1913; reprint, New York: G. P. Putnam's Sons, Capricorn Books, 1958), 17.

90. Dow, "Training in the Theory and Practice of Teaching Art" (as in note 40), 4.

91. Dorr Bothwell and Marlys Mayfield, *Notan: The Dark-Light Principle of Design* (1968; reprint, New York: Dover Publications, 1991), back cover.

92. Rosalind Krauss, *The Originality of the Avant-Garde and Other Modernist Myths* (Cambridge: MIT Press, 1985), 9.

Chapter 5

1. Mary Fuller McChesney, *A Period of Exploration: San Francisco, 1945–1950* (Oakland, Calif.: Oakland Museum Art Department, 1973), 8. Rivera's bottom and its relation to the mural's audiences was an ongoing theme in the criticism and interpretation of the fresco. See Anthony W. Lee, "Diego Rivera's *The Making of a Fresco* and Its San Francisco Public," *Oxford Art Journal* 19, no. 2 (1996): 72–82, for a strong reading of the mural in relation to the politics of, and the audiences for, "public" art in San Francisco. On its covering and Smith's interview with McChesney as the source of the MacAgy story, see Susan Landauer, *The San Francisco School of Abstract Expressionism* (Laguna Beach, Calif.: Laguna Art Museum; Berkeley and Los Angeles: University of California Press, 1996), 35, and 221 nn. 45, 46. I am indebted to Anthony Lee in personal correspondence for further details of the mural's covering.

2. "The Artist in Search of an Academy, Part I," in *Art-as-Art: The Selected Writings of Ad Reinhardt,* ed. Barbara Rose (New York: Viking Press, 1975), 201. Reinhardt offers four types, but the first of them, the Ash Can school artist, is too early to be at stake in the mural and its covering. The essay stirred a good deal of controversy in what had been a community: Sibyl Moholy-Nagy wrote a letter to the editor, Clyfford Still wrote a letter to Reinhardt's dean at Brooklyn College, and Barnett Newman filed suit against Reinhardt for libel.

3. Ibid.

4. Ibid., 202.

5. Ibid.

6. Mark Rothko, quoted in James E. B. Breslin, *Mark Rothko: A Biography* (Chicago: University of Chicago Press, 1993), 351. For T. J. Clark's use of this same letter, see his "In Defense of Abstract Expressionism," *October* 69 (summer 1994), where he notes as obvious Rothko's "irony at the expense of the *nouvelles couches sociales.*" "Condescension," Clark insists, "just *is* the form of the petty bourgeoisie's self-recognition" (46).

7. Rothko, quoted in Breslin, ibid.

8. William C. Seitz, "Abstract-Expressionist Painting in America: An Interpretation Based on the Work and Thoughts of Six Key Figures," Ph.D. diss., Princeton University, 1955, 443. By 1957 two graduate degrees had been awarded for art histories of abstract expressionism: Seitz's Princeton doctoral dissertation of 1955 and Francis Celantano's New York University master's thesis, "The Origins and Development of Abstract Expressionism in the United States," of 1957. The turnaround time for abstract expressionism as art-historical knowledge speaks to both the critical acceptance of the style within the university and the expansion not only of studio programs but also of art history departments and their purview.

9. Seitz, ibid.

10. Hilton Kramer, "California Students," *Art Digest* 29, no. 4 (November 15, 1954): 26–27.

11. Martica Sawin, "Hunter College Students," *Art Digest* 29, no. 13 (April 1, 1955): 27–28.

12. Alfred Frankenstein, "University of Mississippi," *Art Digest* 29, no. 8 (January 15, 1955): 26.

13. Al Newbill, "University of Colorado Group," *Art Digest* 29, no. 2 (October 15, 1954): 30.

14. Hassel Smith, quoted in McChesney, *Period of Exploration* (as in note 1), 9.

15. Deirdre Robson, "The Market for Abstract Expressionism: The Time Lag Between Critical and Commercial Acceptance," *Journal of the Archives of American Art* 25, no. 3 (1985): 21. Robson remarks that the sale of *Autumn Rhythm* marked the "first time a major museum had bought a painting in this style for a price commensurate with what it might pay for a work by a major European artist" (22).

16. College Art News: "New Art Buildings," *College Art Journal* 17, no. 2 (winter 1958): 201.

17. Norman Rice, "Art in Academe," *Arts in Society* 2, no. 3 (1963): 47.

18. Ibid.

19. The National Association of Schools of Design developed standards for professional degrees in the practice of art and for the accreditation of schools offering those degrees. An organization of "leading professional art schools and college art departments," the association was announced in the *Art Digest* of September 15, 1948, on the same page as the initial advertisement for Subjects of the Artist, an art school founded by William Baziotes, David Hare, Robert Motherwell, and Mark Rothko (I will discuss it at some length in the coming pages), and among ads for some seventy other art schools spread across three pages. The National Association of Schools of Design (now of Schools of Art and Design) helped to hasten the demise of private, non–degree-granting studio schools such as Subjects of the Artist; whatever its innovations in pedagogical practice, Subjects of the Artist stood administratively on the wrong side of history. A decade later, in 1958, the *Art Digest*'s September issue contained ads for only sixteen schools; two decades later, the magazine, now called *Arts Magazine*, ran ads for only eight. Of those eight, seven advertised degree programs; of the seventy with which Subjects of the Artist shared its pages in 1948, only four advertised degrees ("Schools of Design Form Association," *Art Digest* 22, no. 20 [September 15, 1948]: 38).

20. Virginia Le Noir Van Duzer Fitzpatrick, "Changes in Curricula, Students, Faculty, and Teaching Styles in the Art Departments of the University of Iowa and Indiana University, 1940 to 1949," Ph.D. diss., School of Education, Indiana University, 1989, 109.

21. Allan Kaprow, "The Effect of Recent Art on the Teaching of Art," *Art Journal* 23, no. 2 (winter 1963–64): 138, 136.

22. Stanley Meltzoff, "David Smith and Social Surrealism," *Magazine of Art* 39, no. 3 (March 1946): 101.

23. Robert Goodnough, introduction to "Artists' Sessions at Studio 35 (1950)," in *Modern Artists in America*, no. 1, ed. Robert Motherwell and Ad Reinhardt (New York: Wittenborn, Schultz, 1952), 9.

24. R. L. Duffus, *The American Renaissance* (New York: Alfred A. Knopf, 1928), 77.

25. McChesney, *Period of Exploration* (as in note 1), 1, 5.

26. Erle Loran, *Cézanne's Composition: Analysis of His Form with Diagrams and Photographs of His Motifs,* 2d ed. (Berkeley and Los Angeles: University of California Press, 1946), 18. The Bauhaus's Cézanne is one of the larger polemical targets of Loran's book: "Cézanne would never have conceived of the idea of making a picture out of triangles, circles, and squares. Those contemporary 'nonobjective' painters who do so . . . would have outraged Cézanne" (9).

27. Albert C. Barnes, *The Art in Painting* (New York: Harcourt, Brace and Company, 1926); and Sheldon Cheney, *Expressionism in Art* (New York: Liveright, 1934).

28. Loran's book cites Barnes and Cheney as important precursors and notes the influence of Hofmann and Glenn Wessels on Cheney's book and on *Cézanne's Composition.* (This debt is acknowledged more fully in a preface to the 1970 edition; from the outset Loran had acknowledged his teacher Cameron Booth, a Hofmann student in Munich and a longtime teacher at the University of Minnesota.)

29. On the Bauhaus in northern California as well as the impact of Hans Hofmann, see Peter Selz, "The Impact from Abroad: Foreign Guests and Visitors," in *On the Edge of America: California Modernist Art, 1900–1950,* ed. Paul J. Karlstrom (Berkeley and Los Angeles: University of California Press, in association with the Archives of American Art, Smithsonian Institution, and the Fine Arts Museums of San Francisco, 1996), 97–120.

30. Oscar Collier, "Mark Rothko," *New Iconograph* 4 (fall 1947): 41; cited in Breslin, *Mark Rothko* (as in note 6), 60.

31. Breslin, ibid., 289.

32. Sally Avery, interview by Tom Wolf, February 19, 1982; and Ben-Zion, interview by Barbara Shikler, August 3–September 21, 1982, in "Mark Rothko and His Times," Archives of American Art, Smithsonian Institution, Washington, D.C.

33. Stanley Kunitz, interview by Avis Berman, December 8, 1983, in "Mark Rothko and His Times," Archives of American Art, Smithsonian Institution, Washington, D.C.

34. Breslin, *Mark Rothko* (as in note 6), 292, from a letter Rothko drafted to Dean Gaede of Brooklyn College.

35. Ibid., 294.

36. Ibid., 616 n. 55. A noisier version of the Bauhaus battle had just taken place at the California School of Fine Arts, where a significant number of the painting faculty left in 1951 to protest the policies and tactics of Ernest Mundt, MacAgy's replacement as director, whom MacAgy had hired initially to represent the Bauhaus at CSFA. Though hired as a sculptor, Mundt had been trained as an architect in Germany—not at the Bauhaus, but well within its sphere. The title of a textbook he published in 1950 seems to sum up much of the dream of Bauhaus teaching: *A Primer of Visual Art: The Basis of Advertising, Posters, Typography, Textiles, Display, Interiors, Industrial Design, Architecture, Sculpture, Photography, Drawing, Painting,* the hierarchy of media and modes of visual expression perhaps an indication of the problem he posed for painters like

Hassel Smith, whom Mundt fired, and Elmer Bischoff and David Park, who re-signed to protest Smith's firing. See Richard Cándida Smith, *Utopia and Dissent: Art, Poetry, and Politics in California* (Berkeley and Los Angeles: University of California Press, 1995), 126–32.

37. H. H. Arnason, "On Robert Motherwell and His Early Work," *Art International* 10, no. 1 (January 1966): 18.

38. Ibid., 20.

39. Ibid., 19.

40. Hegel, quoted in Martin Swales, "Irony and the Novel: Reflections on the German Bildungsroman," in *Reflection and Action: Essays on the Bildungsroman,* ed. James Hardin (Columbia: University of South Carolina Press, 1991), 50. There is an essay to be written on the abstract expressionist bildungsroman that would place the educational problem and the scene of instruction at the center of an understanding of abstract expressionism. The narratives of abstract expressionism—Greenberg's "Late Thirties in New York" and "American Type Painting," for example, and the tellings and retellings of Arshile Gorky's passionate and interrupted apprenticeships that appear at the beginning of almost every New York school history—are stories of "the education of the individual at the hands of the given reality." The passage from youth to adulthood in the bildungsroman is "no longer the slow and predictable progress towards one's father's work." By the nineteenth century, Franco Moretti continues, in place of apprenticeship stood the "uncertain exploration of social space . . . through travel and adventure, wandering and getting lost, 'Bohême' and 'parvenir' " (Franco Moretti, *The Way of the World: The Bildungsroman in European Culture* [London: Verso, 1987], 4). I could add to the list of examples above the other genesis story of abstract expressionism, Harold Rosenberg's tale of abandonment and breakthrough in "American Action Painters." It, too, follows the lines of the bildungsroman—along lines briefly like this. "Many of the painters were 'Marxists' (WPA unions, artists' congresses)," Rosenberg wrote in the pages of *Art News* in 1952. "They had been trying to paint Society. Others had been trying to paint Art (Cubism, Post-Impressionism)—it amounts to the same thing. The big moment came when it was decided to paint . . . just to PAINT" (Harold Rosenberg, *The Tradition of the New* [1960; reprint, Chicago: University of Chicago Press, Phoenix Edition, 1982], 30). Rosenberg's painters and Hegel's hero shed the same poetic goals, the outsize dreams of personal fame and professional ambition, of improving the world and changing reality. And Rosenberg's outcome, his repeated "to paint . . . to paint," might be read as professional maturity, a prosaic getting down to work. Finally, I would note that Serge Guilbaut's *How New York Stole the Idea of Modern Art,* to take the best-known example among the more recent and more critical art histories of abstract expressionism, casts the American artists precisely as adventurers and parvenus, beginning with its title. The question is one of legitimacy even if, like T. J. Clark in his "In Defense of Abstract Expressionism," one comes to love the vulgarity of the artists. Moretti notes the particular relationship between the bildungsroman as a genre and the "*excessive* need for legitimation created by the. . . . interrupting [of] historical continuity" (83).

41. Arnason, "On Robert Motherwell," 17.

42. The statistics are drawn from individual listings in the *American Art Annual* 33 (Washington, D.C.: American Federation of Arts, 1937), 409–502.

43. John P. O'Neill, ed., *Clyfford Still* (New York: Metropolitan Museum of Art and Harry N. Abrams, 1979), 177–78.

44. Philippe de Montebello, in his foreword to O'Neill's 1979 catalogue, thanks "Mr. and Mrs. Still, who themselves have provided the greater part of the text." The 1992 catalogue *Clyfford Still: The Buffalo and San Francisco Collections* reprints the 1979 biography, with additions, under Patricia Still's name. In her introduction, she refers to "the Biographical Chronology that I wrote and compiled for the catalogue of the 1979 one-man exhibition at the Metropolitan Museum" (Thomas Kellein, ed., *Clyfford Still: The Buffalo and San Francisco Collections* [Munich: Prestel-Verlag, 1992], 145).

45. Marvin D. Schwartz, "News and Views from New York," *Apollo* 66 (December 1957): 193.

46. Ibid.

47. April Kingsley, *The Turning Point: The Abstract Expressionists and the Transformation of American Art* (New York: Simon and Schuster, 1992), 155.

48. Clyfford Still, "Cézanne: A Study in Evaluation," master's thesis, Washington State University, Pullman, 1935, 4, 6.

49. Ibid., 7.

50. Maurice Denis, "Cézanne," in *Post-Impressionists in England: The Critical Reception*, ed. J. B. Bullen (London: Routledge, 1988), 67. Denis's essay, translated by Roger Fry, was published in *Burlington Magazine*, January 1910. The necessarily clumsy Cézanne was a commonplace; a number of years later Georges Braque repeated Denis's equation, insisting that Cézanne "worked away from all the *facilities* that talent gives," but, then, "the recourse to talent . . . shows a defect in the imagination." Cézanne, Braque asserted, in language that will resonate later in this chapter, "swept painting clear of the idea of mastery" (William Rubin, "Cézannisme and the Beginnings of Cubism," in *Cézanne: The Late Work*, ed. William Rubin [New York: Museum of Modern Art, 1977], 168, 167).

51. Clive Bell, "The Debt to Cézanne," in *Art* (1913; reprint, New York: G. P. Putnam's Sons, Capricorn Books, 1958), 143.

52. One finds Worringer's words in more than one place. I take them from John Prossor's 1957 "Introduction to Abstract Painting," *Apollo* 66 (1957): 76. Prossor starts with *Abstraction and Empathy* in his opening remarks, insisting that "all theories of aesthetics in relation to modern art are largely founded on the work of Professor Wilhelm Worringer." He glosses Worringer's use of Riegl's volition and the passage I quote in the text in terms that might be familiar to Clyfford Still's Cézanne: "To put it another way, no valid, sincere artistic style is created to fulfil a preconceived, set pattern . . . but is created to satisfy an urgent need felt by its authors to express themselves in a particular way."

53. Lisa Tickner, "Men's Work? Masculinity and Modernism," *Differences* 4, no. 3 (1992): 6.

54. Thomas Hess, *Barnett Newman* (New York: Museum of Modern Art, 1971), 22.

55. In Kingsley, *Turning Point*, 107.

56. Clement Greenberg, "After Abstract Expressionism," in _Modernism with a Vengeance, 1957–1969,_ vol. 4 of _Clement Greenberg: The Collected Essays and Criticism,_ ed. John O'Brian (Chicago: University of Chicago Press, 1993), 132–33.

57. The one-page catalogue is reproduced as appendix B in _The Collected Writings of Robert Motherwell,_ ed. Stephanie Terenzio (New York: Oxford University Press, 1992), 294–95.

58. Kingsley, _Turning Point,_ 105.

59. Motherwell, _Collected Writings,_ 294.

60. Résumé in the Yvonne Thomas papers, Archives of American Art, Smithsonian Institution, Washington, D.C.

61. Duffus, _American Renaissance_ (as in note 24), 76.

62. Quoted in Peter Plagens, _Sunshine Muse: Contemporary Art on the West Coast_ (New York: Praeger, 1974), 161.

63. Motherwell, _Collected Writings,_ 295.

64. Ibid., 61–62.

65. Goodnough, "Artists' Sessions" (as in note 23), 9.

66. Motherwell, _Collected Writings,_ 294.

67. David Hare, quoted in Kingsley, _Turning Point,_ 107.

68. Douglas MacAgy, quoted in McChesney, _Period of Exploration_ (as in note 1), 36.

69. Albert Boime, _The Academy and French Painting in the Nineteenth Century_ (London: Phaidon Press, 1971), 34.

70. Florence Weinstein, quoted in Barbara Cavaliere and Robert C. Hobbs, "Against a Newer Laocoon," _Arts Magazine_ 51, no. 8 (April 1977): 110.

71. In Kellein, _Clyfford Still: Buffalo and San Francisco_ (as in note 44), 161.

72. Yvonne Thomas, quoted in Breslin, _Mark Rothko_ (as in note 6), 265.

73. Mark Rothko, quoted in ibid., 261. The questions were posed by Clay Spohn.

74. Ernest Briggs, quoted in ibid., 259–60.

75. Douglas MacAgy, quoted in ibid., 264.

76. Douglas MacAgy, quoted in McChesney, _Period of Exploration_ (as in note 1), 36.

77. Ernest Briggs, quoted in ibid., 40.

78. Mona Hadler and Jerome Viola, _Brooklyn College Art Department: Past and Present, 1942–1977_ (Brooklyn: Brooklyn College Art Department, 1977), 13. Hadler and Viola also note Reinhardt's "technique" of aphorism and his talking "about—or, rather, around" student work. "Both inside and outside the classroom, to speak of art in the 1950's in America was to speak in philosophical and conceptual terms" (14).

79. Charles Madge and Barbara Weinberger, _Art Students Observed_ (London: Faber and Faber, 1973), 31. Madge and Weinberger have given the site of their case study the pseudonym Midville College of Art.

80. Ibid., 33.

81. Ibid., 31.

82. Quoted in McChesney, _Period of Exploration,_ 27.

83. Harold Rosenberg, untitled catalogue statement for *The Intrasubjectives*, an exhibition at the Sam Kootz Gallery, September 14 to October 3, 1949. Republished in facsimile in Motherwell and Reinhardt, *Modern Artists in America* (as in note 23), 174.

84. Mary Abbott, quoted in Kingsley, *Turning Point* (as in note 47), 107.

85. Fred Martin, quoted in Breslin, *Mark Rothko* (as in note 6), 259.

86. Rosenberg, catalogue statement for *Intrasubjectives*, 174.

87. Jacques Lacan, *Ecrits: A Selection*, trans. Alan Sheridan (New York: W. W. Norton, 1977), 311.

88. Jacques Lacan, *The Four Fundamental Concepts of Psycho-Analysis*, ed. Jacques-Alain Miller, trans. Alan Sheridan (New York: W. W. Norton, 1978), 214 (emphasis in original).

89. Ibid.

90. From Benjamin Townsend, "An Interview with Clyfford Still," *Gallery Notes* 24, no. 2 (Buffalo: Albright-Knox Art Gallery, 1961), reprinted in *New York School: The First Generation, Paintings of the 1940s and 1950s*, ed. Maurice Tuchman (Los Angeles: Los Angeles County Museum of Art, 1965), 32.

91. O'Neill, *Clyfford Still* (as in note 43), 194, 202–3.

92. Lacan, *Ecrits*, 20.

93. Mark Rothko to Murray Israel, quoted in Breslin, *Mark Rothko* (as in note 6), 248–49.

94. Lacan, *Ecrits*, 19.

95. "The Sublime Is Now," in *Barnett Newman: Selected Writings and Interviews*, ed. John P. O'Neill (Berkeley and Los Angeles: University of California Press, 1992), 173.

96. Lacan, *Ecrits*, 4–5.

97. Ibid., 19.

98. Rosenberg, *Tradition of the New* (as in note 40), 27.

99. Ibid., 28.

100. Ibid., 29.

101. Harold Rosenberg, *The Anxious Object* (1966; reprint, Chicago: University of Chicago Press, Phoenix Edition, 1982), 100. Rosenberg was not alone in discussing the artist's identity; Reinhardt devotes much of his writing—his lists of roles and camps and occupations—to finding an identity for the artist, as does David Smith in his public statements through the 1950s, particularly his 1953 address to the American Federation of Arts, "Economic Support of Art in America Today." Smith fashioned his identity in remarkably Lacanian terms: "Identity begins with a certain defensive belligerence and at many times in the artist's life he is forced to use the same means." After that beginning, identity is constructed around the subject, as its fortress, protecting and projecting the subject's singularity as its double: Smith speaks of "the building of identity," and argues both that "identity must be pure and undivided," that it "can never be two things," and that the artist "can have only his identity for company" (*David Smith*, ed. Garnett McCoy [New York: Praeger, 1962], 107–9).

102. Rosenberg, *Tradition of the New*, 65–66.

103. Ad Reinhardt, quoted in McChesney, *Period of Exploration* (as in note 1), 23.

104. Magali Sarfatti Larson, *The Rise of Professionalism: A Sociological Analysis* (Berkeley and Los Angeles: University of California Press, 1977), 50.

105. William Baziotes papers, Archives of American Art, Smithsonian Institution, Washington, D.C.

106. Hassel Smith papers, Archives of American Art, Smithsonian Institution, Washington, D.C. Smith and others taught his course at least through the mid seventies, by which time the school was known as Bristol Polytechnic. By 1975 mystic, preacher, natural scientist, and psychoanalyst had been added to the list; entertainer and craftsman had been dropped.

107. Ibid. From an unpublished, undated interview by Jan Butterfield.

108. In Seitz, "Abstract-Expressionist Painting" (as in note 8), 380.

109. Ibid., 444.

110. In a different but certainly adjacent field, the poet John Crowe Ransom, when he assumed the editorship of the *Kenyon Review* in 1938, wrote to Allen Tate that "the success and permanence of the review would depend on our undertaking a publication on a professional level of distinction, with no reference to local setting whatever" (Thomas Daniel Young, *Gentleman in a Dustcoat: A Biography of John Crowe Ransom* [Baton Rouge: Louisiana State University Press, 1976], 301; see also Gerald Graff, *Professing Literature: An Institutional History* [Chicago: University of Chicago Press, 1987], 157). Later on, Allan Kaprow makes a similar argument, recasting avant-garde alienation as professional involvement: "They are apt to keep to themselves no matter where they live . . . rather than enter into the neighborhood coffee-break or meetings of the P.T.A. This is not unfriendliness so much as it is a lack of commitment to the standard forms of camaraderie, a detachment born partly of the lingering vestiges of alienation and partly of the habits of reflectiveness. Their actual social life is elsewhere. . . . in this, they resemble the personnel in other specialized disciplines and industries in America" (Kaprow, "Should the Artist Become a Man of the World?" *Art News* 63, no. 6 [October 1964]: 35).

111. Morris L. Cogan, "Toward a Definition of Profession," *Harvard Educational Review* 23, no. 1 (winter 1953): 46.

112. Ibid.

113. Seitz, "Abstract-Expressionist Painting," 446 (my emphasis).

114. Kenneth Hudson, "General Education for Art Students," *College Art Journal* 16, no. 2 (winter 1957): 155. Historically, the practice of art at Washington University had divided along the lines of the liberal and the technical; in addition to the art taught at Hudson's art school—the design arts he found lacking in the college, including, at various times, illustration, design, interior decoration, metalwork, wood carving, and bookbinding—art was taught in the college in a Department of Drawing and Art History.

115. Kenneth Hudson, "The Nature and Function of a Professional School of Art," *College Art Journal* 15, no. 4 (summer 1956): 353.

116. Ibid.

117. Newman, "The Sublime Is Now" (as in note 95), 173. This is perhaps not Hudson's argument, or his alone, but part of what Lawrence Alloway named abstract expressionism's "residual sign systems," or what Robert Goldwater implied in describing Rothko's works of the late 1950s as a stop on a

tour, something we stand in front of, "much as today we look (barred from entering by a chain) at the frescoes of some no longer used ancient chapel in an Italian church" (Alloway, "Residual Sign Systems in Abstract Expressionism," *Artforum* 12, no. 3 [November 1973]: 36–42; Robert Goldwater, "Reflections on the Rothko Exhibition," *Arts* 35, no. 6 [March 1961]: 45).

118. Motherwell, *Collected Writings* (as in note 57), 55, 83.

119. Hudson, "General Education for Art Students," 155.

120. Dan Flavin, "On an American Artist's Education," *Artforum* 6, no. 7 (March 1968): 31, 28.

121. Ibid., 31.

122. Ibid., 32.

123. Ibid.

124. Ibid., 29.

Chapter 6

1. Henry S. Dyer, "College Testing and the Arts," in *The Arts in Higher Education,* ed. Lawrence E. Dennis and Renate M. Jacob (San Francisco: Jossey-Bass, 1968), 89.

2. A. Whitney Griswold, "The Natural Allies," in *The Fine Arts and the University,* ed. Murray G. Ross (Toronto: Macmillan of Canada, 1965), 12.

3. Jürgen Habermas, "Modernity—an Incomplete Project," in *The Anti-Aesthetic: Essays on Postmodern Culture,* ed. Hal Foster (Port Townsend, Wash.: Bay Press, 1983), 9.

4. Rosalind E. Krauss, *The Originality of the Avant-Garde and Other Modernist Myths* (Cambridge: MIT Press, 1985), 170.

5. Ibid., 6.

6. Howard Singerman, "Opting Out and Buying In," *LAICA Journal,* no. 19 (June–July 1978): 41.

7. Ibid.

8. Ibid.

9. Andrew Menard, "Are You Not Doing What You're Doing While You're Doing What You Are," *Fox* 1, no. 1 (1975): 39. In a footnote, Menard credits Allan Jones, who taught both of us at Antioch College, for "the idea of film and video becoming popular due to institutional support." It was Allan Jones who first introduced me to Menard's article, and, to say again what I said in my acknowledgments, in many ways this book has its roots in Yellow Springs, Ohio, in 1975. As Menard remarks of his essay, "Credit for this article is hardly mine alone" (48). Perhaps this is also the place to thank Sande Cohen for his close reading of this chapter, and for his suggestions. Part of this chapter initially appeared in the only issue of *More and Less,* a journal Cohen edited at the Art Center College of Design in Pasadena.

10. Dan Flavin, "On an American Artist's Education," *Artforum* 6, no. 7 (March 1968): 32.

11. Allan Kaprow, "Should the Artist Become a Man of the World?" *Art News* 63, no. 6 (October 1964): 37, 58.

12. Ibid., 36.

13. Raymond Parker, "Student, Teacher, Artist," *College Art Journal* 13, no. 1 (fall 1953): 29.

14. Ibid.

15. Ibid., 30.

16. Ibid., 27.

17. Ibid., 30.

18. Lucy Lippard, *Six Years: The Dematerialization of the Art Object from 1966 to 1972* (New York: Praeger, 1973), 8.

19. Krauss, *Originality of the Avant-Garde* (as in note 4), 209.

20. Ibid.

21. Ibid., 210–11.

22. Ibid., 210.

23. Ibid., 211.

24. Charles Sanders Peirce, "Logic as Semiotic: The Theory of Signs," in *Semiotics: An Introductory Anthology,* ed. Robert E. Innis (Bloomington: Indiana University Press, 1985), 11.

25. Emile Benveniste, *Problems in General Linguistics* (Coral Gables, Fla.: University of Miami Press, 1971), 219.

26. Ibid.

27. Krauss, *Originality of the Avant-Garde,* 211.

28. Ibid., 218.

29. Ibid., 217.

30. Ibid.

31. Anne Ayres and Paul Schimmel, *Chris Burden: A Twenty-Year Survey* (Newport Beach, Calif.: Newport Harbor Art Museum, 1988), 76.

32. Ibid.

33. Krauss, *Originality of the Avant-Grade,* 203.

34. Jacques Derrida, *Of Grammatology,* trans. Gayatri Chakravorty Spivak (Baltimore: Johns Hopkins University Press, 1976), 144.

35. Ibid.

36. Craig Owens, *Beyond Recognition: Representation, Power, and Culture,* ed. Scott Bryson et al. (Berkeley and Los Angeles: University of California Press, 1992), 41.

37. Jacques Derrida, "The Theater of Cruelty and the Closure of Representation," in *Writing and Difference,* trans. Alan Bass (Chicago: University of Chicago Press, 1978), 249.

38. *Directory of M.F.A. Programs in the Visual Arts,* rev. ed. (New York: College Art Association, 1996), 6.

39. Irving Sandler, "The School of Art at Yale, 1950–1970: The Collective Reminiscences of Twenty Distinguished Alumni," *Art Journal* 42, no. 1 (spring 1982): 16, 18.

40. George Wald, "The Artist in the University," in the *Report of the Committee on the Visual Arts at Harvard University* (Cambridge: Harvard University, 1956), 43.

41. "The Creative Artist Invades the University," *Arts in Society* 2, no. 3 (1963): 4.

42. Ibid.

43. Gibson Byrd, "The Artist-Teacher in America," *Art Journal* 23, no. 2 (winter 1963–64): 135.

44. Flavin, "An American Artist's Education" (as in note 10), 32.

45. Ibid., 29.

46. Ibid., 31.

47. Ibid., 29.

48. David Smith, "What I Believe about the Teaching of Sculpture," in *David Smith,* ed. Garnett McCoy (New York: Praeger, 1973), 63. Smith delivered his paper to a panel on the teaching of sculpture at the Midwestern University Art Conference in Louisville, Kentucky, October 27, 1950. Despite his blanket dismissal, and without noting the contradiction, Smith goes on to state that he "would stress anthropology such as Boas's study of the creative art in the history of man, psychology as it depicts the function of the creative mind. In writing [he] would include the study of Joyce's work . . . wherein the use of words and relationships function much as in the process of the creative artist's mind" (64). Smith's reading list, and his insistence on reading, situate him well within the discussion of abstract expressionism as a liberal art that I presented in the preceding chapter, particularly because the subject of all his reading—whatever its other subjects—is the artist.

49. Mercedes Matter, "What's Wrong with U.S. Art Schools?" *Art News* 62, no. 5 (September 1963): 41.

50. Ibid.

51. Ibid., 56.

52. Ibid.

53. Ibid.

54. Marcel Duchamp, quoted in Krauss, *Originality of the Avant-Garde* (as in note 4), 206.

55. Krauss, ibid.

56. Judith Adler, *Artists in Offices* (New Brunswick, N.J.: Transaction Books, 1979), 17.

57. Ibid.

58. Donald Kuspit, "Sol LeWitt: The Look of Thought," *Art in America* 63, no. 5 (September–October 1975): 48–50.

59. Bernar Venet, in Donald Karshan, ed., *Conceptual Art and Conceptual Aspects* (New York: New York Cultural Center, 1970), 33.

60. "James Byars speaks at the Nova Scotia College of Art and Design, Halifax, April 21, 1970," transcript in Lippard, *Six Years* (as in note 18), 163–64.

61. Ibid., 164.

62. Ibid.

63. Robert Watts, "The Artist as Teacher," in *The Arts on Campus: The Necessity for Change,* ed. Margaret Mahoney (Greenwich, Conn.: New York Graphic Society, 1970), 59. Dan Flavin, in particular, argues for the artist as a free and inclusive actor in the university: "The universities will have to permit artists to wander in their curricula without degree or responsibility" (Dan Flavin, "Some Remarks . . . Excerpts from a Spleenish Journal," *Artforum* 5, no. 4 [December 1966]: 27).

64. Ibid.

65. Krauss, *Originality of the Avant-Garde* (as in note 4), 245.

66. Ibid., 253.

67. "Specific Objects," in *Donald Judd: Complete Writings, 1959–1975* (Halifax: Press of the Nova Scotia College of Art and Design; New York: New York University Press, 1975), 184.

68. Benjamin Buchloh, "Conceptual Art, 1962–1969: From an Aesthetic of Administration to the Critique of Institutions," *October* 55 (winter 1990): 105–43.

69. Catherine Millet, "Bernar Venet: La fonction didactique de l'art conceptuel," *Art International* 14, no. 10 (December 1970): 37–39.

70. Barbara Rose, "The Value of Didactic Art," *Artforum* 5, no. 8 (April 1967): 32.

71. Ibid., 33.

72. Ibid.

73. Wald, "The Artist in the University" (as in note 40), 47, 43.

74. Sol LeWitt, quoted in Buchloh, "Conceptual Art," 140.

75. Buchloh, ibid., 121.

76. Ibid., 126.

77. Ibid., 119.

78. Ibid., 117–18.

79. Harold Rosenberg, "Educating Artists," in *New Ideas in Art Education*, ed. Gregory Battcock (New York: E. P. Dutton, 1973), 93.

80. Derrida, *Of Grammatology* (as in note 37), 238–39.

81. Paul de Man, *Allegories of Reading: Figural Language in Rousseau, Nietzsche, Rilke, and Proust* (New Haven, Conn.: Yale University Press, 1979), 14.

82. Jacques Lacan, *Ecrits: A Selection,* trans. Alan Sheridan (New York: W. W. Norton, 1977), 175, 167.

83. "Avant-Garde and Kitsch," in *Perceptions and Judgments,* vol. 1 of *Clement Greenberg: The Collected Essays and Criticism,* ed. John O'Brian (Chicago: University of Chicago Press, 1986), 8.

84. Michael Fried, *Three American Painters: Kenneth Noland, Jules Olitski, Frank Stella* (Cambridge: Fogg Art Museum, Harvard University, 1965), 44.

85. Robert Morris, "Notes on Sculpture," in *Minimal Art: A Critical Anthology,* ed. Gregory Battcock (New York: E. P. Dutton, 1968), 234.

86. Michael Fried, "Art and Objecthood," in ibid., 140.

87. Ibid.

88. Ibid., 134.

89. Ibid., 139.

90. Douglas Crimp, "Pictures," in *Art after Modernism: Rethinking Representation,* ed. Brian Wallis (New York: New Museum of Contemporary Art; Boston: David R. Godine, 1984), 176.

91. Fried, "Art and Objecthood," 145.

92. Ibid., 146.

93. Ibid., 146, 127.

94. Ibid., 127. According to Irving Sandler's recollections of Yale, being taken seriously is precisely what the work allows the members of a community of student artists, what gives them their presence as artists.

95. Crimp, "Pictures," 177.

96. Douglas Crimp, "The Photographic Activity of Postmodernism," *October* 15 (winter 1980): 92.

97. Ibid.

98. Owens, *Beyond Recognition* (as in note 36), 45.

99. Fried, "Art and Objecthood," 116–17.

100. Ibid., 117.

101. Ibid., 145. This, finally, is the lesson of the epigraph that Fried chose for "Art and Objecthood," from Perry Miller's life of Jonathan Edwards: "If all the world were annihilated . . . and a new world freshly created, though it were to exist in every particular in the same manner as this world, it would not be the same. Therefore, because there is continuity, which is time, 'it is certain with me that the world exists anew every moment; that the existence of things every moment ceases and is every moment renewed' " (116). The first choice, that of rebuilding a world as though according to a plan, as though it were mapped, has its ties to Jean Baudrillard's simulacrum, a world that would be only an image of itself, a set of conventions. The latter choice is Fried's modernism: we experience the new as natural or essential; the new eclipses the past as rebirth because there is a past, or at least a belief. It is the job of the present to perform that eclipse as an act of faith. For the conventionalist or allegorical work, as Walter Benjamin has taught, the past has always been annihilated.

102. Ibid., 146.

103. Stanley Cavell, quoted in Rosalind Krauss, "Stella's New Work and the Problem of Series," *Artforum* 10, no. 4 (December 1971): 42.

104. Rosalind Krauss, "Pictorial Space and the Question of Documentary," *Artforum* 10, no. 3 (November 1971): 69.

105. Ibid.

106. Fried, "Art and Objecthood," 144.

107. Owens, *Beyond Recognition*, 85.

108. Ibid.

109. Jean-François Lyotard, *The Postmodern Condition: A Report on Knowledge,* trans. Geoff Bennington and Brian Massumi (Minneapolis: University of Minnesota Press, 1984), 35.

110. Owens, *Beyond Recognition*, 217.

111. Lyotard, *Postmodern Condition,* 35.

112. Jean-François Lyotard, "The Sublime and the Avant-Garde," in *The Lyotard Reader,* ed. Andrew Benjamin (Oxford: Basil Blackwell, 1989), 197.

113. Norman Bryson, *Word and Image: French Painting of the Ancien Régime* (Cambridge: Cambridge University Press, 1981), 31.

114. Nikolaus Pevsner, *Academies of Art, Past and Present* (1940; reprint, New York: Da Capo Press, 1973), 60. Pevsner leaves Zuccari's words in Italian: "which '*conversazione virtuosa*' is to Zuccari, '*Madre degli studi e fonte vera di ogni scienza.*' "

115. Bryson, *Word and Image,* 256 n. 10. On the emergence of the Académie française and its struggles with the *Maîtrise,* see Thomas E. Crow, *Painters and Public Life in Eighteenth-Century Paris* (New Haven, Conn.: Yale University Press, 1985), 23–44.

116. Bryson, *Word and Image*, 32. See also Carl Goldstein, *Teaching Art: Academies and Schools from Vasari to Albers* (Cambridge: Cambridge University Press, 1996), 43.

117. Katie Scott, "Hierarchy, Liberty, and Order: Languages of Art and Institutional Conflict in Paris (1766–1776)," *Oxford Art Journal* 12, no. 2 (1989): 60.

118. Quoted in ibid., 70, 68. The academicians' legal brief echoes most directly the definition offered in a Louisiana court case in 1936. The court ruled that "if, after weighing these qualities, manual skill is found to exceed intellectual quality, then the pursuit cannot be qualified as a profession" (in Morris L. Cogan, "Toward a Definition of Profession," *Harvard Educational Review* 23, no. 1 [winter 1953]: 36).

119. Albert Boime, *The Academy and French Painting in the Nineteenth Century* (London: Phaidon Press, 1971), 4.

120. Pevsner, *Academies of Art*, 75.

121. Boime, *Academy and French Painting*, 19.

122. The tension between language and visual representation is named in Norman Bryson's coupling "Discourse, figure," which introduces and structures his history of eighteenth-century French painting and its passage from Le Brun's discursive image to the figures of the rococo and to David.

123. Federico Zuccari, quoted in Erwin Panofsky, *Idea: A Concept in Art Theory*, trans. Joseph J. S. Peake (Columbia: University of South Carolina Press, 1968), 87.

124. Ibid., 88.

125. Giovanni Pietro Bellori, quoted in ibid., 155, 157.

126. Sir Joshua Reynolds, *Discourses on Art*, ed. Robert R. Wark (London: Paul Mellon Centre for Studies in British Art; New Haven, Conn.: Yale University Press, 1975), 45.

127. Paul de Man, *Blindness and Insight: Essays in the Rhetoric of Contemporary Criticism* (Minneapolis: University of Minnesota Press, 1983), 123.

128. Jean Baudrillard, *Simulations*, trans. Paul Foss, Paul Patton, and Philip Beitchman (New York: Semiotext(e), 1983), 95.

129. Ibid., 92.

130. Henry Raleigh, "The Art Teacher versus the Teaching of Art," *Art Journal* 24, no. 1 (fall 1964): 28.

131. Ibid.

132. Ibid.

133. Ibid., 29.

134. Fried, "Art and Objecthood" (as in nn. 85, 86), 143–44.

135. Jean Baudrillard, *For a Critique of the Political Economy of the Sign*, trans. Charles Levin (Saint Louis, Mo.: Telos Press, 1981), 106.

136. Ibid., 111.

137. Ibid., 109.

138. Ibid., 110.

139. Roger de Piles, "The Principles of Painting," in *A Documentary History of Art*, ed. Elizabeth G. Holt (Garden City, N.Y.: Doubleday Anchor, 1958), 2:184.

140. *Directory of M.F.A. Programs in the Visual Arts* (as in note 38), 6.

141. Ibid., 131. Statistics on defense requirements for the degree are derived from individual listings in the directory.

142. Mark Stahl, "Towards an Appreciation: CalArts' Influence on Contemporary Art," in *CalArts: Skeptical Belief(s)*, ed. Suzanne Ghez (Newport Beach, Calif.: Newport Harbor Art Museum; Chicago: Renaissance Society at the University of Chicago, 1988), 12.

143. Hal Foster, *Recodings: Art, Spectacle, Cultural Politics* (Port Townsend, Wash.: Bay Press, 1985), 149.

Chapter 7

1. Norman Rice, "Art in Academe," *Arts in Society* 2, no. 3 (1963): 41.

2. Judith Adler, *Artists in Offices* (New Brunswick, N.J.: Transaction Books, 1979), 3.

3. Allen S. Weller, "The Ph.D. for the Creative Artist," *College Art Journal* 19, no. 4 (summer 1960): 343–44.

4. Allen S. Weller et al., "The Present Status of the M.F.A. Degree: A Report to the Midwest College Art Conference," *Art Journal* 24, no. 3 (spring 1965): 247.

5. *Directory of M.F.A. Programs in the Visual Arts*, rev. ed. (New York: College Art Association, 1996), 5.

6. Ibid.

7. Ibid., 7.

8. The CAA's statement on standards, particularly those for the relationship between studio art faculty and their departments and schools, adopted in 1970, pays close attention to the status of artists as independent professionals. The standards repeat the formal guarantees of occupational autonomy and priority that characterize professional faculties in the university. Among the association's resolutions are (1) that no academic degrees but the M.F.A. be regarded as a qualification for hiring or promotion; (2) that education degrees—the M.A. or M.A.T. in art education, for example—"shall not be required . . . [and] should not be regarded as constituting appropriate preparation"; (3) that the "evaluation of professional development and teaching effectiveness be carried out with the participation of other professional artists"; and (4) that "artists teaching at colleges or universities . . . will not be expected to provide professional services other than those directly relating to their teaching without proper additional compensation." Peer review and the exclusion of competing credentials are crucial markers of professionalization across the occupations. The last item, on the artist's services, addresses an earlier expectation that artists employed by educational institutions would provide murals or design school emblems as part of their employment. The CAA's guidelines insist that the fruits of artists' professional practice, in particular their works of art, belong to them as professionals.

9. Harold Rosenberg, "Everyman a Professional," in *The Tradition of the New* (1960; reprint, Chicago: University of Chicago Press, Phoenix Edition, 1982), 58–73.

10. Harold Wilensky, "The Professionalization of Everyone?" *American Journal of Sociology* 70, no. 2 (September 1964): 137–58.

11. Robert Goodnough, ed., "Artists' Sessions at Studio 35 (1950)," in *Modern Artists in America,* no. 1, ed. Robert Motherwell and Ad Reinhardt (New York: Wittenborn, Schultz, 1952), 21.

12. Ibid.

13. Ibid., 22.

14. See, for example, the introductory sections of Andrew Abbott, *The System of the Professions: An Essay on the Division of Expert Labor* (Chicago: University of Chicago Press, 1988), 1–20; and Bruce A. Kimball, *The "True Professional Ideal" in America: A History* (Cambridge: Blackwell, 1992), 1–10. Morris Cogan's "Toward a Definition of Profession," *Harvard Educational Review* 23, no. 1 (winter 1953): 33–51, is an early attempt at consensus.

15. Wilensky, "Professionalization of Everyone," 144. On the different development of the relations between the professions, higher education, and the state in Germany, France, Great Britain, and the United States, see Abbott, *System of the Professions,* 197–208. Whereas American universities included occupational training within the departments of the university, their European counterparts isolated them in *technische Hochschulen* or *grandes écoles.* "American universities lacked the intense hostility of European universities to the study of 'useful' subjects on the undergraduate level. . . . [T]he universities thus saw little difficulty in founding preprofessional programs. Departments of engineering, 'domestic science,' and physical education proliferated, sometimes as separate schools, but often within general faculties of arts and letters. Such departments were often upgraded to graduate status when the ethic of liberal education seized the university around the First World War" (206). Abbott could add the practice of art to his list, and he goes some way toward explaining the focus of my project in the United States, where even now, to a far greater extent than in Europe, professional training in art takes place in the university.

16. Abbott, *System of the Professions,* 15.

17. Magali Sarfatti Larson, *The Rise of Professionalism: A Sociological Analysis* (Berkeley and Los Angeles: University of California Press, 1977), xvii.

18. Ibid., 34.

19. Ibid., xvii.

20. Rolf Torstendahl, "Introduction: Promotion and Strategies of Knowledge-Based Groups," in *The Formation of Professions: Knowledge, State, and Strategy,* ed. Rolf Torstendahl and Michael Burrage (London: Sage Publications, 1990), 3.

21. Randall Collins, "Changing Conceptions in the Sociology of the Professions," in Torstendahl and Burrage, *Formation of Professions,* 19.

22. Ibid.

23. Ibid., 17–18.

24. Goodnough, "Artists' Sessions" (as in note 11), 21.

25. Pierre Bourdieu, *Distinction: A Social Critique of the Judgement of Taste,* trans. Richard Nice (Cambridge: Harvard University Press, 1984), 481.

26. Jacques Barzun, "The New Man in the Arts," *Arts in Society* 1, no. 1 (1957): 38; reprinted from the *American Scholar,* autumn 1956. By the mid sixties the rise of the amateur had become epidemic—and was viewed as disease— in Alvin Toffler's *Culture Consumers: Art and Affluence in America* (Baltimore:

Penguin Books, 1965). See also Karal Ann Marling, *As Seen on TV: The Visual Culture of Everyday Life in the 1950s* (Cambridge: Harvard University Press, 1994), chapter 2, "Hyphenated Culture: Painting by the Numbers in the New Age of Leisure."

27. Cogan, "Toward a Definition of Profession" (as in note 14), 36.

28. Larson, *Rise of Professionalism* (as in note 17), 45.

29. Gibson Danes, "The Education of the Artist," *College Art Journal* 2, no. 3 (March 1943): 71, 73.

30. Roger L. Geiger, *To Advance Knowledge: The Growth of American Research Universities, 1900–1940* (New York: Oxford University Press, 1986), 21–22.

31. Ibid., 22.

32. Wilensky, "Professionalization of Everyone" (as in note 15), 144.

33. I would like the phrase "private practice" to suggest both an artistic and a professional autonomy. The privateness of writing and painting is, of course, only relative, however central it is to the image and historical presentation of these practices. Howard S. Becker's *Art Worlds* (Berkeley and Los Angeles: University of California Press, 1982) is the classic text on the collaborativeness and worldliness of the arts.

34. Information drawn from *The Schirmer Guide to Schools of Music and Conservatories throughout the World,* ed. Nancy Uscher (New York: Schirmer Books; London: Collier Macmillan, 1988).

35. *California Institute of the Arts Bulletin 1997–98/1998–99* (Valencia: California Institute of the Arts, 1997), 57.

36. Gerald Graff, *Professing Literature: An Institutional History* (Chicago: University of Chicago Press, 1987), 138. Graff credits David Gershom Myers's dissertation, "Educating Writers: The Beginnings of 'Creative Writing' in the American University," Northwestern University, 1989, which was helpful to me as well, not only for the specifics on the passage of creative writing into the university, but also as a model for how to ask similar questions concerning studio art's place there.

37. Lester D. Longman, "Art in Colleges and Universities," in *Fortieth Yearbook of the National Society for the Study of Education: Art in American Life and Education,* ed. Guy Montrose Whipple (Chicago: University of Chicago Press, 1941), 561.

38. Ibid.

39. Edward Levine, "Vision and Its Medium," *Art Journal* 42, no. 1 (spring 1982): 49.

40. Ibid.

41. Or at least that recent sculpture that, in Donald Judd's words, "resembles sculpture more than it does painting, but . . . is nearer to painting," and grows out of the objects of minimal art. "Specific Objects," in *Donald Judd: Complete Writings, 1959–1975* (Halifax: Press of the Nova Scotia College of Art and Design; New York: New York University Press, 1975), 183.

42. Thierry de Duve, *Pictorial Nominalism: On Marcel Duchamp's Passage from Painting to the Readymade,* trans. Dana Polan with the author (Minneapolis: University of Minnesota Press, 1991), 189.

43. Geiger, *To Advance Knowledge* (as in note 30), 25–26.

44. Ibid., 25.

45. Ibid., 29.

46. Michel Foucault, *The Archaeology of Knowledge and the Discourse on Language,* trans. A. M. Sheridan (New York: Pantheon Books, 1971), 223.

47. Ibid.

48. Ibid., 224.

49. Griselda Pollock, "Art, Art School, Culture: Individualism after the Death of the Artist," *Exposure* 24, no. 3 (fall 1986): 21.

50. Ibid., 20–21.

51. Ibid., 27.

52. Ibid., 23.

53. Thomas E. Crow, "Versions of Pastoral in Some Recent Art," in *American Art of the Late Eighties: The Binational,* ed. David A. Ross and Jürgen Harten (Boston: Institute of Contemporary Art and Museum of Fine Arts; Cologne: DuMont Buchverlag, 1988), 20, 22.

54. I want to insist that this tension or doubledness of political art and theory does not necessarily disable its politics, but particularly for works of art on and in local communities, it can become an ethnographic trading in indigenous cultures, a report for outsiders on an authentic inside (see Hal Foster, *The Return of the Real: The Avant-Garde at the End of the Century* [Cambridge: MIT Press, 1996], 171–203). Much of this work, successful or not, creates a slippage between insiders and outsiders, between community members. Much recent art-political practice has relied on that anxiety, playing both inside and out of the art world as itself a local, and exclusionary, community.

55. Andrew Menard, "Are You Not Doing What You're Doing While You're Doing What You Are," *Fox* 1, no. 1 (1975): 39; punctuation as in original.

56. *American Art Directory, 1978,* 47th ed. (New York: R. R. Bowker, 1978), 329–458.

57. Michael McCall, "The Sociology of Female Artists," *Studies in Symbolic Interaction* 1 (1978): 292–93.

58. Ibid., 311.

59. Allan Kaprow, "Should the Artist Become a Man of the World?" *Art News* 63, no. 6 (October 1964): 35.

60. Peter Burke, *The Italian Renaissance: Culture and Society in Italy* (Princeton, N.J.: Princeton University Press, 1986), 43.

61. Harry Braverman, *Labor and Monopoly Capital: The Degradation of Work in the Twentieth Century* (New York: Monthly Review Press, 1974), 443.

62. Ian Burn, *Dialogue: Writings in Art History* (North Sydney: Allen and Unwin, 1991), 105.

63. Ibid., 115.

64. Ibid.

65. Bourdieu, *Distinction* (as in note 25), 2.

66. Ibid., 486.

67. Lester Longman, quoted in Virginia Le Noir Van Duzer Fitzpatrick, "Changes in Curricula, Students, Faculty, and Teaching Styles in the Art Departments at the University of Iowa and Indiana University, 1940 to 1949," Ph.D. diss., School of Education, Indiana University, 1989, 136.

68. Sande Cohen, *Academia and the Luster of Capital* (Minneapolis: University of Minnesota Press, 1993), 61.

69. *Max Weber on Universities: The Power of the State and the Dignity of the Academic Calling in Imperial Germany*, ed. and trans. Edward Shils (Chicago: University of Chicago Press, 1973), 61.

70. Michael Fried, "Art and Objecthood," in *Minimal Art: A Critical Anthology*, ed. Gregory Battcock (New York: E. P. Dutton, 1968), 144.

71. *Max Weber on Universities*, 61.

72. Ibid.

73. Herbert Marcuse, *The Aesthetic Dimension* (Boston: Beacon Press, 1978), 6.

74. "Modernist Painting," in *Modernism with a Vengeance, 1957–1969*, vol. 4 of *Clement Greenberg: The Collected Essays and Criticism*, ed. John O'Brian (Chicago: University of Chicago Press, 1993), 85.

75. Daniel Buren, "The Function of the Studio," trans. Thomas Repensek, *October* 10 (fall 1979): 51.

76. Mary Abbott, quoted in April Kingsley, *The Turning Point: The Abstract Expressionists and the Transformation of American Art* (New York: Simon and Schuster, 1992), 107.

77. Mike Kelley, a product of the University of Michigan and CalArts, has directly addressed this psychologizing of teaching, as well as its cruelty, in his recent work. Kelley's *Educational Complex* uses the discourse of child abuse and recovered "repressed memory" to place his schooling on trial: "I am the reincarnation of Hans Hofmann. Prodigal son. To Sir with love," he writes in a monologue that accompanies the handwritten abuse complaint form that names Hofmann as the "involved party." See Michael Duncan, "A Trip Down False-Memory Lane," *Art in America* 86, no. 1 (January 1998): 45–47, as well as the catalogue *Mike Kelley: The Thirteen Seasons (Heavy on the Winter)* (Cologne: Jablonka Galerie, 1995).

78. Anthony Giddens, *Modernity and Self-Identity: Self and Society in the Late Modern Age* (Stanford, Calif.: Stanford University Press, 1991), 138.

79. Bruce Robbins, *Secular Vocations: Intellectuals, Professionalism, Culture* (London: Verso, 1993), 1–28.

80. Pierre Bourdieu, "The Production of Belief: Contribution to an Economy of Symbolic Goods," *Media, Culture, and Society* 2, no. 3 (July 1980): 291.

81. de Duve, *Pictorial Nominalism* (as in note 42), 186.

82. Ibid., 188.

83. Bourdieu, "Production of Belief," 292.

84. Pierre Bourdieu, "The Invention of the Artist's Life," *Yale French Studies*, no. 73 (1988): 80. Bourdieu's use of *le sérieux* differs from mine here, or rather its fit here in relation to the university-trained artist differs from that of Bourdieu's Flaubert in the 1840s and 1850s. Seriousness is what Frédéric, the would-be artist of Flaubert's *Sentimental Education*, lacks and—as a publicly worn mark of class membership—what Flaubert as a writer eschews. But the mutual inheritance, the "reciprocal appropriation," that so troubles Frédéric is precisely what a university offers and a discipline demands.

85. Ibid.

BIBLIOGRAPHY

Abbott, Andrew. *The System of the Professions: An Essay on the Division of Expert Labor.* Chicago: University of Chicago Press, 1988.

Adams, David. "Frederick S. Lamb's Opalescent Vision of 'A Broader Art.' " In *The Substance of Style: Perspectives on the American Arts and Crafts Movement,* edited by Bert Denker. Winterthur, Del.: Henry Francis du Pont Winterthur Museum, 1996.

Adams, Philip R. "The Fine Arts in Liberal Education." *College Art Journal* 7, no. 3 (spring 1948): 184–90.

Adler, Judith. *Artists in Offices.* New Brunswick, N.J.: Transaction Books, 1979.

Albrecht, Milton C., James H. Barnett, and Mason Griff, eds. *The Sociology of Art and Literature: A Reader.* New York: Praeger, 1970.

Alford, John. "Art, Science, and the Humanities in the College Curriculum, I. The Scope of the Problem." *College Art Journal* 5, no. 3 (March 1946): 162–79.

———. "Practice Courses in College Art Departments: A Survey." *Parnassus* 12, no. 7 (November 1940): 11–14.

Allen, James Sloan. *The Romance of Commerce and Culture: Capitalism, Modernism, and the Chicago-Aspen Crusade for Cultural Reform.* Chicago: University of Chicago Press, 1983.

Alloway, Lawrence. "Residual Sign Systems in Abstract Expressionism." *Artforum* 12, no. 3 (November 1973): 36–42.

American Artists' Congress. *First American Artists' Congress.* New York: American Artists' Congress against War and Fascism, 1936.

Anscombe, Isabelle. *A Woman's Touch: Women in Design from 1860 to the Present Day.* New York: Elizabeth Sifton Books, 1984.

Antler, Joyce. *The Educated Woman and Professionalization: The Struggle for a New Feminine Identity, 1890–1920.* New York: Garland Press, 1987.

Arnason, H. H. "On Robert Motherwell and His Early Work." *Art International* 10, no. 1 (January 1966): 17–35.

Arnheim, Rudolf. *Toward a Psychology of Art: Collected Essays.* Berkeley and Los Angeles: University of California Press, 1966.

Ash, Mitchell G. *Gestalt Psychology in German Culture, 1890–1967: Holism and the Quest for Objectivity.* Cambridge: Cambridge University Press, 1995.

Ayres, Anne, and Paul Schimmel. *Chris Burden: A Twenty-Year Survey.* Newport Beach, Calif.: Newport Harbor Art Museum, 1988.

Bach, Richard F. "Schools, Colleges, and the Industrial Arts." *Art Bulletin* 2, no. 3 (1920): 171–75.

Bailey, Henry Turner. *Art Education.* Boston: Houghton Mifflin, 1914.

Barnes, Albert C. *The Art in Painting.* New York: Harcourt, Brace and Company, 1926.

Barron, Frank. *Artists in the Making.* New York: Seminar Press, 1972.

———. "Originality in Relation to Personality and Intellect." *Journal of Personality* 25, no. 6 (December 1957): 730–42.

Barthes, Roland. *Critical Essays.* Translated by Richard Howard. Evanston, Ill.: Northwestern University Press, 1972.

Barzun, Jacques. "The New Man in the Arts." *Arts in Society* 1, no. 1 (1957): 38–46.

Baudelaire, Charles. *Art in Paris, 1845–1862: Salons and Other Exhibitions.* Edited and translated by Jonathan Mayne. Ithaca, N.Y.: Cornell University Press, 1981.

Baudrillard, Jean. *For a Critique of the Political Economy of the Sign.* Translated by Charles Levin. Saint Louis, Mo.: Telos Press, 1981.

———. *Simulations.* Translated by Paul Foss, Paul Patton, and Philip Beitchman. New York: Semiotext(e), 1983.

Bayer, Herbert, Walter Gropius, and Ise Gropius, eds. *Bauhaus, 1919–1928.* New York: Museum of Modern Art, 1938.

Beam, Lura. "The Place of Art in the Liberal College." *Association of American Colleges Bulletin* 13, no. 3 (May 1927): 265–89.

Beaux, Cecilia. "What Should the College A.B. Course Offer to the Future Artist?" *American Magazine of Art* 7, no. 12 (October 1916): 479–84.

Becker, Carol. Speakeasy. *New Art Examiner* 18, no. 6 (February 1991): 15–17.

Becker, Howard S. *Art Worlds.* Berkeley and Los Angeles: University of California Press, 1982.

Bell, Clive. *Art.* 1913. Reprint. New York: G. P. Putnam's Sons, Capricorn Books, 1958.

Benjamin, Walter. *Illuminations.* Edited by Hannah Arendt, translated by Harry Zohn. New York: Schocken Books, 1969.

Benveniste, Emile. *Problems in General Linguistics.* Coral Gables, Fla.: University of Miami Press, 1971.

Bermingham, Ann. "The Aesthetics of Ignorance: The Accomplished Woman in the Culture of Connoisseurship." *Oxford Art Journal* 16, no. 2 (1993): 3–20.

Blanc, Charles. *The Grammar of Painting and Engraving.* Translated by Kate Newell Doggett. New York: Hurd and Houghton, 1875.

Boas, George. *The Cult of Childhood.* London: Warburg Institute, 1966.

Boime, Albert. *The Academy and French Painting in the Nineteenth Century.* London: Phaidon Press, 1971.

———. "The Teaching Reforms of 1863 and the Origins of Modernism in France." *Art Quarterly* 1, n.s. (1977): 1–39.

Borch-Jacobsen, Mikkel. *Lacan: The Absolute Master.* Translated by Douglas Brick. Stanford, Calif.: Stanford University Press, 1991.

Boris, Eileen. *Art and Labor: Ruskin, Morris, and the Craftsman Ideal in America.* Philadelphia: Temple University Press, 1986.

Bothwell, Dorr, and Marlys Mayfield. *Notan: The Dark-Light Principle of Design.* 1968. Reprint. New York: Dover Publications, 1991.

Bourdieu, Pierre. *Distinction: A Social Critique of the Judgement of Taste.* Translated by Richard Nice. Cambridge: Harvard University Press, 1984.

———. "The Invention of the Artist's Life." *Yale French Studies,* no. 73 (1988): 75–103.

———. "The Production of Belief: Contribution to an Economy of Symbolic Goods." *Media, Culture, and Society* 2, no. 3 (July 1980): 261–93.

Braverman, Harry. *Labor and Monopoly Capital: The Degradation of Work in the Twentieth Century.* New York: Monthly Review Press, 1974.

Breihaupt, Erwin M. "The Basic Art Course at Georgia." *College Art Journal* 17, no. 1 (fall 1957): 19–29.

Breslin, James E. B. *Mark Rothko: A Biography.* Chicago: University of Chicago Press, 1993.

Brosterman, Norman. *Inventing Kindergarten.* New York: Harry N. Abrams, 1997.

Brown, Alice V. V. "Standardization of Art Courses." *Art Bulletin* 1, no. 4 (1918): 110–13.

Bryson, Norman. *Word and Image: French Painting of the Ancien Régime.* Cambridge: Cambridge University Press, 1981.

Buchloh, Benjamin. "Conceptual Art, 1962–1969: From an Aesthetic of Administration to the Critique of Institutions." *October* 55 (winter 1990): 105–43.

Bullen, J. B., ed. *Post-Impressionists in England: The Critical Reception.* London: Routledge, 1988.

Buren, Daniel. "The Function of the Studio." Translated by Thomas Repensek. *October* 10 (fall 1979): 51–58.

Burke, Peter. *The Italian Renaissance: Culture and Society in Italy.* Princeton, N.J.: Princeton University Press, 1986.

Burn, Ian. *Dialogue: Writings in Art History.* North Sidney: Allen and Unwin, 1991.

Byrd, Gibson. "The Artist-Teacher in America." *Art Journal* 23, no. 2 (winter 1963–64): 130–35.

Callen, Anthea. *Angel in the Studio: Women in the Arts and Crafts Movement, 1870–1914.* London: Astragal Books, 1979.

Campbell, James R. "The Pratt Institute." *Century Illustrated Monthly Magazine* 46, no. 6 (October 1893): 870–83.

Cavaliere, Barbara, and Robert C. Hobbs. "Against a Newer Laocoon." *Arts Magazine* 51, no. 8 (April 1977): 110–17.

Cézanne, Paul. *Paul Cézanne Letters*. Edited by John Rewald. London: Bruno Cassirer, 1941.

Cheney, Sheldon. *Expressionism in Art*. New York: Liveright, 1934.

Chipp, Herschel B. *Theories of Modern Art: A Source Book by Artists and Critics*. Berkeley and Los Angeles: University of California Press, 1968.

Cizek, Franz. *Children's Coloured Paper Work*. Vienna: Anton Schroll, 1927.

Clark, Eliot. *History of the National Academy of Design, 1925–1953*. New York: Columbia University Press, 1954.

Clark, T. J. "In Defense of Abstract Expressionism." *October* 69 (summer 1994): 23–48.

Cogan, Morris L. "Toward a Definition of Profession." *Harvard Educational Review* 23, no. 1 (winter 1953): 33–50.

Cohen, Sande. *Academia and the Luster of Capital*. Minneapolis: University of Minnesota Press, 1993.

Coleman, Caryl. "Art in Industries and the Outlook for the Art Student." *Craftsman* 2, no. 4 (July 1902): 189–94.

College Art Association. *Directory of M.F.A. Programs in the Visual Arts*. New York: College Art Association, 1992.

———. *Directory of M.F.A. Programs in the Visual Arts*. Rev. ed. New York: College Art Association, 1996.

College Art News: "New Art Buildings." *College Art Journal* 17, no. 2 (winter 1958): 201.

Collier, Graham. *Form, Space, and Vision: Discovering Design through Drawing*. Englewood Cliffs, N.J.: Prentice Hall, 1967.

Collins, Georgia C. "Women and Art: The Problem of Status." *Studies in Art Education* 21, no. 1 (1979): 57–64.

Committee of the College Art Association. "The Practice of Art in a Liberal Education." *College Art Journal* 6, no. 2 (winter 1946): 91–97.

———. "A Statement on the Practice of Art Courses." *College Art Journal* 4, no. 1 (November 1944): 33–38.

Committee on the Objectives of a General Education in a Free Society. *General Education in a Free Society, Report of the Harvard Committee*. Cambridge: Harvard University Press, 1945.

Committee on the Visual Arts. *Report of the Committee on the Visual Arts at Harvard University*. Cambridge: Harvard University, 1956.

Corse, Sarah M., and Victoria D. Alexander. "Education and Artists: Changing Patterns in the Training of Painters." *Current Research on Occupations and Professions* 8 (1993): 101–17.

Cox, Kenyon. *The Classic Point of View*. With introductory notes by Henry Hope Reed and Pierce Rice. 1911. Reprint. New York: W. W. Norton, 1980.

Crary, Jonathan. *Techniques of the Observer: On Vision and Modernity in the Nineteenth Century*. Cambridge: MIT Press, 1992.

Craven, Thomas. "Men of Art: American Style." *American Mercury* 6, no. 24 (December 1925): 425–32.

"The Creative Artist Invades the University." *Arts in Society* 2, no. 3 (1963): 2–5.

Crimp, Douglas. "The Photographic Activity of Postmodernism." *October* 15 (winter 1980): 91–101.

————. "Pictures." In *Art after Modernism: Rethinking Representation,* edited by Brian Wallis. New York: New Museum of Contemporary Art; Boston: David R. Godine, 1984.

Crow, Thomas E. *Painters and Public Life in Eighteenth-Century Paris.* New Haven, Conn.: Yale University Press, 1985.

————. "Versions of Pastoral in Some Recent Art." In *American Art of the Late Eighties: The Binational,* edited by David A. Ross and Jürgen Harten. Boston: Institute of Contemporary Art and Museum of Fine Arts; Cologne: DuMont Buchverlag, 1988.

Danes, Gibson. "The Education of the Artist." *College Art Journal* 2, no. 3 (March 1943): 70–73.

De Duve, Thierry. "Das Ende des Bauhaus-Modells." In *Akademie zwischen Kunst und Lehre: Künstlerische Praxis und Ausbildung—eine kritische Untersuchung,* edited by Denys Zacharopoulos. Vienna: Akademie der bildenden Künste Wien, 1992.

————. *Pictorial Nominalism: On Marcel Duchamp's Passage from Painting to the Readymade.* Translated by Dana Polan with the author. Minneapolis: University of Minnesota Press, 1991.

————. "Resonances of Duchamp's Visit to Munich." In *Marcel Duchamp: Artist of the Century,* edited by Rudolf E. Kuenzli and Francis M. Naumann. Cambridge and London: MIT Press, 1990.

Deitcher, S. David. "Teaching the Late Modern Artist: From Mnemonics to the Technology of Gestalt." Ph.D. diss., City University of New York, 1989.

De Lauretis, Teresa. *Technologies of Gender: Essays on Theory, Film, and Fiction.* Bloomington: Indiana University Press, 1987.

De Man, Paul. *Allegories of Reading: Figural Language in Rousseau, Nietzsche, and Proust.* New Haven, Conn.: Yale University Press, 1979.

————. *Blindness and Insight: Essays in the Rhetoric of Contemporary Criticism.* Minneapolis: University of Minnesota Press, 1983.

Dennis, Lawrence E., and Renate M. Jacob. *The Arts in Higher Education.* San Francisco: Jossey-Bass, 1968.

Derrida, Jacques. *Of Grammatology.* Translated by Gayatri Chakravorty Spivak. Baltimore: Johns Hopkins University Press, 1976.

————. *The Truth in Painting.* Translated by Geoff Bennington and Ian McLeod. Chicago: University of Chicago Press, 1987.

————. *Writing and Difference.* Translated by Alan Bass. Chicago: University of Chicago Press, 1978.

Dewey, John. *Art as Experience.* New York: Minton, Balch and Company, 1934.

Dewey, John, Albert C. Barnes, Laurence Buermeyer, Thomas Munro, Paul Guillaume, Mary Mullen, and Violette de Mazia. *Art and Education.* Merion, Pa.: Barnes Foundation Press, 1929.

Dickerson, Albert I. *The Orozco Frescoes at Dartmouth.* Hanover, N.H.: Dartmouth College Publications, 1934.

Dow, Arthur Wesley. *Composition: A Series of Exercises in Art Structure for the Use of Students and Teachers.* 13th ed. 1913. Reprint. Garden City, N.Y.: Doubleday, Doran and Company, 1931.

————. "Training in the Theory and Practice of Teaching Art." *Teachers College Record* 9, no. 3 (May 1908): 133–86.

————. "What Kind of Art Courses Are Suitable for the College A.B. Curriculum?" *Art Bulletin* 1, no. 2 (1917): 10–11.

Dudek, Stephanie Z. "Portrait of the Artist as a Rorschach Reader." *Psychology Today*, May 1971, 46–47, 78–84.

Duffus, R. L. *The American Renaissance*. New York: Alfred A. Knopf, 1928.

Durst, David. "Artists and College Art Teaching." *College Art Journal* 16, no. 3 (spring 1957): 222–29.

Efland, Arthur D. "Changing Views of Children's Artistic Development: Their Impact on Curriculum and Instruction." In *The Arts, Human Development, and Education,* edited by Elliot W. Eisner. Berkeley, Calif.: McCutchan Publishing, 1976.

————. *A History of Art Education: Intellectual and Social Currents in Teaching the Visual Arts*. New York: Teachers College Press, 1990.

Fahlman, Betsy. *John Ferguson Weir: The Labor of Art*. Newark: University of Delaware Press, 1997.

————. "Women Art Students at Yale, 1869–1913: Never True Sons of the University." *Woman's Art Journal* 12, no. 1 (spring–summer 1991): 15–23.

Fiedler, Conrad. *Konrad Fiedlers Schriften über Kunst,* 2 vols. Edited by Hermann Konnerth. Munich: R. Piper, 1913–1914.

————. *On Judging Works of Visual Art*. Translated by Henry Schaefer-Simmern and Fulmer Mood. Berkeley and Los Angeles: University of California Press, 1957.

Fitzpatrick, Virginia Le Noir Van Duzer. "Changes in Curricula, Students, Faculty, and Teaching Styles in the Art Departments of the University of Iowa and Indiana University, 1940 to 1949." Ph.D. diss., School of Education, Indiana University, 1989.

Flavin, Dan. "On an American Artist's Education." *Artforum* 6, no. 7 (March 1968): 28–32.

————. "Some Remarks . . . Excerpts from a Spleenish Journal." *Artforum* 5, no. 4 (December 1966): 27–29.

Folds, Thomas M. "Letter to a College Committee." *College Art Journal* 16, no. 1 (fall 1956): 59–63.

Foster, Hal. *Recodings: Art, Spectacle, Cultural Politics*. Port Townsend, Wash.: Bay Press, 1985.

————. *The Return of the Real: The Avant-Garde at the End of the Century*. Cambridge: MIT Press, 1996.

————, ed. *The Anti-Aesthetic: Essays on Postmodern Culture*. Port Townsend, Wash.: Bay Press, 1983.

Foucault, Michel. *The Archaeology of Knowledge and the Discourse on Language*. Translated by A. M. Sheridan. New York: Pantheon Books, 1971.

————. *The History of Sexuality*. Vol. 1. New York: Vintage Books, 1980.

Franciscono, Marcel. *Walter Gropius and the Creation of the Bauhaus in Weimar: The Ideals and Artistic Theories of Its Founding Years*. Urbana: University of Illinois Press, 1971.

Frank, Peter. "Patterns in the Support Structure for California Art." *LAICA Journal*, no. 19 (June–July 1978): 42–43.

Frankenstein, Alfred. "University of Mississippi." *Art Digest* 29, no. 8 (January 15, 1955): 26.

Freedman, Jonathan. *Professions of Taste: Henry James, British Aestheticism, and Commodity Culture.* Stanford, Calif.: Stanford University Press, 1990.

Fried, Michael. "Art and Objecthood." In *Minimal Art: A Critical Anthology,* edited by Gregory Battcock. New York: E. P. Dutton, 1968.

———. *Three American Painters: Kenneth Noland, Jules Olitski, Frank Stella.* Cambridge: Fogg Art Museum, Harvard University, 1965.

Fry, Roger. *Vision and Design.* 1920. Reprint. New York: Meridian Books, 1956.

Garrett, Lillian. *Visual Design: A Problem-Solving Approach.* New York: Reinhold, 1967.

Geiger, Roger L. *Research and Relevant Knowledge: American Research Universities since World War II.* New York: Oxford University Press, 1993.

———. *To Advance Knowledge: The Growth of American Research Universities, 1900–1940.* New York: Oxford University Press, 1986.

Gerrard, Mary D. " 'Of Men, Women and Art': Some Historical Reflections." *Art Journal* 35, no. 4 (summer 1976): 324–29.

Ghez, Suzanne, ed. *CalArts: Skeptical Belief(s).* Newport Beach, Calif.: Newport Harbor Art Museum; Chicago: Renaissance Society of the University of Chicago, 1988.

Giddens, Anthony. *Modernity and Self-Identity: Self and Society in the Late Modern Age.* Stanford, Calif.: Stanford University Press, 1991.

Goldstein, Carl. *Teaching Art: Academies and Schools from Vasari to Albers.* Cambridge: Cambridge University Press, 1996.

———. "Teaching Modernism: What Albers Learned in the Bauhaus and Taught to Rauschenberg, Noland, and Hesse." *Arts Magazine* 54, no. 4 (December 1979): 108–16.

Goldwater, Robert. "Reflections on the Rothko Exhibition." *Arts* 35, no. 6 (March 1961): 42–45.

———. "The Teaching of Art in the Colleges of the United States." *College Art Journal* 2, no. 4, supplement (May 1943): 3–31.

Gombrich, E. H. *Art and Illusion: A Study in the Psychology of Pictorial Representation.* 2d ed., rev. 1961. Reprint. Princeton, N.J.: Princeton University Press, Bollingen Paperback Edition, 1969.

———. *The Sense of Order: A Study in the Psychology of Decorative Art.* Ithaca, N.Y.: Cornell University Press, 1979.

Goodman, Cynthia. "The Hans Hofmann School and Hofmann's Transmission of European Modernist Aesthetics to America." Ph.D. diss., University of Pennsylvania, 1982.

Goodnough, Robert, ed. "Artists' Sessions at Studio 35 (1950)." In *Modern Artists in America,* no. 1, edited by Robert Motherwell and Ad Reinhardt. New York: Wittenborn, Schultz, 1952.

Goodsell, Willystine, ed. *Pioneers of Women's Education in the United States.* New York: McGraw-Hill, 1931.

Graff, Gerald. *Professing Literature: An Institutional History.* Chicago: University of Chicago Press, 1987.

Gray, Christopher. "Cézanne's Use of Perspective." *College Art Journal* 19, no. 1 (fall 1959): 54–64.

Greenberg, Clement. *Clement Greenberg: The Collected Essays and Criticism.* 4 vols. Edited by John O'Brian. Chicago: University of Chicago Press, 1986–93.

Griffin, Worth D. "University Art Training for What?" *College Art Journal* 11, no. 2 (winter 1951–52): 87–92.

Gropius, Walter. *The New Architecture and the Bauhaus.* Translated by P. Morton Shand, with an introduction by Frank Pick. Cambridge: MIT Press, 1965.

———. "Teaching the Arts of Design." *College Art Journal* 7, no. 3 (spring 1948): 160–64.

Hadler, Mona, and Jerome Viola. *Brooklyn College Art Department: Past and Present, 1942–1977.* Brooklyn: Brooklyn College Art Department, 1977.

Hahn, Peter. "Bauhaus and Exile: Bauhaus Architects and Designers between the Old World and the New." In *Exiles and Emigrés: The Flight of European Artists from Hitler,* edited by Stephanie Barron with Sabine Eckmann. Los Angeles: Los Angeles County Museum of Art, 1997.

Hardin, James, ed. *Reflection and Action: Essays on the Bildungsroman.* Columbia: University of South Carolina Press, 1991.

Harris, Ann Sutherland. "Women in College Art Departments and Museums." *Art Journal* 32, no. 4 (summer 1973): 417–19.

Harrison, Charles, and Paul Wood, eds. *Art in Theory, 1900–1990: An Anthology of Changing Ideas.* Oxford: Blackwell, 1992.

Hartmann, Sadakichi. "The Exhibition of Children's Drawings." *Camera Work,* no. 39 (July 1912): 45–46.

Heidegger, Martin. "The Age of the World Picture." In *The Question concerning Technology and Other Essays.* Translated by William Lovitt. New York: Garland, 1977.

Hekking, William M. "What Kind of Technical Art Shall Be Taught to the A.B. Student?" *Art Bulletin* 1, no. 3 (1917): 32–34.

Herdeg, Klaus. *The Decorated Diagram: Harvard Architecture and the Failure of the Bauhaus Legacy.* Cambridge: MIT Press, 1983.

Hess, Thomas. *Barnett Newman.* New York: Museum of Modern Art, 1971.

Hewison, Robert. *John Ruskin: The Argument of the Eye.* Princeton, N.J.: Princeton University Press, 1976.

Hirsch, Stefan. "An Appraisal of Contemporary Art Education." *College Art Journal* 10, no. 2 (winter 1950–51): 150–56.

Hiss, Priscilla, and Roberta Hansler. *Research in the Fine Arts in the Colleges and Universities of the United States.* New York: Carnegie Corporation, 1934.

Hofstadter, Richard, and Wilson Smith, eds. *American Higher Education: A Documentary History.* 2 vols. Chicago: University of Chicago Press, 1961.

Holt, Elizabeth G., ed. *A Documentary History of Art.* Vol. 2. Garden City, N.Y.: Doubleday Anchor, 1958.

Hubbard, Guy Albert. "The Development of the Visual Arts in the Curriculums of American Colleges and Universities." Ph.D. diss., School of Education, Stanford University, 1962.

Hudson, Kenneth. "General Education for Art Students." *College Art Journal* 16, no. 2 (winter 1957): 146–55.

———. "The Nature and Function of a Professional School of Art." *College Art Journal* 15, no. 4 (summer 1956): 352–54.

Hurlburt, Laurance P. *The Mexican Muralists in the United States.* Albuquerque: University of New Mexico Press, 1989.

Hyde, Gertrude S. "Ways and Means of Securing Proper Recognition for Art Teaching in Our Colleges and Universities." *Art Bulletin* 1, no. 4 (1918): 58–61.

Itten, Johannes. *Design and Form: The Basic Course at the Bauhaus.* Translated by John Maass. New York: Reinhold, 1964.

Janson, H. W. "Letter on the Education of Artists in Colleges." *College Art Journal* 4, no. 4 (May 1945): 213–16.

Jarves, James Jackson. *The Art-Idea: Part Second of Confessions of an Inquirer.* New York: Hurd and Houghton, 1864.

Jarzombek, Mark. "De-Scribing the Language of Looking: Wölfflin and the History of Aesthetic Experimentalism." *Assemblage,* no. 23 (April 1994): 29–69.

Jones, Caroline. *Machine in the Studio: Constructing the Postwar American Artist.* Chicago: University of Chicago Press, 1996.

Judd, Donald. *Donald Judd: Complete Writings, 1959–1975.* Halifax: Press of the Nova Scotia College of Art and Design; New York: New York University Press, 1975.

Junod, Philippe. *Transparence et Opacité: Essai sur les fondements théoriques de l'Art Moderne.* Lausanne: Editions L'Age d'Homme, 1976.

Kandinsky, Wassily. *Kandinsky: Complete Writings on Art,* edited by Kenneth C. Lindsay and Peter Vergo. 2 vols. Boston: G. K. Hall, 1982.

Kaprow, Allan. "The Effect of Recent Art on the Teaching of Art." *Art Journal* 23, no. 2 (winter 1963–64): 136–38.

———. "Should the Artist Become a Man of the World?" *Art News* 63, no. 6 (October 1964): 34–37, 58–59.

Karlstrom, Paul J., ed. *On the Edge of America: California Modernist Art, 1900–1950.* Berkeley and Los Angeles: University of California Press, in association with the Archives of American Art, Smithsonian Institution, and the Fine Arts Museums of San Francisco, 1996.

Karshan, Donald, ed. *Conceptual Art and Conceptual Aspects.* New York: New York Cultural Center, 1970.

Kellein, Thomas, ed. *Clyfford Still: The Buffalo and San Francisco Collections.* Munich: Prestel-Verlag, 1992.

Kelley, Mike. *Mike Kelley: The Thirteen Seasons (Heavy on the Winter).* Cologne: Jablonka Gallery, 1995.

Kendall, Fanny. "Lowly Artist Now Earns Big Sums." *Art Student.* School of Applied Art, Battle Creek, Mich. (1920): 9–10.

Kepes, Gyorgy. *Language of Vision.* Chicago: Paul Theobald and Company, 1944.

Keppel, Frederick P., and R. L. Duffus. *The Arts in American Life.* Recent Social Trends in the United States. New York: McGraw-Hill, 1933.

Kimball, Bruce A. *The "True Professional Ideal" in America: A History.* Cambridge: Blackwell, 1992.

Kingsley, April. *The Turning Point: The Abstract Expressionists and the Transformation of American Art.* New York: Simon and Schuster, 1992.

Koffka, Kurt. *Principles of Gestalt Psychology.* New York: Harcourt, Brace and Company, 1935.

Kohler, Wolfgang. *Gestalt Psychology.* New York: Horace Liveright, 1929.

Korzenik, Diana. "The Artist as the Model Learner." In *The Educational Legacy of Romanticism,* edited by John Willinsky. Waterloo, Ontario: Wilfred Laurier University Press, 1990.

Kramer, Hilton. "California Students." *Art Digest* 29, no. 4 (November 15, 1954): 26–27.

Krauss, Rosalind E. *The Optical Unconscious.* Cambridge: MIT Press, 1993.

———. *The Originality of the Avant-Garde and Other Modernist Myths.* Cambridge: MIT Press, 1985.

———. "Pictorial Space and the Question of Documentary." *Artforum* 10, no. 3 (November 1971): 68–71.

———. "Stella's New Work and the Problem of Series." *Artforum* 10, no. 4 (December 1971): 41–44.

Kris, Ernst, and Otto Kurz. *Legend, Myth, and Magic in the Image of the Artist: A Historical Experiment.* New Haven, Conn.: Yale University Press, 1979.

Kristeller, Paul Oskar. "The Modern System of the Arts: A Study in the History of Aesthetics." In *Studies in Renaissance Thought and Letters.* Vol. 3. Rome: Edizioni di Storia e di Letteratura, 1993.

Kuspit, Donald. "Sol LeWitt: The Look of Thought." *Art in America* 63, no. 5 (September–October 1975): 48–50.

Lacan, Jacques. *Ecrits: A Selection.* Translated by Alan Sheridan. New York: W. W. Norton, 1977.

———. *The Four Fundamental Concepts of Psycho-Analysis.* Edited by Jacques-Alain Miller, translated by Alan Sheridan. New York: W. W. Norton, 1978.

Lambourne, Lionel. *Utopian Craftsmen: The Arts and Crafts Movement from the Cotswolds to Chicago.* Salt Lake City, Utah: Peregrine Smith, 1980.

Landauer, Susan. *The San Francisco School of Abstract Expressionism.* Laguna Beach: Laguna Art Museum; Berkeley and Los Angeles: University of California Press, 1996.

Larson, Magali Sarfatti. *The Rise of Professionalism: A Sociological Analysis.* Berkeley and Los Angeles: University of California Press, 1977.

Lasko, Peter. "The Student Years of the *Brücke* and Their Teachers." *Art History* 20, no. 1 (March 1997): 61–99.

Lears, T. J. Jackson. *No Place of Grace: Antimodernism and the Transformation of American Culture, 1880–1920.* New York: Pantheon Books, 1981.

Lee, Anthony W. "Diego Rivera's *The Making of a Fresco* and Its San Francisco Public." *Oxford Art Journal* 19, no. 2 (1996): 72–82.

Lee, Rensselaer. *Ut Pictura Poesis: The Humanistic Theory of Painting.* New York: W. W. Norton, 1967.

Leja, Michael. "Modernism's Subjects in the United States." *Art Journal* 55, no. 2 (summer 1996): 65–72.

Levine, Edward. "Vision and Its Medium." *Art Journal* 42, no. 1 (spring 1982): 48–49.

Levy, Florence N. "Art Education: A Brief Statistical Survey Made by the American Federation of Arts." *Art and Progress* 6, no. 8 (June 1915): 281–82.

Lippard, Lucy. *Six Years: The Dematerialization of the Art Object from 1966 to 1972.* New York: Praeger, 1973.

Logan, Frederick M. *Growth of Art in American Schools.* New York: Harper and Brothers, 1955.

————. "Kindergarten and Bauhaus." *College Art Journal* 10, no. 1 (fall 1950): 36–43.

Longman, Lester D. "Better American Art." *Parnassus* 12, no. 6 (October 1940): 4–5.

————. "Why Not Educate Artists in Colleges?" *College Art Journal* 4, no. 3 (March 1945): 132–36.

Loran, Erle. *Cézanne's Composition: Analysis of His Form with Diagrams and Photographs of His Motifs.* 2d. ed. Berkeley and Los Angeles: University of California Press, 1946.

Lovano-Kerr, Jessie, Vicki Semmler, and Enid Zimmerman. "A Profile of Art Educators in Higher Education: Male/Female Comparative Data." *Studies in Art Education* 18, no. 2 (1977): 21–77.

Lowry, W. McNeil. "The University and the Creative Arts." *Arts in Society* 2, no. 3 (1963): 7–21.

Lukehart, Peter M., ed. *The Artist's Workshop.* Washington, D.C.: National Gallery of Art, 1993.

Lyotard, Jean-François. *The Lyotard Reader.* Edited by Andrew Benjamin. Oxford: Basil Blackwell, 1989.

————. *The Postmodern Condition: A Report on Knowledge.* Translated by Geoff Bennington and Brian Massumi. Minneapolis: University of Minnesota Press, 1984.

Macdonald, Stuart. *The History and Philosophy of Art Education.* New York: American Elsevier, 1970.

Macherey, Pierre. *A Theory of Literary Production.* Translated by Geoffrey Wall. London: Routledge and Kegan Paul, 1978.

Madge, Charles, and Barbara Weinberger. *Art Students Observed.* London: Faber and Faber, 1973.

Malvern, S. B. "Inventing 'Child Art': Franz Cizek and Modernism." *British Journal of Aesthetics* 35, no. 3 (July 1995): 262–72.

Manzella, David. "The Teaching of Art in the Colleges of the United States." *College Art Journal* 15, no. 3 (spring 1956): 241–51.

Marcuse, Herbert. *The Aesthetic Dimension.* Boston: Beacon Press, 1978.

Marling, Karal Ann. *As Seen on TV: The Visual Culture of Everyday Life in the 1950s.* Cambridge: Harvard University Press, 1994.

Marzio, Peter C. *The Art Crusade: An Analysis of American Drawing Manuals, 1820–1860.* Washington, D.C.: Smithsonian Institution Press, 1976.

Matter, Mercedes. "What's Wrong with U.S. Art Schools?" *Art News* 62, no. 5 (September 1963): 40–41, 56–58.

McCall, Michael. "The Sociology of Female Artists." *Studies in Symbolic Interaction* 1 (1978): 289–318.

McCausland, Elizabeth, Royal Bailey Farnum, and Dana P. Vaughan, eds. and comps. *Art Professions in the United States.* New York: Cooper Union Art School, 1950.

McChesney, Mary Fuller. *A Period of Exploration: San Francisco, 1945–1950.* Oakland, Calif.: Oakland Museum Art Department, 1973.

Meltzoff, Stanley. "David Smith and Social Surrealism." *Magazine of Art* 39, no. 3 (March 1946): 98–101.

Menard, Andrew. "Are You Not Doing What You're Doing While You're Doing What You Are." *Fox* 1, no. 1 (1975): 31–48.

Meyer, Ursula. *Conceptual Art.* New York: E. P. Dutton, 1972.

Millet, Catherine. "Bernar Venet: La fonction didactique de l'art conceptuel." *Art International* 14, no. 10 (December 1970): 37–39.

Mitchell, W. J. T. "Spatial Form in Literature: Toward a General Theory." In *The Language of Images,* edited by W. J. T. Mitchell. Chicago: University of Chicago Press, 1980.

Modern Artists in America, no. 1. Edited by Robert Motherwell and Ad Reinhardt. New York: Wittenborn, Schultz, 1952.

Moffatt, Frederick C. *Arthur Wesley Dow (1857–1922).* Washington, D.C.: Smithsonian Institution Press, 1977.

Moholy-Nagy, László. *The New Vision* (1928), 4th rev. ed., and *Abstract of an Artist.* New York: Wittenborn, Schultz, 1947.

———. *Vision in Motion.* Chicago: Paul Theobald and Company, 1956.

Mohr, Joland Ethel. "Higher Education and the Development of Professionalism in Post–Civil War America: A Content Analysis of Inaugural Addresses Given by Selected Land-Grant College and University Presidents, 1867–1911." Ph.D. diss., University of Minnesota, 1984.

Monroe, Gerald M. "The Artists Union of New York." Ph.D. diss., New York University, 1971.

Moretti, Franco. *The Way of the World: The Bildungsroman in European Culture.* London: Verso, 1987.

Morey, Charles R. "The Fine Arts in Higher Education." *College Art Journal* 3, no. 1 (November 1943): 2–10.

Morris, Robert. "Notes on Sculpture." In *Minimal Art: A Critical Anthology,* edited by Gregory Battcock. New York: E. P. Dutton, 1968.

Morris, William. *William Morris: Stories in Prose, Stories in Verse, Shorter Poems, Lectures, and Essays.* Edited by G. D. H. Cole. London: Nonesuch Press, 1948.

Motherwell, Robert. *The Collected Writings of Robert Motherwell.* Edited by Stephanie Terenzio. New York: Oxford University Press, 1992.

Munsterberg, Hugo. *American Patriotism and Other Social Studies.* New York: Moffat, Yard and Company, 1913.

Myers, David Gershom. "Educating Writers: The Beginnings of 'Creative Writing' in the American University." Ph.D. diss., Northwestern University, 1989.

Nesbit, Molly. "Ready-Made Originals: The Duchamp Model." *October* 37 (summer 1986): 53–64.

Neumann, Eckhard, ed. *Bauhaus and Bauhaus People,* rev. ed. New York: Van Nostrand Reinhold, 1993.

Nevins, Allan. *The State Universities and Democracy.* Urbana: University of Illinois Press, 1962.

Newbill, Al. "University of Colorado Group." *Art Digest* 29, no. 2 (October 15, 1954): 30.

Newmen, Barnett. *Barnett Newman: Selected Writings and Interviews.* Edited by John P. O'Neill. Berkeley and Los Angeles: University of California Press, 1992.

Ocvirk, Otto G., Robert O. Bone, Robert E. Stinson, and Philip R. Wigg. *Art Fundamentals: Theory and Practice,* 4th ed. Dubuque, Iowa: Wm. C. Brown, Publishers, 1981.

O'Neill, John P., ed. *Clyfford Still.* New York: Metropolitan Museum of Art and Harry N. Abrams, 1979.

Orozco, José Clemente. "New World, New Races, and New Art." *Creative Art* 4, no. 1 (January 1929): 44–46.

Owens, Craig. *Beyond Recognition: Representation, Power, and Culture.* Edited by Scott Bryson, Barbara Kruger, Lynne Tillman, and Jane Weinstock. Berkeley and Los Angeles: University of California Press, 1992.

Palmer, Archie M., and Grace Holton. *College Instruction in Art.* Washington, D.C.: Association of American Colleges, 1934.

Panofsky, Erwin. *Idea: A Concept in Art Theory.* Translated by Joseph J. S. Peake. Columbia: University of South Carolina Press, 1968.

———. *Meaning in the Visual Arts.* Garden City, N.Y.: Doubleday Anchor, 1955.

Parker, Raymond. "Student, Teacher, Artist." *College Art Journal* 13, no. 1 (fall 1953): 27–30.

Parsons, Talcott. *Action Theory and the Human Condition.* New York: Free Press, 1978.

Peirce, Charles Sanders. "Logic as Semiotic: The Theory of Signs." In *Semiotics: An Introductory Anthology,* edited by Robert E. Innis. Bloomington: Indiana University Press, 1985.

Perry, Walter S. "The Art School: Its Relation to the Arts and Crafts." *Craftsman* 2, no. 4 (July 1902): 195–200.

Pevsner, Nikolaus. *Academies of Art, Past and Present.* 1940. Reprint. New York: Da Capo Press, 1973.

———. *Pioneers of Modern Design from William Morris to Walter Gropius.* New York: Museum of Modern Art, 1949.

———. *The Sources of Modern Architecture and Design.* New York: Praeger, 1968.

Pickard, John. "The Future of the College Art Association." *Art Bulletin* 2, no. 1 (1919): 5–9.

———. "President's Address (April 26, 1916)." *Art Bulletin* 1, no. 2 (1917): 13–15.

———. "President's Address (April 6, 1917)." *Art Bulletin* 1, no. 3 (1917): 42–46.

Plagens, Peter. *Sunshine Muse: Contemporary Art on the West Coast.* New York: Praeger, 1974.

Pollock, Griselda. "Art, Art School, Culture: Individualism after the Death of the Artist." *Exposure* 24, no. 3 (fall 1986): 20–33.

Pope, Arthur. *Art, Artist, and Layman: A Study of the Teaching of the Visual Arts.* Cambridge: Harvard University Press, 1937.

———. *The Language of Drawing and Painting.* Cambridge: Harvard University Press, 1949.

———. Letters to the Editor: "On Training Artists." *College Art Journal* 6, no. 3 (spring 1947): 226–28.

———. "The Teaching of Drawing and Design in Secondary Schools." *Art Bulletin* 1, no. 3 (1917): 46–51.

Prossor, John. "Introduction to Abstract Painting." *Apollo* 66 (1957): 75–87.

Raleigh, Henry. "The Art Teacher versus the Teaching of Art." *Art Journal* 24, no. 1 (fall 1964): 27–29.

Rannells, Edward W. "The Midwestern College Art Conference." *College Art Journal* 3, no. 2 (January 1944): 64–68.

———. "The Theory of Requiredness in the Understanding of Art." *College Art Journal* 5, no. 1 (November 1945): 15–17.

———. "Training the Eye to See." *College Art Journal* 5, no. 2 (January 1946): 113–16.

Reff, Theodore. "Cézanne on Solids and Spaces." *Artforum* 16, no. 2 (October 1977): 34–37.

Reinhardt, Ad. *Art-as-Art: The Selected Writings of Ad Reinhardt.* Edited by Barbara Rose. New York: Viking Press, 1975.

Reynolds, Sir Joshua. *Discourses on Art.* Edited by Robert R. Wark. London: Paul Mellon Centre for Studies in British Art; New Haven, Conn.: Yale University Press, 1975.

Rice, Norman, "Art in Academe." *Arts in Society* 2, no. 3 (1963): 38–49.

Richard, Lionel. *Encyclopédie du Bauhaus.* Paris: Editions Somogy, 1985.

Risatti, Howard. "A Failing Curricula." *New Art Examiner* 17, no. 1 (September 1989): 24–26.

———. "Formal Education." *New Art Examiner* 20, no. 6 (February 1993): 12–15.

———. "Protesting Professionalism." *New Art Examiner* 18, no. 6 (February 1991): 22–24.

Risenhoover, Morris, and Robert T. Blackburn. *Artists as Professors: Conversations with Musicians, Painters, Sculptors.* Urbana: University of Illinois Press, 1976.

Ritchie, Andrew C., director. *The Visual Arts in Higher Education.* New York: College Art Association, 1966.

Rivera, Diego. *Portrait of America.* With an explanatory text by Bertram D. Wolfe. New York: Covici, Friede, 1934.

———. "The Revolution in Painting." *Creative Art* 4, no. 1 (January 1929): 23–30.

Robbins, Bruce. *Secular Vocations: Intellectuals, Professionalism, Culture.* London: Verso, 1993.

Robertson, David Allan, ed. *American Universities and Colleges.* Washington, D.C.: American Council on Education; New York: Charles Scribner's Sons, 1928.

Robson, Deirdre. "The Market for Abstract Expressionism: The Time Lag between Critical and Commercial Acceptance." *Journal of the Archives of American Art* 25, no. 3 (1985): 19–23.

Rochfort, Desmond. *The Murals of Diego Rivera.* With a political chronology by Julia Engelhardt. London: Journeyman Press, 1987.

Roos, Frank J. "Art Department: The University of Georgia." *Parnassus* 12, no. 8 (December 1940): 20–22.

Rose, Barbara. "The Value of Didactic Art." *Artforum* 5, no. 8 (April 1967): 32–36.

——, ed. *Readings in American Art, 1900–1973.* New York: Holt, Rinehart and Winston, 1975.

Rosenberg, Harold. *The Anxious Object.* 1966. Reprint. Chicago: University of Chicago Press, Phoenix Edition, 1982.

——. "Educating Artists." In *New Ideas in Art Education*, edited by Gregory Battcock. New York: E. P. Dutton, 1973.

——. *The Tradition of the New.* 1960. Reprint. Chicago: University of Chicago Press, Phoenix Edition, 1982.

Ross, Murray G., ed. *The Fine Arts and the University.* Toronto: Macmillan of Canada, 1965.

Rubin, Jeanne S. "The Froebel-Wright Kindergarten Connection: A New Perspective." *Journal of the Society of Architectural Historians* 48 (March 1989): 24–37.

Rubin, Laurie, Evonne Levy, Gabriele Bleeke-Byrne, Anne E. Dawson, Patricia Lynn Price, Victoria Potts, J. Duncan Berry, Cynthia E. Roman, Laura Olmstead Tonelli, Chittima Amornpichetkul, and Mary Braun-Anderson. *Children of Mercury: The Education of Artists in the Sixteenth and Seventeenth Centuries.* Providence, R.I.: Department of Art, Brown University, 1984.

Rubin, William, ed. *Cézanne: The Late Work.* New York: Museum of Modern Art, 1977.

Rudolph, Frederick. *The American College and University: A History.* Athens: University of Georgia Press, 1990.

Rury, John L. *Education and Women's Work: Female Schooling and the Division of Labor in Urban America, 1870–1930.* Albany: State University of New York Press, 1991.

Rusk, William Sener, ed. *Methods of Teaching the Fine Arts.* Chapel Hill: University of North Carolina Press, 1935.

Ruskin, John. *The Elements of Drawing; Three Letters to Beginners.* New York: John Wiley and Sons, 1886.

——. *Lectures on Art Delivered before the University of Oxford in Hilary Term, 1870.* Oxford: Clarendon Press, 1870.

——. *Sesame and Lilies.* New York: John Wiley and Sons, 1889.

——. *The Works of John Ruskin.* Vol. 16. Edited by E. T. Cook and Alexander Wedderburn. London: George Allen; New York: Longmans, Green and Company, 1905.

Sandler, Irving. "The School of Art at Yale, 1950–1970: The Collective Reminiscences of Twenty Distinguished Alumni." *Art Journal* 42, no. 1 (spring 1982): 14–21.

Sawin, Martica. "Hunter College Students." *Art Digest* 29, no. 13 (April 1, 1955): 27–28.

"Schools of Design Form Association." *Art Digest* 22, no. 20 (September 15, 1948): 38.

Schwartz, Marvin D. "News and Views from New York." *Apollo* 66 (1957): 193–94.

Scott, Katie. "Hierarchy, Liberty, and Order: Languages of Art and Institutional Conflict in Paris (1766–1776)." *Oxford Art Journal* 12, no. 2 (1989): 59–70.

Seitz, William C. "Abstract-Expressionist Painting in America: An Interpretation Based on the Work and Thoughts of Six Key Figures." Ph.D. diss., Princeton University, 1955.

Sheehy, Jeanne. "The Flight from South Kensington: British Artists at the Antwerp Academy." *Art History* 20, no. 1 (March 1997): 124–53.

Shiff, Richard. *Cézanne and the End of Impressionism: A Study of the Theory, Technique, and Critical Evaluation of Modern Art.* Chicago: University of Chicago Press, 1984.

Singerman, Howard. "Opting Out and Buying In." *LAICA Journal,* no. 19 (June–July 1978): 40–41.

Smith, David. *David Smith.* Edited by Garnett McCoy. New York: Praeger, 1973.

Smith, Holmes. "Problems of the College Art Association." *Art Bulletin* 1, no. 1 (1913): 6–10.

Smith, Richard Cándida. *Utopia and Dissent: Art, Poetry, and Politics in California.* Berkeley and Los Angeles: University of California Press, 1995.

Soucy, Donald, and Mary Ann Stankiewicz, eds. *Framing the Past: Essays on Art Education.* Reston, Va.: National Art Education Association, 1990.

Stafford, Barbara Maria. *Body Criticism: Imaging the Unseen in Enlightenment Art and Medicine.* Cambridge: MIT Press, 1991.

Stankiewicz, Mary Ann. "The Creative Sister: An Historical Look at Women, the Arts, and Higher Education." *Studies in Art Education* 24, no. 1 (1982): 48–56.

———. " 'The Eye is a Nobler Organ': Ruskin and American Art Education." *Journal of Aesthetic Education* 18, no. 2 (summer 1984): 51–64.

Stein, Roger B. *John Ruskin and Aesthetic Thought in America, 1840–1900.* Cambridge: Harvard University Press, 1967.

Steppat, Leo. "Can Creative Art Be Taught in College?" *College Art Journal* 10, no. 4 (summer 1951): 385–88.

Still, Clyfford. "Cézanne: A Study in Evaluation." Master's thesis, Washington State University, Pullman, 1935.

Summers, David. "The 'Visual Arts' and the Problem of Art Historical Description." *Art Journal* 42, no. 4 (winter 1982): 301–10.

Taylor, Harold. "Symposium Statement: The Role of the University as a Cultural Leader." *Arts in Society* 3, no. 4 (1965–66): 456–65.

Taylor, James Monroe, and Elizabeth Hazelton Haight. *Vassar.* New York: Oxford University Press, 1915.

Terman, Lewis M., and Catharine Cox Miles. *Sex and Personality: Studies in Masculinity and Femininity.* New York: McGraw-Hill, 1936.

Teuber, Marianne L. "*Blue Night* by Paul Klee." In *Vision and Artifact,* edited by Mary Henle. New York: Springer, 1976.

Thompson, Eleanor Wolf. *Education for Ladies, 1830–1860: Ideas on Education in Magazines for Women.* New York: King's Crown Press, 1947.

Tickner, Lisa. "Men's Work? Masculinity and Modernism." *Differences* 4, no. 3 (1992): 1–37.

Toffler, Alvin. *The Culture Consumers: Art and Affluence in America.* Baltimore: Penguin Books, 1965.

Torstendahl, Rolf, and Michael Burrage, eds. *The Formation of Professions: Knowledge, State, and Strategy.* London: Sage Publications, 1990.

Triggs, Oscar Lovell. *Chapters in the History of the Arts and Crafts Movement.* 1902. Reprint. New York: Arno Press, 1979.

Tuchman, Maurice, ed. *New York School: The First Generation, Paintings of the 1940s and 1950s.* Los Angeles: Los Angeles County Museum of Art, 1965.

Vattimo, Gianni. *The Transparent Society.* Translated by David Webb. Baltimore: Johns Hopkins University Press, 1992.

Veblen, Thorstein. *The Theory of the Leisure Class: An Economic Study of Institutions.* New York: Macmillan Company, 1905.

Veysey, Laurence R. *The Emergence of the American University.* Chicago: University of Chicago Press, 1965.

Viola, Wilhelm. *Child Art and Franz Cizek.* Vienna: Austrian Junior Red Cross, 1936.

Wangler, Wolfgang, and Katja Rose. *Bauhaus—gegenständliches Zeichnen bei Josef Albers.* Cologne: Verlag der Zeitschrift "Symbol," 1987.

Watrous, James S. "Technique Courses as Art History." *College Art Journal* 2, no. 1 (November 1942): 7–11.

Watts, Robert. "The Artist as Teacher." In *The Arts on Campus: The Necessity for Change,* edited by Margaret Mahoney. Greenwich, Conn.: New York Graphic Society, 1970.

Wayne, June. "The Male Artist as a Stereotypical Female." *Art Journal* 32, no. 4 (summer 1973): 414–16.

Weber, Max. *Max Weber on Universities: The Power of the State and the Dignity of the Academic Calling in Imperial Germany.* Edited and translated by Edward Shils. Chicago: University of Chicago Press, 1973.

Weinberg, Jonathan. *Speaking for Vice: Homosexuality in the Art of Charles Demuth, Marsden Hartley, and the First American Avant-Garde.* New Haven, Conn.: Yale University Press, 1993.

Weinberg, Louis. "What Kind of Technical Art Shall Be Taught to the A.B. Student?" *Art Bulletin* 1, no. 3 (1917): 35–42.

Weller, Allen S. "The Ph.D. for the Creative Artist." With responses by Manuel Barkan, F. Louis Hoover, and Kenneth E. Hudson. *College Art Journal* 19, no. 4 (summer 1960): 343–52.

Weller, Allen S., Norman Boothby, Jerome J. Hausman, Henry R. Hope, Alden Megrew, Frank Seiberling, and James R. Shipley. "The Present Status of the M.F.A. Degree: A Report to the Midwest College Art Conference." *Art Journal* 24, no. 3 (spring 1965): 244–49.

Wheeler, Candace. "Art Education for Women." *Outlook,* no. 55 (January 2, 1897): 81–87.

Whipple, Guy Montrose, ed. *Fortieth Yearbook of the National Society for the Study of Education: Art in American Life and Education.* Chicago: University of Chicago Press, 1941.

White, Barbara Ehrlich. "A 1974 Perspective: Why Women's Studies in Art and Art History?" *Art Journal* 35, no. 4 (summer 1976): 340–44.

White, Barbara Ehrlich, and Leon S. White. "Survey on the Status of Women in College Art Departments." *Art Journal* 32, no. 4 (summer 1973): 420–22.

Whitford, Frank. *Bauhaus.* London: Thames and Hudson, 1984.

Wickiser, Ralph L. "The Artist as a Teacher." *College Art Journal* 11, no. 2 (winter 1951–52): 121–22.

Wilensky, Harold L. "The Professionalization of Everyone?" *American Journal of Sociology* 70, no. 2 (September 1964): 137–58.

Wilson, Brent, and Harland Hoffa. *The History of Art Education: Proceedings from the Penn State Conference.* Reston, Va.: National Art Education Association, 1985.

Wingler. Hans M. *The Bauhaus: Weimar, Dessau, Berlin, Chicago.* Cambridge: MIT Press, 1969.

Woodward, Ellsworth. "Supply and Demand." *Art Bulletin* 2, no. 2 (1919): 71–77.

———. "What Instruction in Art Should the College A.B. Course Offer to the Future Artist?" *Art Bulletin* 1, no. 2 (1917): 19–20.

Woody, Thomas. *A History of Women's Education in the United States.* 2 vols. New York: Science Press, 1929.

Wygant, Foster. *Art in American Schools in the Nineteenth Century.* Cincinnati, Ohio: Interwood Press, 1983.

Ziegfeld, Ernest. *Art in the College Program of General Education.* New York: Teachers College, 1953.

INDEX